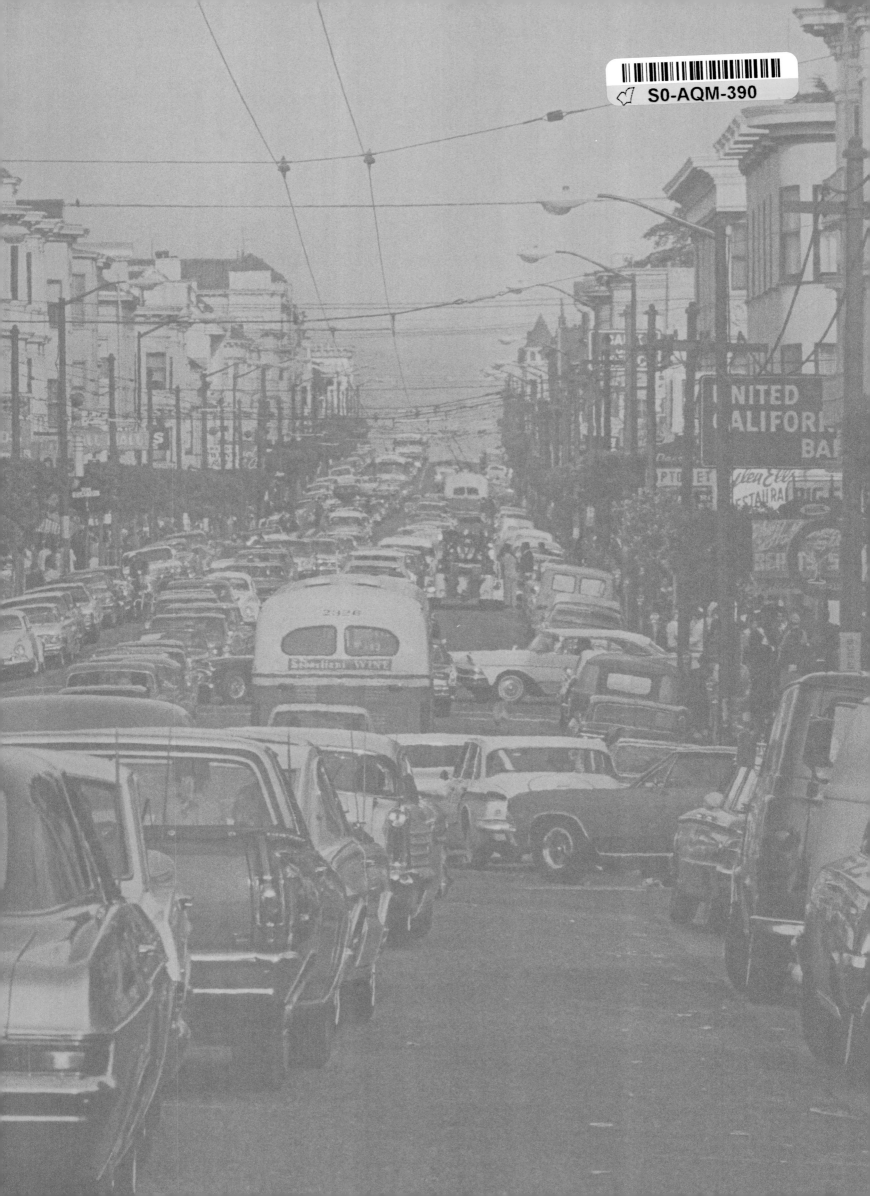

Help
In
Producing
Peacefull
Individual
Existence

I KNOW YOU BELIEVE YOU UNDERSTAND WHAT YOU THINK I SAID, BUT I AM NOT SURE YOU REALIZE THAT WHAT YOU HEARD IS NOT WHAT I MEANT.

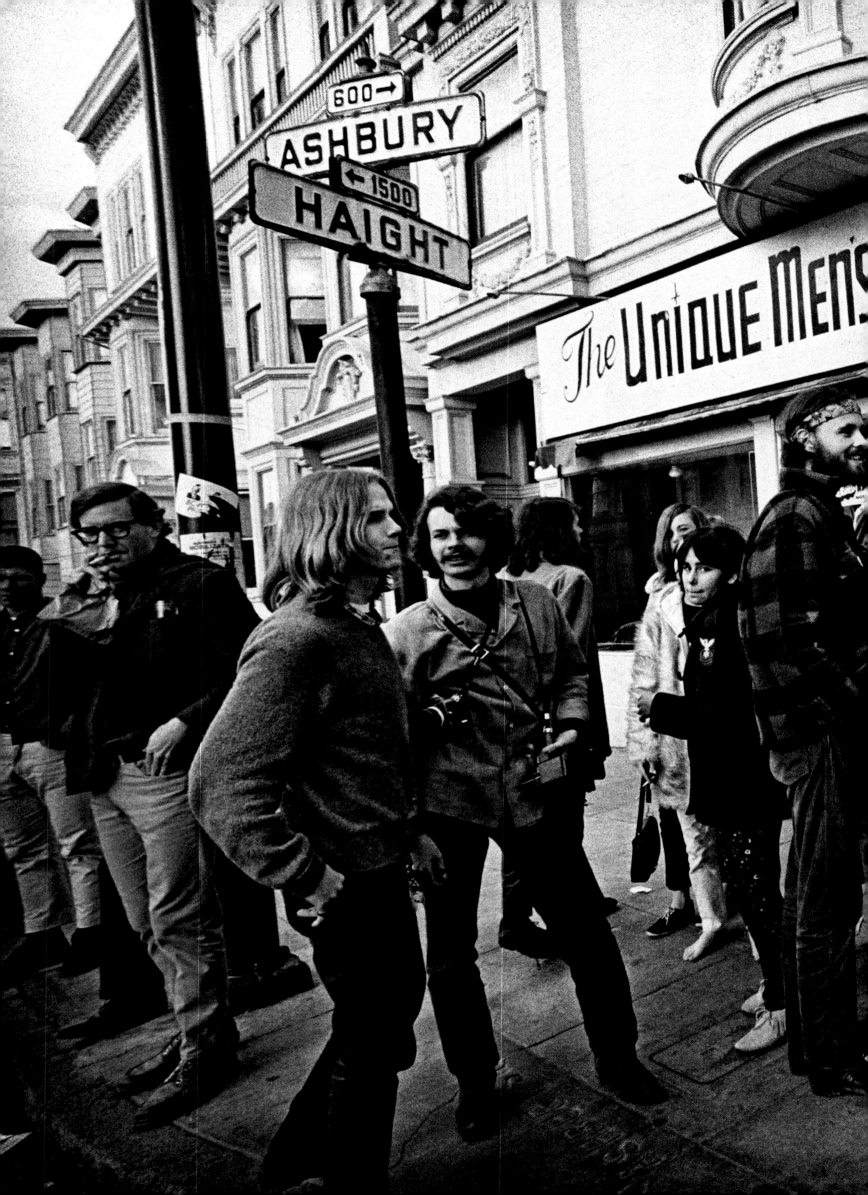

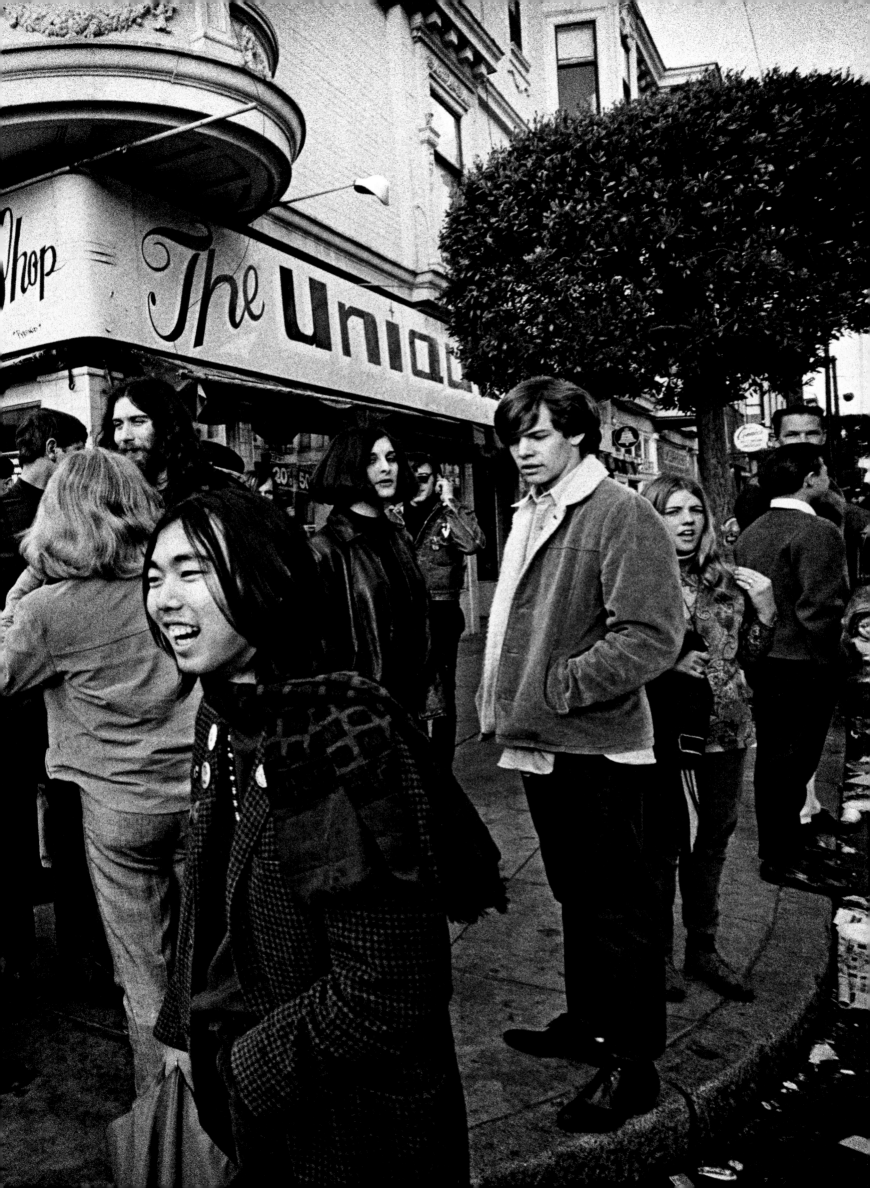

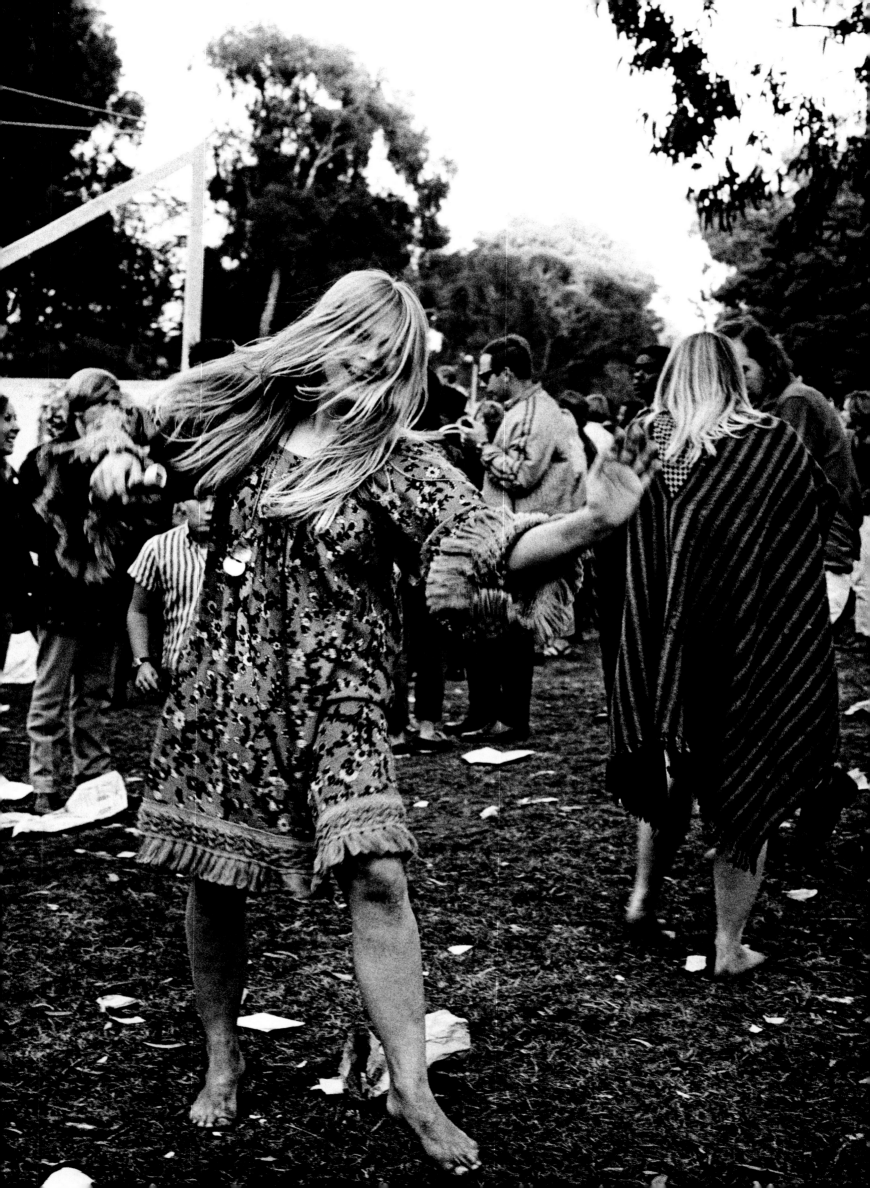

THE HAIGHT

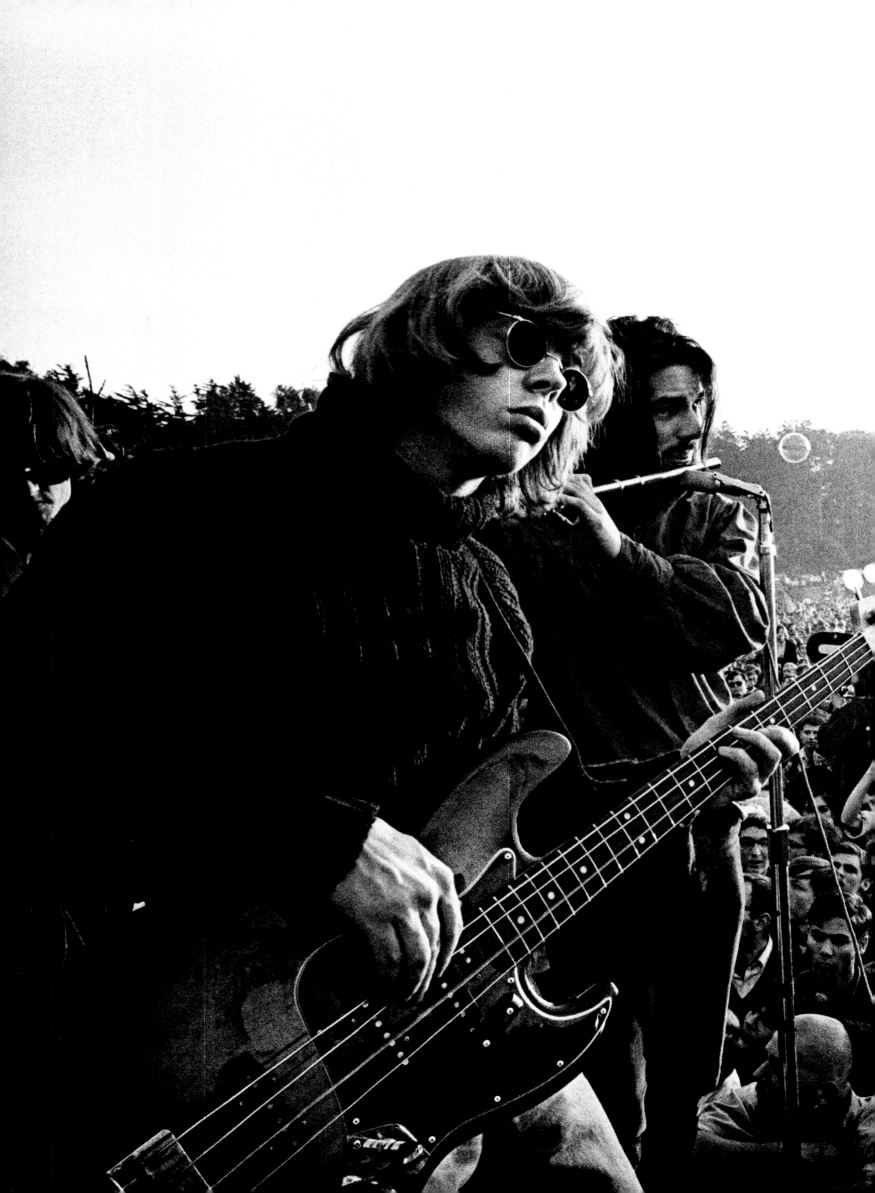

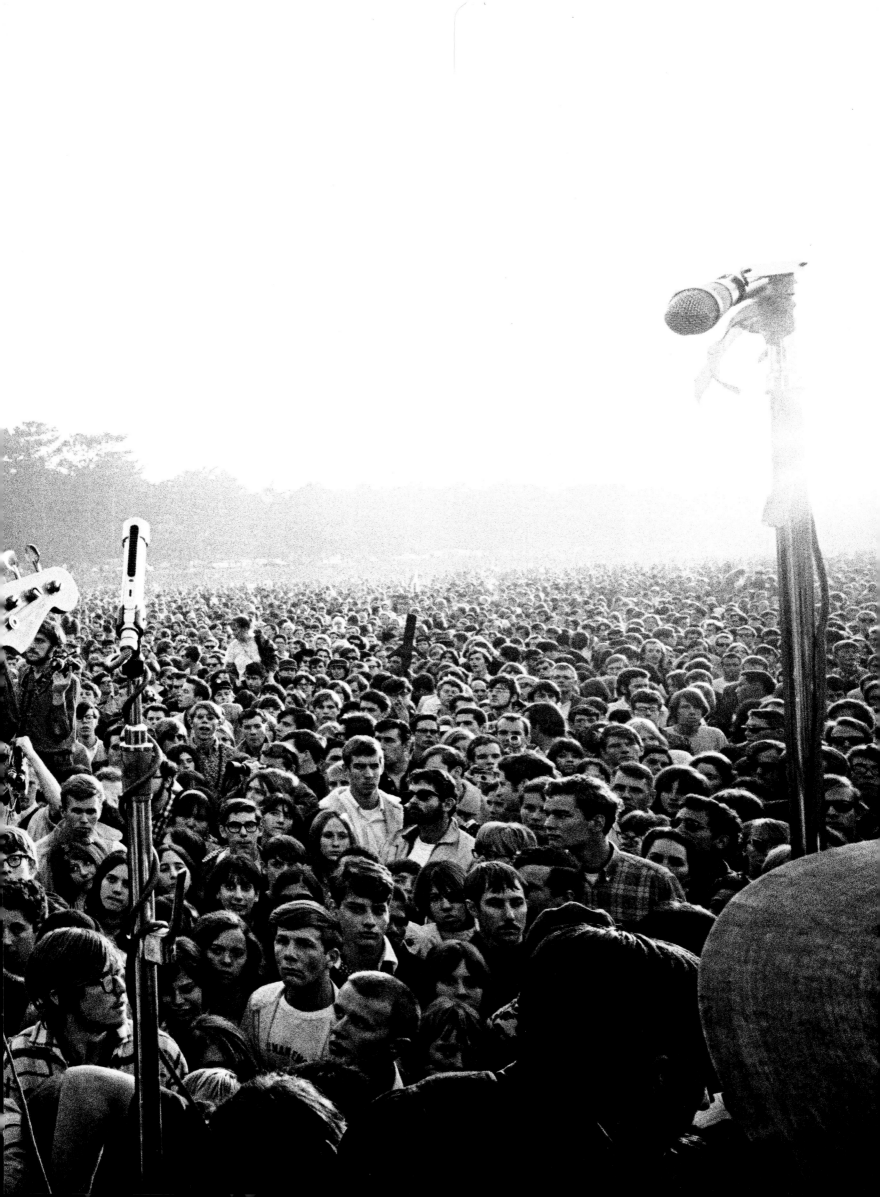

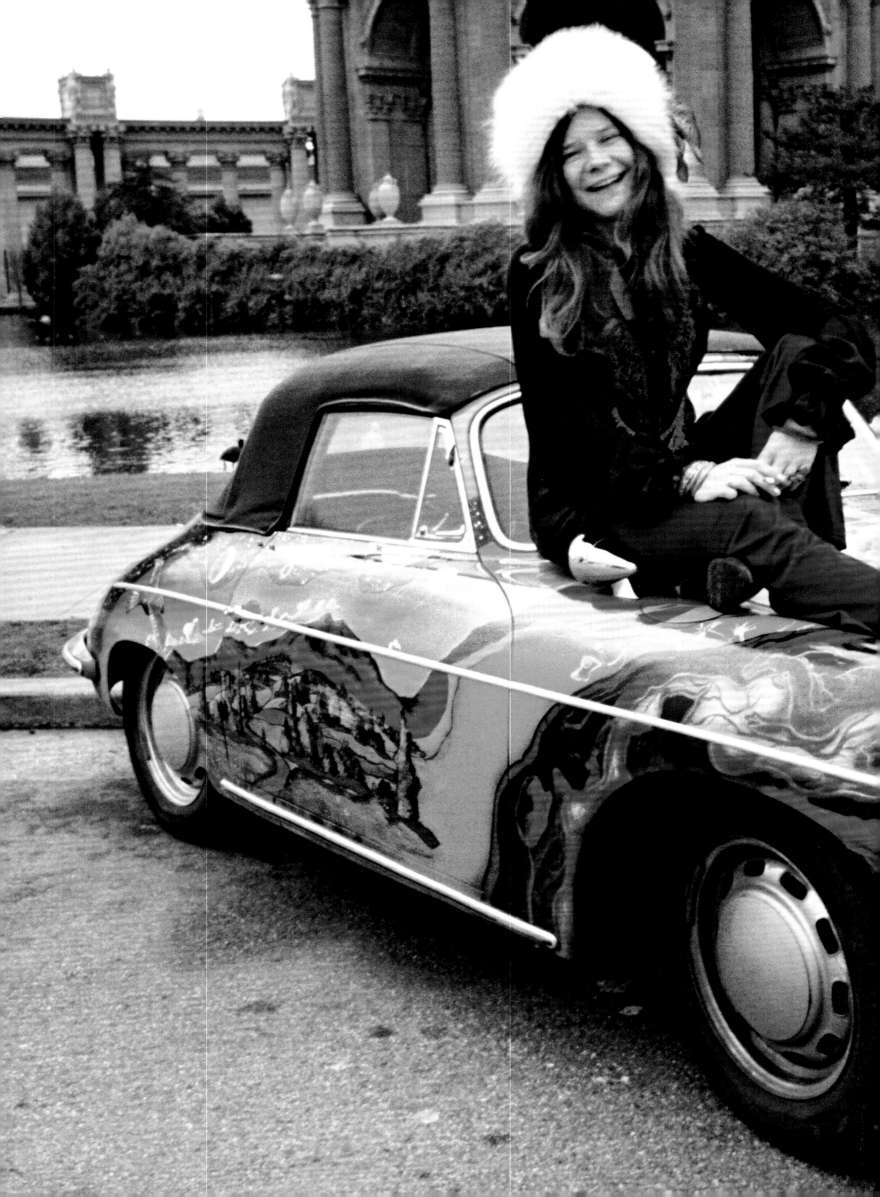

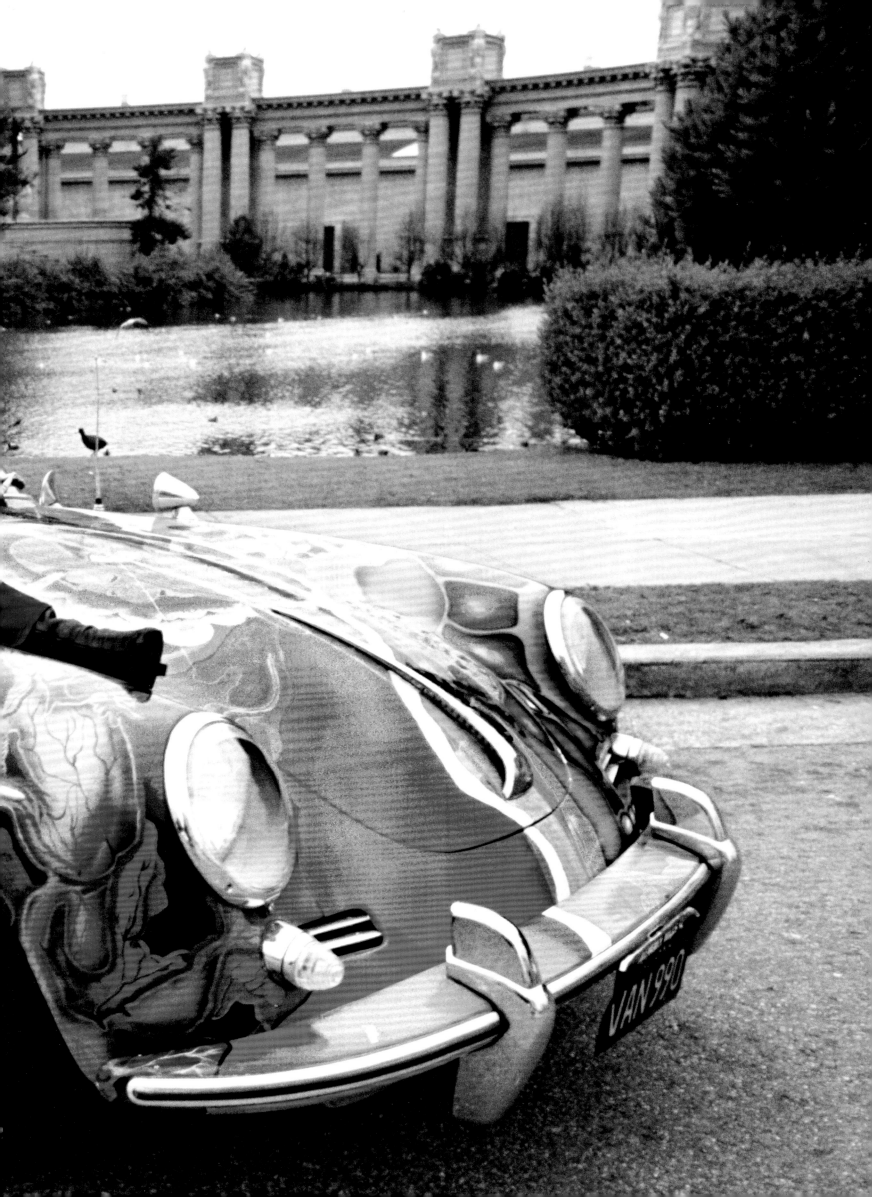

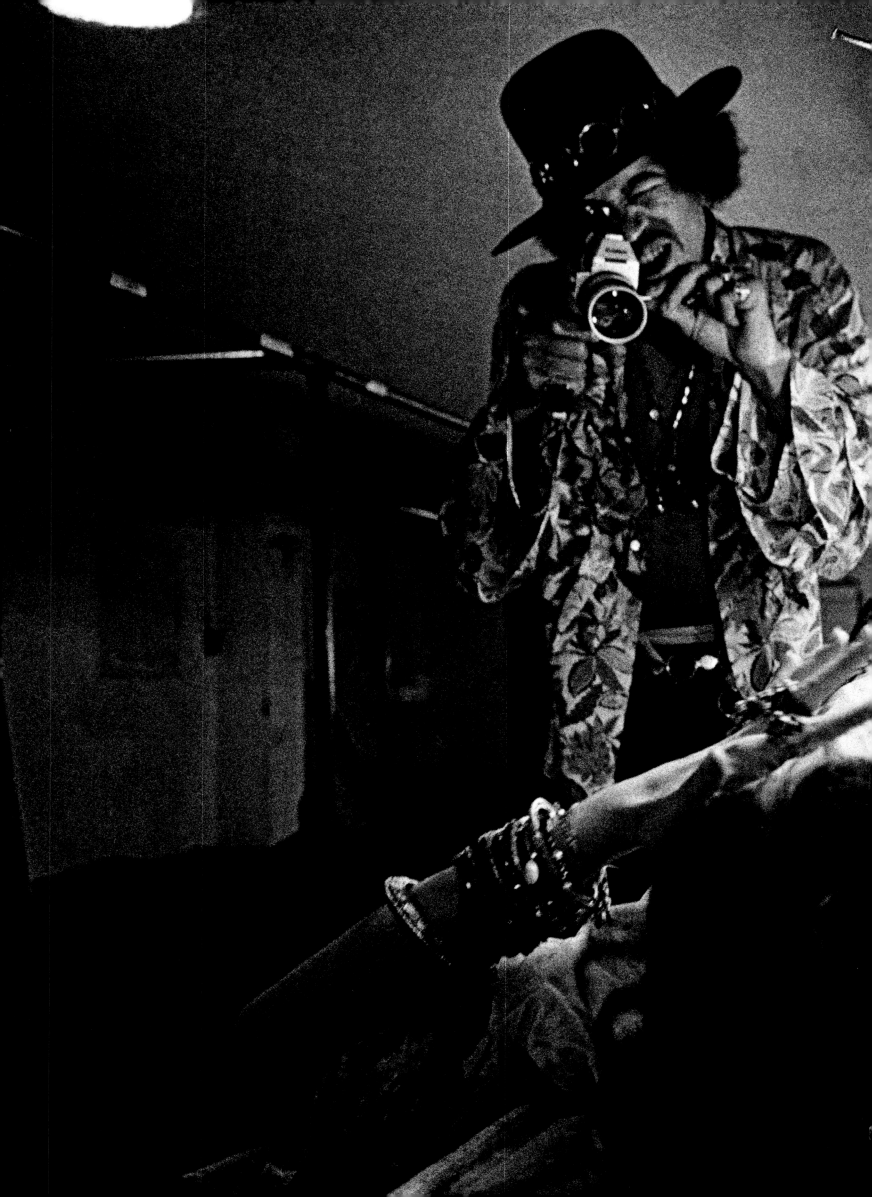

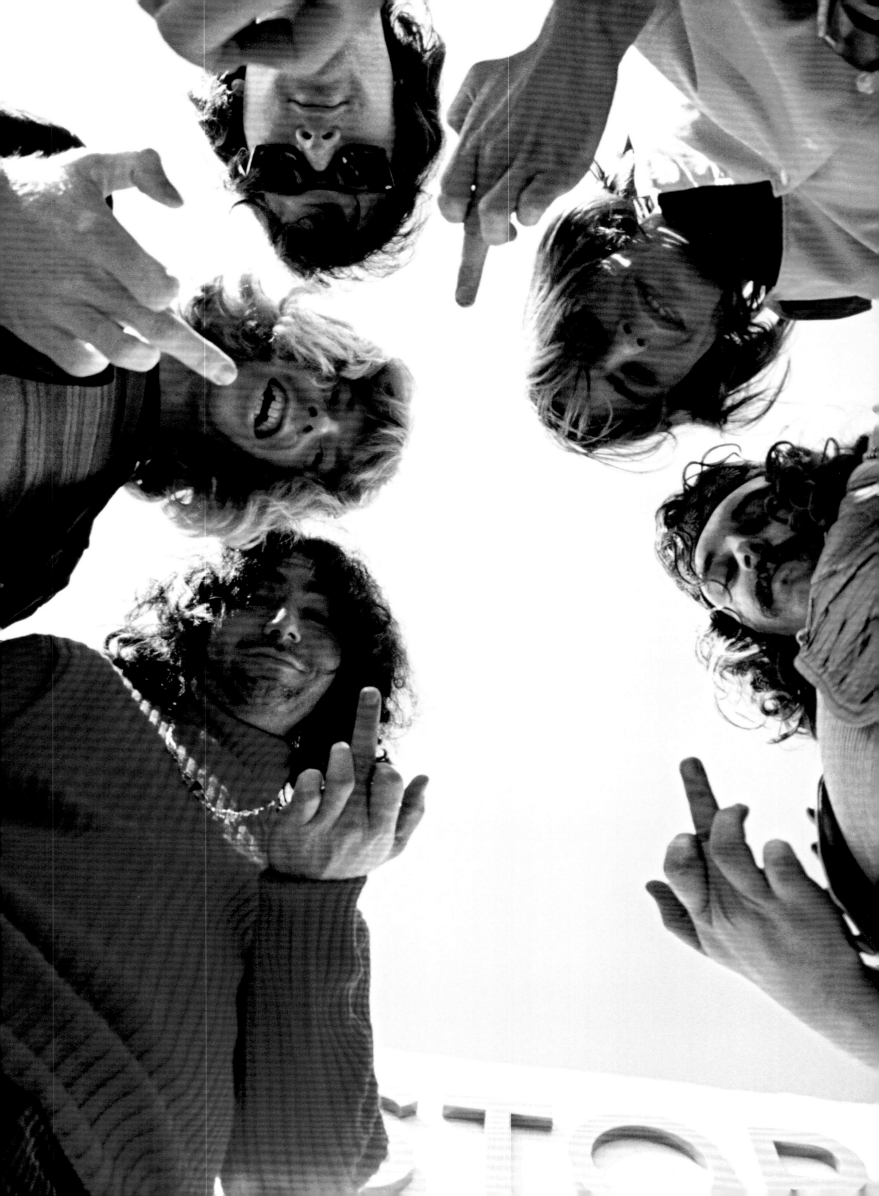

THE HAIGHT
LOVE, ROCK, AND REVOLUTION

THE PHOTOGRAPHY OF JIM MARSHALL

WRITTEN BY **JOEL SELVIN**
PREFACE BY **DONOVAN**
FOREWORD BY **JORMA KAUKONEN**
AFTERWORD BY **JOHN POPPY**

INSIGHT EDITIONS

San Rafael, California

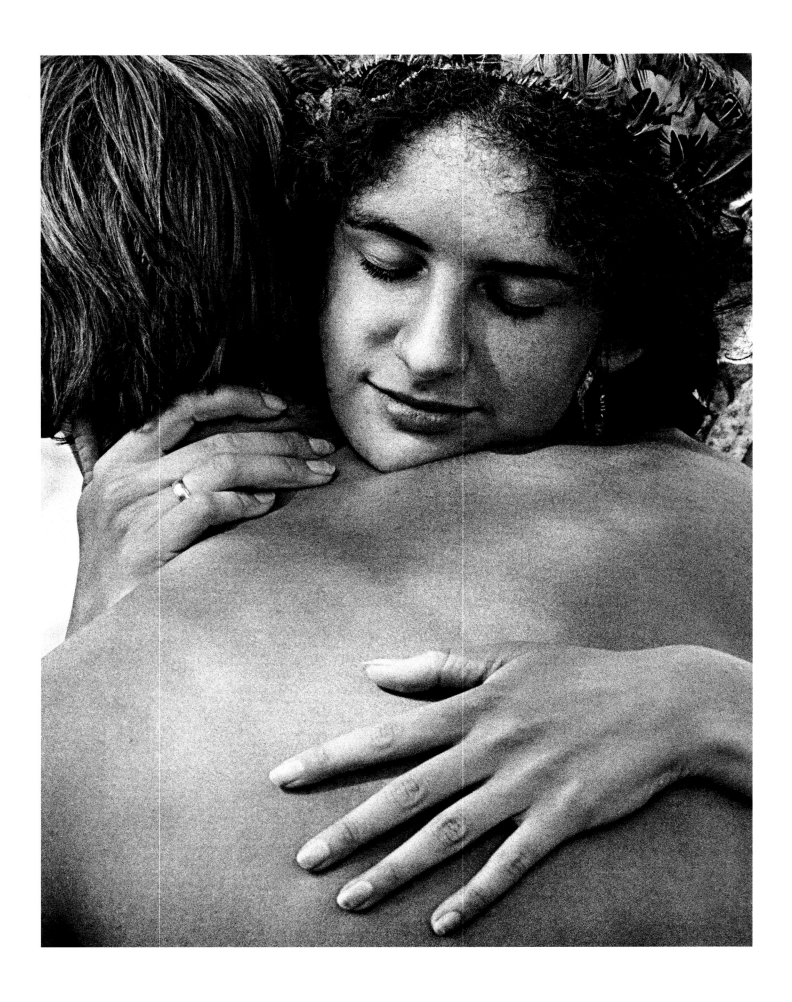

"The idea of a quick, widespread evolution of a new human being has survived. Like any discovery that makes perfect sense once someone has made it, none of this appears startling on the surface . . . A bird probably never thinks of air; water is nothing special to a fish. But when we stand back and take the perspective offered by Jim's pictures, we can see how far we have come, and how fast, and how difficult it would be to turn back to the way we were before the Haight-Ashbury burst upon us in 1967."

—FROM AN EARLY OUTLINE FOR *THE HAIGHT* BY JIM MARSHALL,
TEXT BY JOHN POPPY, NEVER PUBLISHED.

CONTENTS

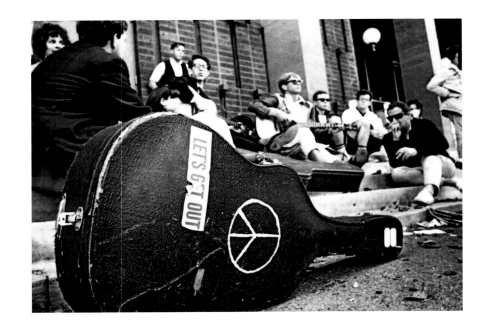

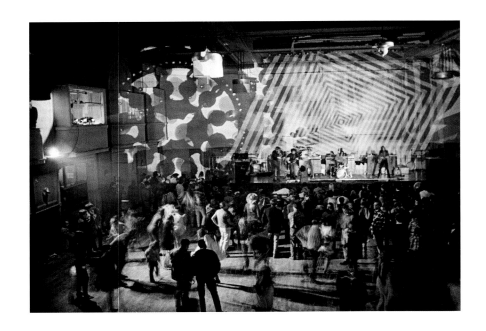

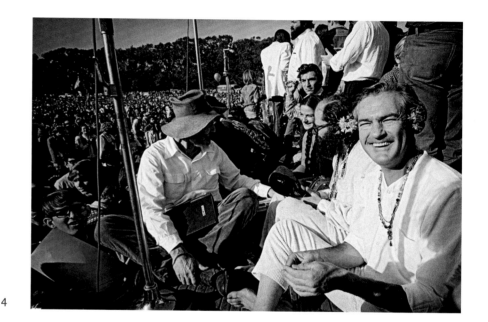

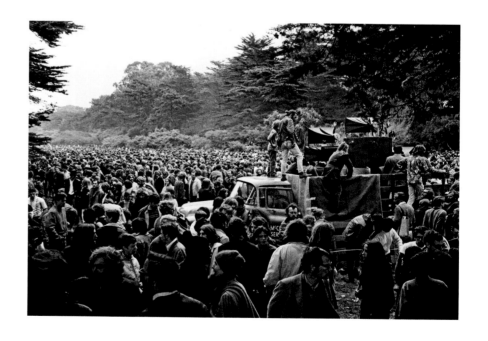

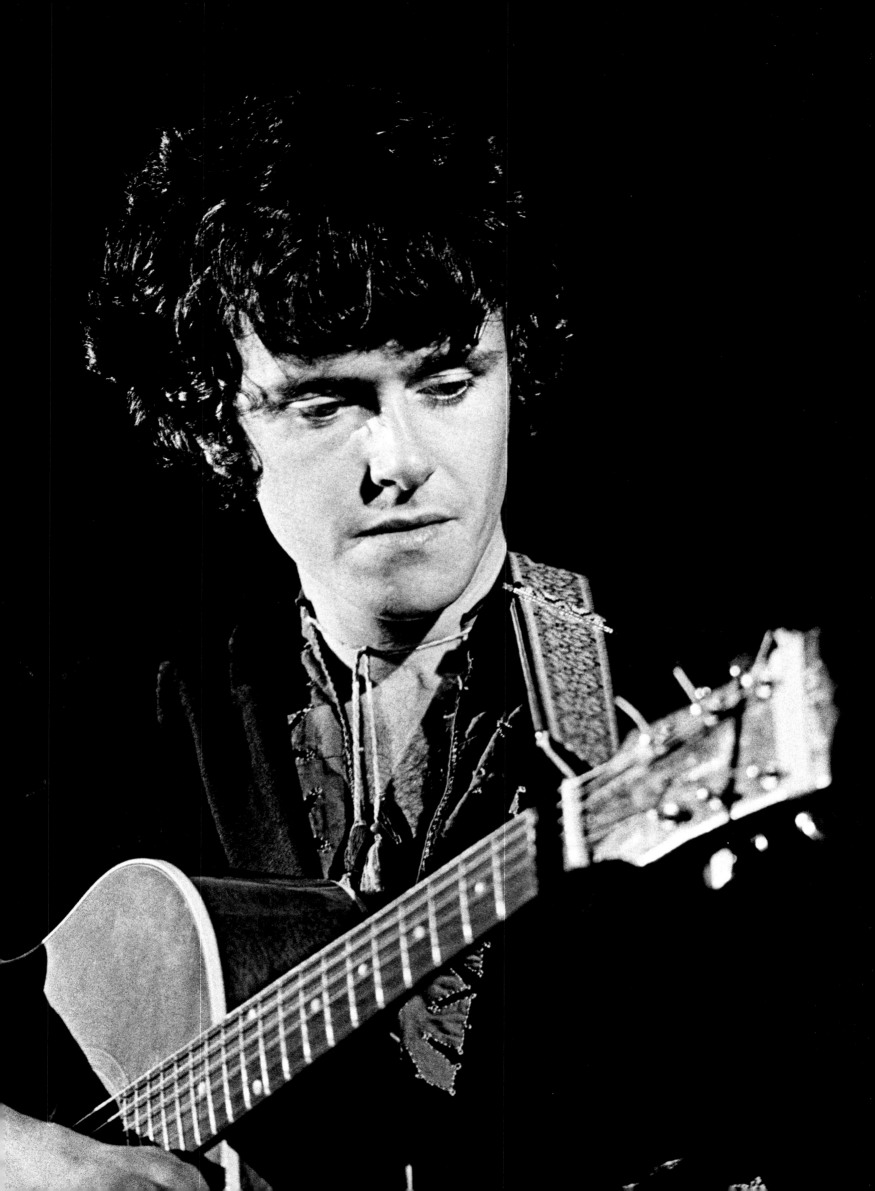

PREFACE

THERE ARE SO MANY important stories behind Jim's images, and his photographs of my Cow Palace concert are no exception. They were taken the same week I gave Jann Wenner the very first Rolling Stone Magazine Interview, which was published in the premiere issue in 1967. The San Francisco underground was searching for a newspaper that represented their music and culture, and I wanted to help Jann be that voice. And on the scene, Jim was the eye and the lens.

My concert itself was not without some controversy. Ralph Gleason, writer for The San Francisco Chronicle, and an important figure for us all, attended my concert and hailed my arrival on the scene. At the same time, he blasted Bill Graham for booking me into what he felt was a huge, unfeeling venue. Bill, on the other hand, assured me that he had sold so many tickets that he had to use the Cow Palace. Gleason wrote that next time I should play in a real theatre.

Jim's photographs of me that night chronicle my first performance in San Francisco, the city of the emerging higher consciousness.

Jim caught the nuances of historic moments as they were happening. His photography of the Haight-Ashbury in particular. My song 'Fat Angel', name checks The Jefferson Airplane, and my work also reflects the West Coast Jazz and Beat Poetry that flourished in San Francisco. My favorite photo of Jim's is Brian Jones and Hendrix. And of course Grace and Janis in colour.

So it's a pleasure to say some words for Jim Marshall and his huge body of fine work. As Neil says, 'Rock & Roll is Here To Stay'. And that goes for Jim Marshall's photographs too!

Ireland 2014

(OPPOSITE) *Donovan, 1967*

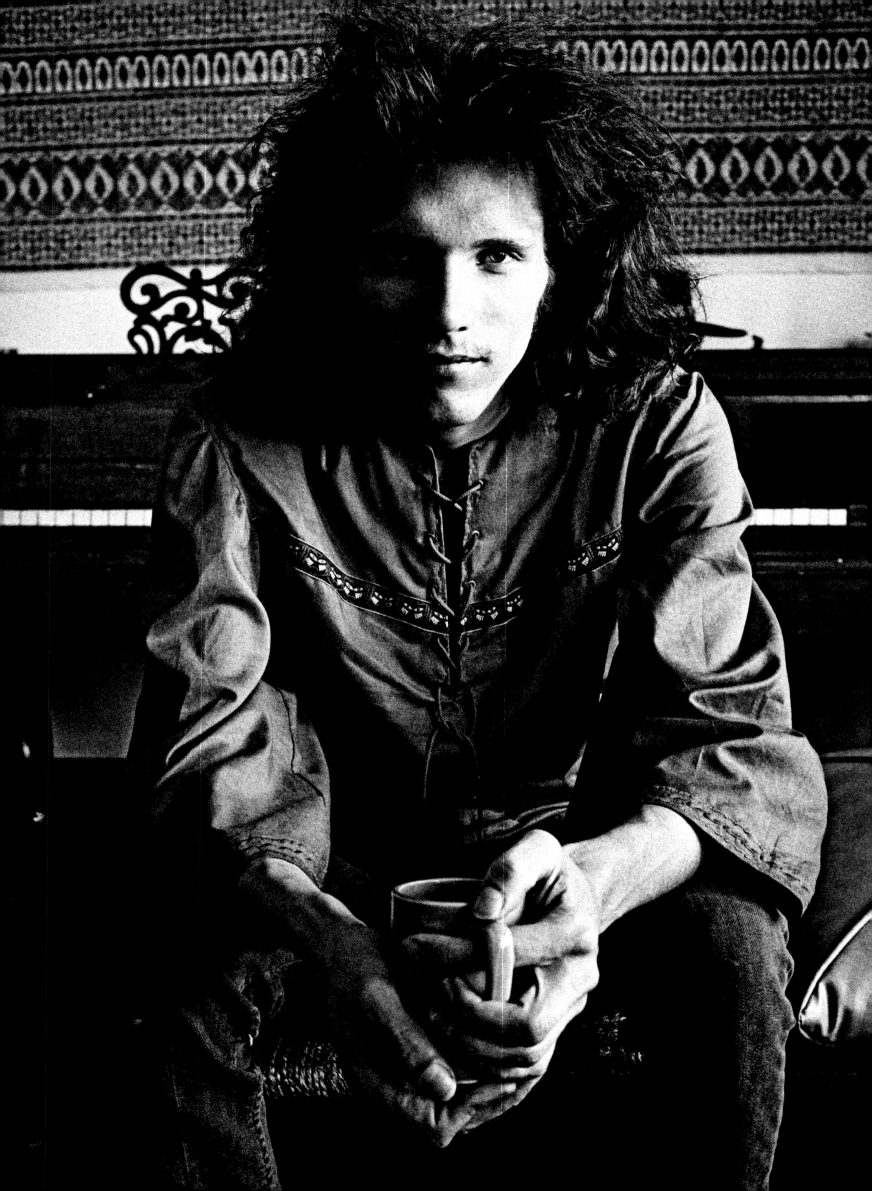

FOREWORD
BY JORMA KAUKONEN

PEOPLE WHO KNEW JIM MARSHALL will recall that there was no one quite like him on the planet. To say that he was "old school," would be more than an understatement. His beloved Leicas were as much a part of his dress as his jacket. His neck was always garlanded with cameras and lenses. Jim had spent so many years documenting the music scene he so loved that a retrospective of his work does more than merely display his powerful photography: It reflects the history of the contemporary music of his time—without boundaries. His passion for art, combined inexplicably with his irascibility, allowed him to get close to the artists in a very personal way. But how did this happen? Taken out of context, he would have been considered by most to be quite an asshole. For some strange reason, though, this was all part of his eccentric appeal. He took so many great candid shots of everyone—musicians, writers, bystanders, protesters—that we could spend years analyzing them. At live performances, he would get up close and personal, but remain detached in a way. He got all kinds of great shots of these now legendary performances, yet you never would have known he was there.

Beyond these live shots and candids, however, there was another side to his shooting. I remember he was hired to do some promotional shots for the Jefferson Airplane. In one of them, the band is in a circle looking down. You can't see it, but Jim is lying on his back in the middle of the circle shooting up. We didn't like posing for pictures. It almost seemed too much like work—trying to hold poses, not talking, behaving ourselves—it just wasn't us. But Jim had a vision for the shot: "Get in a circle . . . find a position . . . don't move. . . ." He was always so intense, and he was especially so on this particular occasion. We just couldn't stay still. Someone was always screwing up, and Jim started to go crazy. He bathed us in profanity, and we loved every minute. I thought he was going to have a heart attack. At some point in this dysfunctional exchange he saw what he wanted and got the shot, which lives on today.

That was Jim. He was opinionated at best with no boundaries, verbal or otherwise. Though he was self-destructive in many ways, his work does not reflect this. He was brilliant, with an eye for the moment and a perfect sense of timing. He was one of a kind in a most creative era—and the pictures in this book demonstrate that.

(OPPOSITE) *Jorma Kaukonen, 1968*

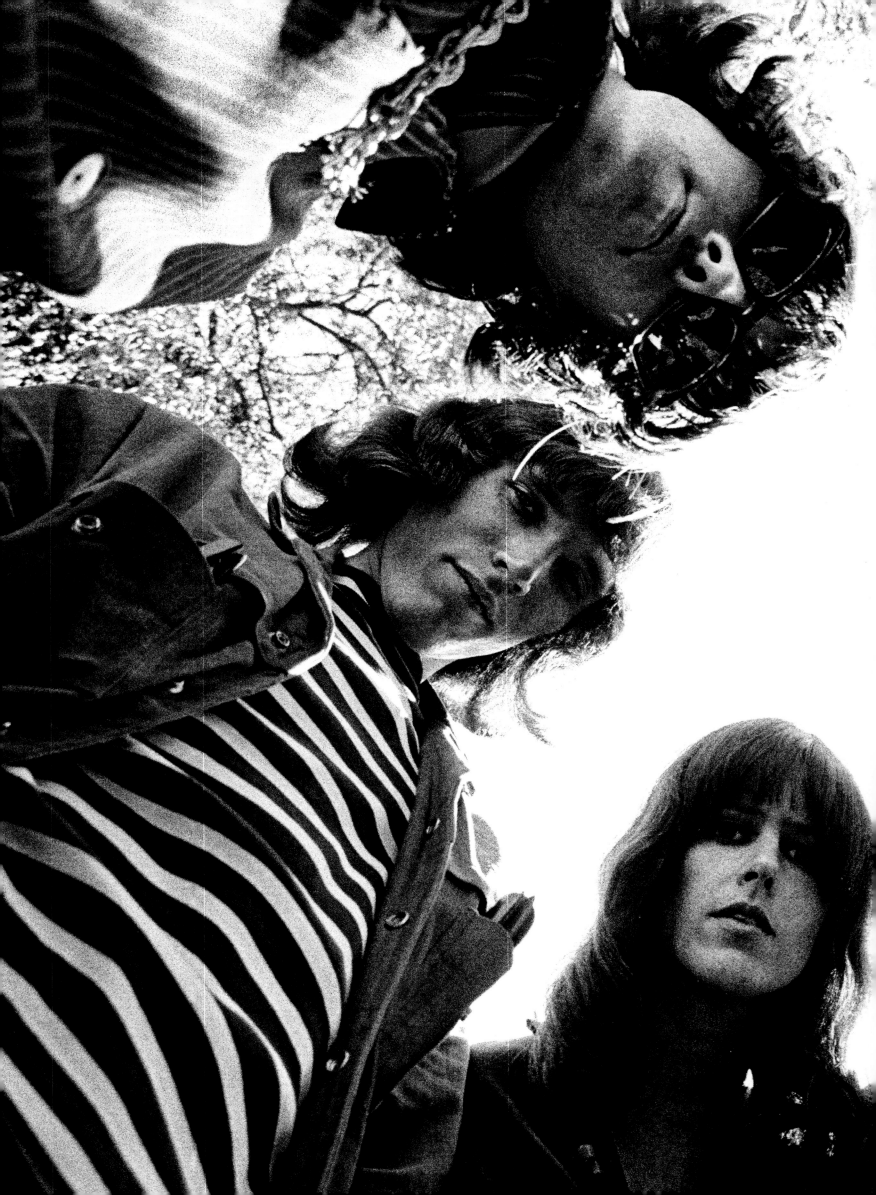

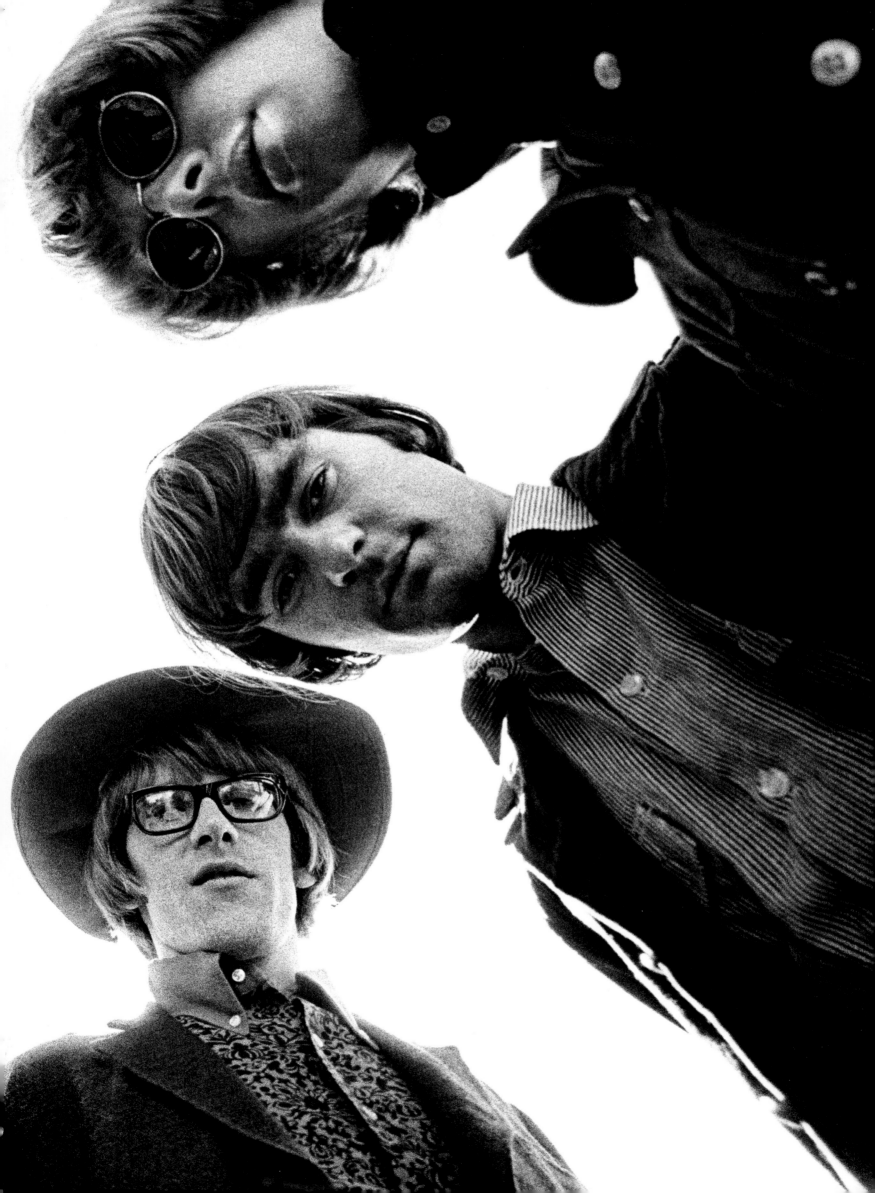

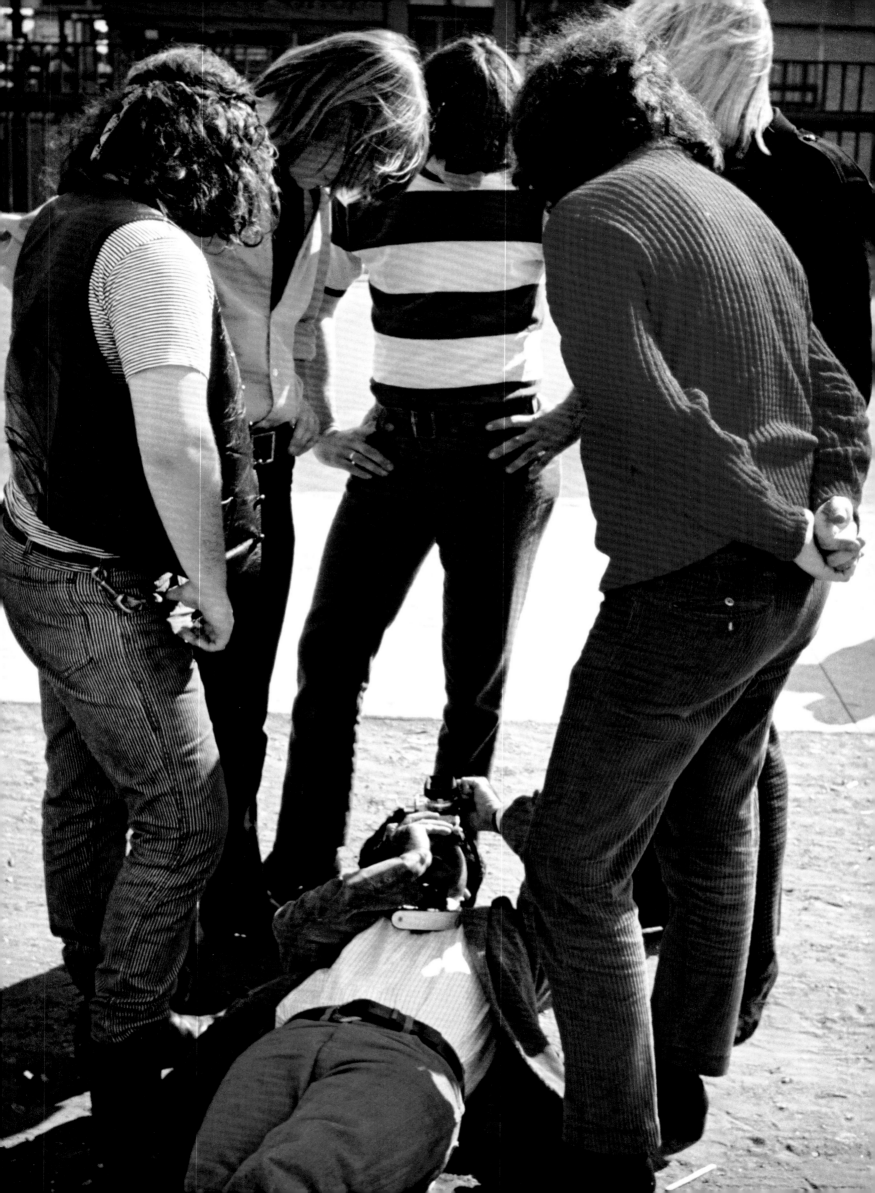

MARSHALL IN SAN FRANCISCO

JIM MARSHALL returned to his hometown of San Francisco at age twenty-eight in 1964. He had lived in New York City for two years, where he went to see if he had what it took to become a professional photographer. He did.

In New York, Marshall made album covers for jazz greats, caught the incipient Greenwich Village folk scene exploding, and photographed poverty in Appalachia for a national magazine. He shot Miles, Monk, and Coltrane. He covered the Newport Folk Festival. He took a picture of Bob Dylan kicking a tire down Sixth Avenue that proved to be one of the key images of Dylan's early career.

He came back to San Francisco to mend, regroup, and start fresh. The previous year in New York, 1963, had been a nonstop, blinding whirlwind of album covers, studio sessions, and nightclub gigs. After Manhattan, San Francisco was a provincial backwater—a quiet, unconventional city on the far end of the continent. He moved back into his mother's apartment in the Richmond District.

Today, after his death at age seventy-four in 2010, the true scope of Marshall's artistry is being recognized. He was given a Trustees Award for lifetime achievement by the Grammys in 2014 (alongside the Beatles, Kris Kristofferson, the Isley Brothers, Ennio Morricone, and other peers). His work continues to be published almost every day, and his exhibit schedule has never been busier.

More importantly, his entire lifetime of photographs has been scrutinized for the first time ever. His archives are being digitized, a massive undertaking, and his tens of thousands of proof sheets sorted through, many for the first time since Marshall put them away. In his files, thousands of brilliant, never-before-seen photographs have been discovered. Some of these photos are as good as anything Marshall ever took. One of the first projects on which the Marshall estate embarked was a book of his photos chronicling the golden age of the Haight.

In his files were more than one hundred thousand images from this period and neighborhood, totaling more than three thousand proof sheets. There were more than two hundred rolls of color, almost all entirely unseen. On a number of occasions, when I was allowed rare access to his proof sheets and would point out an unprinted gem, Marshall would look at the shot with some surprise, like he had never seen it before. "You're right—that's a good shot," he would say. As with most professional photojournalists, Marshall shot the assignment, checked the proof to see what he would print, and never looked back. He left some of his best work unprinted on those proof sheets. This excavation is digging into nothing less than the most important historical visual record of the era by the scene's most distinguished photographer.

What Marshall left behind was an astonishing portrait of a brief moment in time that was over before anybody knew what had happened, but still reverberates today in music, fashion, politics, and more. Marshall was there, and he captured the explosion from the earliest days with the cunning eye of the brilliant photojournalist he was. He shot the rock bands—music was his bread and butter—and he shot them in detail: onstage, backstage, at home, in his studio. But he also carefully recorded the cultural scenes of the day—street life, fashion, loving couples, angry cops, war protesters, dancing hippies—the full crazy panorama of those wild times.

Marshall was an amazing photographer. He never cropped his shots. The compositions were always perfect. His proof sheets are a marvel. He had an uncanny ability to anticipate action and emotion and click the Leica just as it happened. He loved guns, cars, single-malt scotch. And music. You can see the music in his photos.

(PRECEDING PAGES) Jefferson Airplane at Golden Gate Park, 1967; (OPPOSITE) Jim Marshall photographing the Grateful Dead, 1967

Before he went to New York, Marshall already knew his way around the San Francisco music scene. He knew the jazz clubs of North Beach. He had haunted the Jazz Workshop, photographed Duke Ellington at the Monterey Jazz Festival, freelanced occasional photos to local papers. He took a shot of John Coltrane giving an interview at the Berkeley home of *San Francisco Chronicle* columnist Ralph Gleason that was eventually hung by President Obama in the White House. Obama sent Marshall a signed photo of himself standing next to the framed shot on the wall.

For fifty dollars down and twelve twenty-four-dollar monthly payments, Marshall bought his first Leica in 1959. He never considered another profession. He sold his first photo—a shot of comedian Lord Buckley—for fifteen dollars and landed twenty-five dollars for a photo on the back of an album by singer Bev Kelly for Riverside Records. Marshall had photographed both acts at a niterie called the Coffee Gallery on Grant Avenue, a strip of restaurants, bars, and coffeehouses where the beatnik set could be found, on a crusty, dark alley in the shadow of Telegraph Hill. Marshall was hip to the scene, and he knew how to take a photograph. He went to New York to take on the big city.

When Marshall returned to San Francisco two crucial years later, the town had changed. North Beach still had jazz clubs, but the scene had started to dry up when the topless bars moved in. The coffee shops on Grant Avenue still had chess games and espresso. Enrico Banducci still ran his hungry i where Mort Sahl held sway and the Kingston Trio had recorded their live album. Basin Street West, where Lenny Bruce had been arrested for obscenity for saying "cocksucker" in his act, ran jazz and rhythm and blues acts through the house. Ann's 440 Club across the street, where Johnny Mathis had been discovered, was long closed.

San Francisco in the '50s had been a cauldron of nonconformity and social experiments. It was no accident that Jack Kerouac made San Francisco the destination for his cross-country hitchhikers in the novel *On the Road*. That book became a beatnik bible and, by itself, drew thousands of would-be Dean Moriartys to San Francisco from across the country. They read the book and decided to live the life.

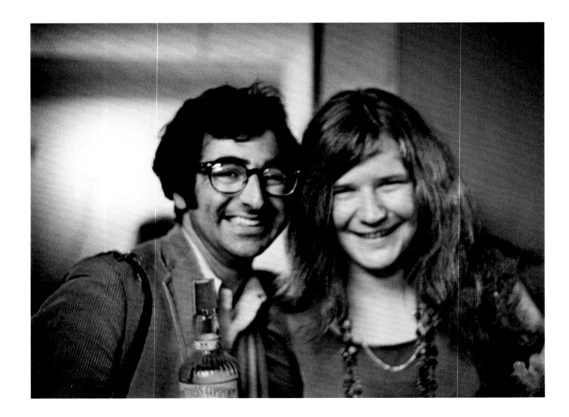

(LEFT) *Jim Marshall and Janis Joplin, 1968;* (ABOVE) *Jerry Garcia and Jim Marshall in the Winterland dressing room, 1967*

26

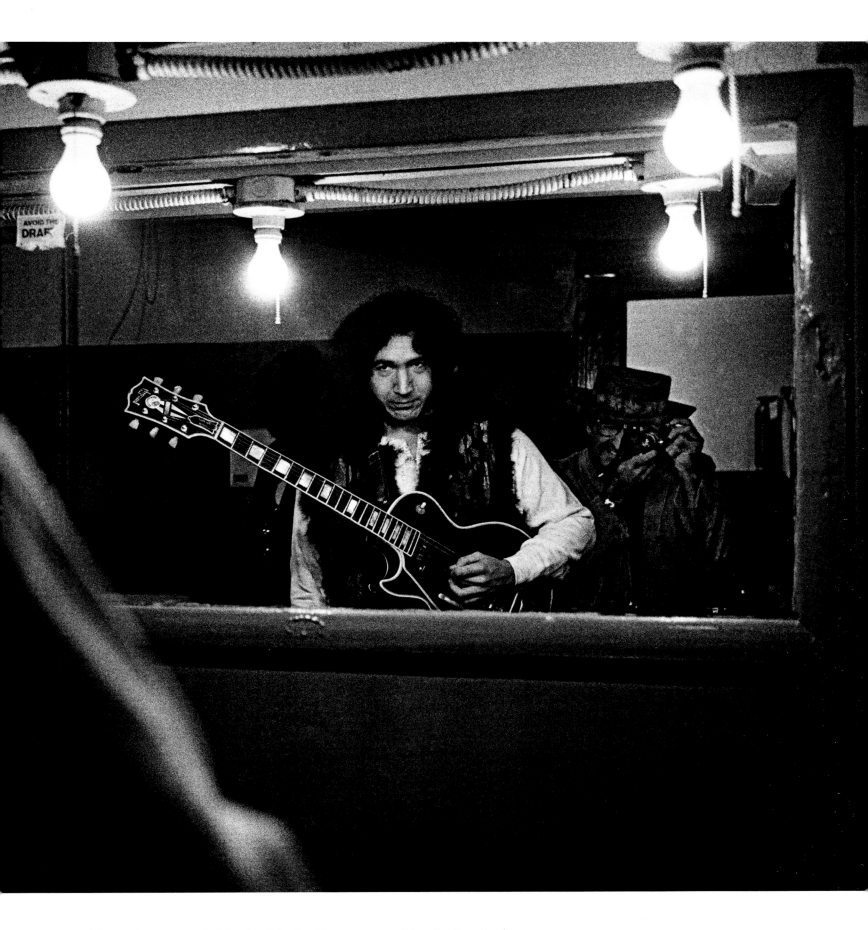

The novel sent out a coded signal and slowly, without anyone noticing, San Francisco began to attract like-minded youth. North Beach drew them. Prospective poets could be found reading in the easy chairs in the basement of City Lights Books, the store run by beat poet Lawrence Ferlinghetti, whose *A Coney Island of the Mind* was one of the epic pieces of beat literature. Folksingers sang in the coffeehouses. Hipsters dug the jazz in the clubs. But stirrings of a new kind were beginning to be heard across town.

Marshall came back to San Francisco at the exact right time. Within months, the city was bubbling with events in small neighborhoods that would spill over the rest of the earth in due course, although that potential was hardly evident. The early days of that phenomenon were so rooted in little corners of San Francisco, the events passed without notice outside a small circle of people. Marshall was one of them.

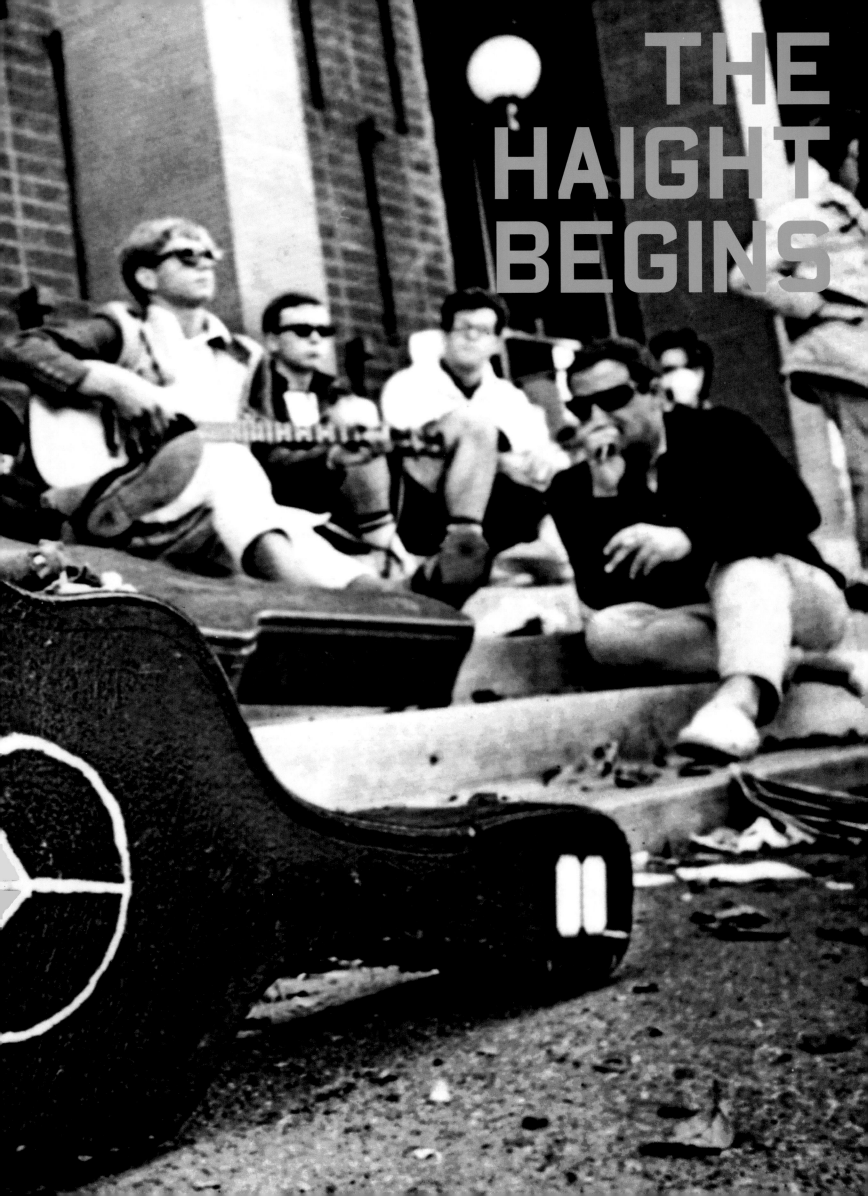

THE
HAIGHT
BEGINS

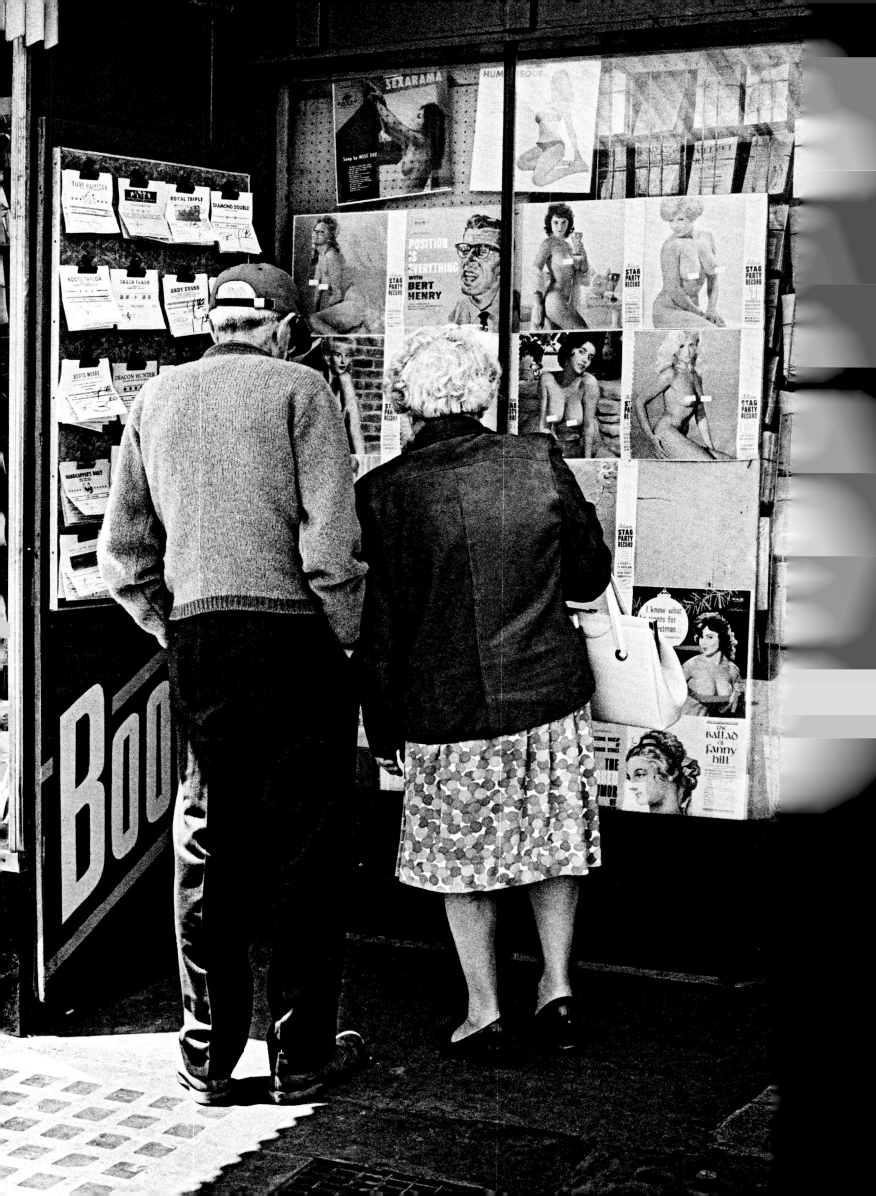

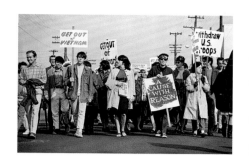

President Lyndon Johnson increases the American troop levels in Vietnam and anti-war protests begin to erupt on college campuses. In the wake of the Watts riot, the president's "Great Society" seems even further out of reach, although his War on Poverty, the newly enacted Medicare program, and Voting Rights Act offer some hope. In London, designer Mary Quant introduces the miniskirt. *Mary Poppins* wins the Oscar for Best Picture and *Bonanza* still rules TV ratings on Sunday night. The Beatles release "Help!" and gas is thirty-one cents a gallon.

THE HAIGHT-ASHBURY WAS A QUIET, residential neighborhood on the edge of Golden Gate Park, bordered by a block-wide median strip that jutted out from the park called the Panhandle. It was a racially mixed area filled with huge Victorian houses that had survived the 1906 earthquake, bulging with bay windows and topped with gables. Many of these old, giant homes had been turned into rooming houses, popular with Irish workers. It was also a short trip on the bus line to the San Francisco State campus, and the prospect of renting rooms for twenty-five dollars a month began to attract independent students.

The city had a long tradition of embracing the unconventional. San Francisco was founded in the Gold Rush of 1849 that brought desperate men in search of riches to the far coast of the Western World. The town never developed the kind of landed aristocracy that thrived for generations in the East Coast and instead cultivated an almost perverse, independent maverick spirit. For years, nineteenth-century San Franciscans lauded one delusional citizen who proclaimed himself Emperor Norton, the entire city playing along with the gag for the rest of the benighted soul's life.

San Francisco was a waterfront city on the edge of the world, a favorite liberty port and a bawdy good time for all who lived there. Al Jolson learned to dance the Texas Tommy on the Barbary Coast. The population blossomed after the war with plentiful work and a booming economy. The town was a solidly Democratic, middle-class enclave on one end of the Golden Gate Bridge where life was possible.

As this new generation grew out of youth, troubling signs of conflict began to emerge. In this age of affluence, ideals became important. The struggle for these young people to find meaning in modern life was only beginning. These issues were faced by young people everywhere, but Haight-Ashbury was ground zero.

The relative calm of the Eisenhower era came to an end when political protests arrived in San Francisco in 1960. Police used fire hoses to sweep off demonstrators on the City Hall steps, who were taking exception to hearings by the House Un-American Activities Committee. Civil rights protesters began to stage a series of sit-ins in October 1963 that rocked the Bay Area. Police arrested 167 protesters, mostly college students, during a sit-in at the Sheraton Palace Hotel and, weeks later, more than a hundred demonstrators in a sit-in at a Cadillac dealership. The civil rights movement was a nationwide cause, spearheaded by Southern leaders, but it struck a particularly vibrant nerve in the San Francisco area. Many older liberals in the area were shocked by the confrontations with authority, but some old-time union members could recall clashes with police. A seething undercurrent of social unrest and a growing sense of injustice spread through college-aged youth at San Francisco State and across the bay at UC Berkeley.

Further feeding that unease and disquiet was the escalating war in far-off Vietnam, a dubious conflict few understood, but as more troops were called up, the pressure on draft-age males increased. These young people grew up in the promise of post-war America, free from the fear of deprivation that haunted their parents in the Depression and Second World War. They had been brought up to believe their future was assured. This growing sense of powerlessness and alienation among the youth needed only a spark to ignite.

LSD was the catalyst. Into this brewing realm of discontent and yearning, LSD was a grenade that detonated. In Berkeley, Augustus Stanley Owsley III became the first person to privately produce the psychoactive drug, legally manufactured by Sandoz Laboratories in Switzerland since 1947. The drug had been quietly used in progressive psychiatric circles in California (and elsewhere) since the late '50s. Owsley studied scientific journals for two weeks in the library at UC Berkeley and started producing the drug in his Berkeley home in 1964. In February 1965, Berkeley police raided his lab and confiscated his equipment. Owsley successfully sued for the return of his equipment, since the police suspected him of making methamphetamine and LSD was not yet illegal.

He moved to Los Angeles and between March and May of 1965 produced an estimated three hundred thousand doses of acid before moving back to San Francisco, where he began to distribute his product.

(PRECEDING PAGES) *Musicians and onlookers gather on the street, 1965; (OPPOSITE) An elderly couple examines images on display near a newsstand, 1965; (ABOVE) Protesters strike out against the war in Vietnam, 1965*

Owsley was not alone. Word had been rapidly spreading about a miracle drug that unlocked the mind and created a new consciousness. The CIA had long been interested in the properties of the drug and had run some clandestine tests in San Francisco during the '50s, including spraying the civilian population to test dispersal rates. The more ambitious tests were shut down after one square john committed suicide after being given an unsuspecting dose at a CIA-operated bordello, an episode that was hushed up for years.

But the CIA was still running tests at the Menlo Park Veteran's Hospital, near bucolic Stanford University, sixty miles south of San Francisco, where author Ken Kesey first encountered the drug as a paid subject for psychiatric testing. His experiences with the program led him to write the best-selling novel *One Flew Over the Cuckoo's Nest*, and his royalties allowed him to buy a rambling log house in the wooded hills in nearby La Honda, where he privately continued his experiments with the drug, along with a group of miscreants and reprobates who called themselves the Merry Pranksters.

In 1964, when Kesey's second novel, *Sometimes a Great Notion*, was released, the troupe made a cross-country trip in a converted school bus, loudly painted in garish Day-Glo colors, outfitted with loudspeakers, filming everything they did, loaded on LSD. The destination sign on the front read FURTHUR and on the back it said CAUTION: WEIRD LOAD.

Back home at La Honda, Kesey decided to hold an LSD-fueled public party he dubbed "The Acid Test" in San Jose and, to serve as house band, recruited a group of former folk musicians who had only recently swapped their banjos for electric guitars. He served punch laced with the drug and created an otherworldly environment with colored lights, strobes, random sounds, and the music supplied by the band, everybody concerned under the influence of LSD. The band was called the Warlocks, but they would soon change their name to the Grateful Dead.

In the Haight, a young Texan named Chet Helms was throwing parties of his own in the rosewood-lined basement ballroom of one of the neighborhood's trademark Victorians at 1050 Page Street. Helms had been raised by his Baptist preacher grandfather, and he approached the new community with a kind of missionary zeal. He was a pot dealer and dumpster diver who visited many of the rapidly expanding households of young people who were growing their hair, smoking marijuana, taking LSD, and thinking about things in a different way. He knew this community was mushrooming under his feet—his work put him in a unique position to be in touch with the growing subculture—and he began to organize weekly jam sessions. He charged fifty cents admission, and the place was packed every week. He began to put together a loose-knit house band consisting of some of the residents of the rooming house and neighbors.

(ABOVE) *Ken Kesey, 1967;* (RIGHT) *Converted school bus, 1967;* (BELOW) *Sidewalk chalk graffiti along Haight Street, 1965*

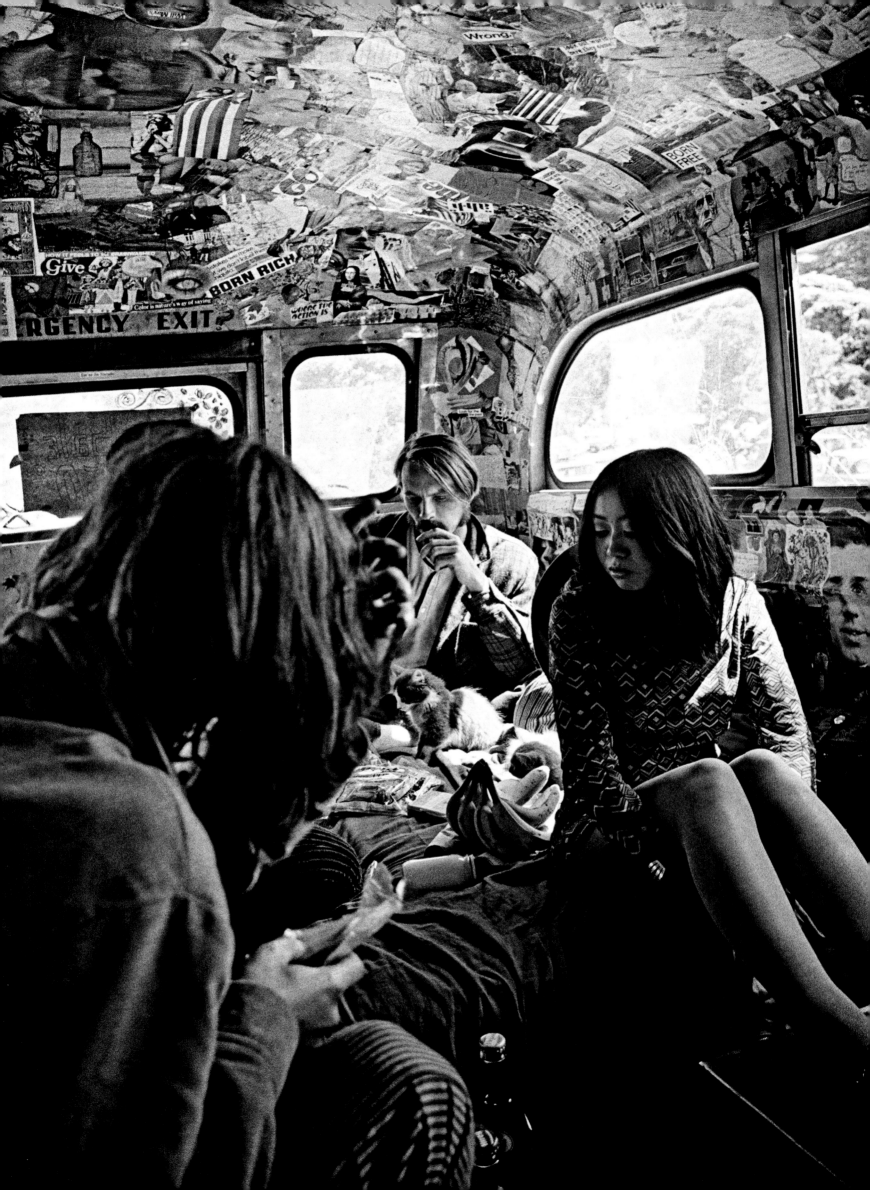

He brought a guitarist to the jam session named James Gurley, who he met at the Pine Street commune, another hot spot. With Sam Andrews on guitar and vocals and Peter Albin sharing vocals and playing bass, Helms was close to having a band that could play in public. They scrapped the name Blue Yard Hill and decided on Big Brother and the Holding Company. Gurley was a maniacal lead guitarist—his father was a demolition derby driver who used to strap his son to the hood of the car and drive him through burning hoops; Gurley still didn't have any eyebrows when he first moved to town. He was known on Pine Street for spending hours playing guitar and listening through a stethoscope. He aimed to merge Lightnin' Hopkins and John Coltrane in his style. The Pine Street building was a community nerve center. A few Pine Streeters would later decide to throw a pivotal dance at Longshoremen's Hall.

A tidal convergence swept the local underground the second weekend of October 1965. In Berkeley, a huge Vietnam War protest on the UC campus drew a disparate crew of politicos and weirdoes. The acidheads of the Haight and the student protesters of Berkeley were different cultures with shared interests, but this summit meeting had an awkward moment when a clearly stoned Ken Kesey and his Merry Pranksters showed up in the bus and made an indecipherable, garbled appearance, Kesey tootling away tunelessly on a harmonica. Another former jug band turned electric rockers, Country Joe and the Fish, performed earlier that day from a flatbed truck and handed out copies of a new record they wrote and made expressly for the event, "I Feel Like I'm Fixin' to Die Rag." Beat poets such as Allen Ginsberg and Lawrence Ferlinghetti read their poems.

The crowd spilled out on the streets singing the Beatles' "Help!" As the mass of people moved down Telegraph Avenue toward the city limits, a phalanx of Oakland police barred the street. As the protesters swarmed up to the police line, out of nowhere members of the outlaw motorcycle club Hell's Angels roared up on their Harleys and immediately waded into the crowd, kicking war protester ass. The police didn't know who to arrest or who to club. They went after everybody and a melee ensued.

That night, four Pine Streeters who called themselves the Family Dog presented a dance/concert at the Longshoremen's Hall they called A Tribute to Dr. Strange. The bizarre artwork on the posters they hung on telephone poles around town made it clear that a weird time was to be had by all. Fresh from the summer as the house band of the Red Dog Saloon in Virginia City, Nevada, were the Charlatans, a group of acid-soaked Haight-Ashbury college students who had been playing Old West dress-up and taking acid all summer in a renovated old-time frontier saloon. Under the musical influence of the leading Los Angeles underground rock group, the Byrds, the Charlatans practiced a good-timey, old-fashioned sound that matched the band's polished vintage look. Also appearing was a group made up of former folk musicians that had only recently started performing in town with the unusual name Jefferson Airplane. Another band on the bill was called the Great Society and featured guitarist Darby Slick; his brother, Jerry Slick, on drums; and Jerry's wife, Grace Slick, on keyboard and vocals.

About a thousand people crowded the hall, but almost every person had the same thought when they first surveyed the audience: *I had no idea there were so many of us.* For many months, young people all over San Francisco had been growing their hair, smoking pot, and getting good and strange in the privacy of their own homes. This was the first time they came together in public. For many, there was a flash of recognition—this

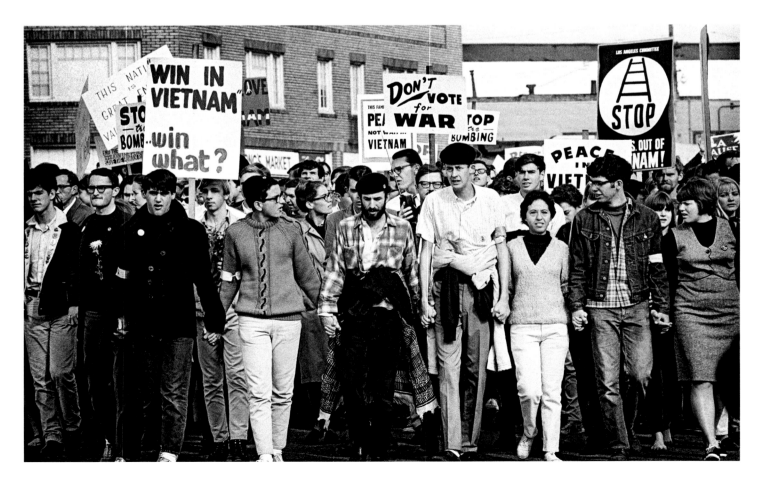

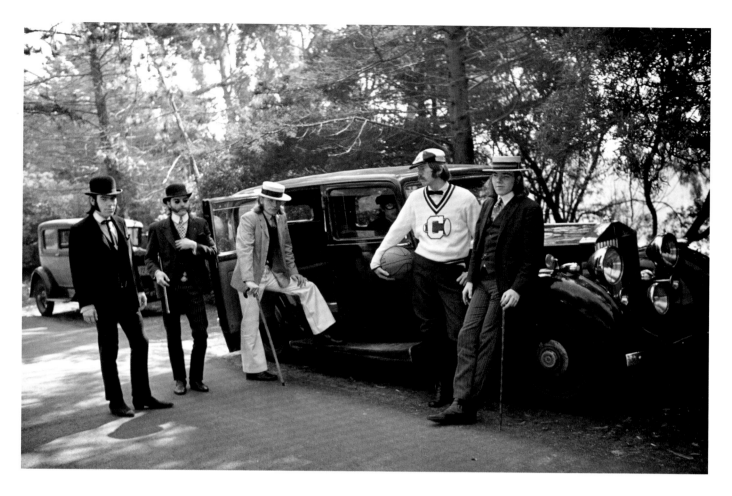

was an entire community of freaks brewing. People were dressed in crazy, thrift-store outfits, dancing madly in circles, and openly smoking pot.

An aspiring musician named John Cipollina climbed up on the side of the stage and looked out at the sea of longhaired people in second-hand clothing, dressed for a costume party, high as kites, and marveled. He was living in a car on the side of Mount Tam in Marin County, across the Golden Gate Bridge, growing his hair, and thinking about joining a band. This made up his mind.

Chet Helms was so thrilled by the event, he dashed out to borrow strobe projectors from the Tape Music Center, an experimental music laboratory that specialized in what was then called "happenings," and brought them back to splash lights on the dark walls of the cavernous concrete hiring hall. Ralph Gleason, the distinguished

(OPPOSITE) Vietnam protesters hold hands as they march, 1965; (ABOVE) The Charlatans in Golden Gate Park, 1966. A few images from this shoot can be found in their compilation album, The Amazing Charlatans; *(BELOW) Chet Helms and the Family Dog, 1967*

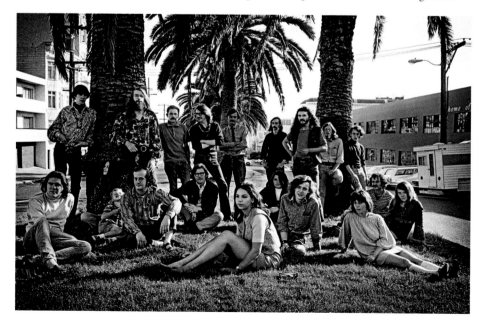

jazz critic for the *San Francisco Chronicle*, watched from the balcony, standing next to a cub reporter from the *Daily Cal* student newspaper named Jann Wenner, two years away from starting *Rolling Stone*. Gleason gushed over the evening in his column. He wrote:

> The bar did no business and the coke machine ran out. That's where it was at. Long lines of dancers snaked through the crowd for hours, holding hands. Free-form improvisation ("self expression") was everywhere. The clothes were a blast. Like a giant costume party.
>
> They all seemed to be cued into Frontier Days and ranged from velvet Lotta Crabtree to Mining Camp desperado, Jean la Fitte leotards, I. Magnin Beatnik, Riverboat Gambler, India Imports exotic and Modified Motorcycle Rider Black Leather-and-Zippers, alongside Buckskin Brown.
>
> It was a gorgeous sight. The lights played over the floor, the bands wailed out their electronic music, and the audience had a blast! One spectator danced by himself at the edge of the bandstand and finally became the night's first topless, taking off his shirt, the better to flex his muscles.
>
> The dances were variations on everything of the past decade, the Hitch-Hike, the Jerk, the Dog, the Hully Gully, all improved on and individually performed for self-expression.
>
> Dixieland trumpet player Bob Scobey once said that dancing was "only an excuse to get next to a broad." Since the New Morality supplies that need elsewhere, the dance floor is no longer the scene of the sexual expression it was. Now it is becoming a training ground for the free-est generation this country has seen and they dance beautifully.

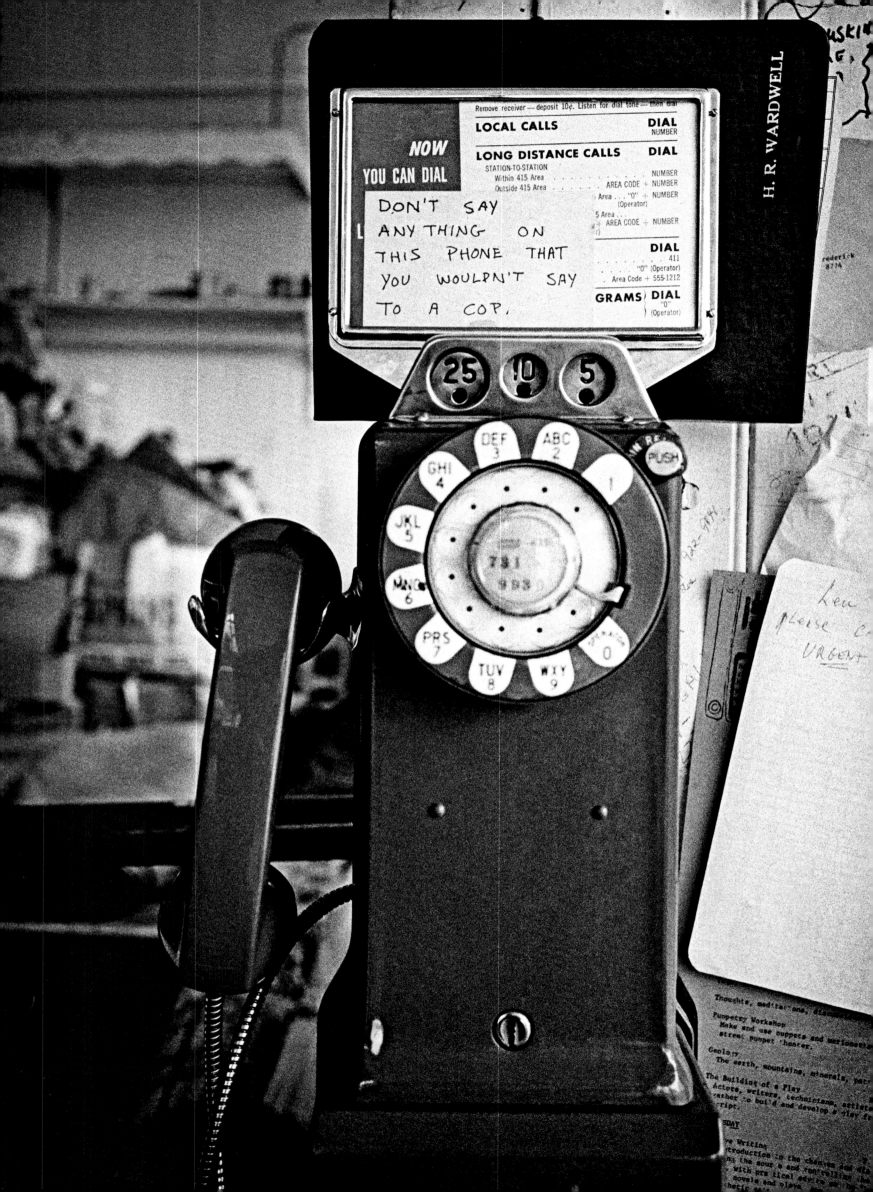

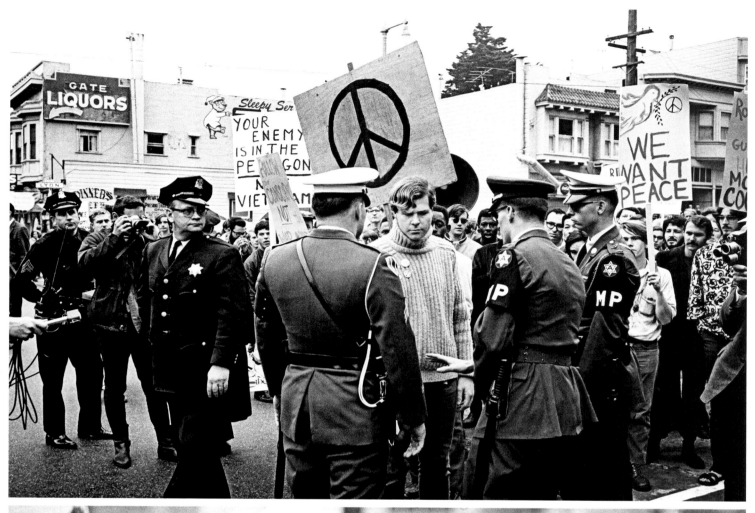

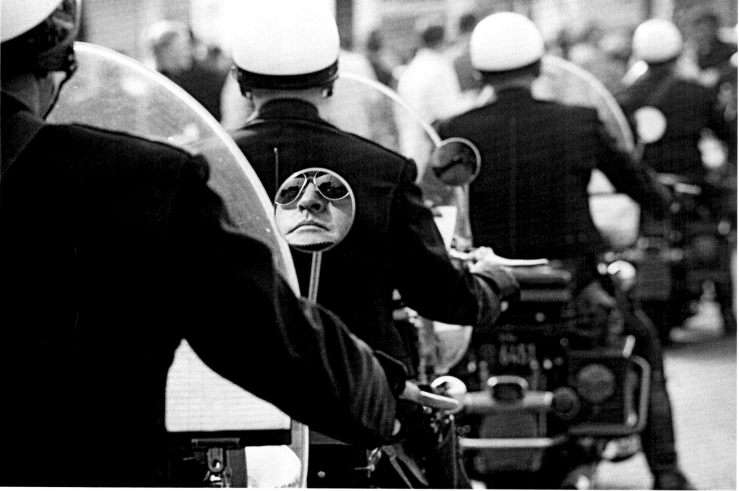

(OPPOSITE) *Pay phone in the Haight, 1967;* (TOP) *Military police engage a war protester, 1967;* (ABOVE) *Police motorcade during a Vietnam protest, 1965*

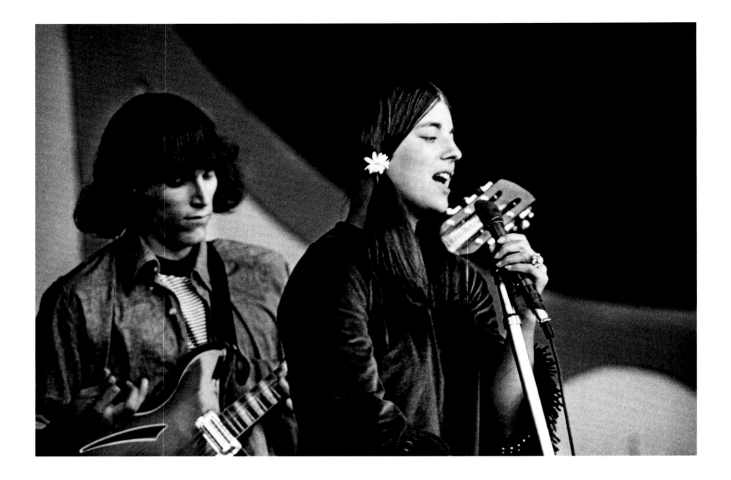

JEFFERSON AIRPLANE TAKES OFF IN THE WEEKS FOLLOWING A TRIBUTE TO DR. STRANGE,

JEFFERSON AIRPLANE QUICKLY EMERGED AS THE LEADING ROCK BAND OF THE RAPIDLY BURGEONING scene. The band had taken over a former pizza parlor in the Marina District and opened a nightclub called the Matrix, where their weekly appearances were drawing crowds. *San Francisco Chronicle* columnist Ralph Gleason wandered into the place a few weeks later and anointed the Airplane in his column. He recognized that something unique was in gestation. He wrote:

It's not really a rock 'n' roll group. Few are any longer. It's a contemporary-popular-music-folk-rock unit and we have no less cumbersome phrase to use so far. They sing everything from Bob Dylan to the blues, from Burl Ives to Miriam Makeba.

The Airplane had not quite settled on what the band was going to do, but the musicians had transported their contemporary folk music repertoire into the realm of electric rock. Balin, Toly, and Kantner supplied vocal harmonies, and Balin did most of the lead vocals. The band sprinkled a few originals such as "Come Up the Years" or "It's No Secret" amid a repertoire that mixed contemporary soul like "Tobacco Road" with Dylan covers. In the beginning, the Airplane kept one foot solidly in the folk world, using folk musicians such as Barbara Dane, Jesse Fuller, or guitarist Sandy Bull as opening acts at the band's club, and was little more than a folk group with electric instruments themselves.

The band came together one night a few months earlier when Paul Kantner, a folk musician from the South Bay, played three songs at the open mike of the Drinking Gourd, a club that appealed to the collegiate crowd on Union Street. Nobody paid much attention to Kantner, but as he packed up his banjo and guitar, a young man approached him and asked if wanted to talk about forming a group. His name was Marty Balin.

Balin, recently separated from his wife and child, looked hip, even though he was sporting a recent haircut, and he held definite ideas about where today's folk scene was heading. He most recently belonged to

a folk group called the Town Criers, although he had been singing and dancing most of his life, acting in musicals and even cutting a couple of teen-appeal 45s for a Hollywood record label. He caught a young Bob Dylan at Gerde's Folk City in Greenwich Village. He saw the Beatles movie, *A Hard Day's Night*, and he knew there was something in the wind.

He and Kantner began to pull a group together. Kantner saw Signe Toly sing at the Drinking Gourd and asked Balin to contact her. Kantner also remembered guitarist Jorma Kaukonen from hanging out in South Bay folk clubs when he was attending San Jose State. Son of a diplomat, Kaukonen had learned fingerpicking blues guitar from Reverend Gary Davis in New York City. He was a hulking, raw-boned Viking with a deft touch on guitar. Kaukonen thought up the crazy name Jefferson Airplane.

The band attracted a manager, Matthew Katz, an older, mysterious figure in a Spanish-brimmed hat with an acetate of an unreleased Dylan song he used to ingratiate himself with the group. Katz dubbed the new sound "fojazz"—a contraction of "folk" and "jazz"—and printed business cards for the Matrix that said "San Francisco's Only Fojazz Nightclub." After the Gleason column alerted the record industry in Hollywood, Katz and the band went down to meet with producer Phil Spector, who was surrounded with armed bodyguards and failed to impress the peaceniks from San Francisco. Poet Rod McKuen, who had sold a lot of records himself, introduced Katz and the band to RCA Victor, who signed the group to record. Jefferson Airplane jumped to the top of the pack.

(THESE PAGES) *Members of Jefferson Airplane, Signe Toly Anderson, Marty Balin, Jorma Kaukonen, and Jack Casady, perform at the Monterey Jazz Festival, 1966*

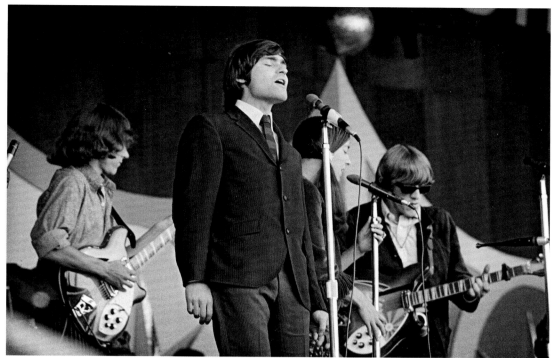

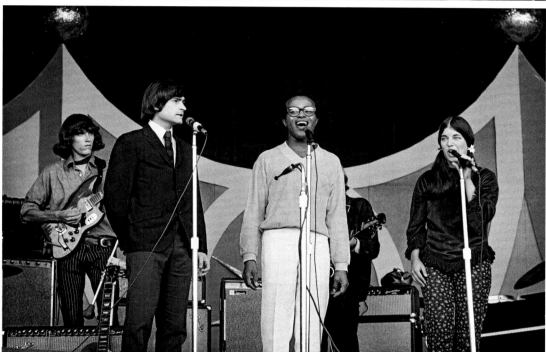

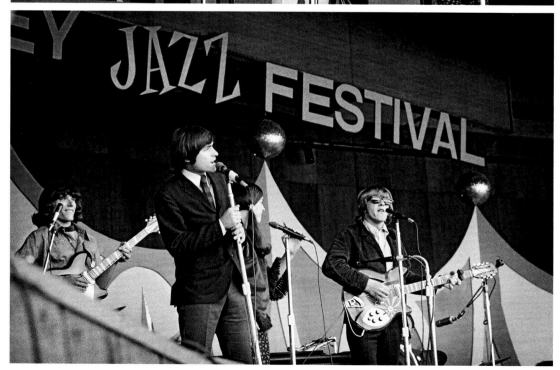

BILL GRAHAM FINDS THE FILLMORE THE WEEK AFTER A TRIBUTE TO DR. STRANGE, ONE

OF THE FAMILY DOG, OUTSPOKEN LURIA CASTELL, ENTHUSED TO GLEASON IN THE AFTERGLOW OF THE landmark event. "San Francisco can be the American Liverpool," she said. The Gold Rush mentality always strikes a chord in San Francisco.

The Family Dog threw another couple of shows, but splintered in the fractious spirit often fostered by strong, irreverent personalities thrown together. Chet Helms was dying to take over their scene. Meanwhile, another promoter appeared in town.

The San Francisco police arrested the left-wing agit-prop theatrical group called the San Francisco Mime Troupe on charges of indecency for performing a sixteenth-century Italian play free in the park. To raise money for the legal defense fund, someone suggested throwing a party in the Mime Troupe's loft headquarters in downtown San Francisco. The job of organizing the benefit fell to the troupe's business manager, a former actor from New York named Bill Graham.

Graham was an orphan refugee who survived a brutal escape from the Nazis across France by foot as a child (his sister died on the same trip). He was raised by foster parents in the Bronx and grew to love dancing to Latin music as a waiter in the Catskills. He wanted to be an actor and went to Hollywood, where he was up for a lead part with James Whitmore for a TV series called *The Law and Mr. Jones*. When he was passed over for the role, he pressed his agent for a reason. "Your physiognomy is too heavy," the agent said. Graham decided to quit acting. Two days later, he moved to San Francisco, took a job as office manager for Allis-Chalmers, and began to work on the side as business manager for the Mime Troupe.

Graham knew nothing about the scene. Since Jefferson Airplane sometimes rehearsed at the Mime Troupe loft, he booked the band. Other offers of support poured in for what became known as the "Appeal Party." The bill listed folk guitarist Sandy Bull, Greenwich Village poets turned rockers the Fugs, and beat poet Lawrence Ferlinghetti. After the Pine Street producers called and offered their help, Graham added the Family Dog to the bill, presuming it was an animal act.

On the night of the Mime Troupe benefit on November 6, 1965, the loft was jammed; the crowd was backed down the stairs and out the door, and the line outside extended around the block into the street. Graham stood outside the door, snatching dollar bills out of people's extended fingers, stuffing then into a green bag. When the bag was full, his way was blocked and he couldn't get up the stairs, so a basket was lowered from the second floor for him to put the money in. When it was over at six in the morning with Allen Ginsberg chanting his mantras, Graham drove home on his motor scooter with more than four thousand dollars in his backpack. He started planning his next benefit the following day.

The Fillmore Auditorium was owned by Charles Sullivan, a black entrepreneur who ran jukeboxes and cigarette machines all over Northern California. He also dabbled in presenting rhythm and blues shows and regularly featured acts like Little Richard or the Temptations at the Fillmore. The Fillmore District, which housed the venue, had been a predominantly black neighborhood since before the war, when it hosted a strip of nightclubs and gin mills that catered exclusively to a black clientele. Louis Armstrong dropped by Jimbo's Bop City on Fillmore one night to hear Charlie Parker—their only known encounter— and left with his nose wrinkled after a few minutes. Teenage Etta James, who grew up in the neighborhood, auditioned for R&B producer Johnny Otis after a show at the Primalon Ballroom on Fillmore, and he whisked her off to Los Angeles and a recording career the next morning. Ralph Gleason told Graham about the Fillmore Auditorium. Graham rented the thousand-seat hall with the little balcony from Sullivan for sixty dollars for his next benefit, Appeal II.

Graham turned up with a poster for his show at a televised press conference by folksinger Bob Dylan at the KQED-TV studios. He handed a copy to Dylan, who brandished it for the cameras. "It looks pretty good," Dylan said. "I would go if I could, but unfortunately I won't be here."

(OPPOSITE) *Bill Graham, 1968;*
(RIGHT) *Bill Graham in the Fillmore Auditorium, 1968*

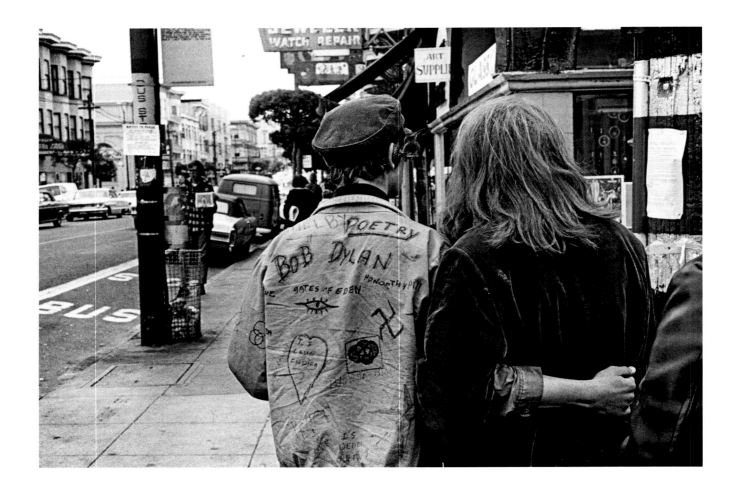

BOB DYLAN COMES TO TOWN IN THE POP MUSIC WORLD AT THIS POINT, SAN FRANCISCO MIGHT AS WELL HAVE NOT EVEN BEEN ON THE MAP. TOP FORTY DISC JOCKEY TOM DONAHUE HAD SOME

success with a small label called Autumn Records with hits by Bobby Freeman ("C'mon and Swim") and the Beau Brummels ("Laugh Laugh") that were produced by a talented teenager named Sylvester Stewart before he changed his name to Sly Stone. Otherwise, San Francisco didn't exist in the pop music universe.

The Beatles and the Rolling Stones dominated the world of rock music from lofty perches across the Atlantic. The vitality and cheeky humor of the Beatles and the dark, sardonic bent of the Stones had struck home with college-age music fans. They were making rock and roll that wasn't only for teenagers. The robust British beat group explosion had been echoed by a thousand American rock bands, from the Young Rascals in New York to the Byrds in Los Angeles. When the Rolling Stones came to play the S.F. Civic Auditorium in May 1965—the night after the band recorded "Satisfaction" in a Hollywood recording studio—there were dozens of people in the audience thinking about starting rock groups, including future members of Jefferson Airplane, the Grateful Dead, Big Brother and the Holding Company, and the Charlatans. Rock and roll musicians were the new cultural heroes, and nobody was more heroic at that moment than Bob Dylan.

The twenty-four-year-old Dylan was at his dazzling height. He had stood the folk music world on end the previous July at the Newport Folk Festival by playing electric rock backed by members of the Paul Butterfield Blues Band (including guitarist Mike Bloomfield), but the furor had largely died down. "Like a Rolling Stone" hit the Top Ten that fall, and his latest piercing folk-rock invective, "Positively 4th Street," was currently heading up the charts. His witty, fierce music was being received on a par with Lennon and McCartney, especially in hip circles, and he cultivated an elusive air of mystery around himself.

Dylan's concert appearance at the Berkeley Community Theatre was treated like a visit from royalty. In addition to the unprecedented television press conference (arranged and hosted by *Chronicle* columnist Gleason), Dylan held court at a sidewalk café on Berkeley's Telegraph Avenue and had drinks at the North Beach artists' bar, Tosca Café, with guitarist Robbie Robertson from his band and beat poets Allen Ginsberg and Michael McClure.

Marshall had photographed Dylan extensively in New York City, and Dylan remembered him well. Marshall took them across the street, where they posed in the alley beside the City Lights bookstore, Ferlinghetti's place. The photos captured a passing of the torch. Dylan had taken beat poetry and transformed it into pop music.

Dylan, too, had turned a musical corner, touring with the Canadian rock and roll band the Hawks since August and blasting out his new electric rock sound. Dylan sensed the seismic shift underground and was digging for something to say. He articulated a lot of thoughts that were floating around the gathering collective consciousness. "There's something happening here, but you don't know what it is, do you, Mr. Jones?" he sang in "Ballad of a Thin Man."

The Berkeley show was a ragged mess of tangled electric guitar, thrashing drums, and bleating harmonica, but it came to a persuasive close with "Ballad of a Thin Man," "Positively 4th Street," and "Like a Rolling Stone." Dylan was still finding his way into this new territory. Everyone was.

(ABOVE) *A young couple walks down Haight Street, 1967;* (RIGHT) *Robbie Robertson, Michael McClure, Bob Dylan, and Allen Ginsberg in the alley behind City Lights, 1965*

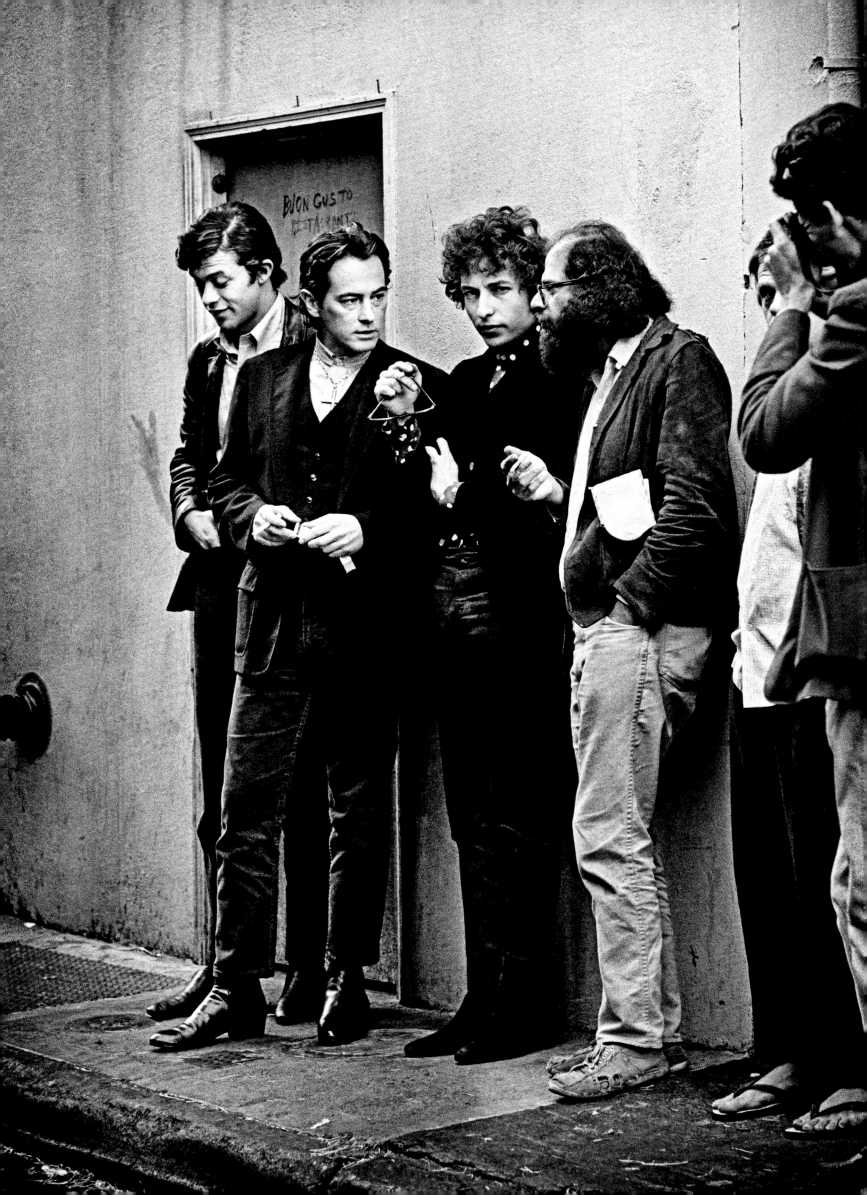

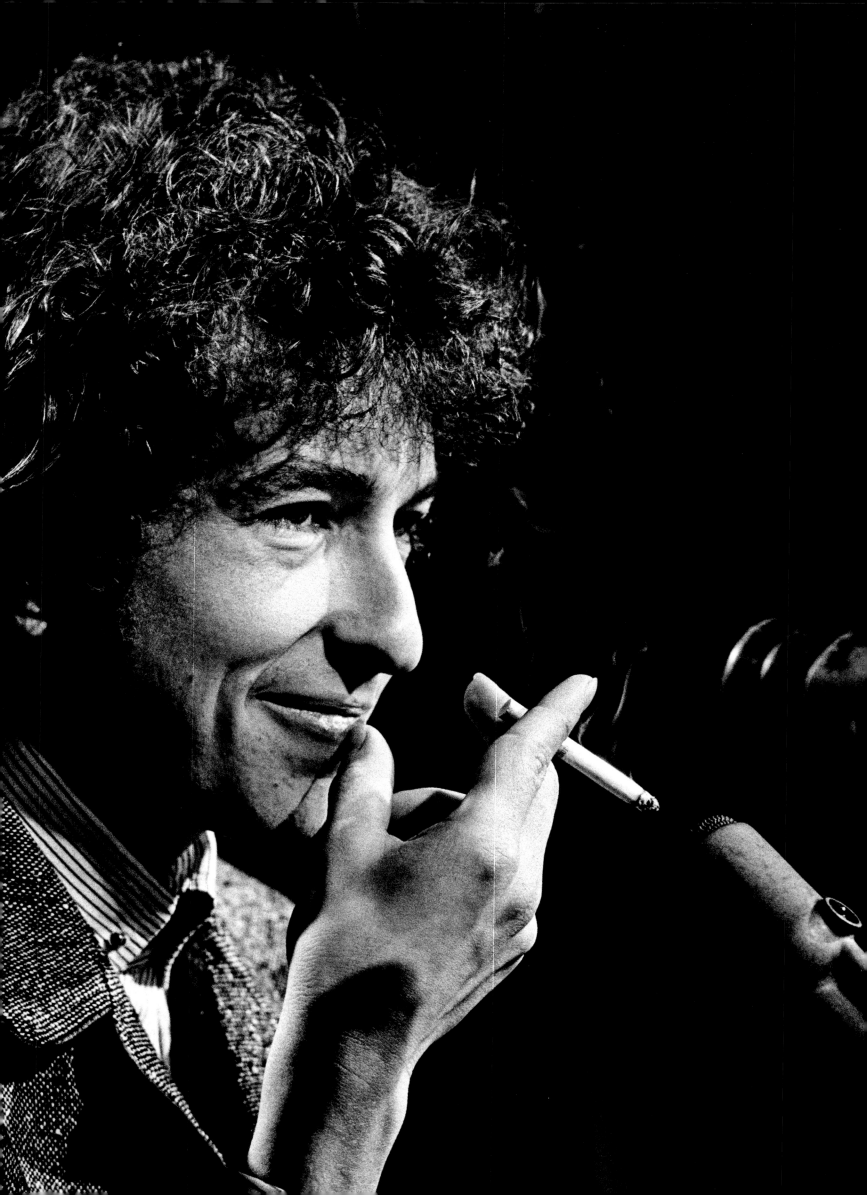

(OPPOSITE) *Bob Dylan at a televised press conference in the studios of KQED, 1965;* (ABOVE) *Bob Dylan and Robbie Robertson at the Berkeley Community Theatre, 1965*

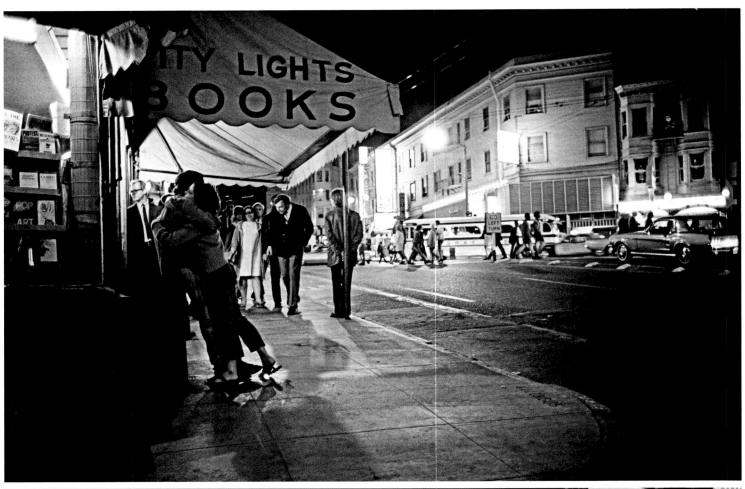

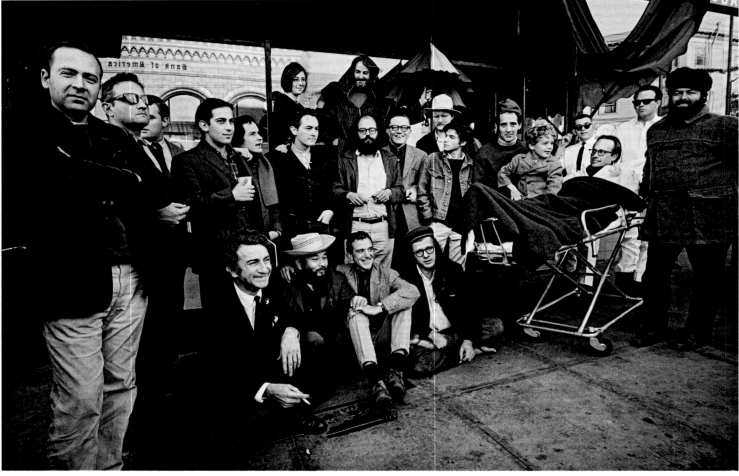

(TOP) *City Lights bookstore on Columbus Avenue at Broadway, 1968;* (ABOVE AND OPPOSITE) *The last gathering of the beats at City Lights, 1965*

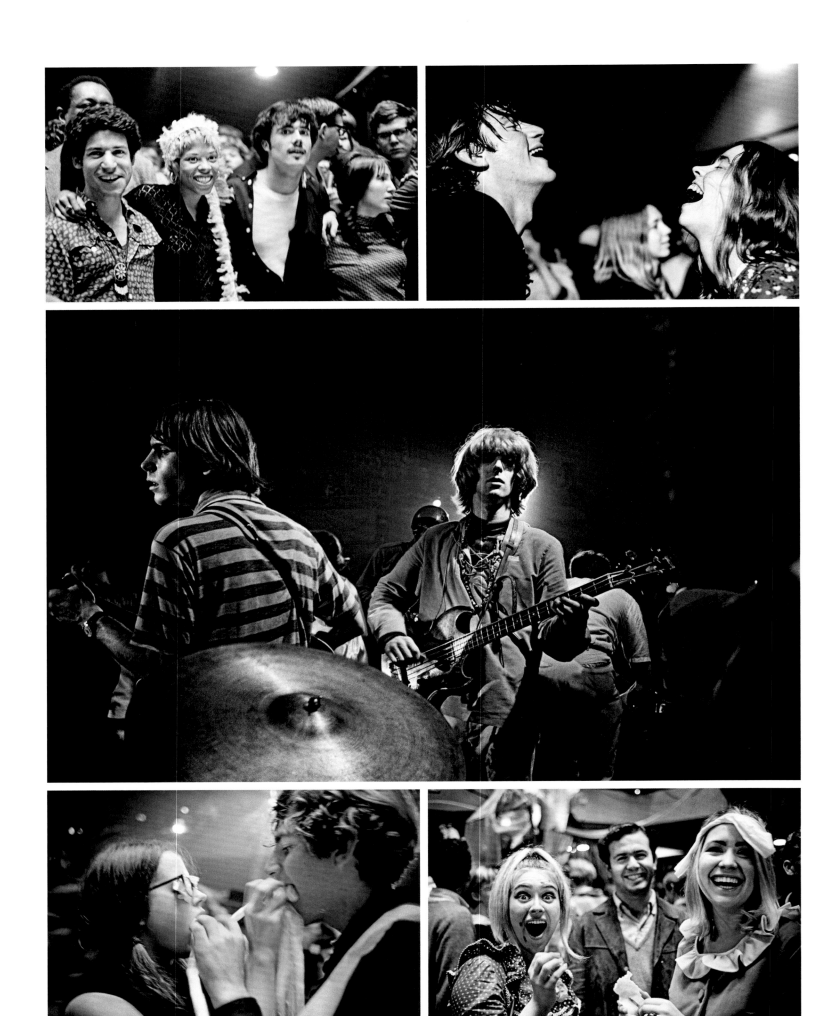

(THESE PAGES) *Images of the Trips Festival, 1966. Crowds revel and dance as the Grateful Dead (center, right), Big Brother and the Holding Company, and others perform at the three-day event.*

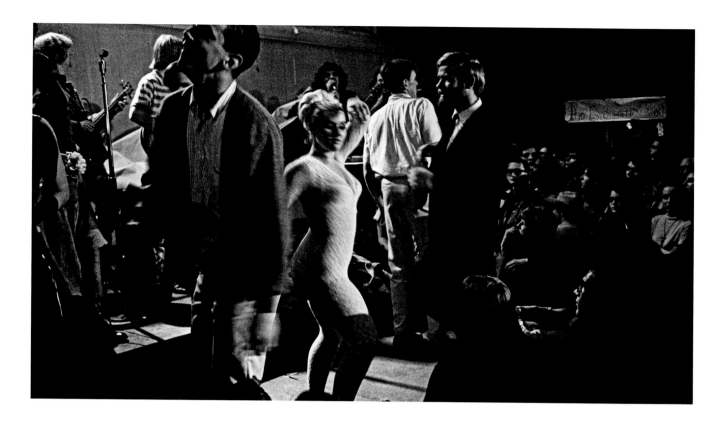

THE TRIPS FESTIVAL BILL GRAHAM'S APPEAL II AT THE FILLMORE AUDITORIUM ON DECEMBER 10

WAS THE FIRST TIME THE GRATEFUL DEAD APPEARED UNDER THAT NAME, AND GRAHAM WAS SO NERVOUS about the name change he put FORMERLY THE WARLOCKS on the poster. The Fillmore that night was another overcrowded mob scene and jazzman John Handy, one of the evening's announced headliners, showed up late from a nightclub gig across town. By the time he fought his way through the crowd to the backstage, he found a furious Graham, pointing at his watch and screaming, "Look at the fucking time." Handy turned around and left.

Chet Helms watched from the bar—under the sign NO BOOZE—and introduced himself to Graham at the end of the evening. They agreed to meet and talk about throwing more shows.

Kesey, who had been staging his public Acid Tests around the Bay Area all December, pulled into the Fillmore the first week in January 1966. Although the Pranksters were able to construct the massive scaffolding that held the light show and Ron Boise's Thunder Machine was on hand, the Dead's gear wouldn't work, so the evening subsisted on weird, Prankster-recorded taped music. The audience, who had been dipping liberally into garbage cans of dosed Kool-Aid, didn't mind. Kesey and the Pranksters had plenty of acid. Owsley had introduced himself a couple of months earlier. When the cops showed up, they took in the passive, peaceful, weird scene with some amazement. "They're in love," explained the hall's regular security guard. The cops closed the place down anyway at two in the morning.

Two weeks later, Kesey took over the Longshoremen's Hall for a three-day Trips Festival, literally advertising the exact nature of the event: *Can you pass the acid test?* The Pranksters approached Bill Graham about producing the chaotic event. Graham knew nothing of the Pranksters, their anarchistic inclinations, or their motto, "Never trust a Prankster." He also knew nothing about LSD.

The Monday before the event Kesey was sentenced to six months in county jail for possession of marijuana. Two nights later, he was arrested on a San Francisco rooftop and again charged with possession of marijuana. A second conviction could carry a five-year sentence, and Kesey was cracking under the strain. His girlfriend, Mountain Girl, was seven months pregnant with their baby. He decided to split the scene after the weekend.

At the Trips Festival, Graham scurried around with a clipboard under his arm, trying to maintain order. He didn't know the Pranksters and was mystified to find one letting people in without paying. "Bill, we've made enough money," he said. Graham was incredulous.

Graham hadn't met Kesey, but later that night, when he found some character in a silver space suit and helmet with the visor propped up letting in more people for free through a side door, he had a suspicion. "Ken?" he asked.

The character looked up, plopped his visor down over his face, and walked off. Of course it had been Kesey.

Big Brother and the Holding Company played. Sam Andrew got into a screaming match with Graham. Andrew was flying on a massive dose of LSD and whiplashed between intense joy and utter fear during his time onstage. The Dead were supposed to follow Big Brother, but the band's lead guitarist couldn't be found. After the light show started flashing a message on the wall (JERRY GARCIA—PLUG IN), he wandered back to the stage, more than slightly disoriented from a rather heroic dose of LSD he had consumed. When he picked up his guitar, he slowly realized that his guitar was broken. The neck had been snapped off after somebody stepped on the guitar, and it was swinging free on the strings.

Garcia was standing there helpless when some guy in a cardigan sweater carrying a clipboard strode up to him and took the guitar away. He fell to his knees, put his clipboard down, and valiantly tried to jam the neck back in place. As Garcia watched the futile effort, he felt himself warm to this odd stranger who wanted so much to help. It was the first time he met Bill Graham. But the Dead were never going to play that night. They would have to come back the next night.

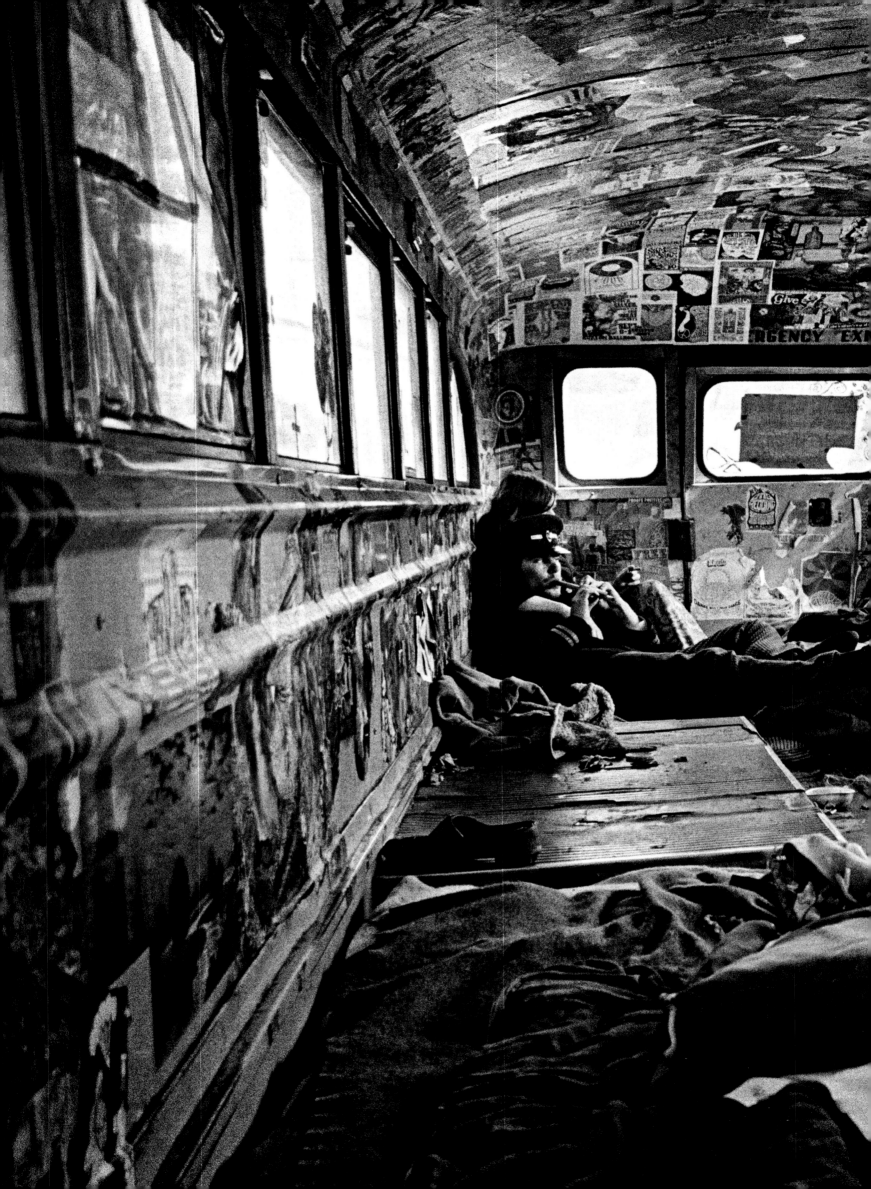

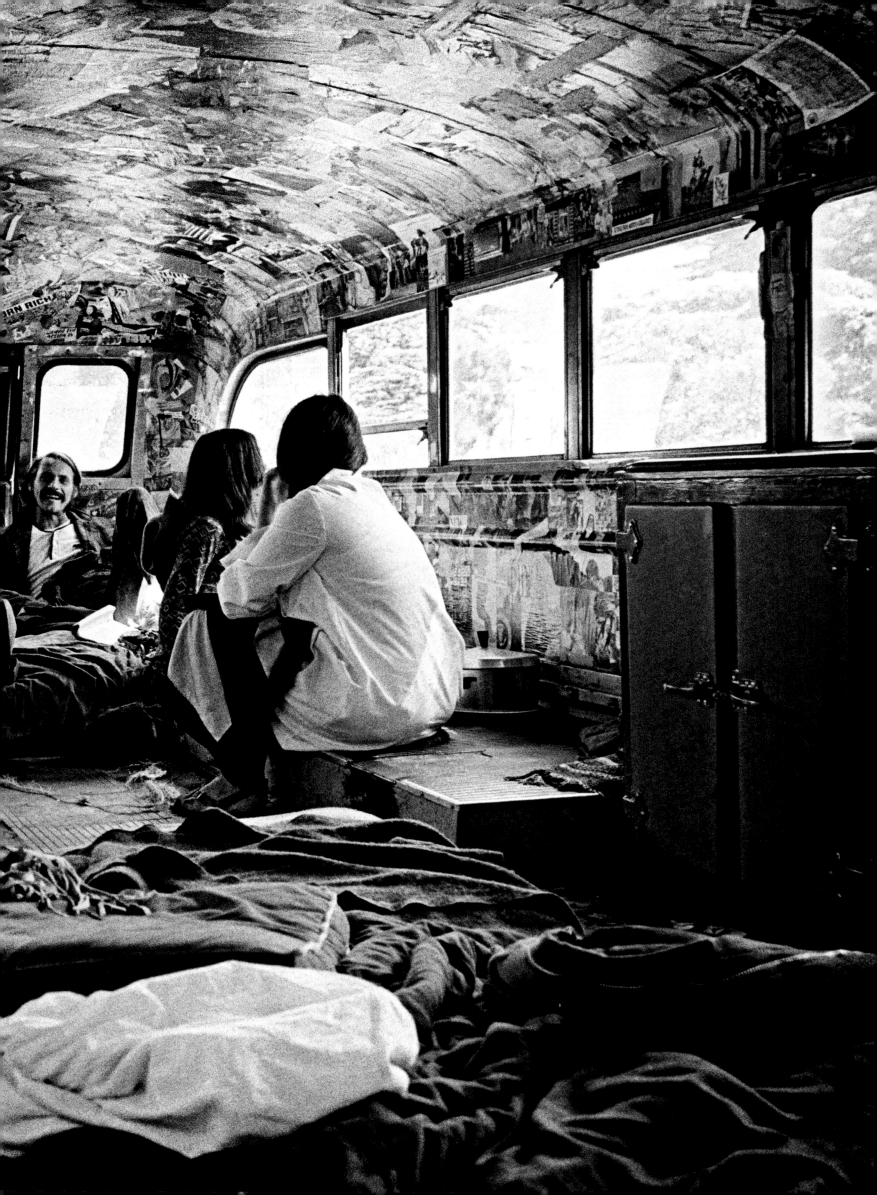

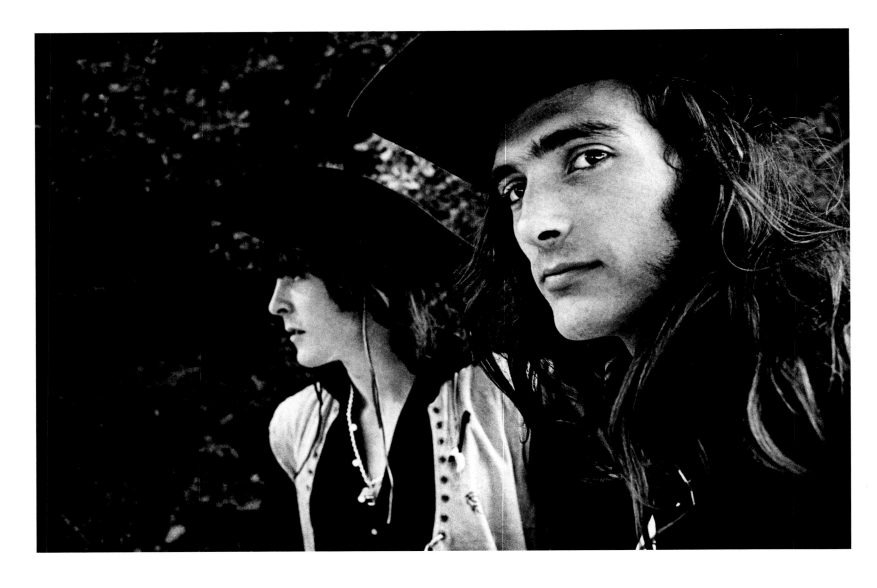

QUICKSILVER MESSENGER SERVICE ON A GOOD NIGHT, QUICKSILVER MESSENGER SERVICE
COULD MATCH THE AIRPLANE OR THE DEAD LICK FOR LICK, AND THE BAND SHARED MANY BILLS IN
those heady early days. Quicksilver started when guitarist John Cipollina ran into guitarist Gary Duncan and drummer Greg Elmore
with a mutual friend on the streets of North Beach after A Tribute to Dr. Strange, which they had all attended. Duncan and Elmore were
fresh from a teen rock band in the Central Valley called the Brogues that had made a couple of nowhere 45s, but they were getting shaggy,
sleeping in the mutual friend's basement. Within days, the three musicians were jamming together at Chet Helms's Wednesday night
soiree in the Haight, while a couple of members of the South Bay band the Warlocks looked on from the crowd.

Cipollina knew vocalist Jimmy Murray and bassist David Freiberg, a former folksinger to whom Cipollina loaned an electric bass he had rattling around his car trunk. They had been hired to form a band behind songwriter Dino Valenti, but that prospect evaporated when Valenti was busted and sent to jail on drug charges. Valenti was a story himself. A charismatic hustler with a powerful voice, he had grown up around carnival midways and spent time in the Village. Valenti wrote the song "Get Together," which became something of an anthem of the love crowd after versions were recorded by the Airplane and the Youngbloods, but he sold the copyright for chump change to raise money for his hapless defense.

With all five musicians now living together in the North Beach basement, the band quickly took shape and even played a couple of dates at the Matrix before they settled on a name. It was Murray who pointed out that all five band members were Virgos—four shared two birthdays—and proposed the name Quicksilver Messenger Service.

The new group earned two hundred dollars for the first gig—the Christmas party for the Committee, the popular San Francisco improvisational satirical group—and promptly rented a shack on the mudflats of Larkspur in Marin County. They had no money and ripped up the neighbor's boardwalk to burn for heat, but they had a rock band.

(PRECEDING PAGES) *Inside a converted school bus, 1967;* (ABOVE) *Greg Douglass and John Cipollina, 1968;* (RIGHT) *John Cipollina at the Berkeley Folk Festival, 1968;* (FOLLOWING PAGES) *Quicksilver Messenger Service, 1968*

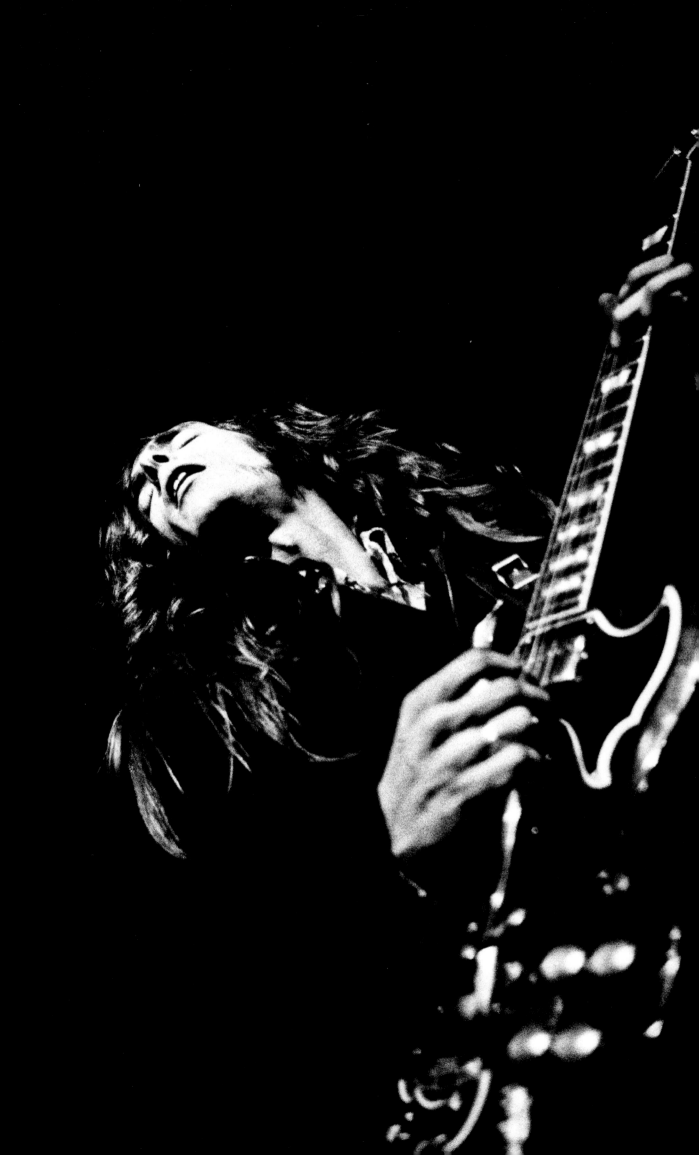

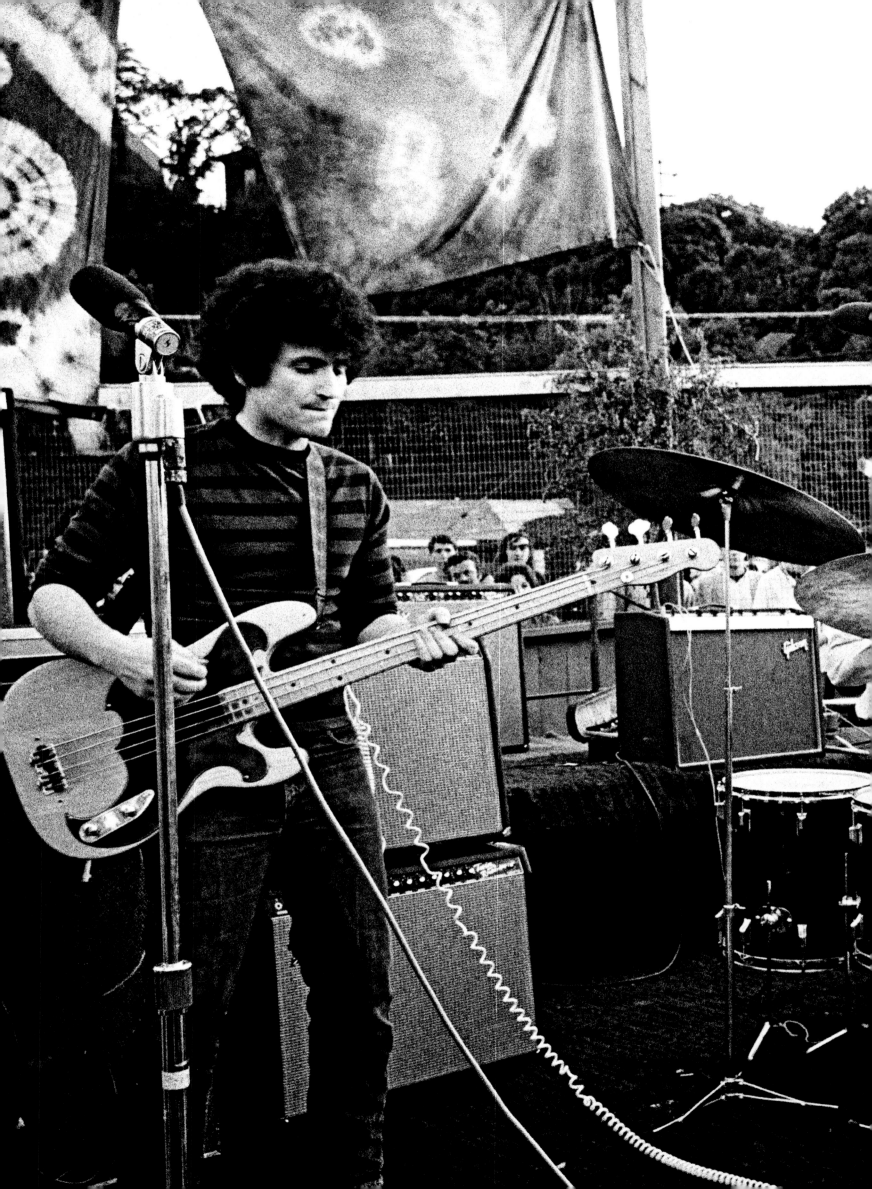

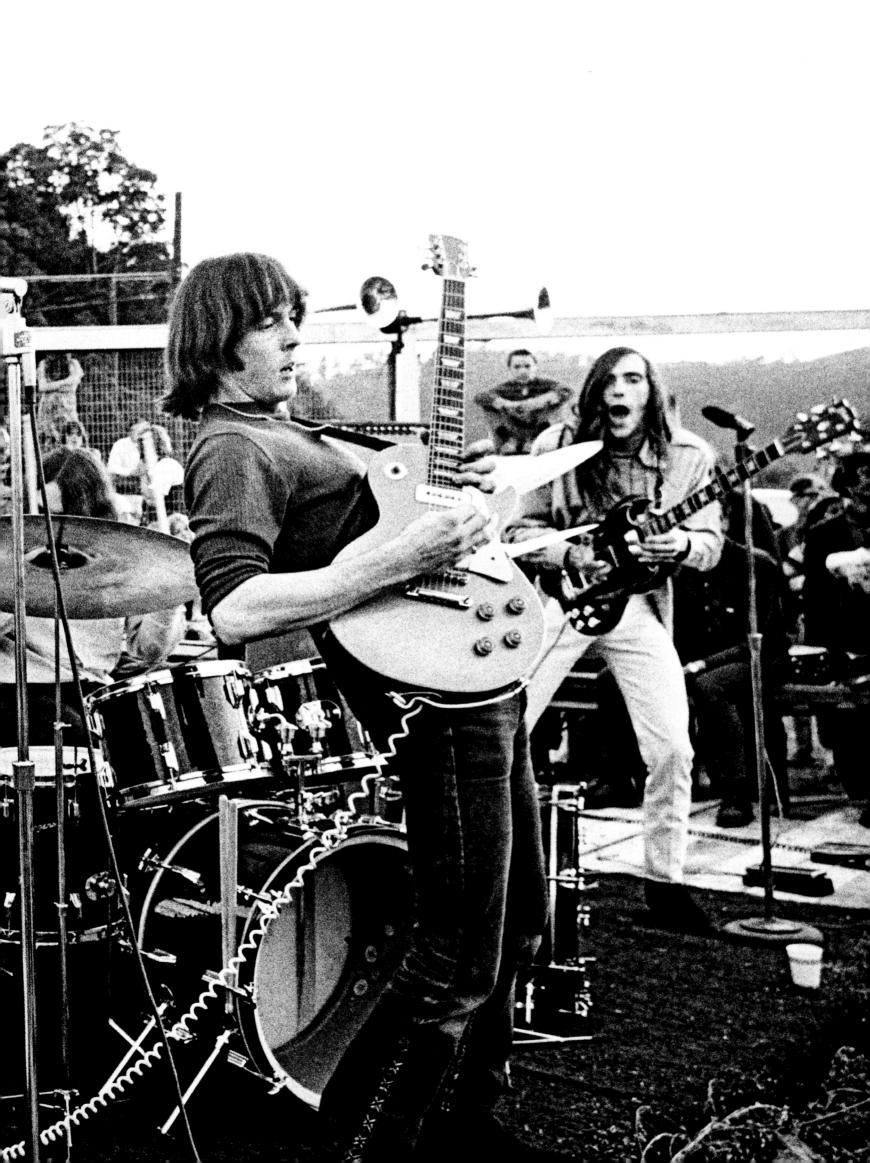

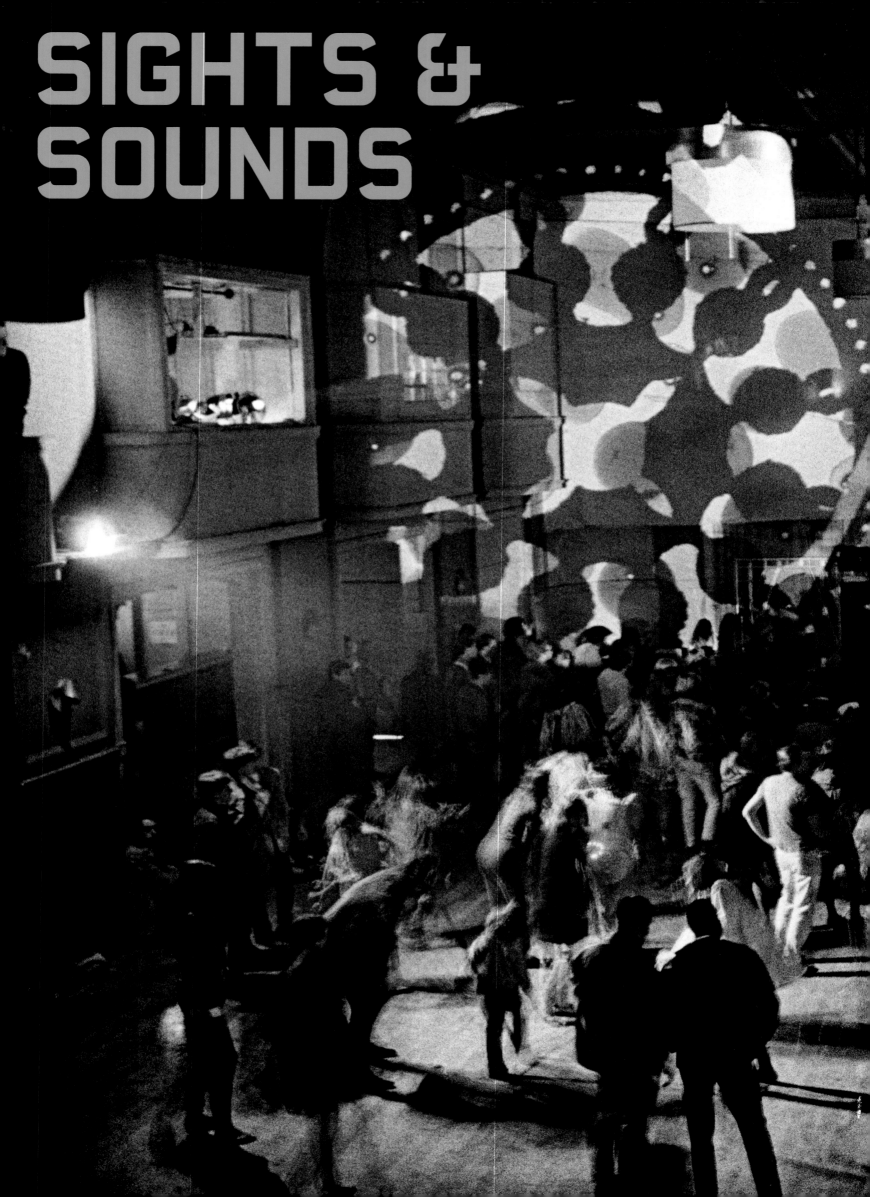

SIGHTS & SOUNDS

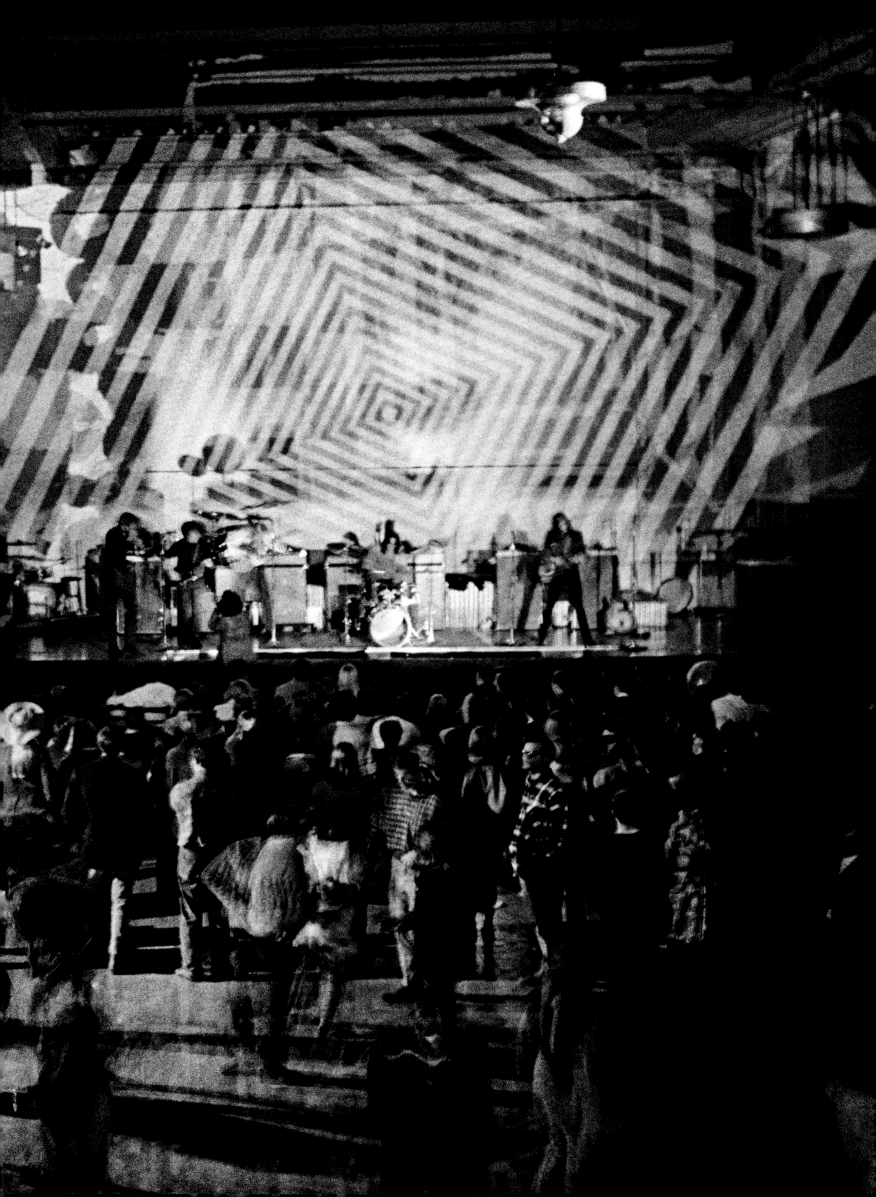

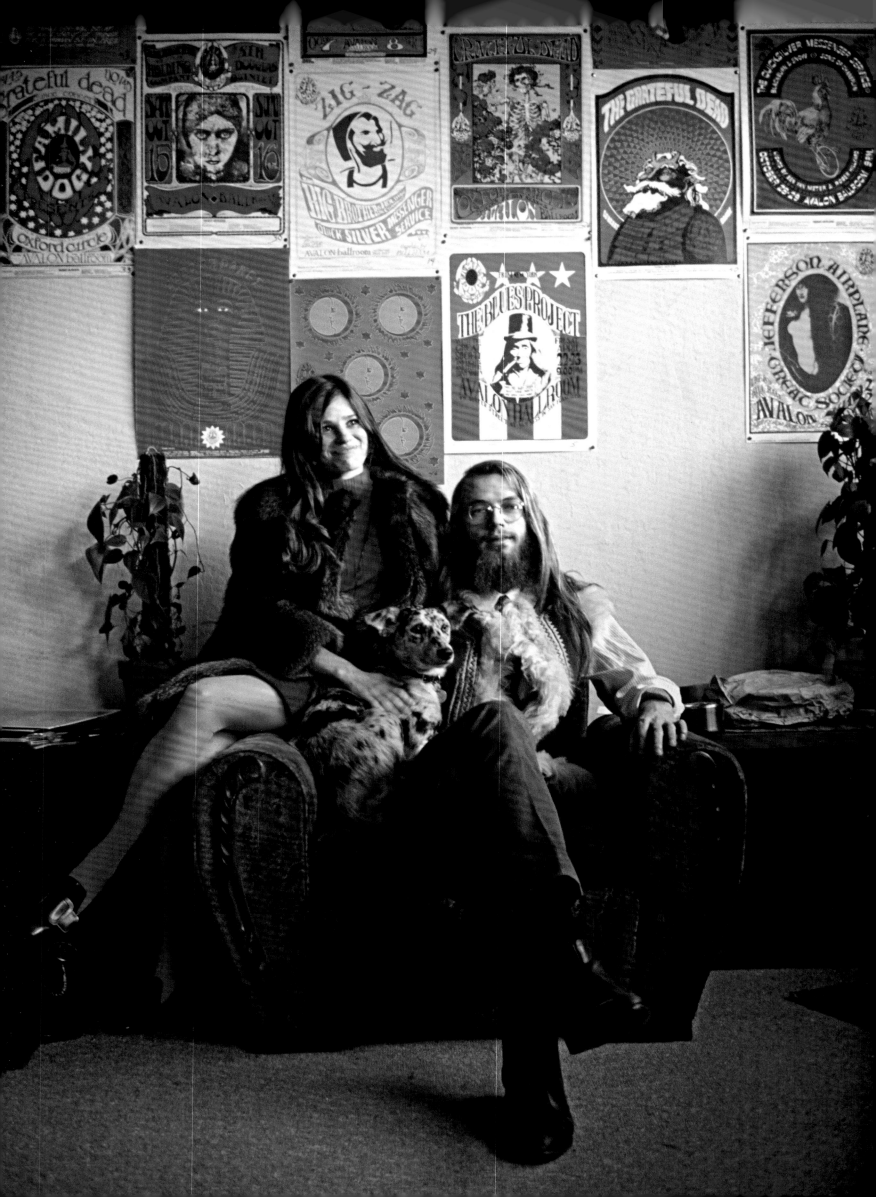

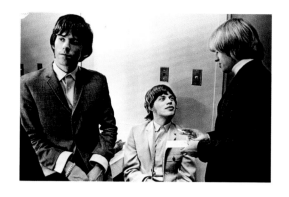

Ronald Reagan enters politics, elected governor of California. The new Rolling Stones hit is "Under My Thumb," and the new Beach Boys album, *Pet Sounds*, is barely noticed. Mod London is at its height with Carnaby Street fashions. The Houston Astrodome, "the eighth wonder of the world," opens. *Star Trek* starts on television. Average price of a new car: $2,650. *Valley of the Dolls* by Jacqueline Susann tops the best-seller list.

BILL GRAHAM left the Mime Troupe and opened his own operation at the Fillmore Auditorium the weekend after the Trips Festival with Jefferson Airplane. The poster read, SIGHTS AND SOUNDS OF THE TRIPS FESTIVAL! The following show, with Helms as his partner, he presented "Batman," a dance-concert modeled quite specifically on the Family Dog shows at Longshoremen's. Quicksilver Messenger Service played, and to encourage ticket sales, they raffled off a mynah bird, which, unfortunately, was deaf by the end of the weekend after sitting on the stage in his cage with the rock bands blasting all three nights.

The next concert the partners produced brought the Paul Butterfield Blues Band to town in April, a watershed event in the exploding scene. The band was already very well known in the San Francisco underground through their hard-driving first album on Elektra Records, nominally a folk label. Backing Dylan at Newport only added to the band's hip currency. Butterfield guitarist Mike Bloomfield had taken off from classic Chicago blues guitar stylings into realms the rock world had never before seen. He flashed startling electric bottleneck guitar on "Shake Your Moneymaker" from the band's first album. He played on Dylan's triumphant "Like a Rolling Stone," and although the album featuring the thirteen-minute piece would not be released until that fall, the band was already playing "East-West," the masterful, soaring composition Bloomfield conceived on an LSD trip. Bloomfield was rock's first guitar hero.

Butterfield himself was a freak of nature, a young white man so thoroughly drenched in the blues, he was like the reincarnation of Little Walter. His harmonica playing took on the timbre of a tenor saxophone. Elvin Bishop, a blues-mad farm boy from Iowa and Bloomfield's counterpart on second guitar, could match him every step of the way. They borrowed the rhythm section from the Howlin' Wolf band. San Francisco had never seen musicians like these and the town was ready. These men were titans. Jefferson Airplane (featuring the group's new bass player, Jack Casady) completed the bill.

Although Graham originally balked at the twenty-five-hundred-dollar price, he and Helms counted the proceeds at the end of the night and agreed a return engagement would be a great idea. That Monday morning, Graham set his alarm clock for six in the morning and called New York to make the deal, cutting out his partner while he was still asleep in bed. "If you want to stay in this business," he told Helms, "get up early."

Graham could be as charming as he could be abrasive. He was driven to succeed, and his attention to detail never flagged. He could pick up and empty an ashtray, barely losing a step, striding across the hall to introduce the next act. He ran his small operation with a secretary, a stage manager, and the same security guard

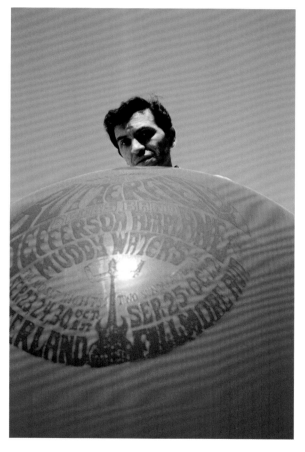

who worked for Sullivan. His wife did the artwork for the posters. He spoke with a thick Bronx accent, used his considerable street smarts to compensate for his lack of knowledge about the music scene or the hip world, and was definitely no hippie. He did not take LSD.

The Fillmore Auditorium was upstairs in a yellow brick building on the corner. Graham put a barrel of apples at the top of the stairs and a sign that read, FREE—TAKE ONE. Plastic sheets draped the walls and light show crews working in the balcony bathed the walls and stage in pulsing, colored multi-media projections. People flexed plastic trays of colored oils in time to the music. Film loops played behind flashing moiré patterns. The back end of the hall was lit by ghostly black fluorescents, and a

(PRECEDING PAGES) *Quicksilver Messenger Service performs at a light show, 1966;* (OPPOSITE) *Chet Helms, 1966;* (TOP) *The Rolling Stones backstage at the New Civic Auditorium, the San Francisco stop on their first American tour, 1965;* (RIGHT) *Bill Graham advertising "The Sound: A Dance Party" featuring Paul Butterfield Blues Band, Jefferson Airplane, and Muddy Waters at Winterland, 1966*

Day-Glo peacock had been painted on the wall. The tiny stage was about three feet off the ground. People would leave their babies on blankets in the back and dance in front of the stage. Admission was a modest three dollars.

Within weeks, Helms found another spot, the Avalon Ballroom, an upstairs hall with a balcony and a sprung dance floor that was built in 1911 on the corner of Van Ness Avenue and Sutter Street. All through that spring, both ballrooms drew enthusiastic crowds and presented an array of the new local acid-rock bands—Jefferson Airplane, Grateful Dead, Quicksilver Messenger Service, Big Brother and the Holding Company, Country Joe and the Fish—alongside acts from out of town that fit into

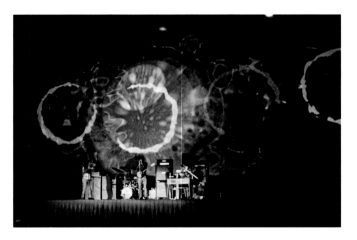

the new underground rock scene—Blues Project from New York, Love, the Mothers, the Leaves, the Turtles, and others from Los Angeles, Daily Flash from Seattle, Sir Douglas Quintet from Texas. The bills often featured blues greats such as Howlin' Wolf, Muddy Waters, Lightnin' Hopkins. Rock and roll pioneer Bo Diddley proved an especially popular attraction in a number of appearances at the Avalon.

Outside of occasional mentions in Ralph Gleason's column, these events both drew hundreds of people every week and received little attention from anyone outside the halls. What they saw and heard inside those rooms was a rapturous, encompassing, vivid experience. It was

impossible not to be swept up by the sounds, sights, fragrances, and overwhelming atmosphere of these places. The music was extraordinary, but the audience was as much a part of the show as the performers, and the phenomenon at this point was almost exclusively limited to the people who participated, almost like a not-so-secret society, an ecstatic tribal rite.

Chet Helms always liked to make the distinction between Apollonian theater under spotlights on a proscenium stage—the gateway to the gods—and a Dionysian revel, where there was no difference between audience and performers. The stages at the Fillmore and Avalon were small, low to the ground, and the bands were slathered in moving, flashing, pulsing colored lights. There was no stage lighting, no spotlights. The rooms were giant tureens, swimming in sounds, lights, and dancing bodies.

The massive, complicated light shows grew out of some experiments by Bill Ham, manager of the Pine Street house, who built a light show in a box in the building's basement. Invited by Helms to develop his light show at the Avalon, Ham added liquid projection where bubbles of colorful oil belched and bounced in time to the music as operators wiggled plastic plates holding the mixture under opaque projectors. Light show artists began to add layers of visuals—slides, film loops, strobe lights, different projectors—and their crews expanded to where as many as a dozen people kept themselves busy in the balconies of the dancehalls, improvising with lights in collaboration with the musicians. They blanketed the ballrooms with ever-expanding visuals set to the music. The light show companies were credited on the posters.

Posters advertising these dances grew more bold and imaginative every week. For the Avalon Ballroom, artists Alton Kelley and his partner Stanley Mouse were expanding the vocabulary of visual language with images they brought back from LSD experiences. Mouse and Kelley both had backgrounds in motorcycle pinstriping. Mouse was somewhat well known for his monster car art in Detroit featuring crazed rodents behind gearshifts and steering wheels. Kelley, one of the four original Family Dog members, had drawn the handbill for A Tribute to Dr. Strange.

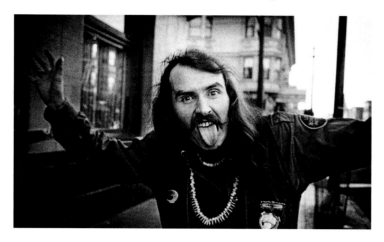

They rummaged the public library for images they pasted into inspired collages, like the famous skull and roses poster they did for a Grateful Dead show at the Avalon. That one they lifted from *The Rubiyat of Omar Khayyam*. They used Edward Curtis photographs of Native Americans, Smokey the Bear, the Zig-Zag man, anything they could lay their hands on. They turned out more than a poster a week and kept a Mason jar with liquid LSD in their refrigerator.

They were making posters for the Avalon that looked like the music sounded. Kelley was the idea man and Mouse the detail guy, although they were such close collaborators they could draw on the same canvas at the same time. At the Fillmore, where the posters were by decree more legible and less extravagantly psychedelic, artist Wes Wilson got into a dispute with Graham over money and drew his case into his posters—one poster showed his pregnant, naked wife reaching out for money. His last poster for Graham was decorated with a serpent holding a dollar sign between his teeth.

Other extraordinary poster artists, such as Victor Moscoso and Rick Griffin, soon emerged, and these artists revitalized the century-old art of poster making to heights not seen since Toulouse-Lautrec. The artists were also every bit as much original characters as the musicians. Without really knowing it, they were developing America's first electric folk art. They somehow managed to capture some visual/graphic essence of the experiment and communicate it vividly. The posters caught fire with the public. People snatched the posters out of store windows almost as soon as they were posted and began decorating bedrooms in crash pads all over the Haight.

The Haight was blooming. Not only were hordes of young people gravitating daily to the neighborhood, but stores catering to the wacky youngsters began cropping up. The brothers Jay and Ron Thelin, who grew up working in their father's Woolworth's on Haight, pioneered the strip with their Psychedelic Shop, a kind of headquarters

for the new residents in the neighborhood across the street from their dad's old store. Other hip shops soon followed, like a boutique called Mnasidka. Soon there was a health foods store called Far Fetched Foods, another clothing store named Blushing Peony, and the I/Thou coffeehouse. Longtime residents mixed comfortably with the colorful kids. San Francisco's long-standing affair with the unconventional was on their side. When police arrested Graham under a 1909 law forbidding a minor unaccompanied by an adult to attend dances, even the staid *San Francisco Chronicle* editorial page cried foul. Newspapers started to fondly call these kids "hippies."

They packed into the neighborhood's Victorians, three, four, or more to a room, sleeping on the floor, sharing meals with the whole household, splitting the rent into tiny pieces. They decorated out of dumpsters and the Salvation Army. Glass bead curtains were popular substitutes for bedroom doors. They lived like happy refugees in these overrun rooming houses they started calling crash pads.

They dressed in post-mod thrift store chic, draped in beads and bracelets. The girls favored bright colors and long peasant skirts. The boys wore jeans, long hair, scraggly beards, and Navy pea coats and other Army surplus wear was popular. Boots or sandals were optional. Coats and ties were not. Fashion was a statement or, most accurately, anti-fashion was an anti-statement. But as the culture evolved, a fashion of its own did develop out of the cast-off rags and the dishabille the first hippies affected.

At this point, the phenomenon was restricted to a few college-age youth living in the Haight and elsewhere. Although it was clearly spreading, even beyond San Francisco to isolated spots like New York's East Village or Venice Beach in Los Angeles, it was still a germ in incubation. San Francisco was the petri dish.

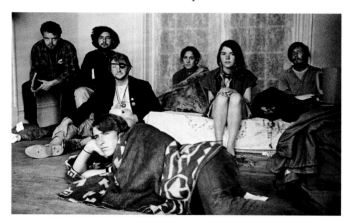

With the vast expanse of Golden Gate Park at the end of the street, the new members of the Haight fanned out into the park every day. They claimed one spot as Hippie Hill and sat around smoking joints and strumming guitars. The bands occasionally performed impromptu concerts around the park and in the Panhandle. It was easy to roll up a flatbed truck loaded with gear, plug into a generator or string extension cords from a nearby building, and play. The park officials had a tacit understanding with the Airplane and the Dead that if they didn't announce the concerts or draw an unmanageable crowd, nobody would care. Through the summer months of 1966, both bands enjoyed many free concerts in the park, where hippie girls danced barefoot and an American archetype—as strong and enduring as cowboys in the Wild West—was born.

(OPPOSITE) *Various light show images, 1966;* (TOP) *Poster artist Alton Kelley, 1967;* (RIGHT) *A crash pad in the Haight, 1967;* (FOLLOWING PAGES) *Bill Graham in his office at the Fillmore, 1967*

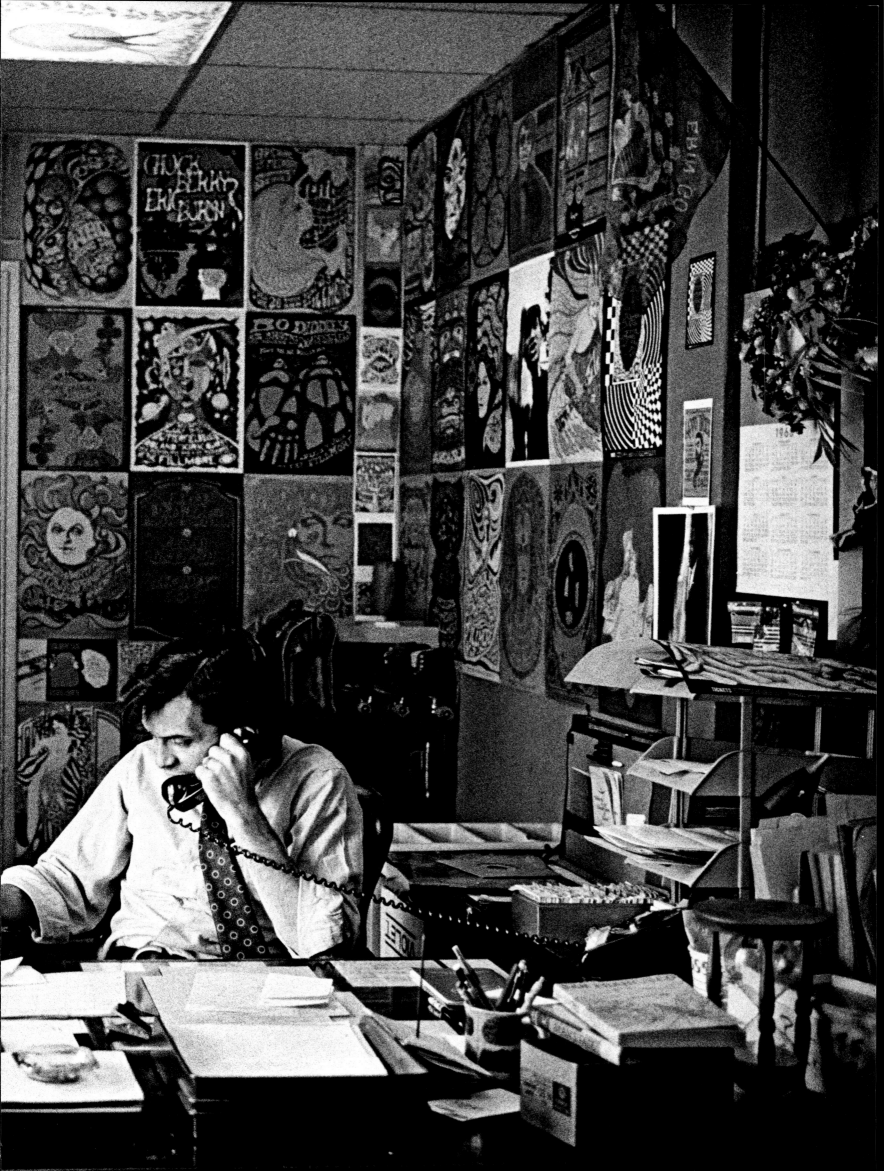

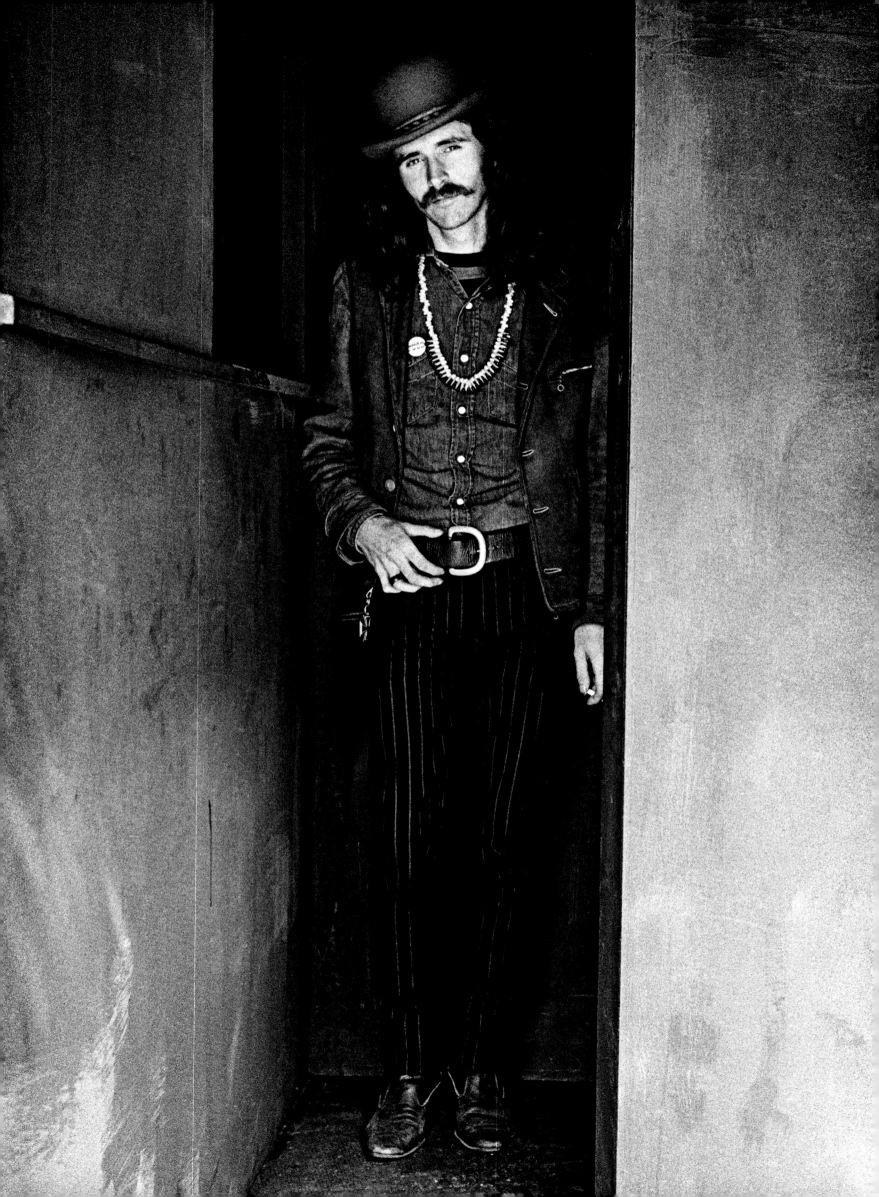

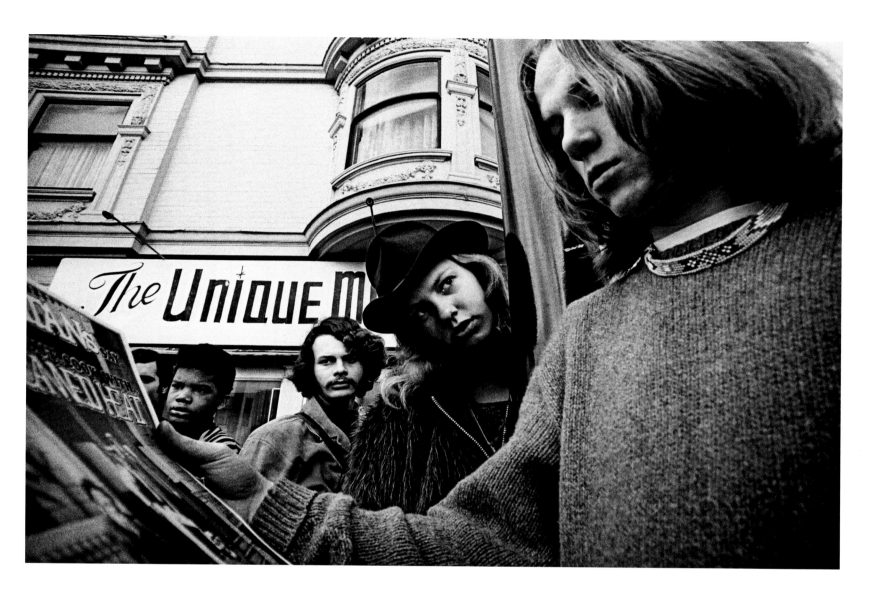

Those first years it was really a great neighborhood, the Haight-Ashbury. Everybody knew everybody. It was really fun. Everybody was really enjoying themselves. It was sort of the opposite of the beatnik era. They all dressed in black and were on kind of a downer. We all came out of the rock and roll world and not World War II. We had this background behind us of Chuck Berry and Little Richard. This whole other kind of genre thing going on with the music and stuff. The beatniks were into jazz, and we were the rock generation. Kind of a total reverse. Kind of filled a spot. A lot of freedom was derived out of that period, like how you look. Nobody cared anymore, but before that people were kind of uptight. . . . For that short period of time, it was really fun, and we had a helluva good time. That was a long-running party. —ALTON KELLEY

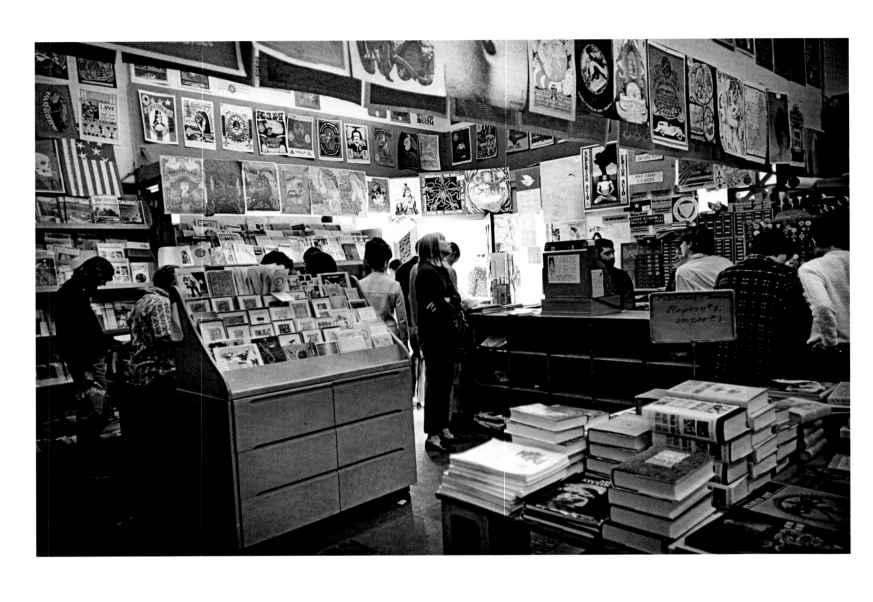

(PRECEDING PAGES) *Alton Kelley (left); a man and woman admire a concert poster (right), 1967;* (ABOVE) *Posters for sale, 1967;* (RIGHT) *Stanley Mouse, 1967;* (FOLLOWING PAGES) *Street scenes from the Haight, 1967*

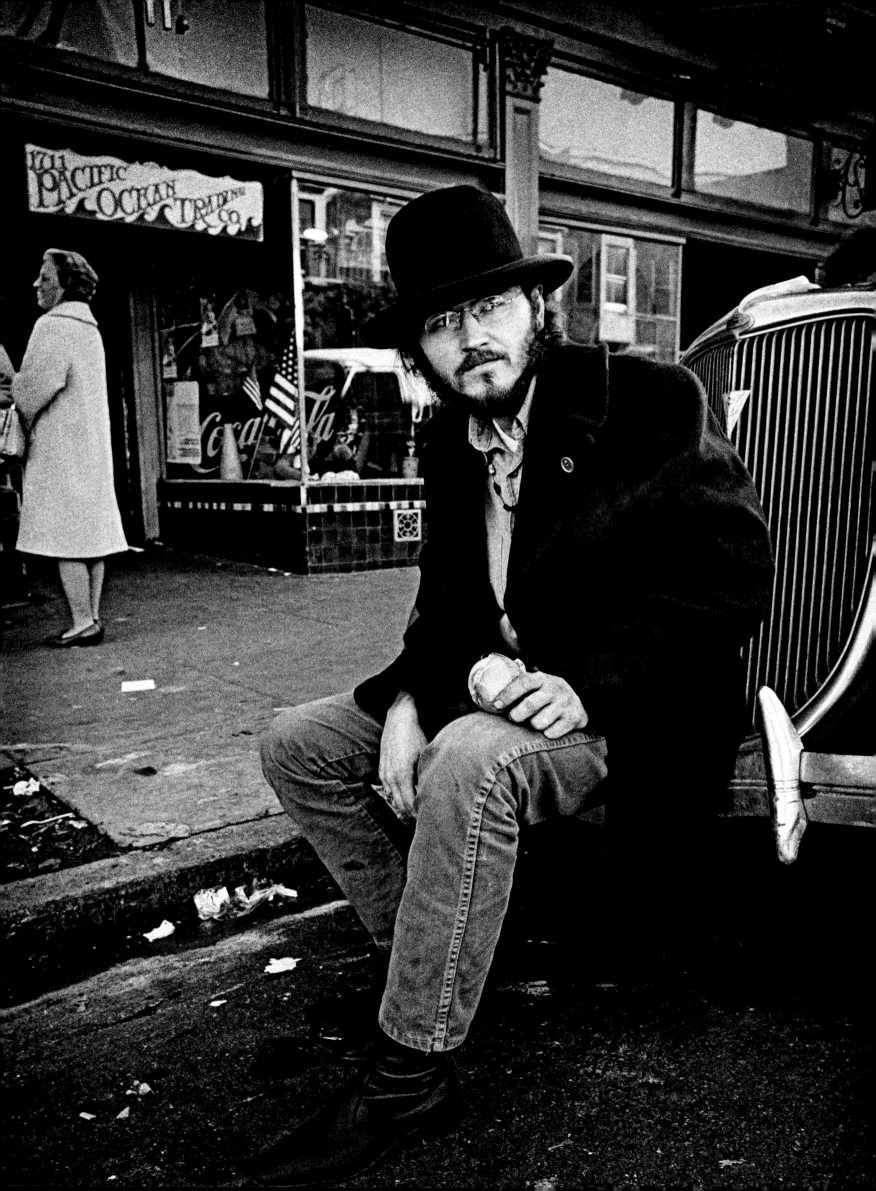

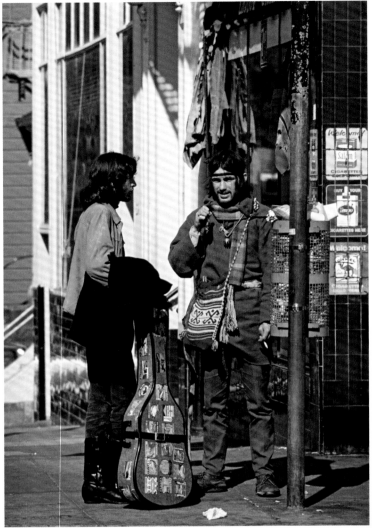

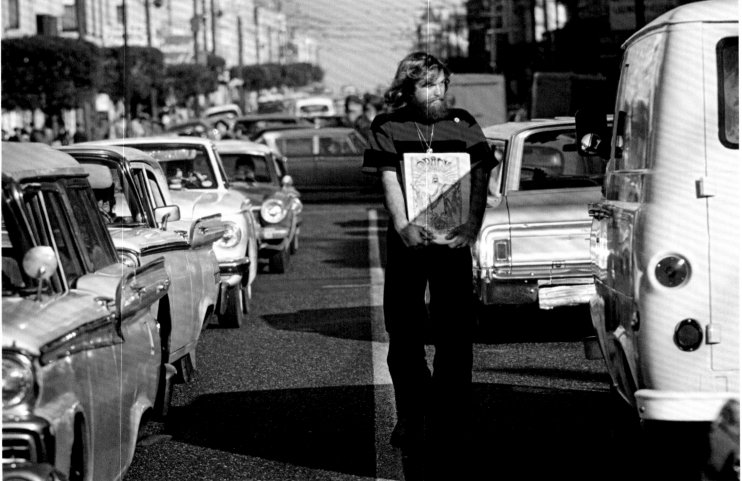

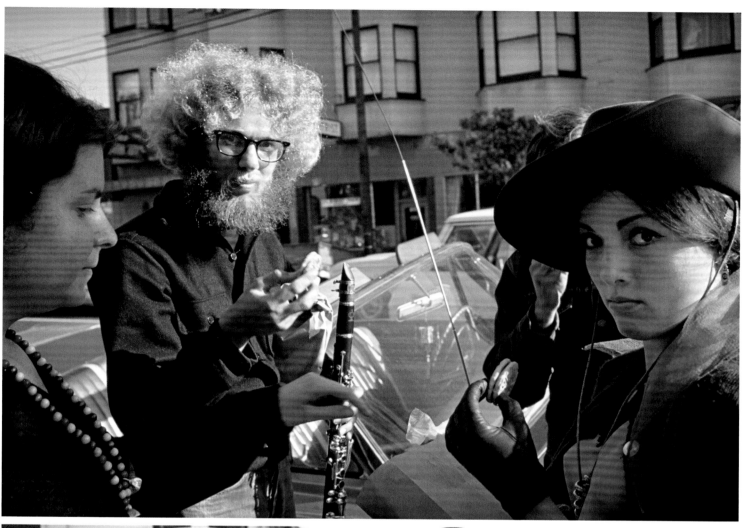

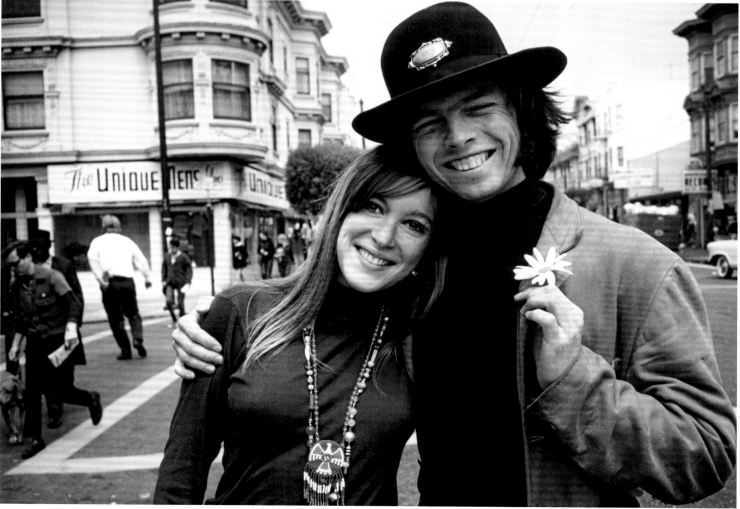

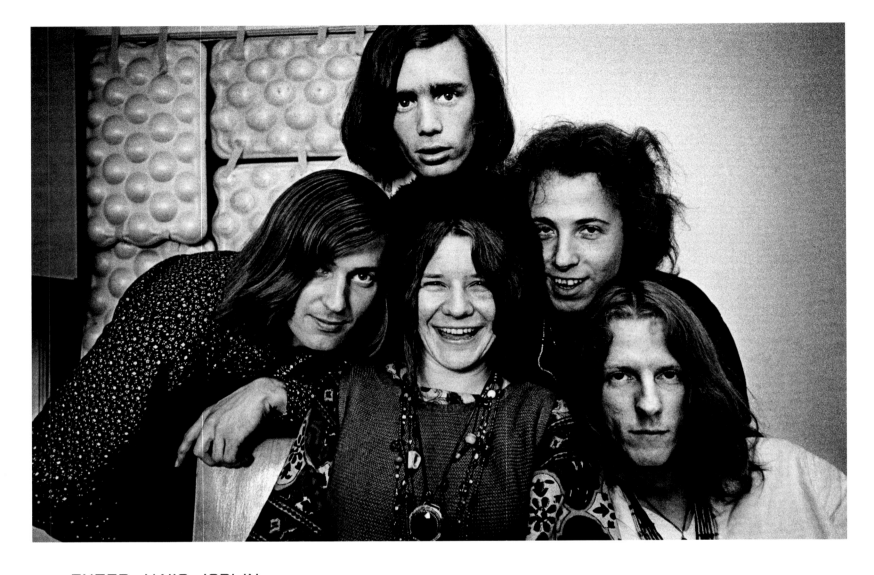

ENTER JANIS JOPLIN CHET HELMS KNEW JANIS JOPLIN FROM THEIR DAYS AT THE UNIVERSITY
OF TEXAS IN AUSTIN. SHE HAD TRIED SAN FRANCISCO BEFORE, WHERE SHE MADE THE ROUNDS OF THE
folk clubs doing her Memphis Minnie blues bit (and even came to know Jorma Kaukonen of the Airplane in South Bay folk circles),
but ran back to Texas with her tail between her legs with a meth habit and a shoplifting bust. Helms, too busy running his Avalon
empire, sent their fellow Texan Travis Rivers to convince Joplin into joining Big Brother and the Holding Company. She had never
sung with a band before, but she was game to give this electric rock thing a shot.

In June 1966, this girl in a thin, sleeveless cotton
blouse, shorts, bad skin, and her hair piled on her head
in a bun showed up where Big Brother was rehearsing
at the Mouse and Kelley studios, an old firehouse
on Henry Street. The band was not immediately
impressed, but they worked her into the act and gave
her a microphone on the side of the stage at the Avalon
that next weekend. She did a few numbers. The band
members talked afterward about whether to keep her or
not. They decided to keep her.

With Helms as the band's manager, Big Brother and
the Holding Company was a regular feature on Avalon
bills. Guitarist Gurley had developed a volcanic style,
and bassist Albin had an attractive, serviceable voice,
but the band lacked focus—a problem not uncommon
to the early San Francisco psychedelic bands. Joplin was
joining a boy's club, but Helms watched a female vocalist

work so well for the Airplane and thought Joplin might
be the answer.

Janis Joplin, of course, turned out to be one of the
great contributors to the Haight music scene, but her
beginnings with the band were humble. She had to find
her way at first. For all her bluster, bravado, and brazen
behavior, there was an insecure, vulnerable homely girl
not far beneath—a volatile combination that she slowly
started to mine with Big Brother. When she first came
to town, the band lived communally in an old hunting
lodge in the woods of Marin. They soon moved back to
the city. Joplin took an apartment off the Panhandle in
the heart of the Haight, where she was merely another
funky chick, frequently seen strolling with her dog,
hanging out with pals on the sidewalk. As in any small
town, she was well known in the neighborhood's stores
and bars.

(ABOVE) *Big Brother and the Holding Company,
1967;* (RIGHT AND FOLLOWING PAGES) *Janis Joplin in
her apartment on Lyon Street, 1968*

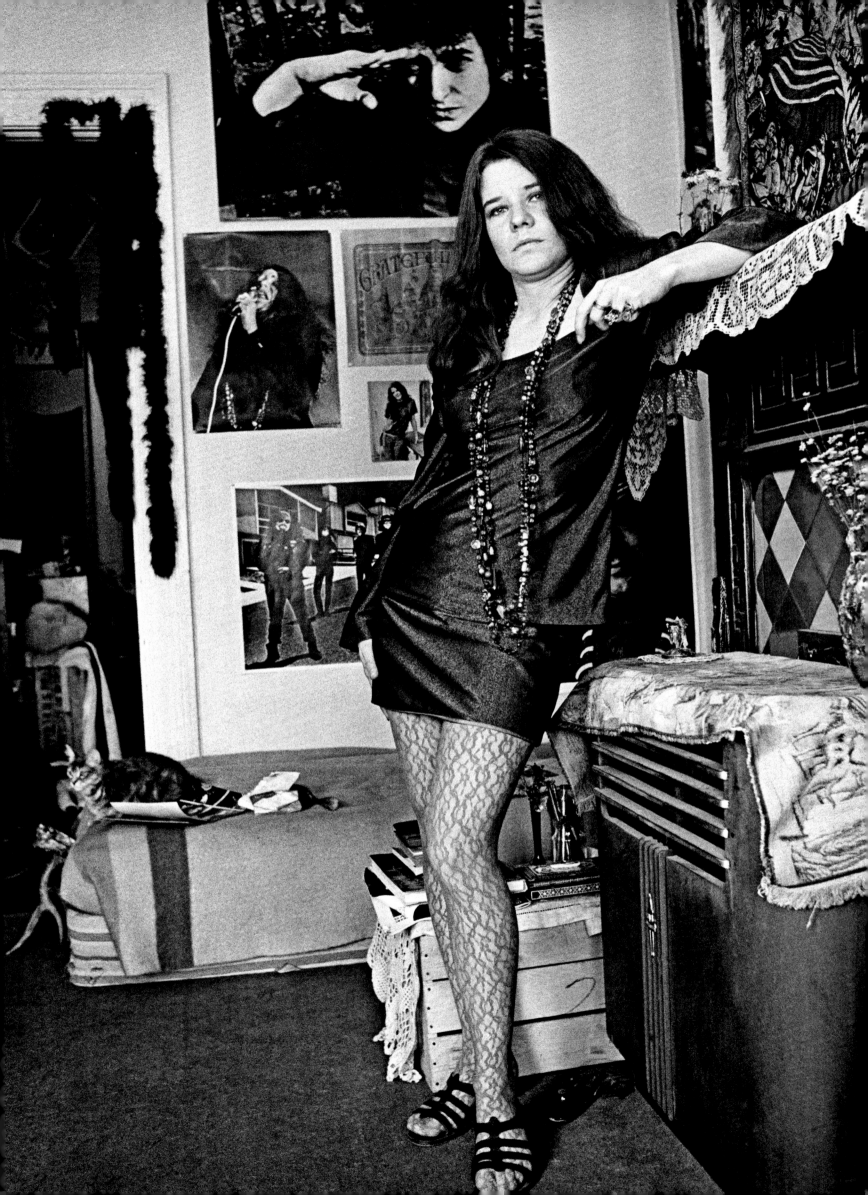

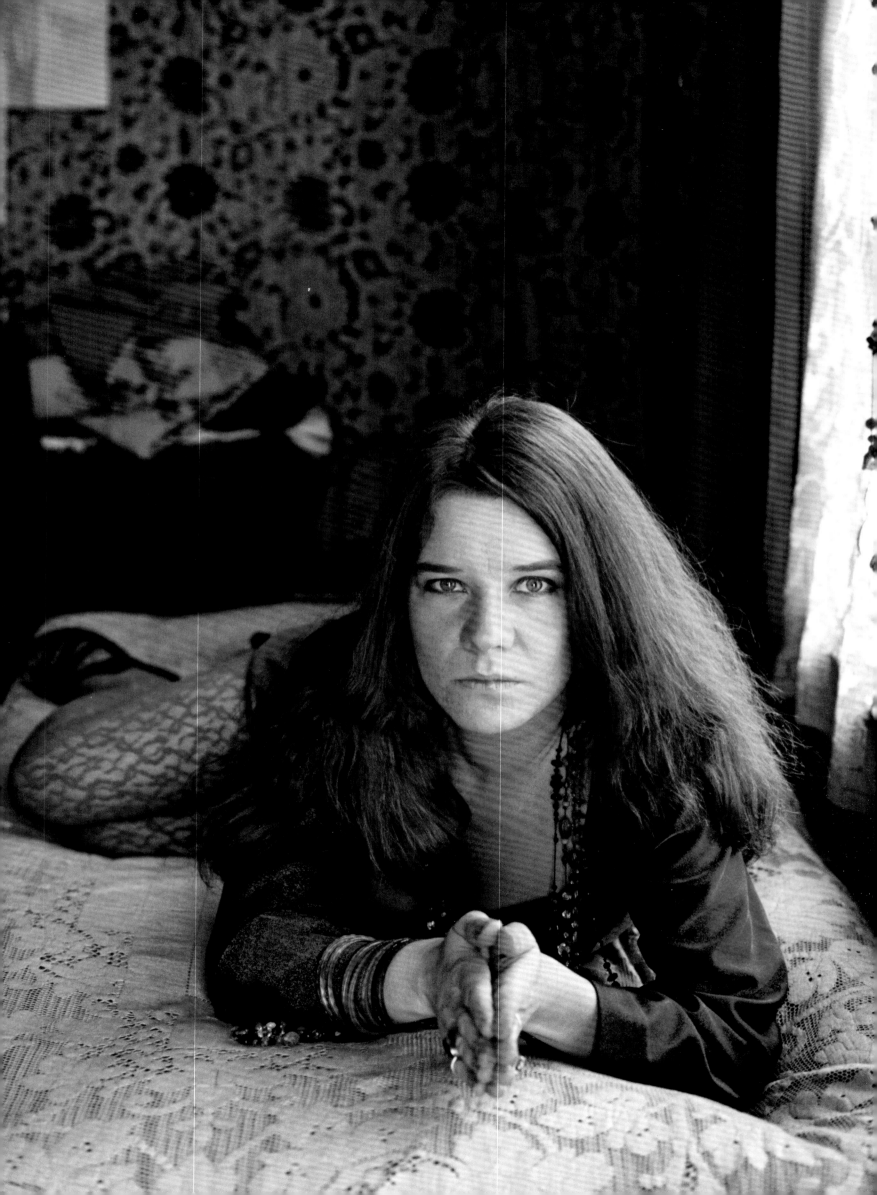

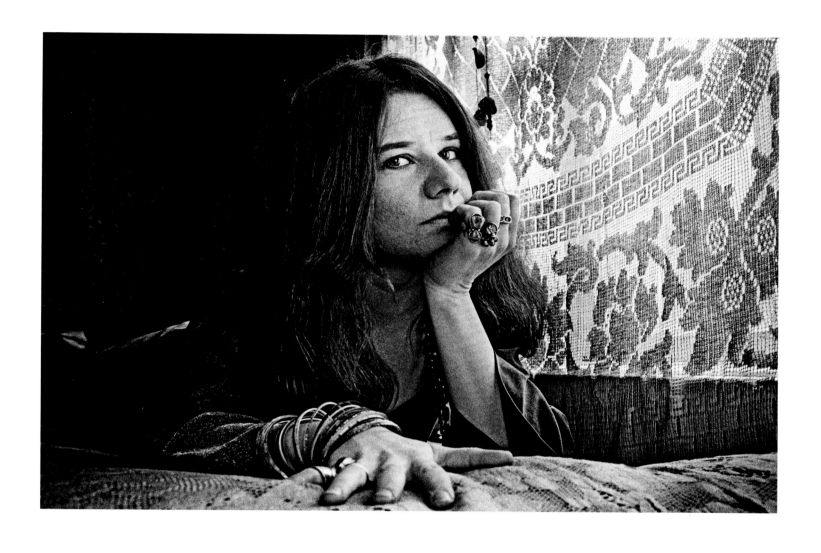

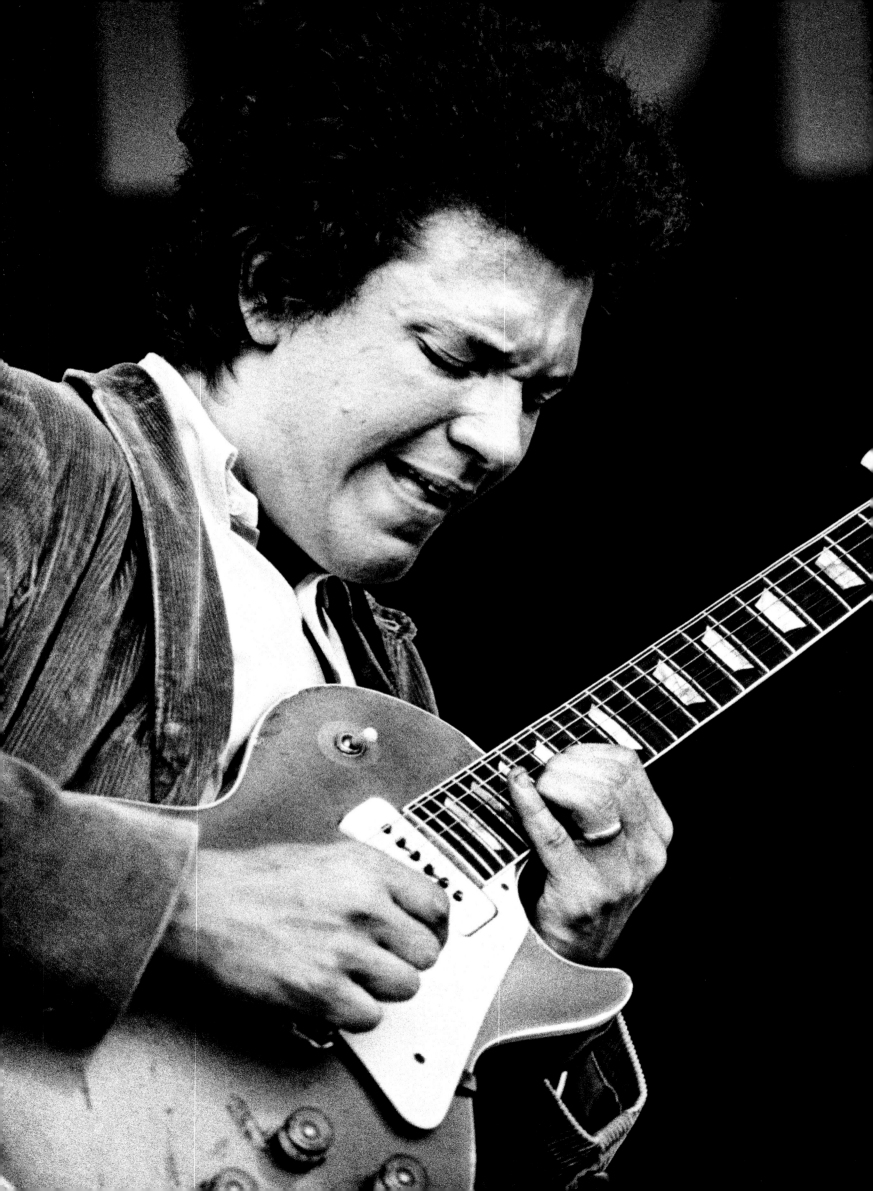

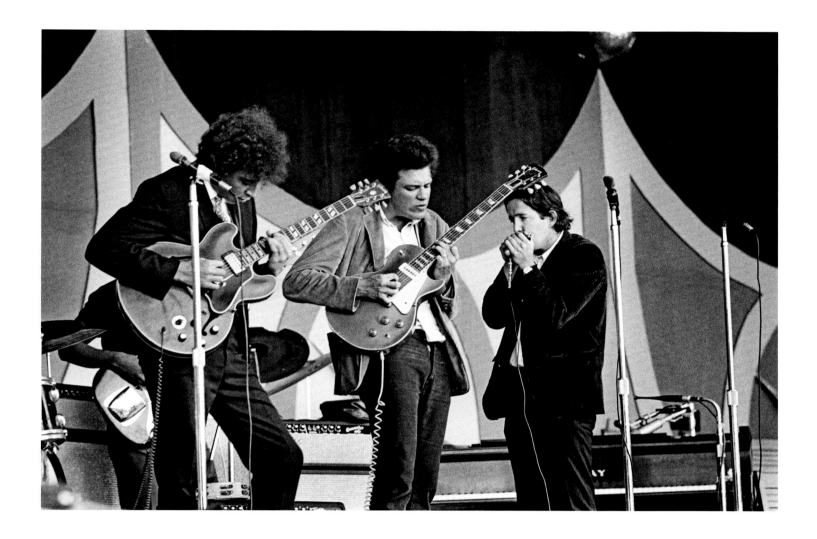

MONTEREY JAZZ LONGTIME ADVISER RALPH GLEASON COUNSELED THE MONTEREY JAZZ FESTIVAL INTO REPRESENTING THE NEW SCENE ON ITS ANNUAL SATURDAY AFTERNOON BLUES CONCERT THAT September. Alongside standard Monterey fare such as Duke Ellington, Count Basie, Gerry Mulligan, Dave Brubeck, Carmen McRae, and Cannonball Adderley, the traditional Saturday afternoon blues bill featured the Paul Butterfield Blues Band and Jefferson Airplane, along with Muddy Waters and Big Mama Thornton. Marshall first shot the Monterey Jazz Festival in 1960, and he wouldn't miss the biggest gig the Airplane had yet played. The band was bringing the spirit of improvisation—the heart of jazz music—to electric rock. In the cross-generational spirit of the booking, jazz vocalist Jon Hendricks of Lambert, Hendricks and Ross sat in with the group. This new underground rock had not yet found its way out of college-area record stores, and even that was only beginning. The Monterey Jazz Festival afternoon was a precursor to sweeping events that would take place on the same stage less than a year away. All those musicians would be back.

But, for the time being, this new rock music was almost exclusively confined to the dance halls of San Francisco, although the music was also rapidly evolving elsewhere. Out of Los Angeles, New York, and London, underground rock bands were exploring new vistas in pop music, starting by breaking the three-minute song barrier. As the audience for records switched from buying singles to albums, the kinds of music recording artists made started to change. In November 1965, the Beatles, at the time the music's

leading artist, released an album called *Rubber Soul* that contained no singles. The album contained crude efforts at augmenting the band's basic sound, using stereo effects and, in general, a less commercial approach. Three weeks later, the group released a double-sided hit single, "Daytripper/We Can Work It Out"—not featured on any album—that sounded like a bullet coming out of car dashboard speakers. The Beatles were sending a message that the band wanted to make records in different ways.

(OPPOSITE) *Mike Bloomfield of the Paul Butterfield Blues Band at the Monterey Jazz Festival, 1966;*
(ABOVE) *The Paul Butterfield Blues Band, 1966*

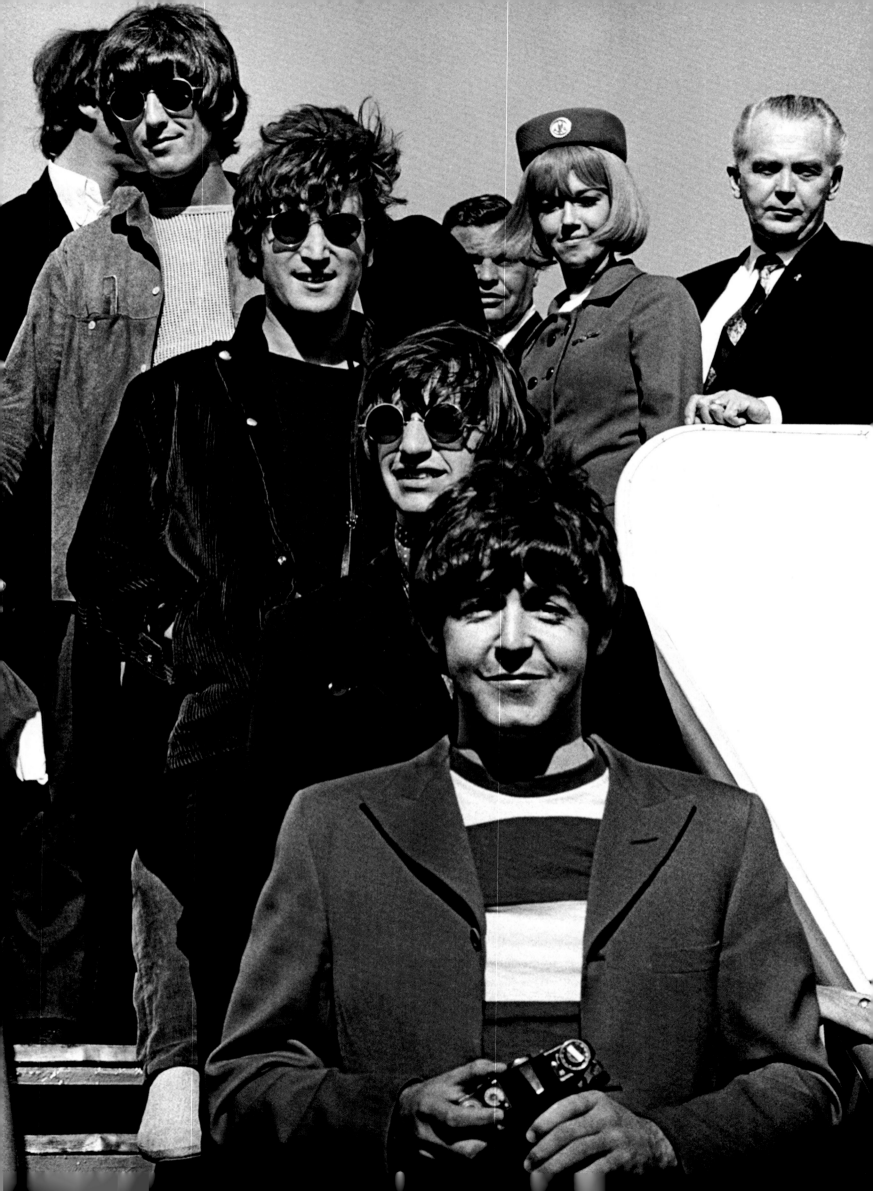

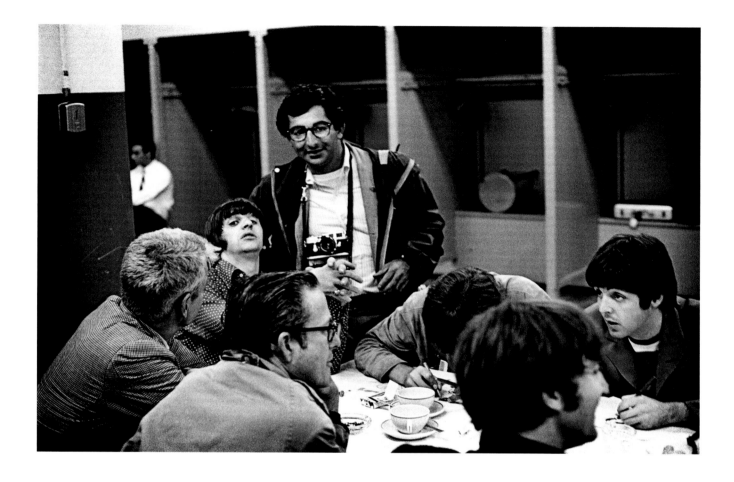

THE END OF THE BEATLES

THE BEATLES ARRIVED IN SAN FRANCISCO FOR WHAT TURNED OUT TO BE THE GROUP'S FINAL SCHEDULED PUBLIC PERFORMANCE AUGUST 29 AT CANDLESTICK PARK. The band's new album, *Revolver*, contained vague psychedelic touches, but the brief set from a stage set up at second base and surrounded by a chain-link fence contained no songs from the album. The Beatles jetted into town and out, spending a total of five hours on the ground.

The Beatles were not immune to the changes swirling in the underground and, in fact, had already been introduced to the use of LSD, but any state visits by the Beatles to the Haight were going to have to wait. Candlestick would be the final show of a breakneck three-week U.S. tour, rushing in and out of baseball stadiums with police escorts, bickering and bitching among themselves.

The concert was produced by KYA disc jockey Tom Donahue and his partner, Bobby Mitchell. A giant bear of a man, not unlike a young Orson Welles, Donahue came to San Francisco in 1961, chased out of Philadelphia by a payola scandal. He ran a radio station tip sheet, owned a small record company that had managed a couple of big hits, and held forth on a popular nightly AM radio show he invariably opened with the line, "I'm here to clean up your face and mess up your mind."

Backstage, the Beatles mingled with Ralph Gleason of the *Chronicle*, folksinger Joan Baez, and her sister Mimi Farina. Marshall had photographed Baez since the Newport Folk Festival—when she was the famous folksinger and her boyfriend Bob Dylan was the little known newcomer—and her face was one of the great loves of his camera for the rest of his life. Marshall shows

even Paul McCartney captured by the luminous beauty of the young Baez, at the time, one of the most popular female vocalists in the world. He shot John Lennon catching a smoke while being interviewed by Gleason. When the groundskeeper announced that he would not allow the band to be transported to stage across his freshly mowed field in an armored truck, Donahue told him, "Okay, you can go out there and tell those people there's not going to be a show."

San Francisco Giants baseball fans already knew about the cold sea breeze that blew through Candlestick at night games, but the weather was so crisp McCartney felt compelled to mention it. "Sorry about the weather," he said.

The band whisked through eleven songs in about a half hour, climbed aboard the armored car, and was in their jet flying out of town minutes later. There had been considerable talk within the group about whether or not to continue live performances. Lennon especially was opposed. He and George Harrison both brought cameras onstage at Candlestick to record what they thought could possibly be an historic event. On the plane flying back to Los Angeles, Harrison later reported thinking, *That's it—I don't have to be a Beatle anymore.*

(OPPOSITE) The Beatles arrive in San Francisco, August 1966; (ABOVE) Jim Marshall backstage with the Beatles, taken with Marshall's camera, 1966; (FOLLOWING PAGES) Paul McCartney and John Lennon perform at Candlestick Park during the band's last U.S. concert, 1966

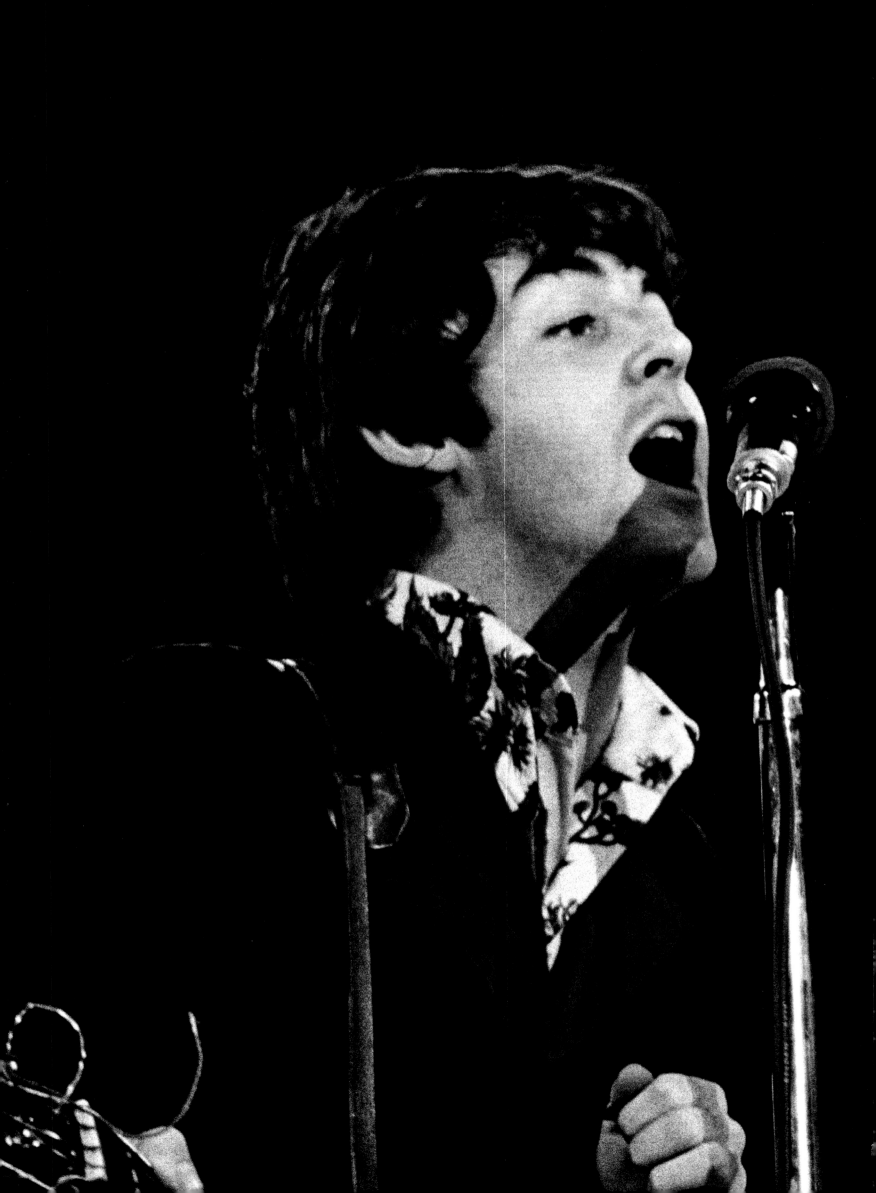

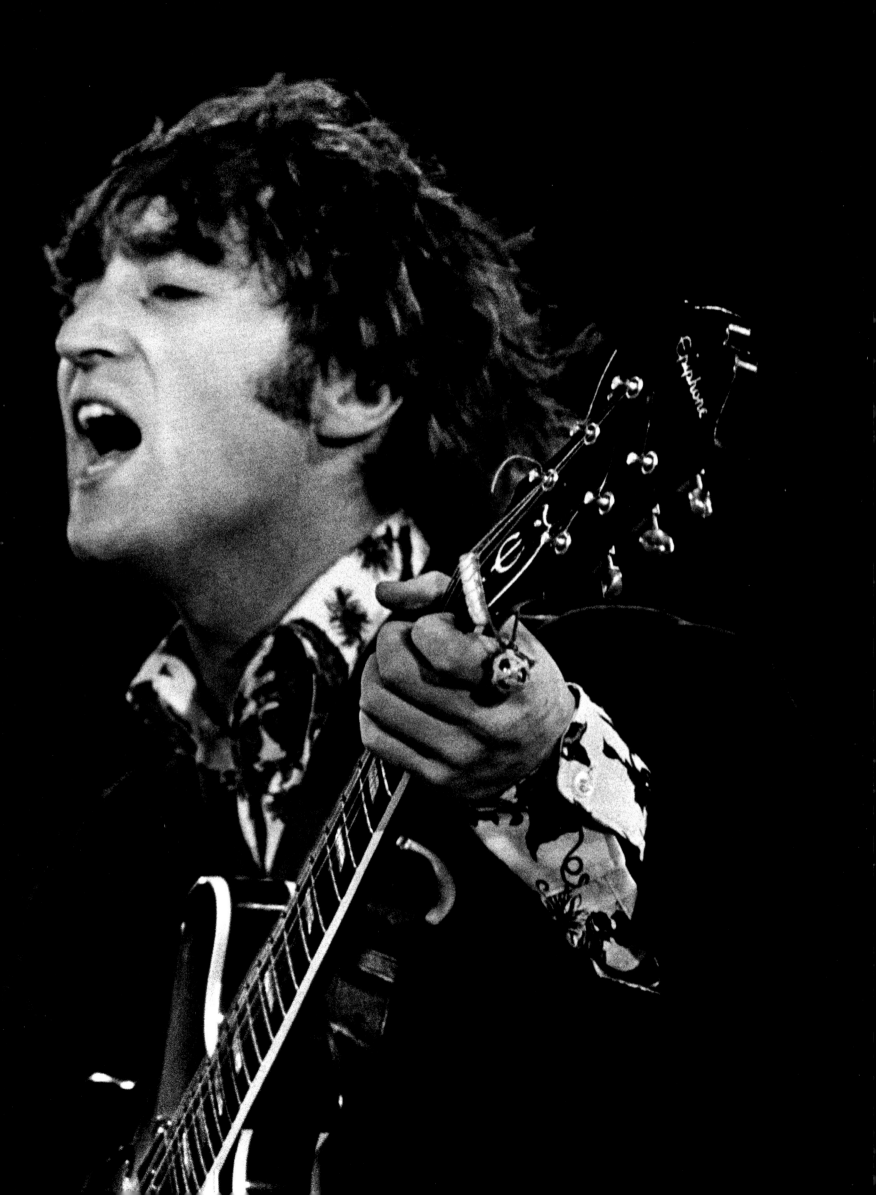

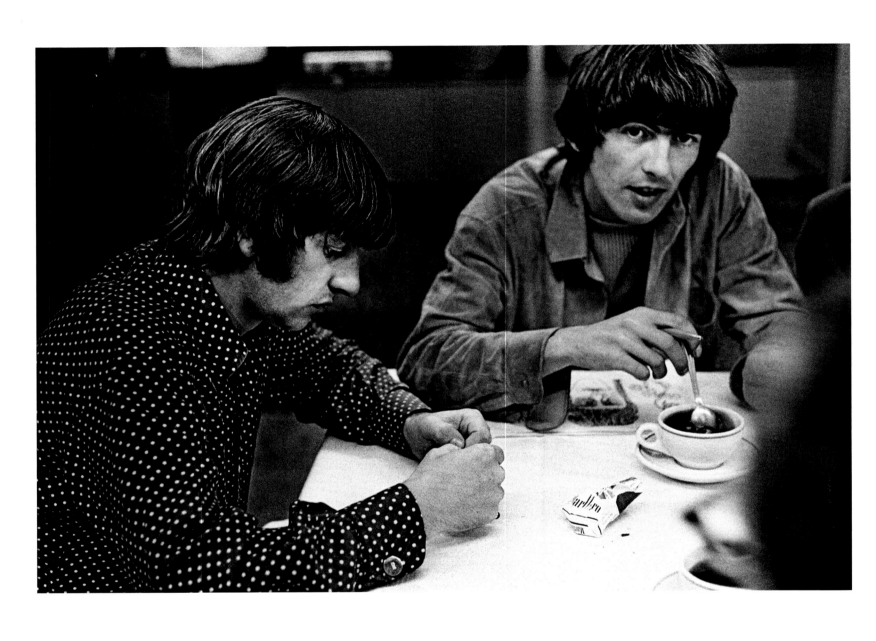

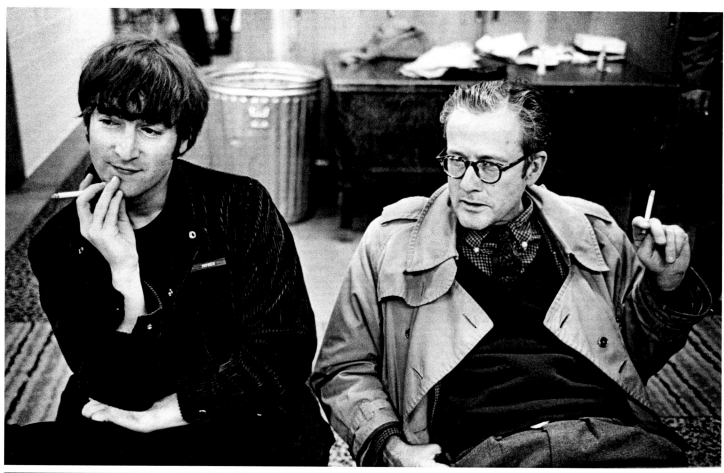

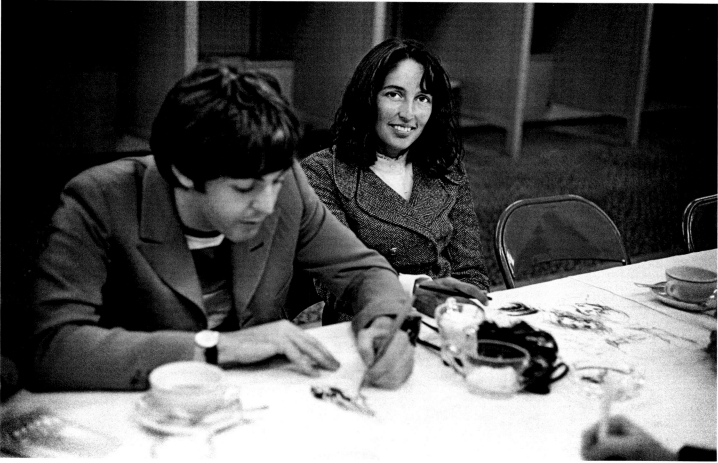

(TOP) *John Lennon and* Chronicle *critic Ralph Gleason, 1966;* (ABOVE) *Paul McCartney and Joan Baez, 1966;* (FOLLOWING PAGES) *The Beatles walking to Candlestick stage, 1966*

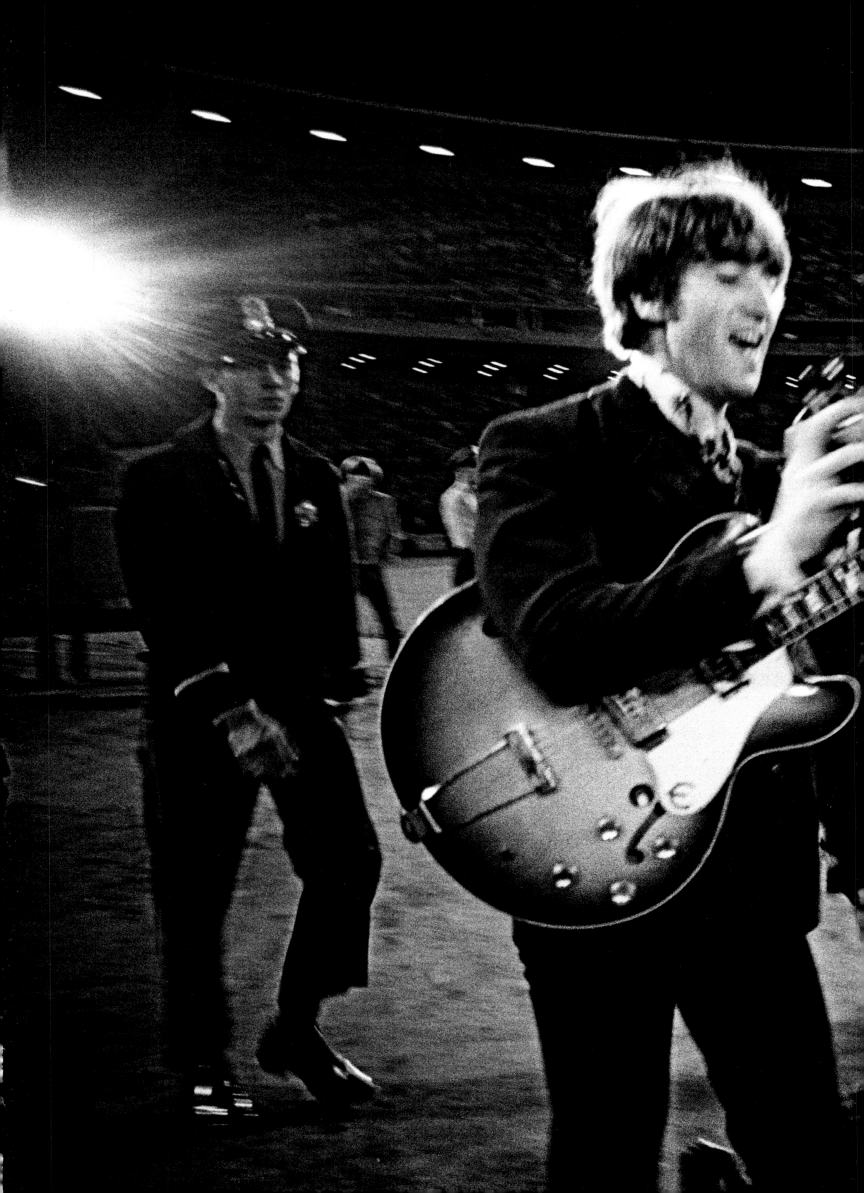

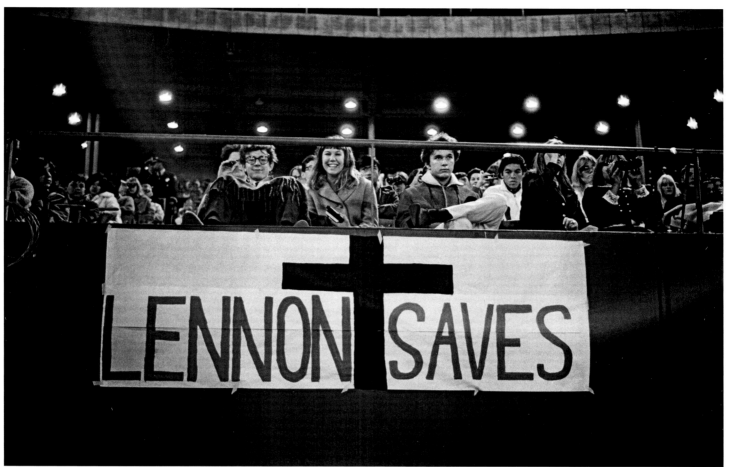

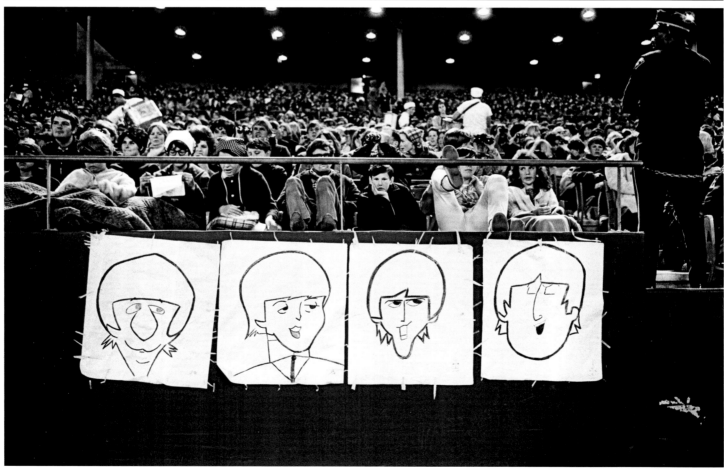

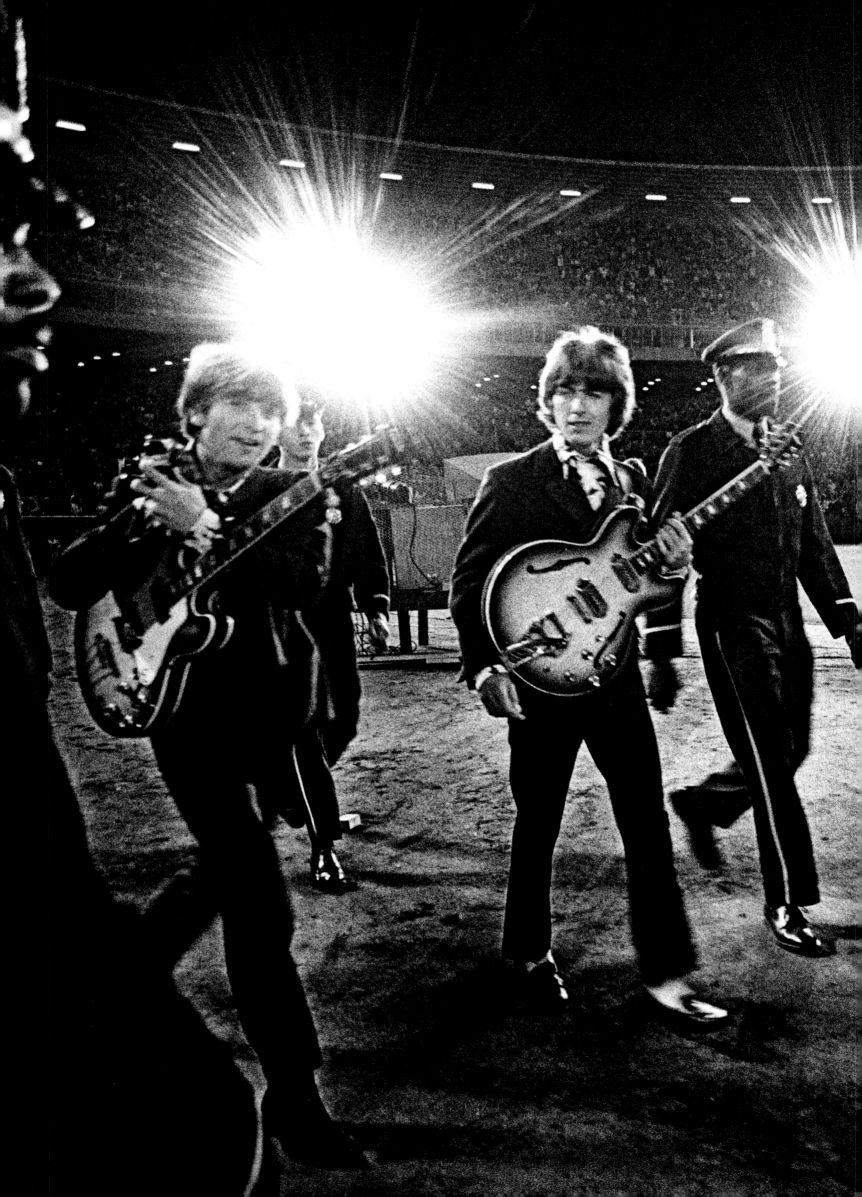

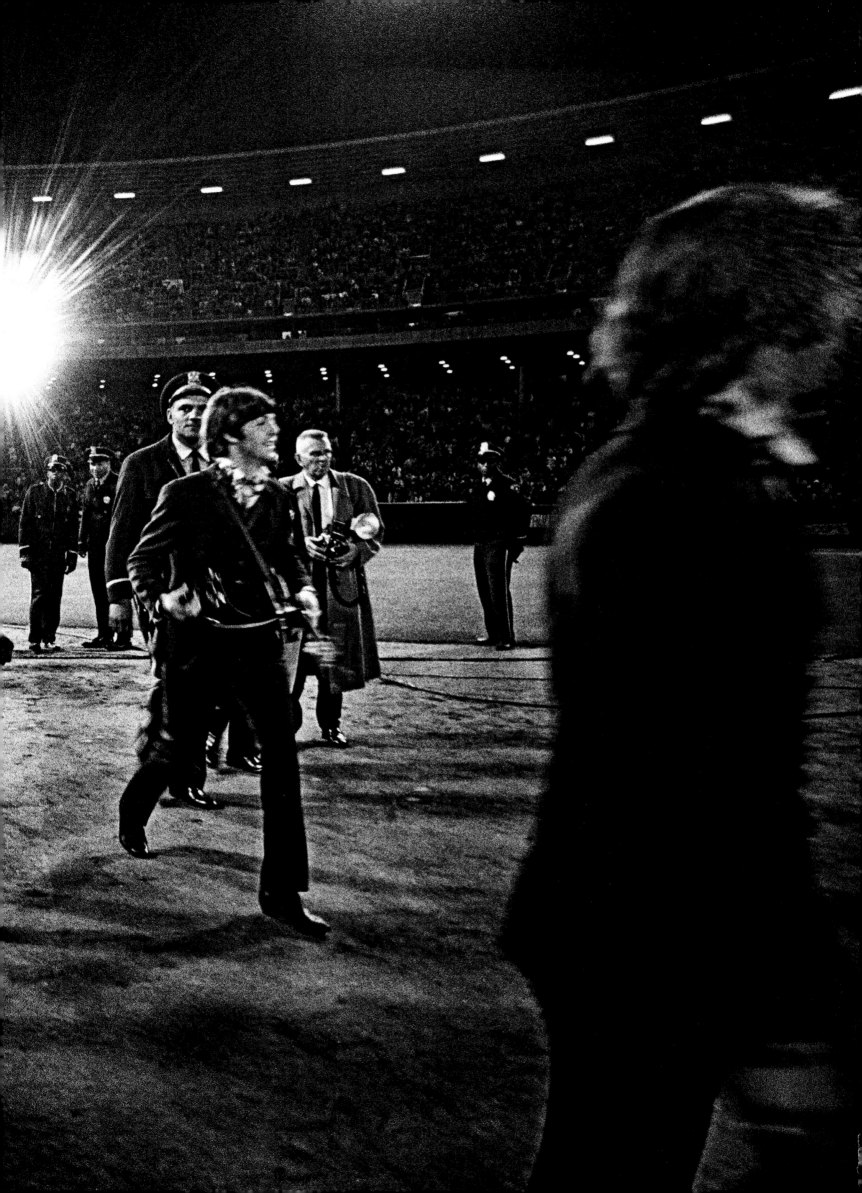

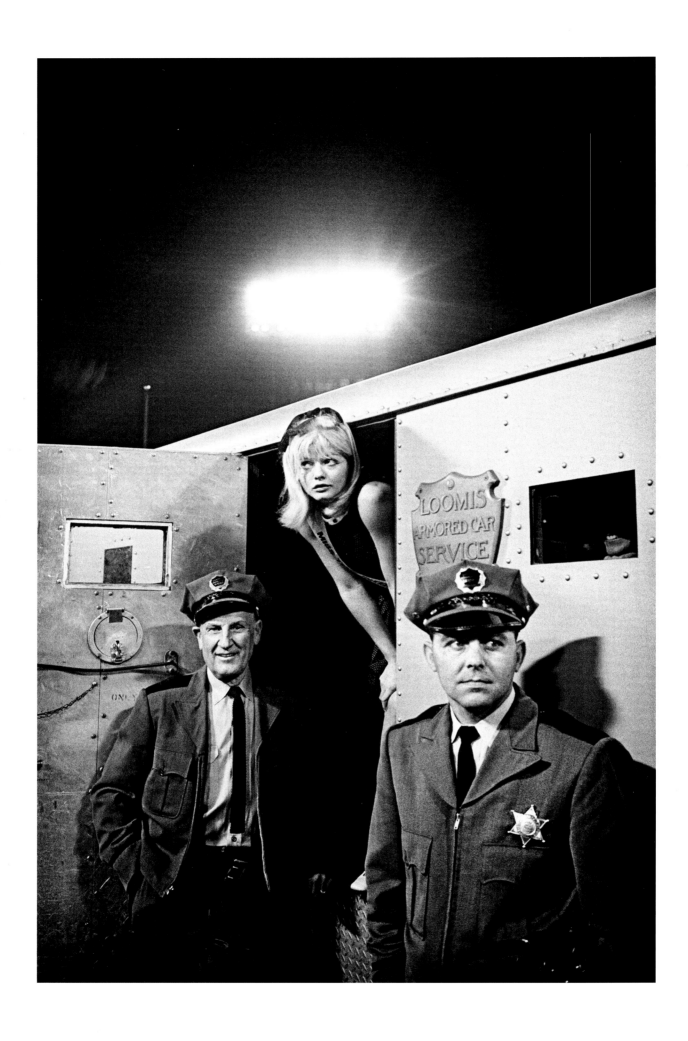

(ABOVE) *An armored car waits for the band near the stage, 1966;* (OPPOSITE PAGES) *Beatles fans show their love for the band, Candlestick Park, 1966;* (CENTER) *The Beatles walking to stage, 1966*

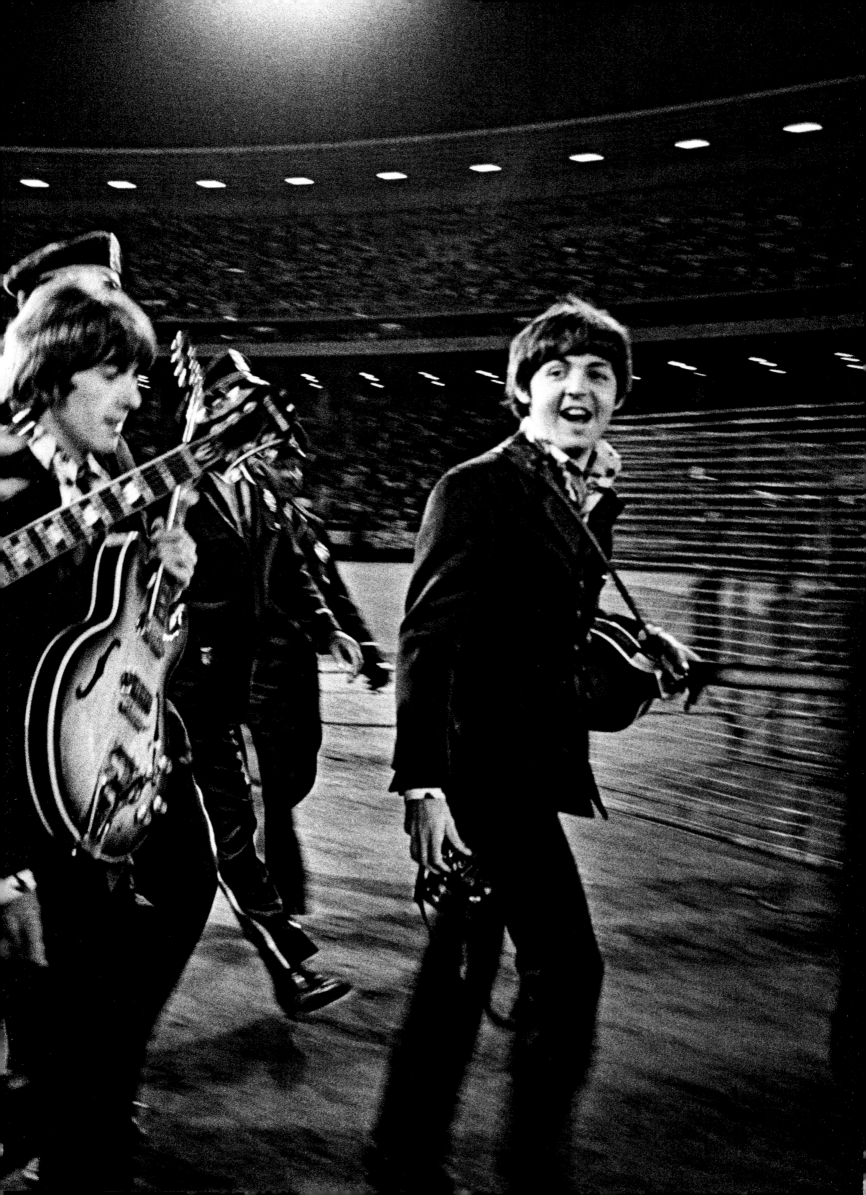

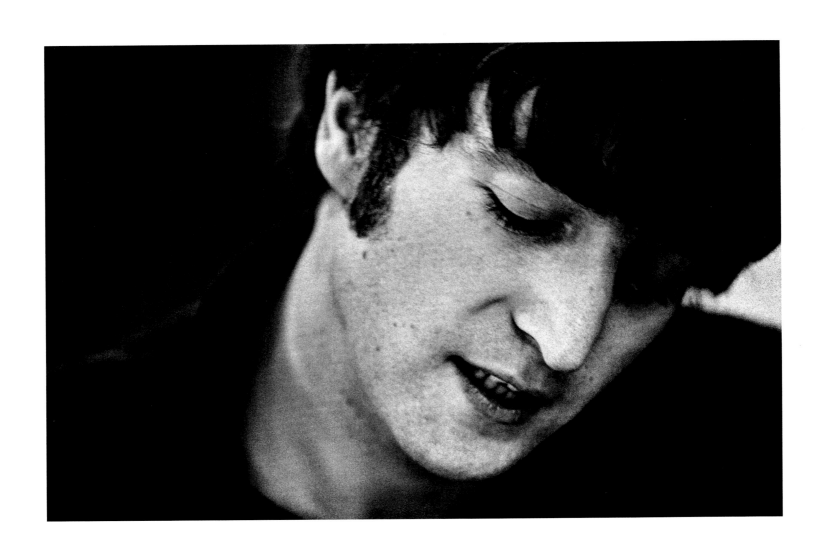

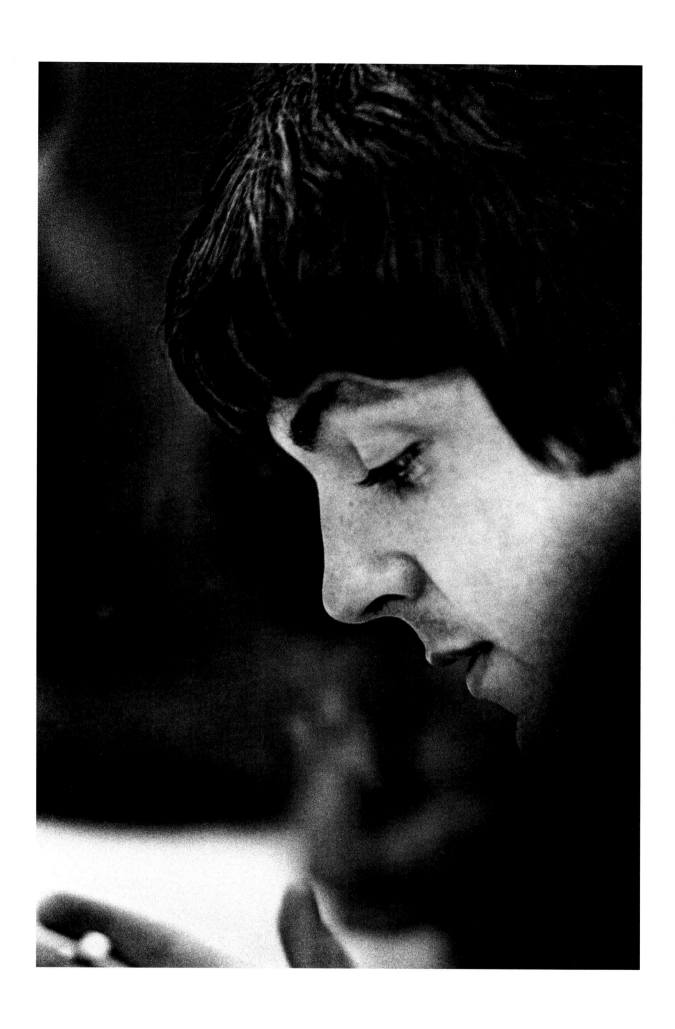

(THESE PAGES) *John Lennon (left) and Paul*
McCartney (right) at Candlestick Park, 1966

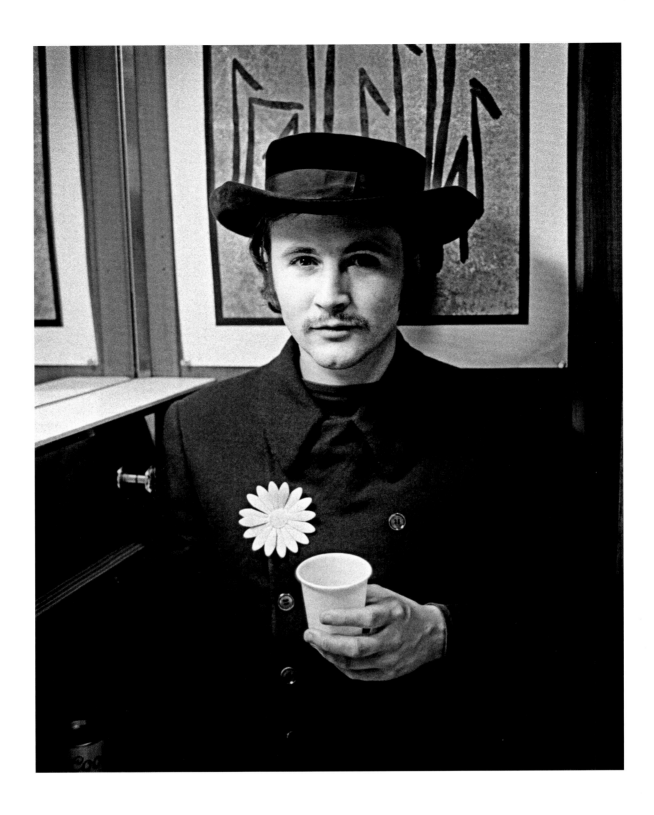

THE L.A. SCENE IN LOS ANGELES, THE BYRDS WERE THE FIRST IMPORTANT UNDERGROUND ROCK

BAND. THE GROUP HAD A NUMBER ONE HIT WITH BOB DYLAN'S "MR. TAMBOURINE MAN" THE YEAR before. Their latest Top Forty hit was the psychedelicized "Eight Miles High." David Crosby of the Byrds knew Paul Kantner of the Airplane when the two were starting out in the San Jose/Santa Cruz folk scene. Other psychedelic groups were springing up on the Sunset Strip. The second album by Love, *Da Capo*, released in November 1966, devoted one entire album side to a near nineteen-minute piece. The Doors were experimenting with extended compositions in Hollywood clubs.

The underground rock bands from Los Angeles found themselves welcome in San Francisco. The Byrds made a number of Fillmore appearances. By virtue of the band's Top Forty hits, the group was a frequent subject for *TeenSet*, and Marshall photographed the band a number of times, both in San Francisco and Los Angeles.

Buffalo Springfield was another interesting Los Angeles underground band. After the Stephen Stills song about the curfew riots outside Sunset Strip teen clubs, "For What It's Worth," the band made a mark with the guitar playing of Stills and Neil Young, who was also contributing some provocative pieces to the Springfield songbook. The band made regular trips to San Francisco, playing shows at the Fillmore and elsewhere. Guitarists Neil Young and Stephen Stills were very much in tune with what was going on in the Haight, kindred spirits and curious counterparts. Los Angeles bands like the Byrds and Springfield returned from San Francisco dates having shared bills with the new San Francisco bands and quickly began to adopt some of the ideas. At this point, these bands were little more than rumors with funny names outside the Bay Area, but these Los Angeles bands were running reconnaissance missions.

(ABOVE) *David Crosby, 1967;* (RIGHT) *Buffalo Springfield, 1967*

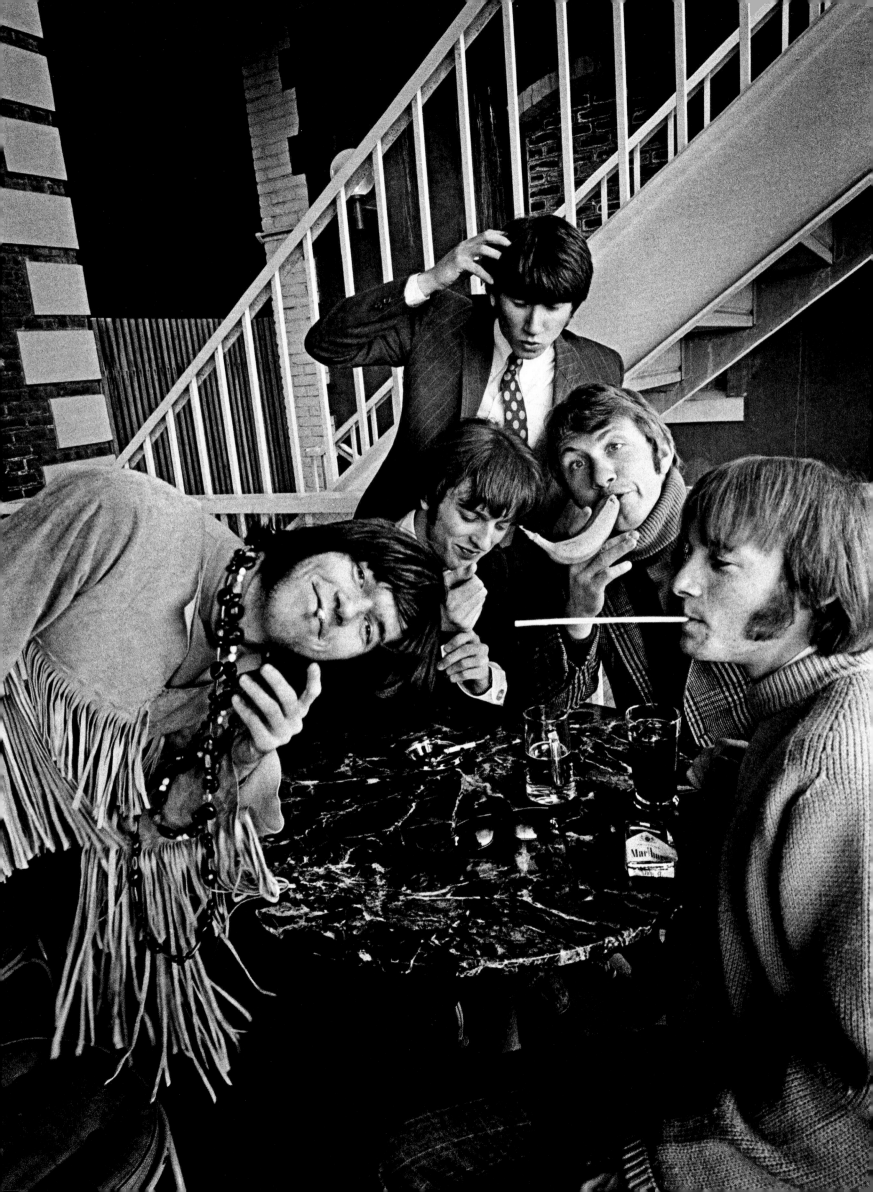

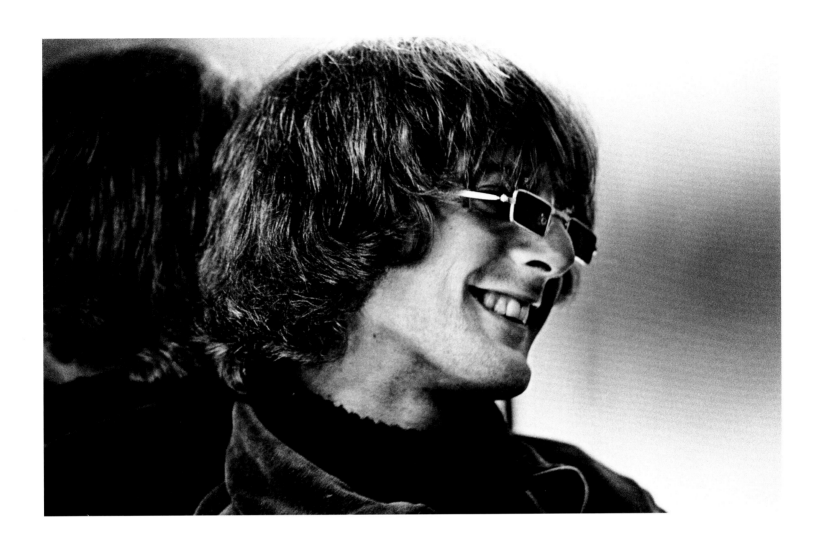

(ABOVE) *Roger McGuinn, 1965;*
(OPPOSITE) *The Byrds backstage in a tiny dressing room at the Civic Center on the same bill as the Rolling Stones, 1965*

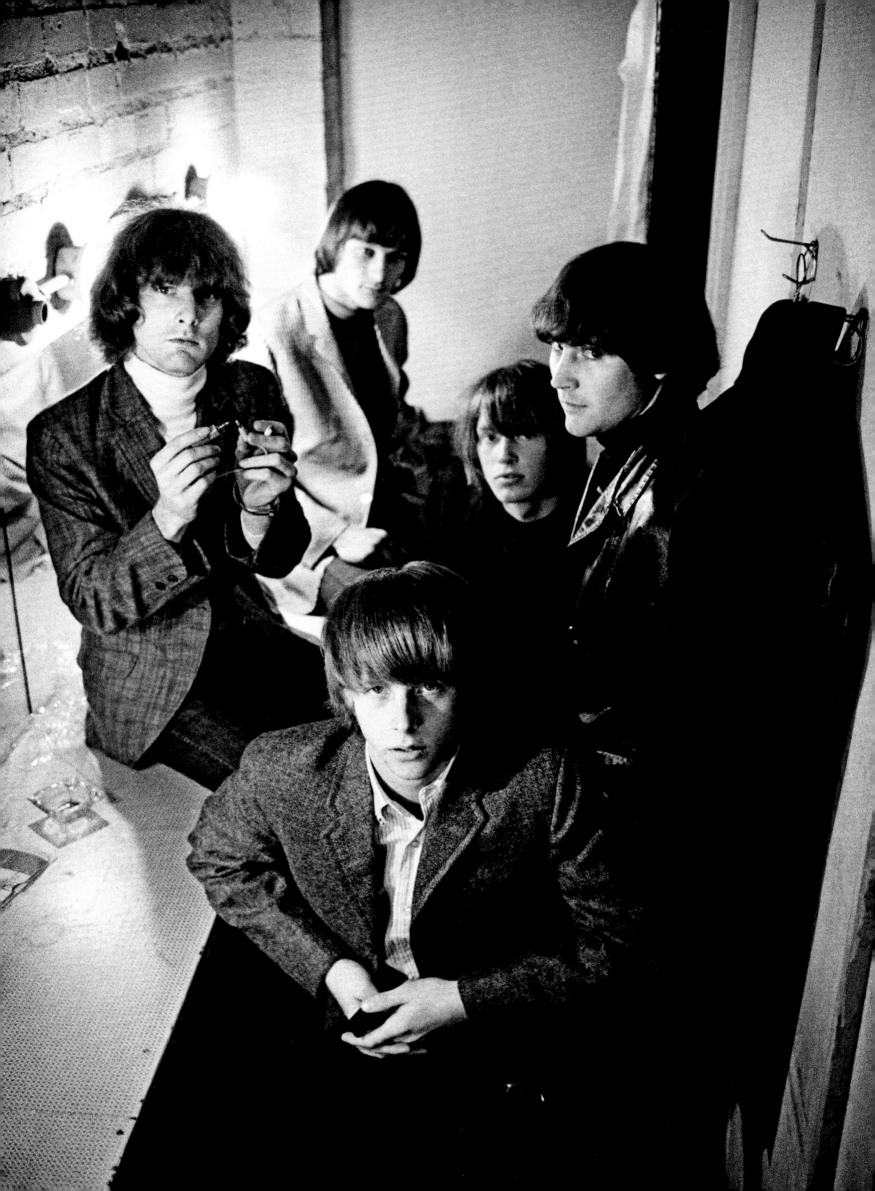

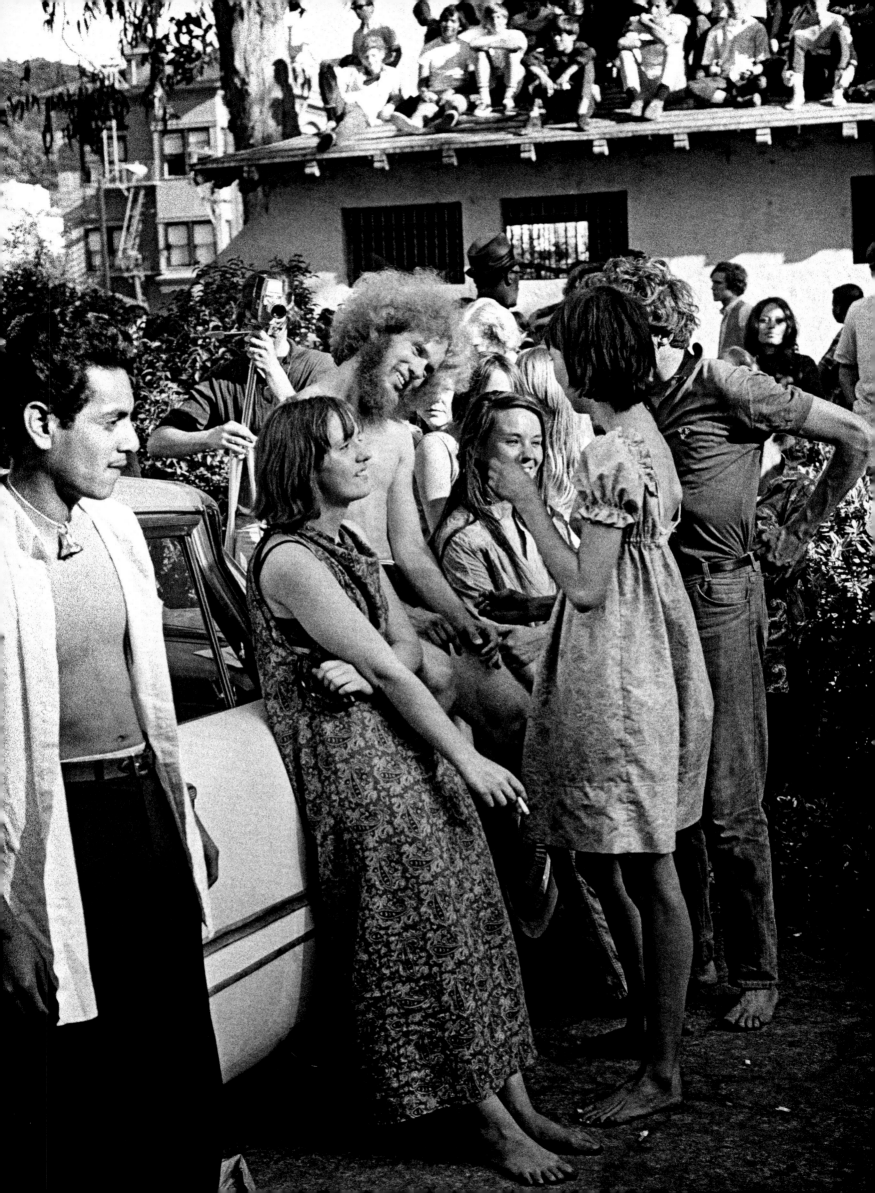

THE HAIGHT BLOOMS

NEW PEOPLE WERE MOVING INTO THE HAIGHT EVERY DAY. GOD'S EYES MADE OF YARN SPROUTED ON WINDOWS IN THE NEIGHBORHOOD. IMAGES DRAWN FROM EASTERN mysticism or Native American lore were popular. The sidewalks were thronged with young, long-haired people. Stores catering to their trade were popping up all along the street. Some outlandish hippies opened the Free Store, a kind of anything-goes thrift shop where all the merchandise was given away. At the Drogstore, a gal working behind the soda fountain who called herself Magnolia Thunderpussy made erotic ice cream dishes like the Montana Banana, which featured two strategic scoops of ice cream, a banana, and a spritz of whipped cream. Traffic crowded the street. Word of the new community growing in the Haight-Ashbury had rapidly spread and was attracting interest. Volkswagen vans and converted school buses with flowers painted on their sides were starting to appear parked around the area. The former rooming houses were filling up with new transients.

The rules were off. A full-scale revolution in personal lifestyle was taking place, widespread rejection of accepted values, questioning of authority, and embracing new, sweeping ideals. The Haight was turning into a Utopian experiment, almost on its own momentum. A group of firebrand freethinkers who came together and called themselves the Diggers began to lay out community-organizing principles in a series of broadsides. A multi-colored tabloid appeared called the *Haight-Ashbury Oracle*, much more cultural and hippie visionary than the decidedly leftist political slant of the other underground newspaper across the Bay, the *Berkeley Barb*.

The Berkeley side of the movement was always more politicized. The Berkeley rebels were activists who believed in storming the bastions of power. In the Haight, politics seemed less relevant. The Haight philosophy centered more on rejection of existing values and the establishment of a new construct based on more personal freedoms. Like Marlon Brando's character in *The Wild Ones* says when he is asked what he is rebelling against—"What do you got?" Many elements figured in the equation—LSD was the X factor.

Love was everywhere and out in the open. The birth control pill had freed young women, and the sexual revolution was under way. The allure of free love added immeasurably to the appeal of the growing hippie myth. Sex was part of the new openness. Women were shedding restrictive roles from the past. Interracial couples brazenly broke that taboo. These black-and-white couplings were a product of the personal politics of the hippies. Rather than marching in the streets for civil rights, these young people practiced integration in their bedrooms and beyond.

Drugs also played an important role in the scene—not just LSD, but marijuana and more esoteric psychedelics such as peyote. But especially marijuana. A lot of the economic underbelly of the new community came from pot dealers who imported kilos of pressed marijuana bricks from Mexico that sold for ninety dollars on the street. A small matchbox filled with grass retailed for five bucks. Pot was plentiful and everywhere. Perfumed smoke filled every rock concert.

Marijuana was like a hippie sacrament. Of course, pot had been around forever. Greek historian Herodotus

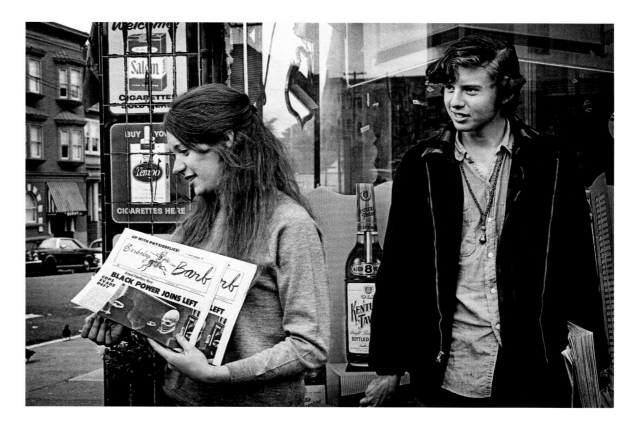

(OPPOSITE) *A diverse crowd gathers outside as a man records the scene, 1967;* (ABOVE) *A woman distributes the* Berkeley Barb, *a weekly underground newspaper, 1967*

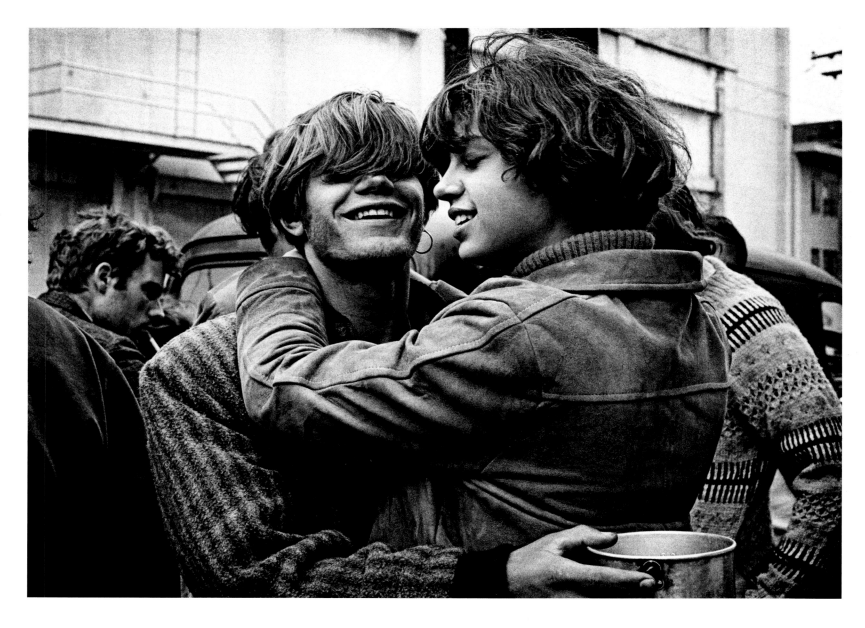

reported its use. Jazz musicians smoked weed long before rock music was invented, and marijuana always circulated in a subterranean, clandestine world. The hippies simply brought the practice out in public. Everywhere in the Haight people puffed on joints rolled in yellow Zig-Zag wheat straw rolling papers. The dance halls were like marijuana speakeasies.

LSD had spread around the world. Tim Leary, a former Harvard psychiatrist, had become famous for advocating its use. An obscure Eastern religious tract, *The Tibetan Book of the Dead*, became popular as a spirit guide to LSD trips. Eastern mysticism was suddenly in vogue, and the ragas of Indian classical musician Ravi Shankar were part of the Haight soundtrack. The proliferation of psychedelic artwork and music was spreading the word. As little as a single dose of LSD could profoundly affect an individual's belief systems and core values. Although each acid trip was individual, people who took acid began to gravitate toward one another because of the bond of the shared experience. As hundreds of thousands of people around the world began to experiment with psychedelics, a collective consciousness started to accumulate, and everywhere this new LSD underground cropped up, road signs pointed back to the Haight-Ashbury. A new era was dawning over San Francisco.

Marshall captured the daily life of the Haight. He wandered the streets, his Leica around his neck, picking up images from everywhere. He zoomed around town on his motorcycle, always with at least one Leica hanging around his neck (at any given moment, as many as four cameras would dangle from his neck and shoulders). Change was a palpable sensation in the air. Every day promised fresh adventure. It wasn't simply that people were looking different, dressing different, even acting different. It wasn't only the music in the air. There was some sunny optimism blooming inside these people, a promise of freedom, a whiff of a future far removed from a cold, uncaring past. It was part of the weather in San Francisco, blowing in the wind you might say.

Fresh from the highly competitive world of New York photojournalists, Marshall quickly recognized a professional opportunity and became the studio photographer of choice for the San Francisco rock scene. Many of his photographs appeared in a Los Angeles–based magazine, *TeenSet*, which included many of the hit rock bands that passed through town with records on the radio. There were not a lot of professional media outlets for rock music photographers. Although Marshall's specialty was always candid action shots, onstage and off, he did a number of studio portraits that appeared in the magazine as well. There were other good photographers on the scene—Herb Greene, Gene Anthony, etc.—but Marshall had a drive and ambition that was frequently not a part of the hippie scene. Marshall soon became swept up in recording the remarkable scenes that were occurring on an almost daily basis in front of his lens.

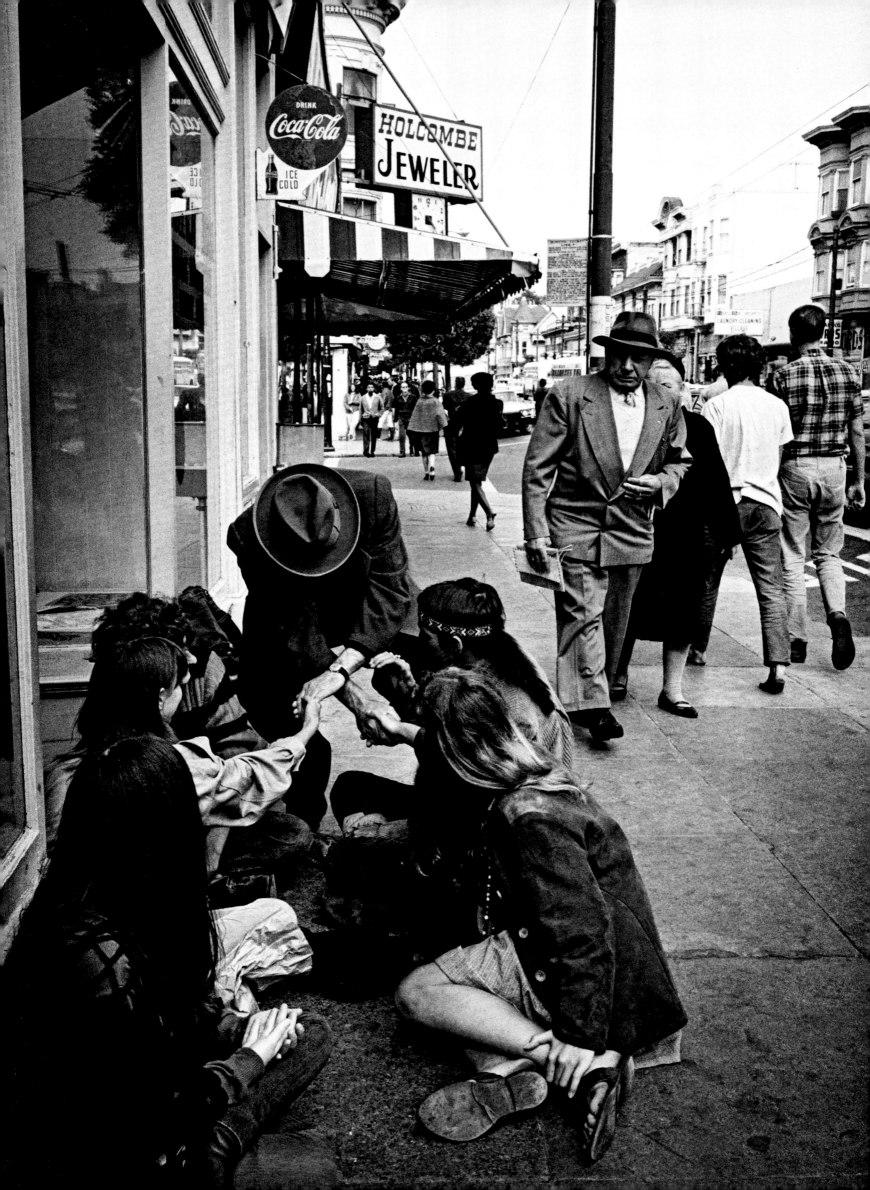

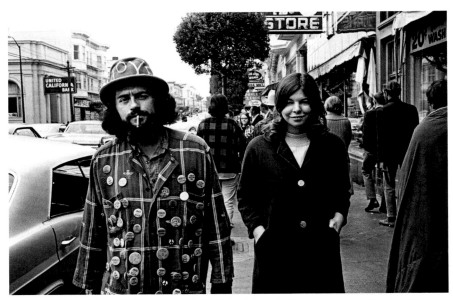

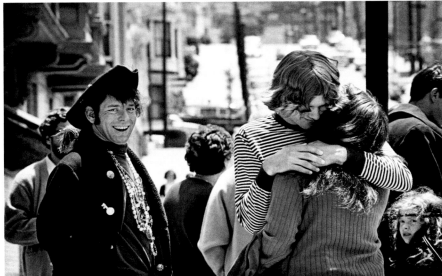

(PREVIOUS PAGES AND ABOVE) *Street scenes from the Haight, 1967;* (RIGHT)
Dino Valenti, writer of the hippie anthem "Get Together," 1967

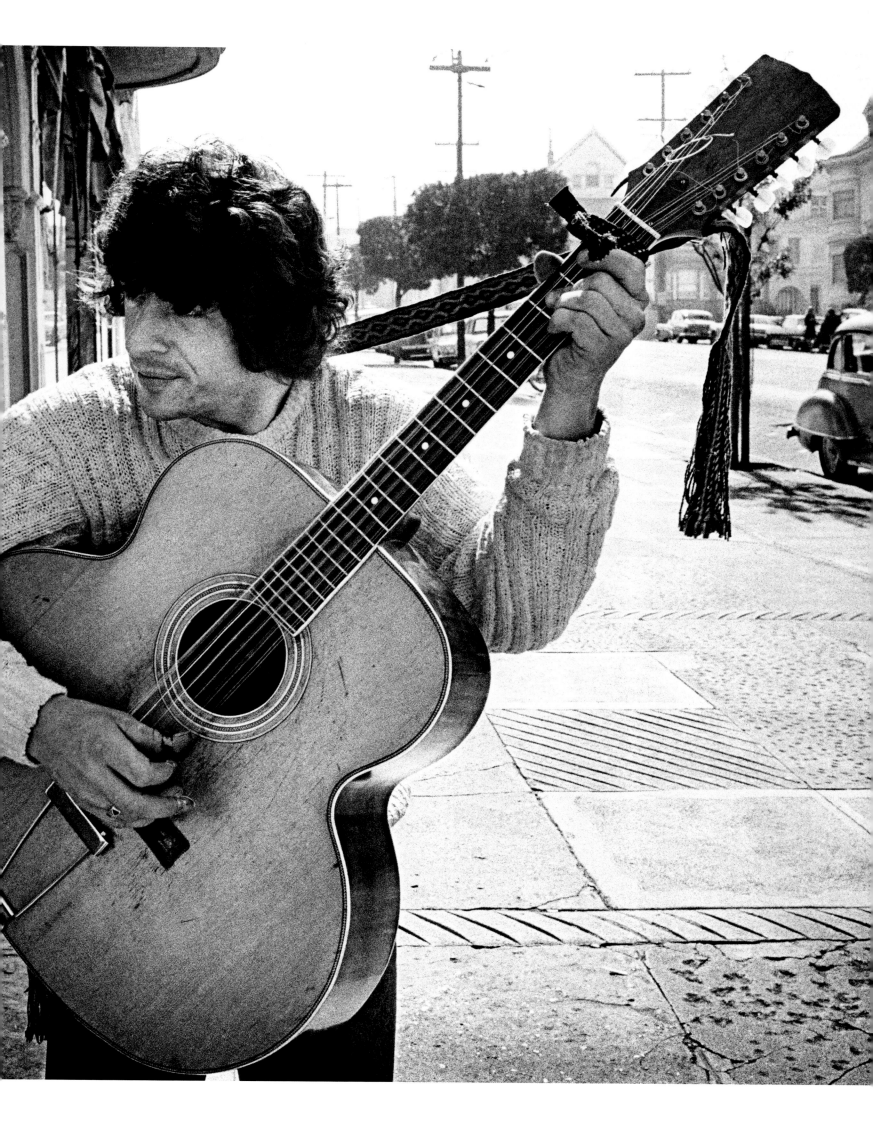

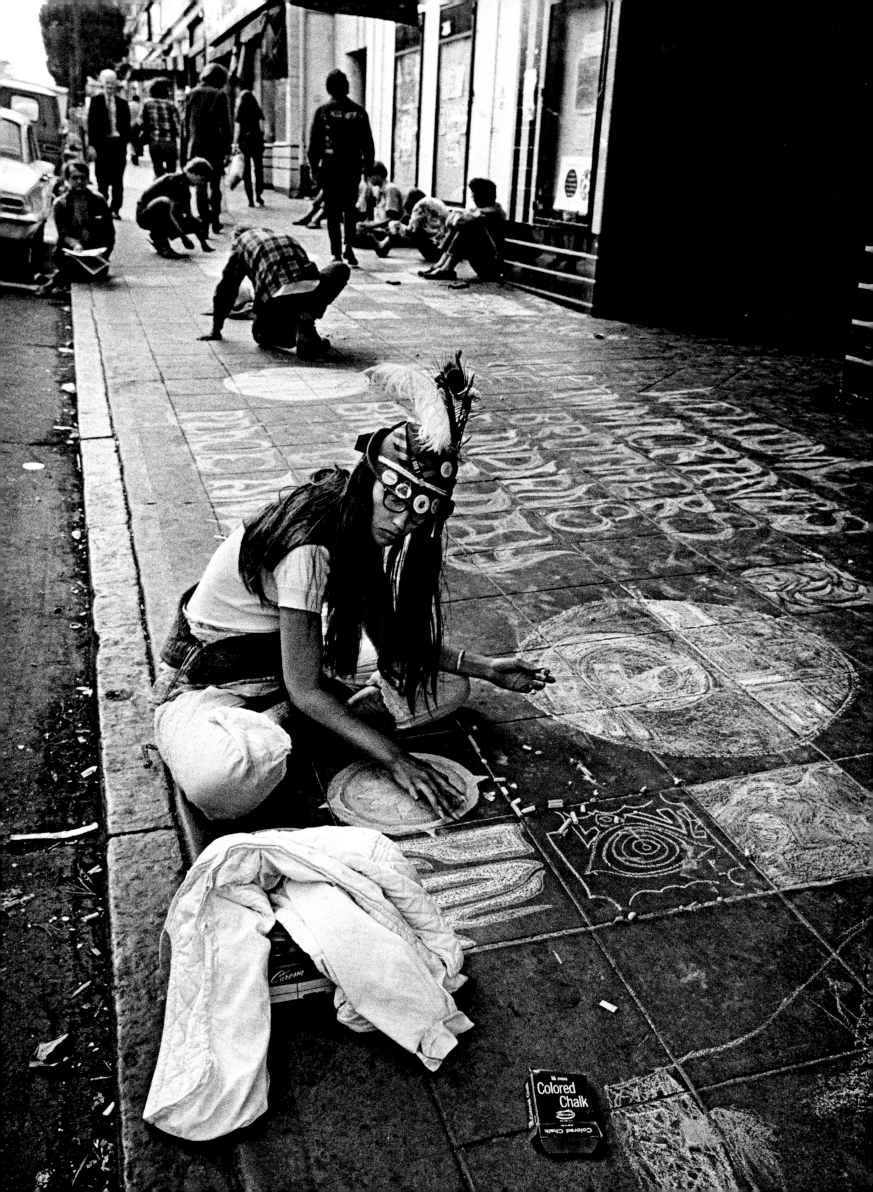

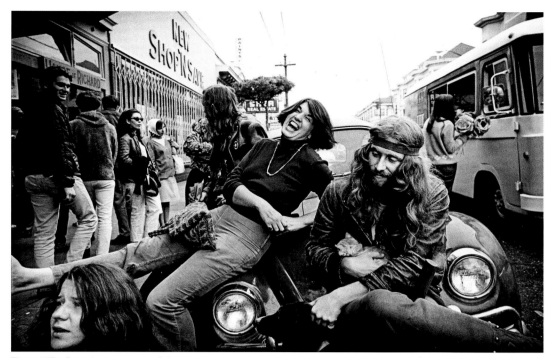

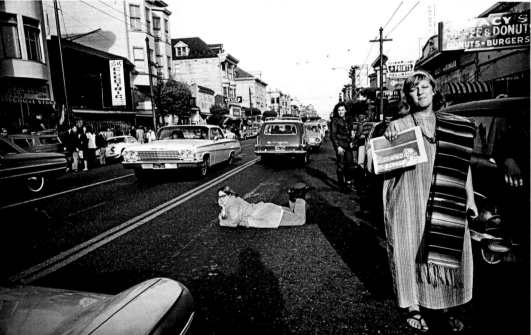

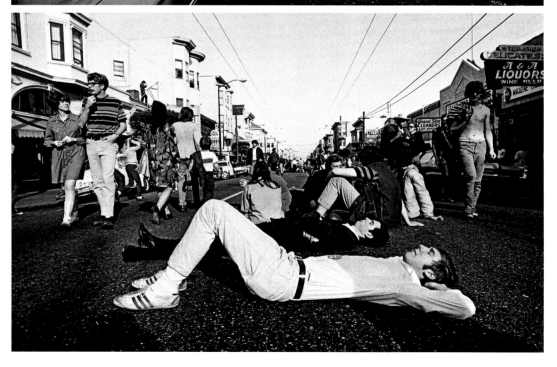

(OPPOSITE) *A woman decorates the sidewalk with chalk art, 1967;* (THIS PAGE) *Haight residents, including Janis Joplin (top), gather on the street and block traffic, 1967;* (FOLLOWING PAGES) *Celebrant at Rathayatra Festival on Haight Street. Behind her, Krishna devotees pass out* prasad *(sacred food) as Hayagriva plays cymbals atop the Rathayatra float, 1967*

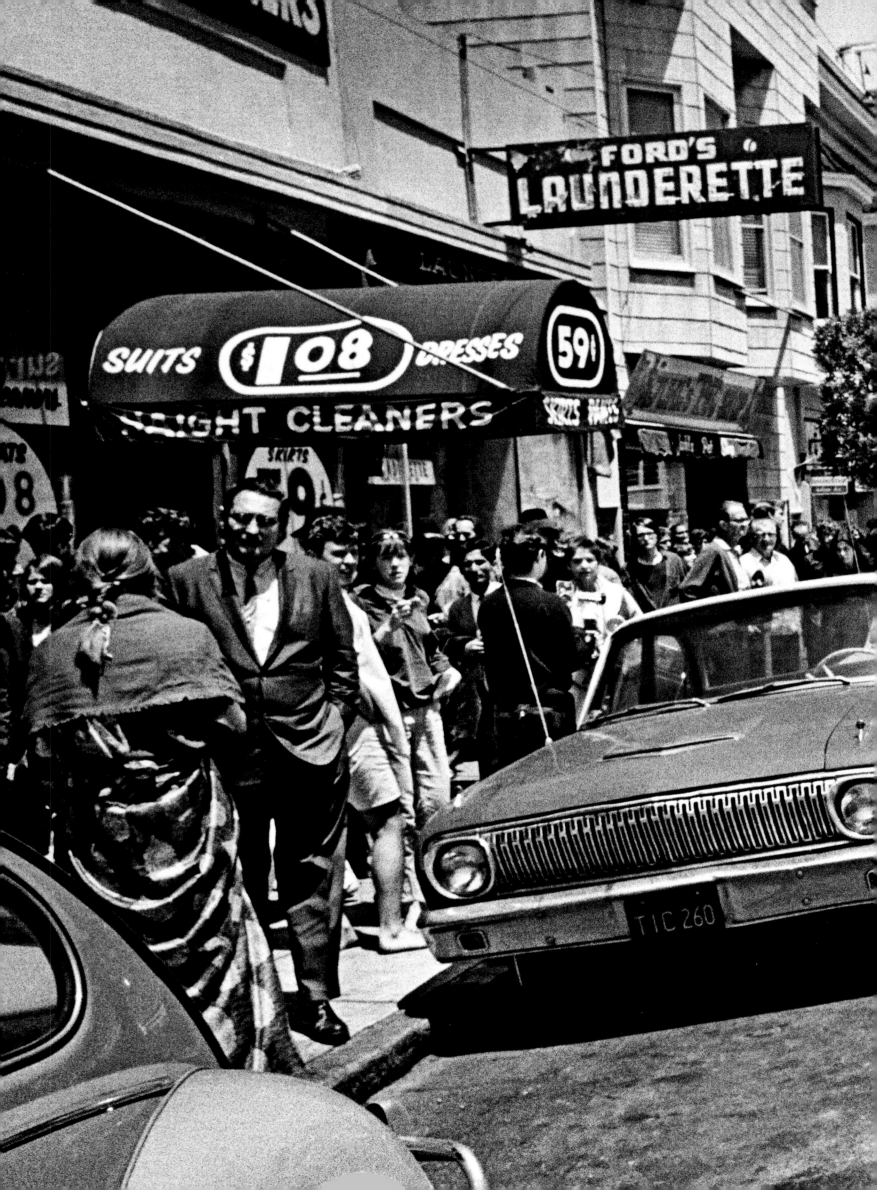

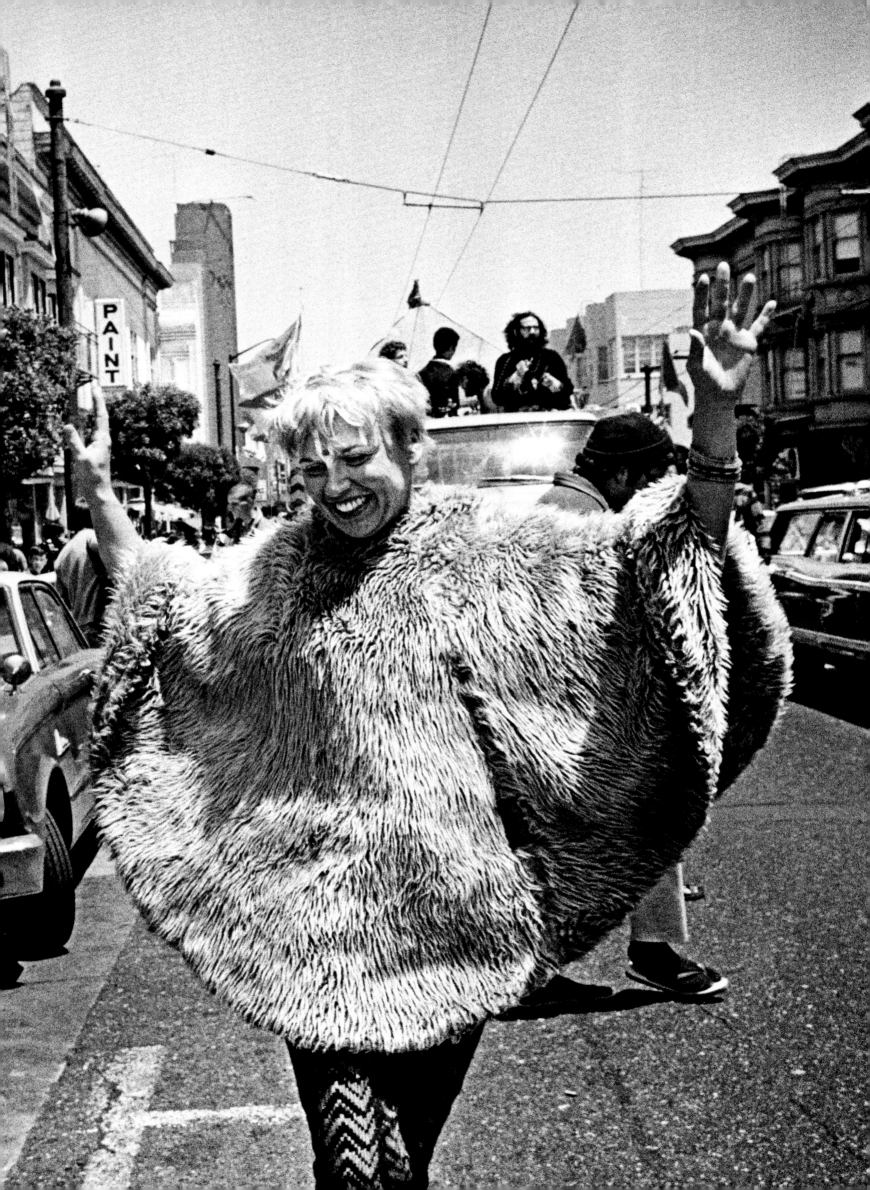

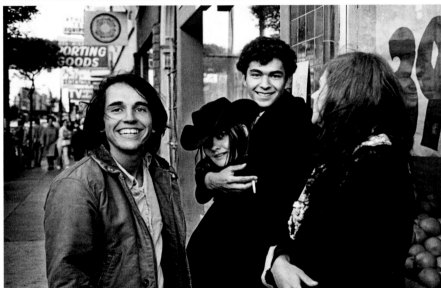

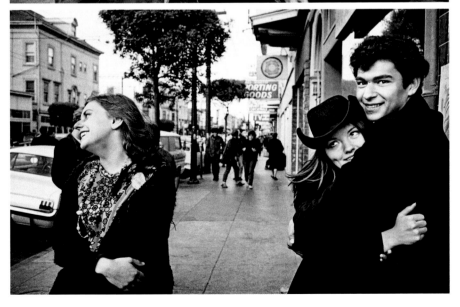

(ABOVE) *Haight Street scenes, 1967.*
Images from this series were featured
in Look *magazine's "Hippie Story";*
(RIGHT) *Car art, 1967*

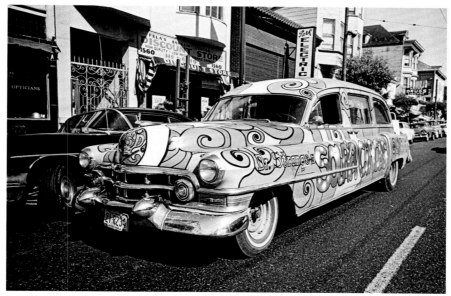

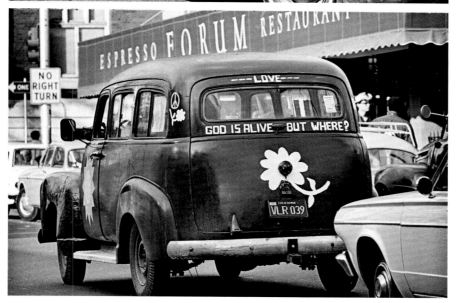

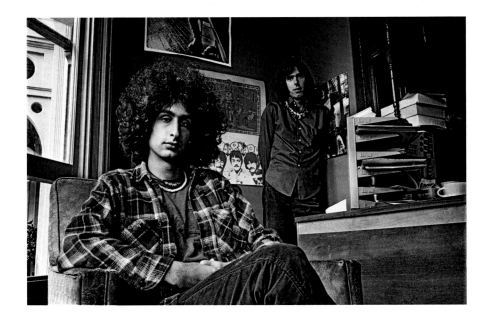

THE GRATEFUL DEAD COME TO THE HAIGHT
THE HAIGHT COMMUNITY CELEBRATED THE PASSING OF A LAW MAKING LSD ILLEGAL IN THE STATE OF CALIFORNIA ON THE DAY THE LAW was scheduled to go into effect, October 6, with a concert in the Panhandle called "Love Pageant Rally." Working out of the *Oracle* office, community organizers put together a broadside, which was duly delivered to City Hall, to the delight of the amused local press.

"When in the flow of human events it becomes necessary for the people to cease to recognize the obsolete social patterns which have isolated man from his consciousness and create the youthful energies of the world revolutionary communities of harmonious relations to which the two-billion-year-old life process entitles them . . ." it began.

Several hundred people showed up that Thursday afternoon in the Panhandle to hear Big Brother and the Holding Company and the Grateful Dead. The Prankster bus was there and, briefly, so was Kesey, now a fugitive from justice. FBI agents looking for him were also there. Kesey had given an interview to the *Chronicle* admitting he attended the Trips Festival and visited a creative writing class at Stanford while the cops were looking for him. He pledged to keep turning up, he told the paper, "to put salt in J. Edgar Hoover's wounds."

"Love Pageant Rally" was so successful the organizers repaired to their apartment that night and immediately started to plan an even larger event in the near future that would be called the Human Be-In.

The FBI grabbed Kesey on the Bayshore Freeway on October 8. He made bail, and his lawyer asked the judge to consider moderating any possible harsh sentence if Kesey would take public action to persuade youth against LSD. Never trust a Prankster. Kesey wanted to hold an "Acid Graduation" on Halloween—to take people "beyond acid," he said—and talked Bill Graham into producing the event at Winterland and the Grateful Dead into playing. At the last minute, Graham heard rumors that Kesey planned to put LSD in the water system and wipe it on handrails and doorknobs, where it could be ingested through the skin. Graham pulled the plug. The Dead played somewhere else, and the Pranksters held a private celebration in a South of Market warehouse.

The Dead had settled in the stately Victorian at 710 Ashbury with the street number in stained glass above the front door. The band's co-manager, Danny Rifkin, had worked as manager of the rooming house at the address while he was still a student at S.F. State. After meeting the Palo Alto–based rock band and coming aboard, he began to slowly move members into his house, beginning with Ron McKernan, aka Pigpen, who he gave a prominent room right off the kitchen. The older Irish workers fled and, in no time, he had filled the house with band members, crew, and their girlfriends. Garcia had paired up with Mountain Girl, who had broken up with Kesey before he went on to Mexico, and they took the attic room.

The Dead played almost every weekend at either the Fillmore or the Avalon, sprinkling impromptu daytime concerts in the park into the band's schedule. The group had outgrown Kesey and the Acid Tests and was practicing long-form group improvisations based around blues and R&B numbers. Pigpen was always good to lead the crowd in some marathon version of "Turn On Your Lovelight" or "Midnight Hour" (Joan Baez and sister Mimi Farina joined the fray for a half-hour version at the Fillmore one night). Whenever the Dead was on a bill, a special contingent of unwashed, dancing ultra-hippies always turned up. They began to call themselves Deadheads.

The band and crew filled not only 710 Ashbury but also a nearby former church on Belvedere Street. The two managers kept an office in the front room. The band rehearsed almost daily at the Sausalito Heliport, and most nights, everybody was in bed by midnight (except Pigpen, who would often stay up drinking and playing the blues). Garcia rose early and started practicing in his room at six in the morning. The band held a sumptuous Thanksgiving feast that year for all their friends, and bassist Phil Lesh offered a toast. "These are the good old days," he said.

Around the same time, the Diggers began giving away free food in the Panhandle every afternoon. They acquired the food from neighboring merchants— vegetables on the verge of spoiling, day-old bread—and almost immediately fifty to a hundred people showed up every day. The new, younger people moving into the Haight were changing the nature of the community. They slept in the park, ate the Diggers' food, and begged for money on the streets. A number were teenage runaways from all over California and the rest of the country. The older merchants were beginning to complain, and the police were keeping a closer watch.

(ABOVE) Grateful Dead managers Danny Rifkin (left) and Rock Scully (right), 1967; (RIGHT) The Grateful Dead, 1967

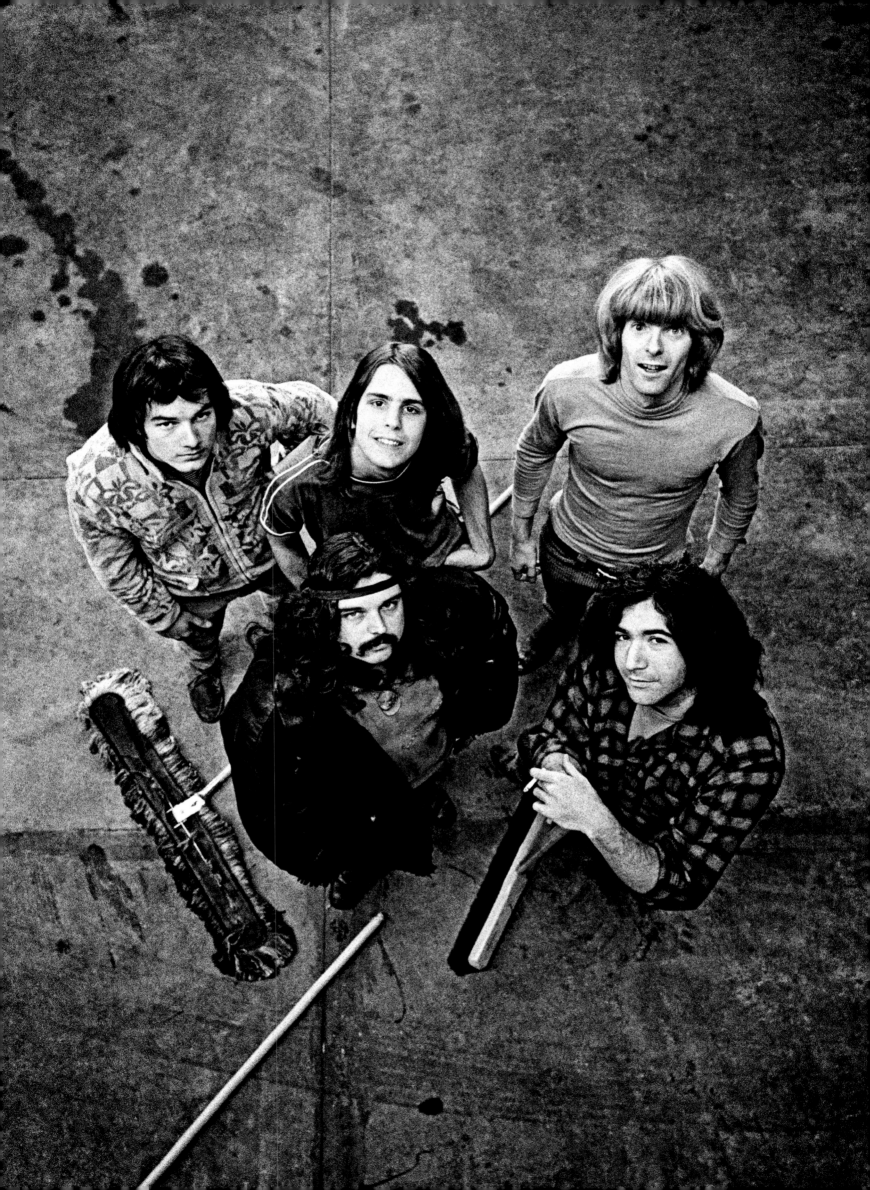

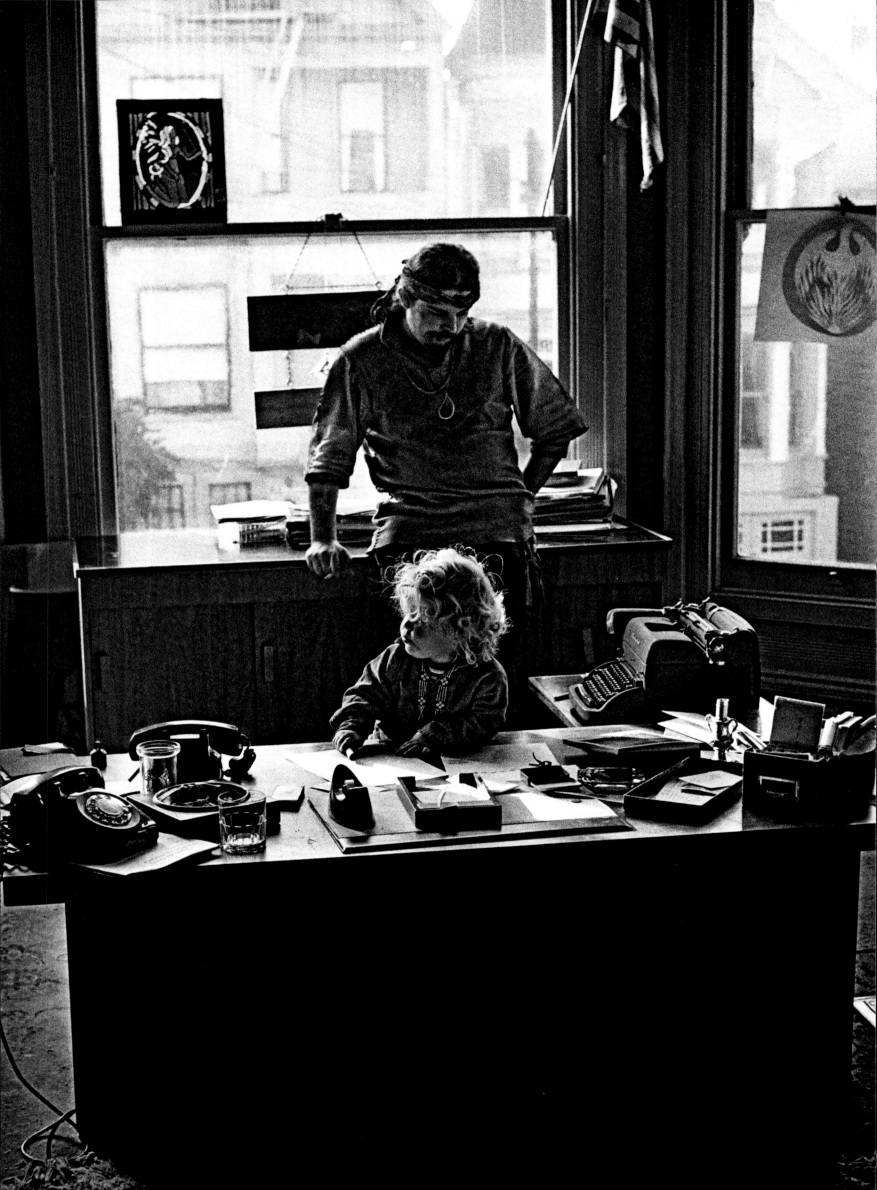

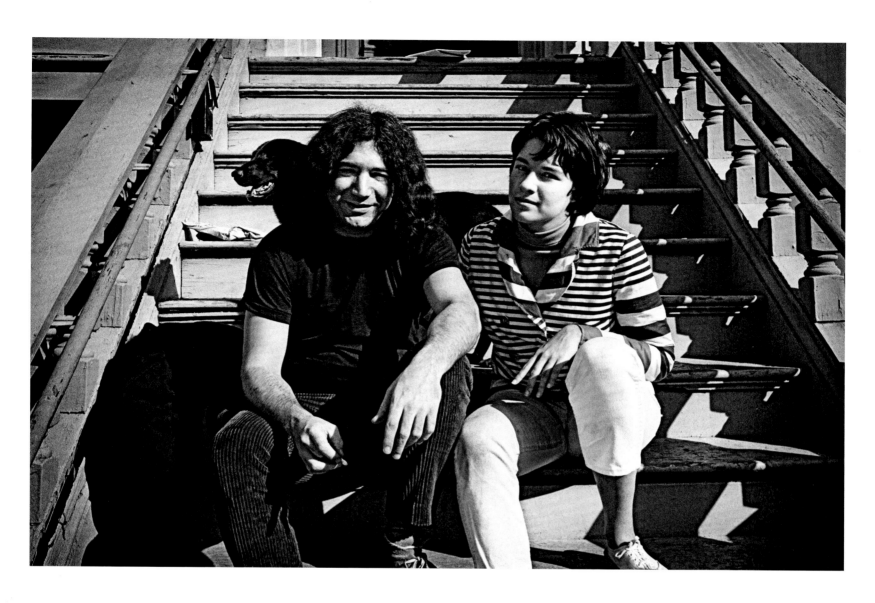

We were living at 710 Ashbury Street and just kind of aghast at the amount of people that showed up down on Haight Street every day. It was incredible numbers of just sort of loose roaming, very young people. Summer was foggy that year, so people were kind of cold and uncomfortable.

People wanted to have an alternative to whatever American culture was telling them they had to do at that time. In 1967, the Vietnam War had been going on. There was the draft. There was a lot of unemployment. People needed something else to look at. I think between folk music and beatniks and Black Panthers and the anti-war movement and the civil rights movement, there was a lot of questioning and unrest going on, mental unrest. People weren't satisfied with the status-quo thinking and wanted to grow up to be something different.

I think that a lot of it's about having given ourselves permission to be weird. We gave ourselves permission. We also gave other people permission to be weird—to try to think outside of the box of convention. I think that's been terribly useful. —Carolyn "Mountain Girl" Garcia

(OPPOSITE) *Pigpen, 1968*; (ABOVE) *Jerry Garcia and Mountain Girl on the steps of 710 Ashbury Street, 1967*

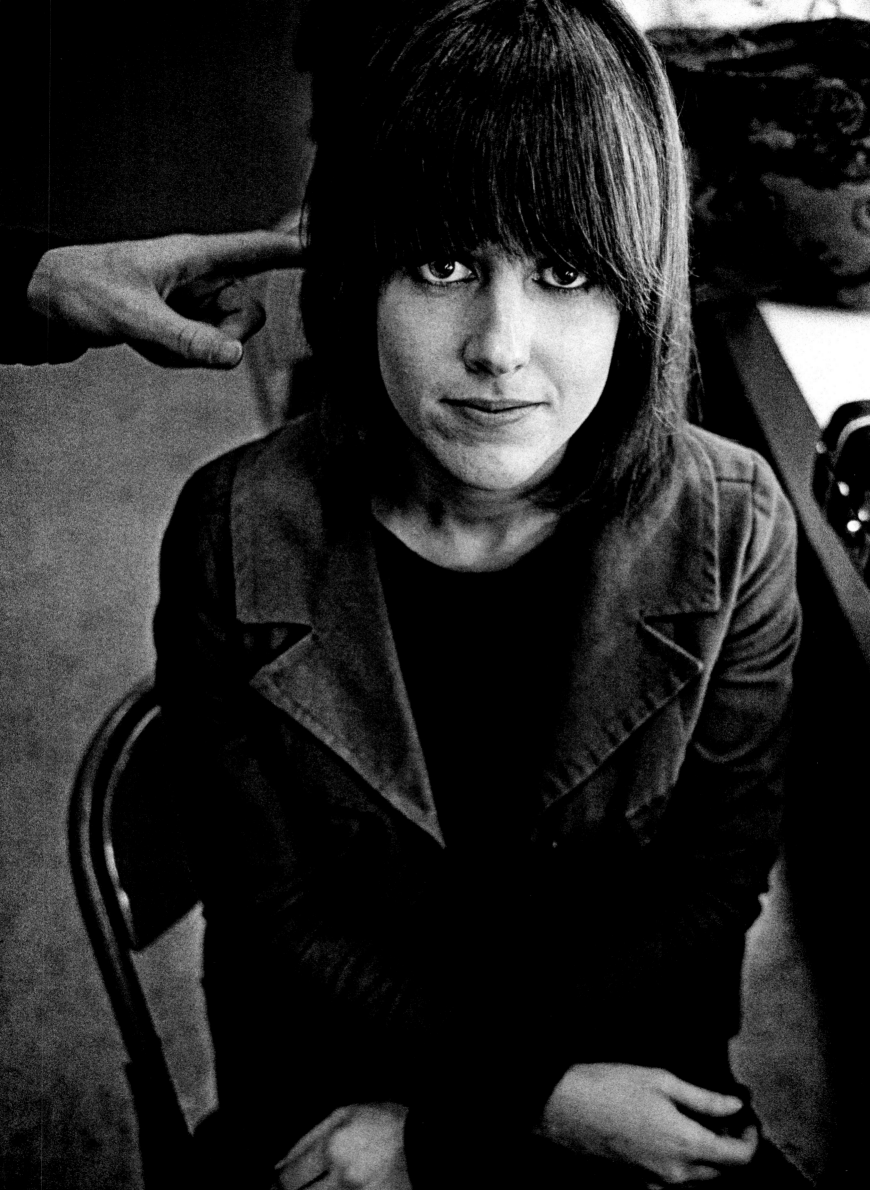

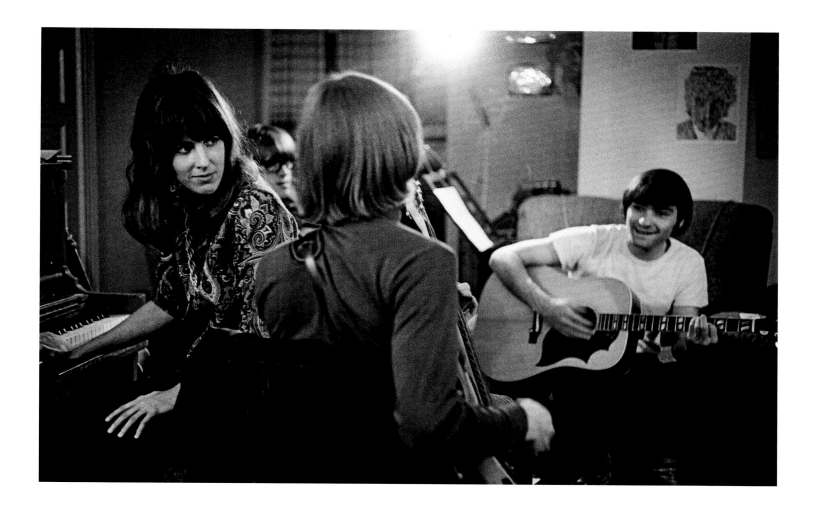

GRACE SLICK JOINS THE AIRPLANE JEFFERSON AIRPLANE VOCALIST SIGNE TOLY WANTED
TO QUIT THE BAND. SHE HAD GOTTEN MARRIED AND HAD A BABY. SHE FOUND THE COMBINED STRAINS
of new motherhood and the rock band unbearable (plus the band hated her husband, who toured as the group's lighting director). The
Airplane immediately offered the post to Grace Slick, the gorgeous former model whose band, the Great Society, had been struggling
without much success since appearing on A Tribute to Dr. Strange the year before. The band had gone into the studio with producer
Sly Stone to record their version of "Somebody to Love" for Tom Donahue's record label, but nothing satisfactory came from the
session. She brought with her from her old group two show-stopping songs, "Somebody to Love" and "White Rabbit."

The band's first album, *Jefferson Airplane Takes
Off*, had been released, and the group planned to start
the next album later in October in Hollywood. Signe
was scheduled to sing with the band two final nights
at Winterland. The first night, there were flowers
backstage for the departing singer and Grace watched
from the wings. The next night, Signe didn't show and
an unprepared, scared shitless Grace Slick made her
debut with the Airplane under fire.

(The first night at Winterland, the Paul Butterfield
Blues Band brought onstage a friend from Chicago to jam
named Steve Miller, who earned a standing ovation by
announcing he was moving to town and forming a band.)

Grace's planned debut took place the following
weekend at the Matrix, the small club the band helped
start. This one, final appearance was part of a lawsuit
settlement between the band and their partners in the
former pizza parlor. In San Francisco, the Airplane
qualified as stars, and this rare appearance in a small club
brought an avid, enthusiastic sold-out crowd. Marshall
knew this would be a signal event in the mushrooming
San Francisco rock scene, and he caught not only the
excitement of the crowd in the small club, but the
relaxed bonhomie of the band members backstage.

Although Grace Slick would help make the Airplane
one of the most famous rock bands of the day, she was an

untried musician leaving her husband and his brother's
band to join what was already the most successful and
promising group on the scene. She sat quietly backstage.

Jerry Garcia of the Grateful Dead went with the
Airplane for the recording sessions in Los Angeles in
November. The band had fired the controlling Matthew
Katz as manager and was on the verge of hiring Bill
Graham in that capacity. The Airplane had moved
solidly into a comfortable electric rock sound after
more than a year in the ballrooms, the folky flavor of
the first album almost entirely gone. The songs for the
new album sounded rich and strong, especially the two
Grace Slick numbers.

(OPPOSITE AND RIGHT) *Grace Slick, 1967;*
(TOP) *Jefferson Airplane, 1967*

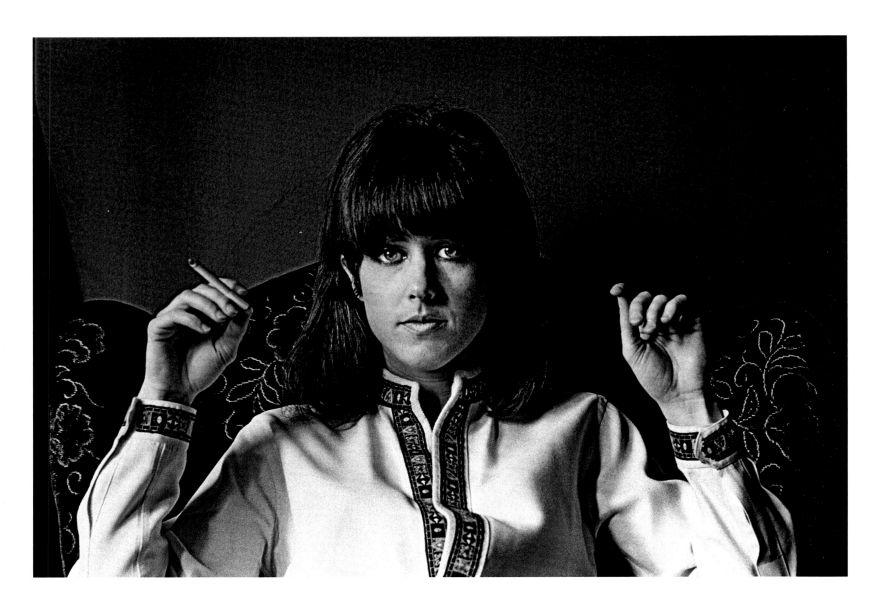

I never thought of myself as being this star, whatever that stuff means. So it was more amusing to me than anything else. That people would call you an artist on a contract . . . that would amuse me. Artist, what do you mean? I'm a fuck off, not an artist. 'Cause a lot of the guys are really good musicians and I'm not. I went to see the Jefferson Airplane play and I said that looks like a lot more fun than being a model for Magnin's. Wow, that's much better. I knew I could sort of sing, because my mother was a singer. But it just looked like a lot more fun than what I was doing. Them calling me an artist—not Pablo Casals here—this is rock and roll.

I did pretty much most of the stuff I had in mind. I don't sit around thinking I wasted my life making breakfast for old Fred. Uh-uh. Didn't do it. —Grace Slick

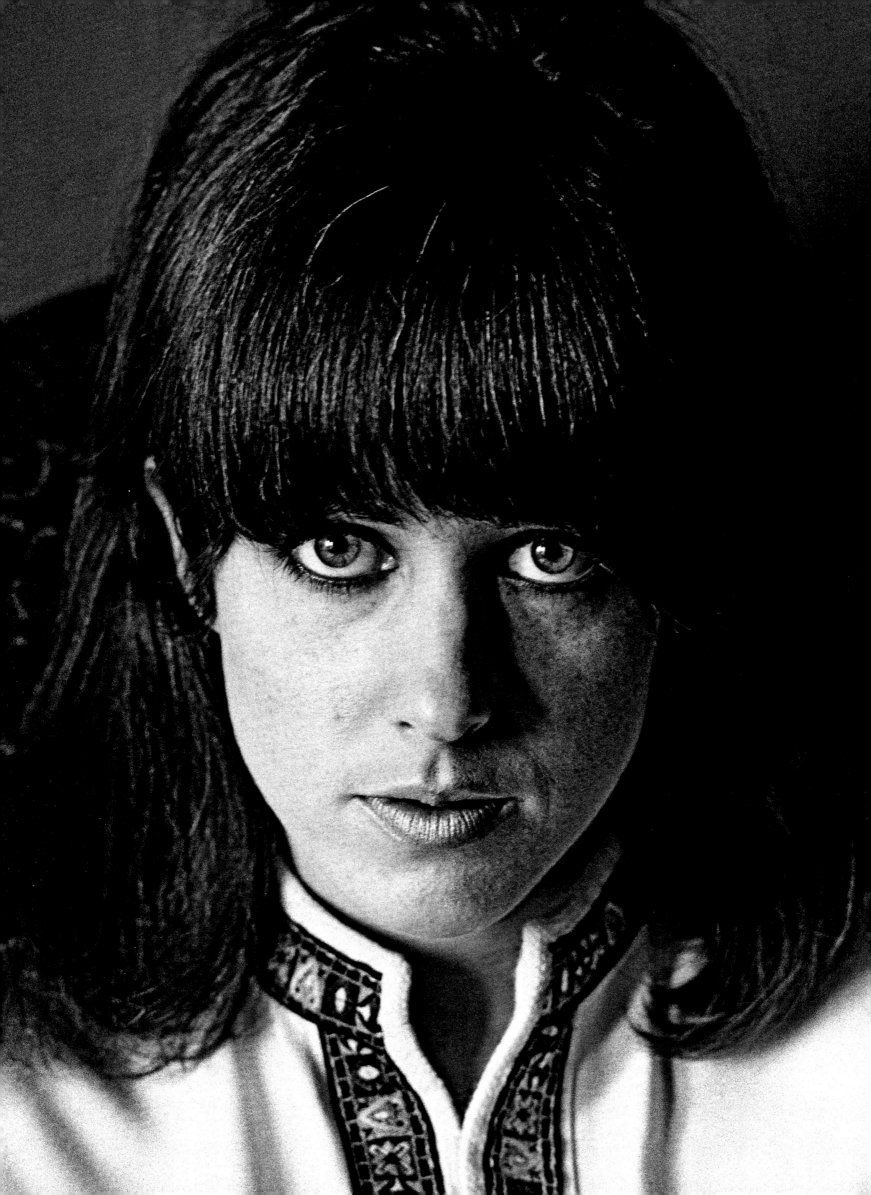

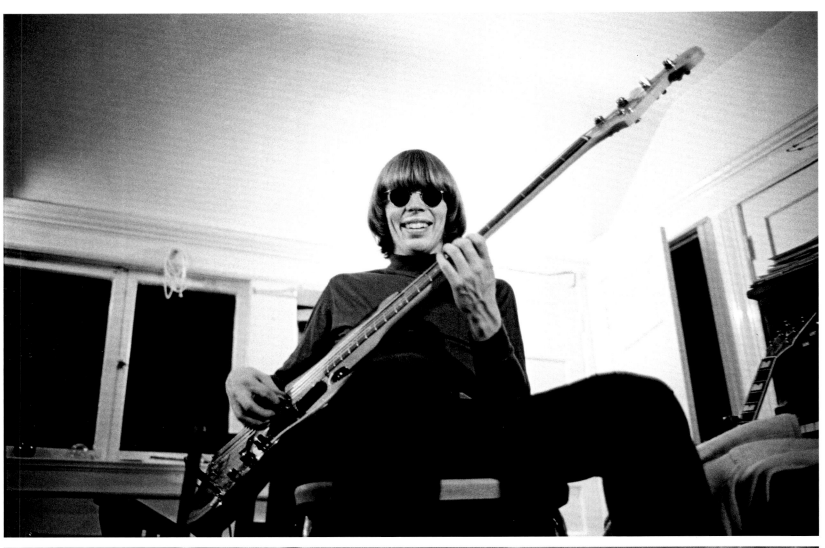

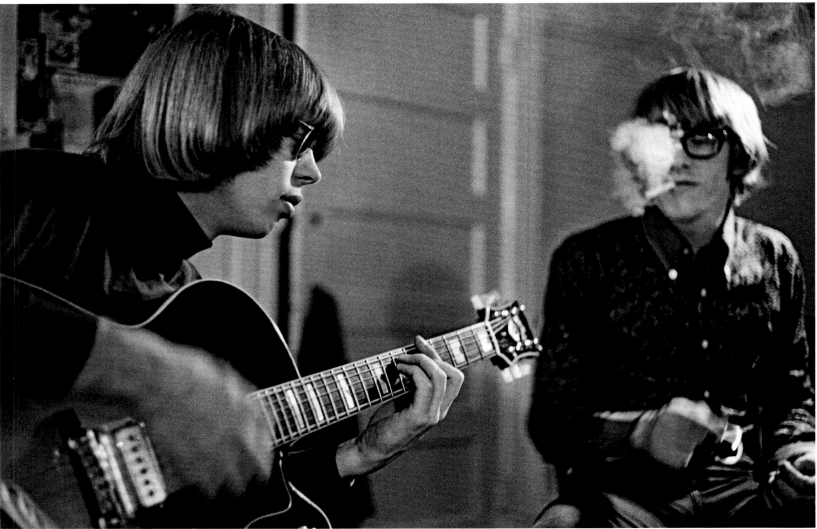

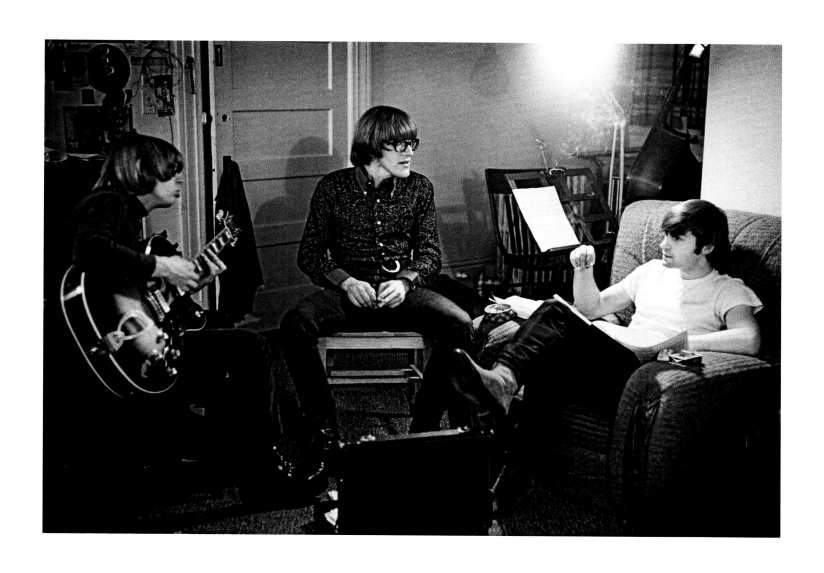

(THESE PAGES) *Jefferson Airplane during a songwriting session, 1967;* (OPPOSITE TOP) *Jack Casady;* (OPPOSITE BOTTOM) *Jack Casady and Paul Kantner;* (ABOVE) *Jack Casady, Paul Kantner, and Marty Balin;* (FOLLOWING PAGES) *Jefferson Airplane, 1967*

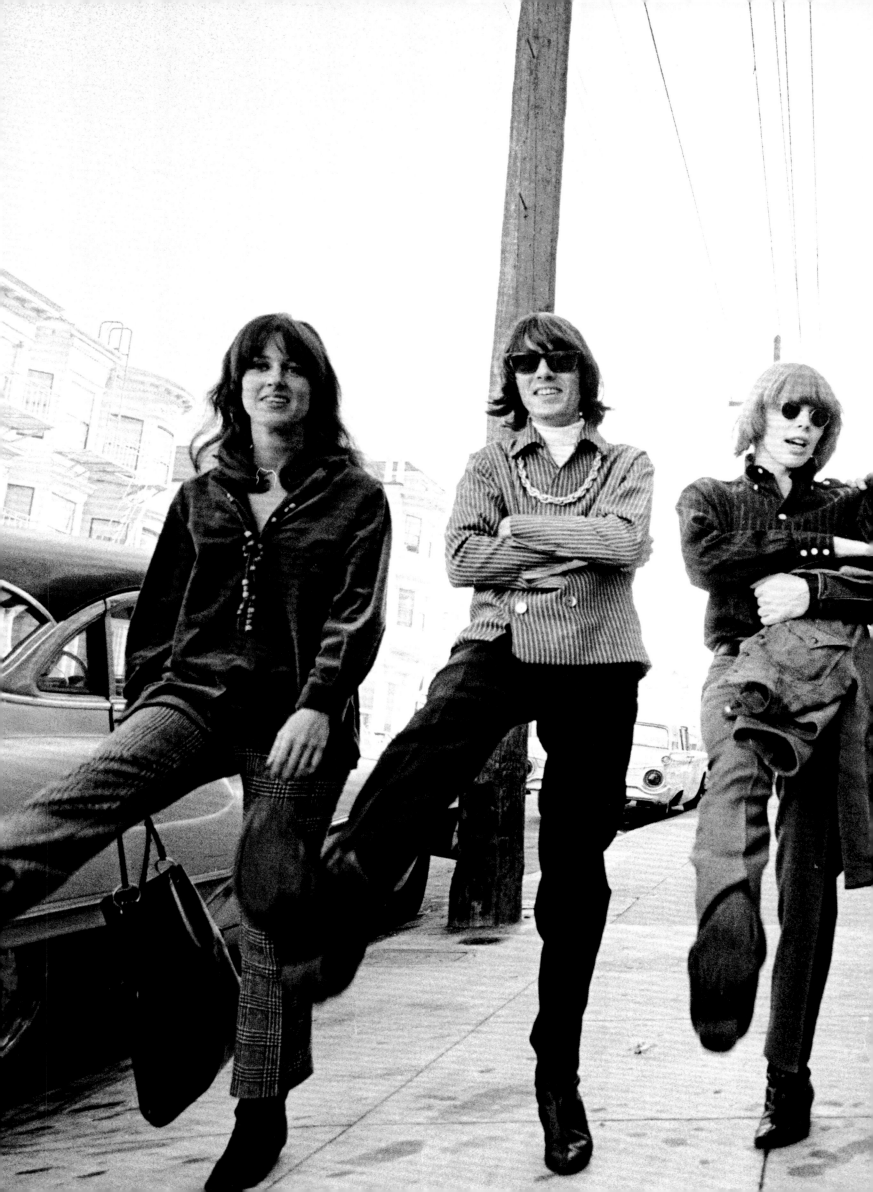

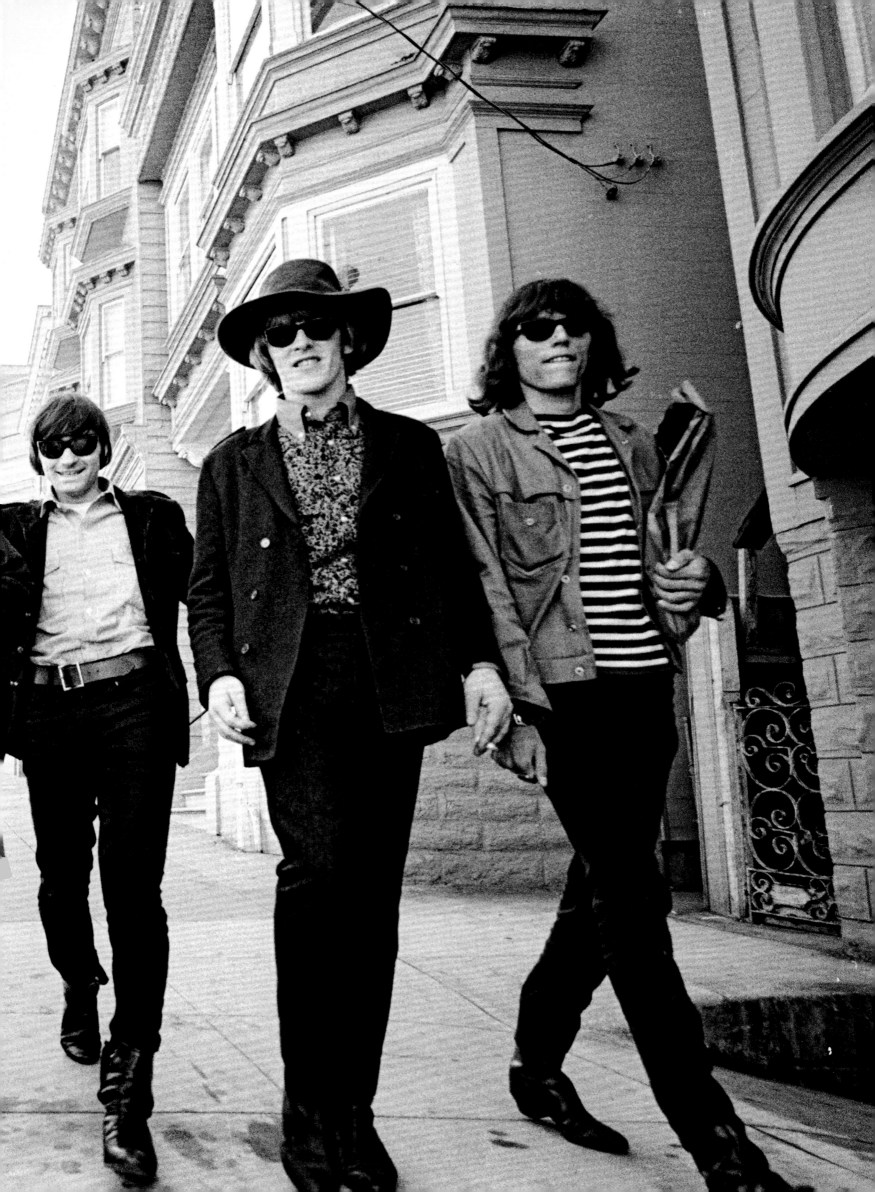

THE PERFECT STORM

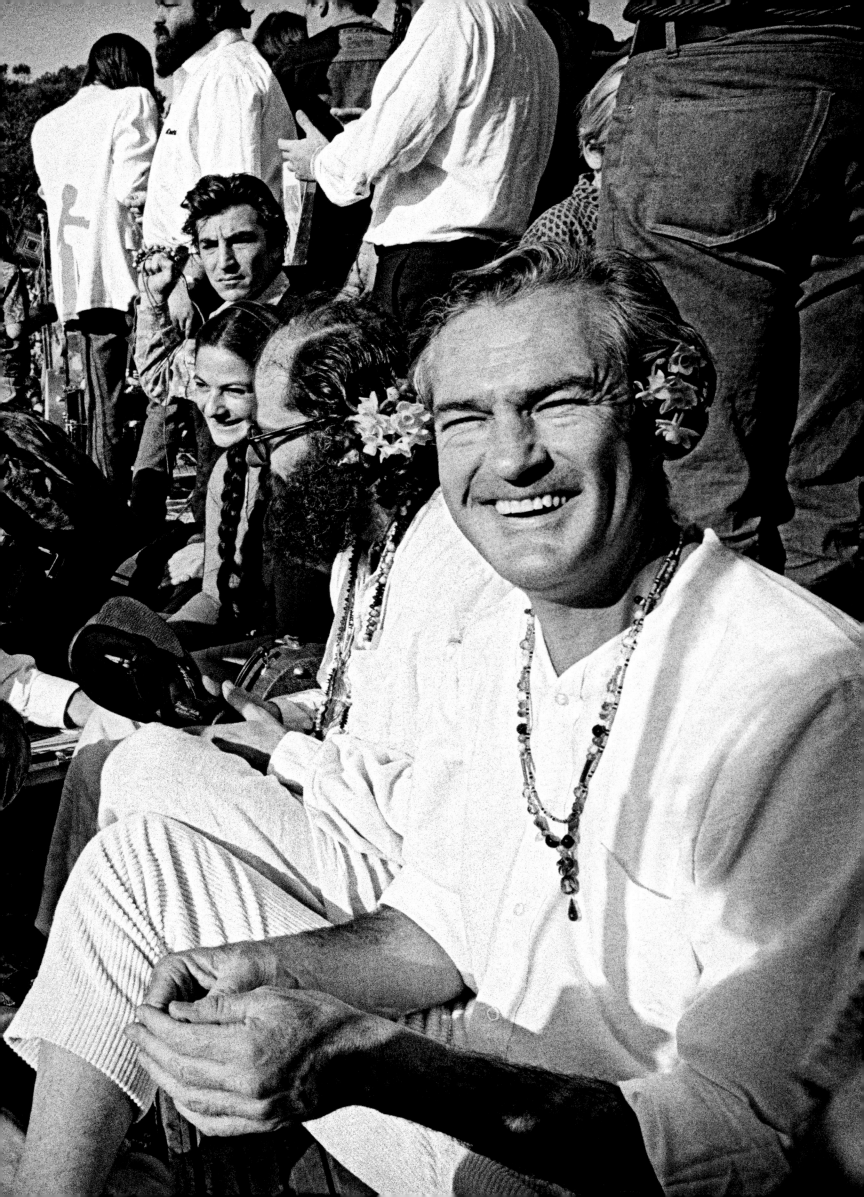

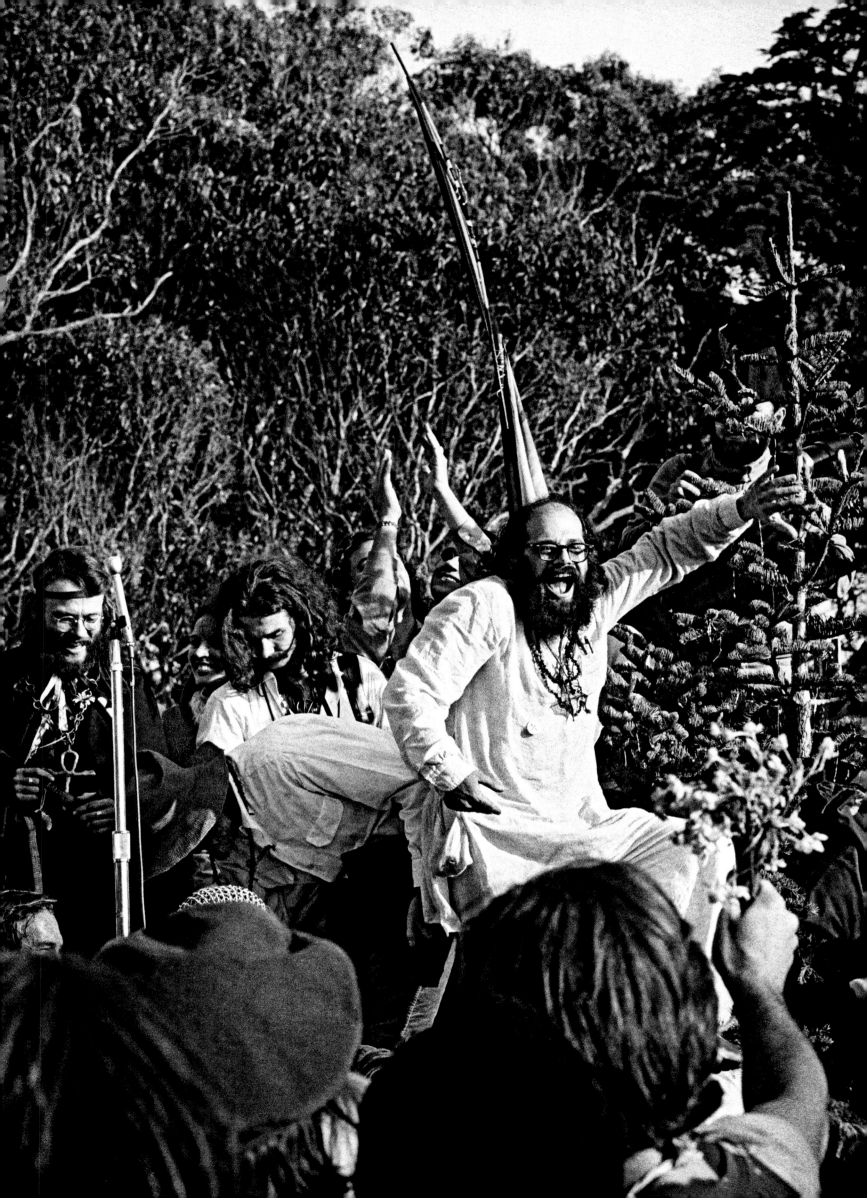

Muhammad Ali is stripped of his heavyweight boxing title for his refusal to be drafted. "No Viet Cong ever called me nigger," he says. Tens of thousands of war protesters march on Washington D.C. The world's first heart transplant is conducted by Dr. Christiaan Barnard in South Africa. The Israelis capture the Gaza Strip in the Six-Day War. *Hair* opens off-Broadway, and the Beatles album *Sergeant Pepper's Lonely Hearts Club Band* is the soundtrack of the summer.

THE HUMAN BE-IN was the brainchild of a confederation of Haight community figures, including LSD evangelist Michael Bowen and *Oracle* editor Allen Cohen. They managed to finagle a permit for January 14, 1967, to use the Polo Fields, a massive open field on the west end of Golden Gate Park. The date was selected in consultation with an astrologer who used to manage Quicksilver Messenger Service. Berkeley political radical Jerry Rubin spoke at a press conference announcing the event, alongside poets, artists, Diggers, and musicians held at the Print Mint on Haight Street. Rubin's presence signaled a merging of the strident political activism of the Berkeley underground and the more sybaritic consciousness-raising of the Haight community. Several different posters and handbills advertised the event, which had no fewer than three names—"Pow-Wow," "Human Be-In," and "Gathering of the Tribes."

The Be-In blew everybody's mind. As concert-goers walking the two and half miles from Haight Street to the site crested the last hill, they saw a mass of humanity overflowing the six square city blocks of the Polo Fields. Perhaps as many as one hundred thousand people spread out across the massive field and spilled out into the trees. A little more than a year earlier, people had been astonished to find a thousand freaks at A Tribute to Dr. Strange. The first experience at the Be-In was a mass self-recognition.

Most of the San Francisco bands played. Jazz flautist Charles Lloyd sat in with Jefferson Airplane. A parachutist descended on the crowd during the set by the Grateful Dead. The sound system was barely up to the size of the crowd, and the electrical connection kept getting unplugged during the day. During the Quicksilver Messenger Service set, after the electricity was interrupted again, the Hell's Angels took charge of guarding the cable. The notorious "outlaw" motorcycle club, who had been a presence on the scene since the early days with Kesey, also handled the lost children—talk about lambs lying down with lions.

LSD guru Timothy Leary made his first San Francisco appearance and urged the crowd to "turn on, tune in, and drop out." Leary, with his Eastern mysticism and frank campaign for raised consciousness, was the polar opposite of the Kesey crowd in California. The Pranksters thrived on social confrontation and madcap antics, while Leary preached a more contemplative, almost religious approach to LSD. The two camps maintained an uneasy peace, bonded by their shared chemical enthusiasm.

Leary, who believed the psychedelic experience should be guided by "set and setting," established a church he called the League for Spiritual Discovery and declared LSD a sacrament. "A psychedelic trip is a journey into new realms of consciousness," Leary wrote in his book, *The Psychedelic Experience*. He was very much the radiant figure at the Be-In, wearing a white Nehru suit and hippie beads and walking barefoot, a blissful, acid-drenched smile pasted on his face.

The Diggers served a thousand free turkey sandwiches, made from turkeys donated by Augustus Owsley Stanley, who also donated generous samples of his latest product, White Lightning, a small white pill containing a potent dose of LSD, passed out by the thousands in the crowd. The members of the Los Angeles rock band the Doors, in town to play the Fillmore, wandered around the field in a daze.

Beat poets Lawrence Ferlinghetti, Gary Snyder, and Allen Ginsberg represented the tribal elders. After Gary Snyder blew the ceremonial conch shell, bringing the afternoon to a close, the crowd disappeared, picking up every piece of trash, leaving the field pristine. Later that night, after some revelers obstructed traffic on Haight Street, the police swooped down and arrested nearly fifty people, including the manager of the Print Mint, who simply stepped outside to see what was happening.

The Be-In caught a skeptical public and police force by surprise—an entirely peaceful, incense-scented afternoon of poetry and music in the park enjoyed by a crowd the size of a small city. The vast size of the crowd served notice that the word about the new community of the Haight—and the new rock music—was expanding exponentially. What had only months before been confined to a small neighborhood in San Francisco was now drawing vast crowds and beginning to be heard around the world.

(PRECEDING PAGES) *Timothy Leary at the Human Be-In in Golden Gate Park, 1967;* (OPPOSITE) *Allen Ginsberg at the Human Be-In;* (ABOVE) *Muhammad Ali, 1968*

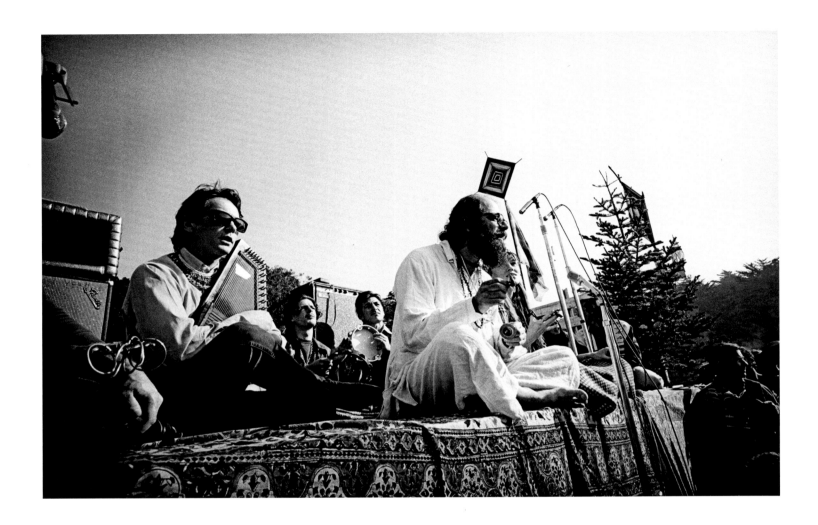

At the Human Be-In, I was sitting onstage next to Allen Ginsberg and Gary Snyder. Timothy Leary was up there and Lenore Kandel. I sang one of my poems, "The God I Worship Is a Lion." It was the first great congregation of young seeker people, known as the counterculture, who were drawing together to create their own huge family, and to celebrate it in their own huge tribe, and to celebrate it with music and dance and song and psychedelics and some real good political things.

The spirit still exists in the faces and bodies and stances of so many people I see around me. Somebody comes up and says, "Whatever happened to the Summer of Love?" And I'm looking at him, and I see a person who believes in the environment, believes in doing away with factory farming, believes we shouldn't be killing people because they're wearing turbans, and believes we don't necessarily have to get our oil under somebody else's soil.

There was also a great spread of Asian consciousness, in everything from what we call spiritual thinking to food. A whole widening of our understanding and experience of the world, through foods, meditation, concentration, travel, repressions left on the dance floor. . . . The beats had inspired them, no doubt about it, but we were able to learn things from them—their sense of community. —Michael McClure

(ABOVE) *Michael McClure playing the harp on stage at the Human Be-In, with Allen Ginsberg;* (RIGHT) *Timothy Leary*

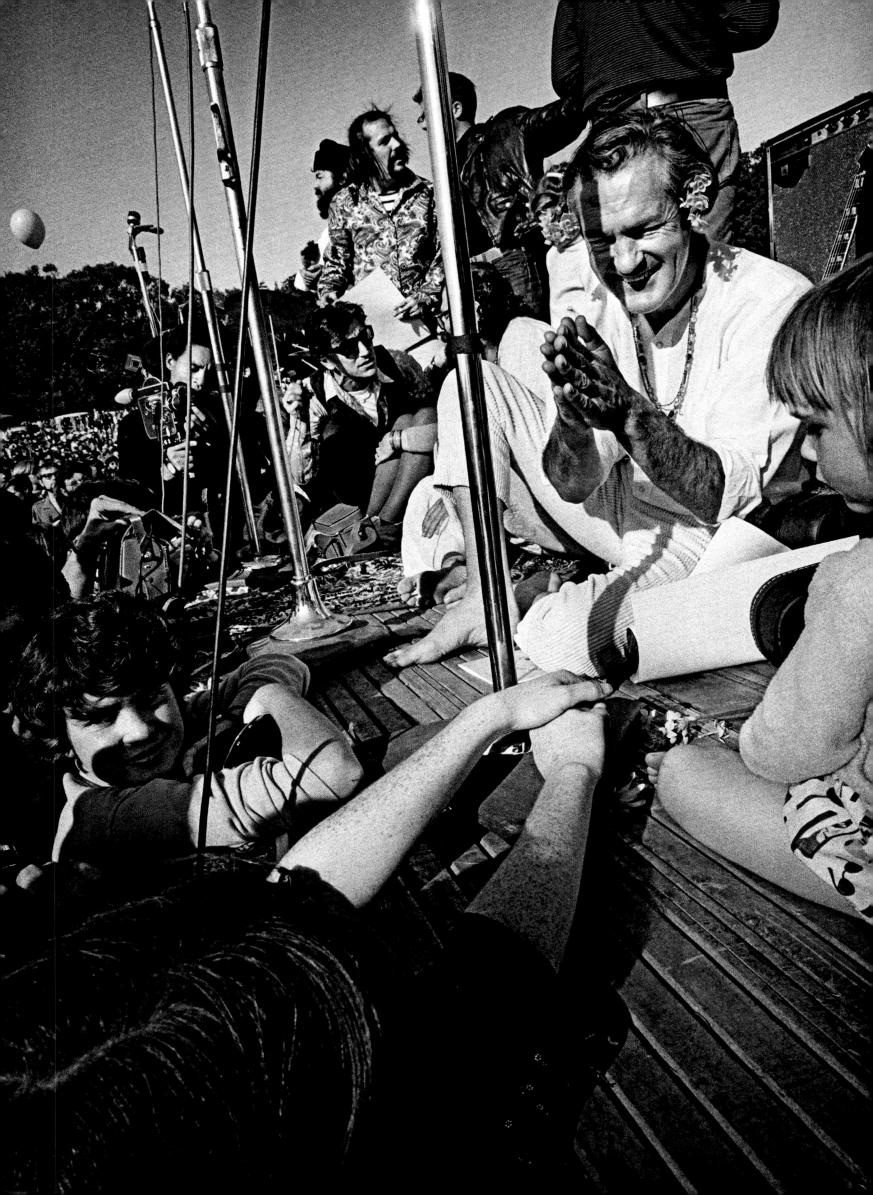

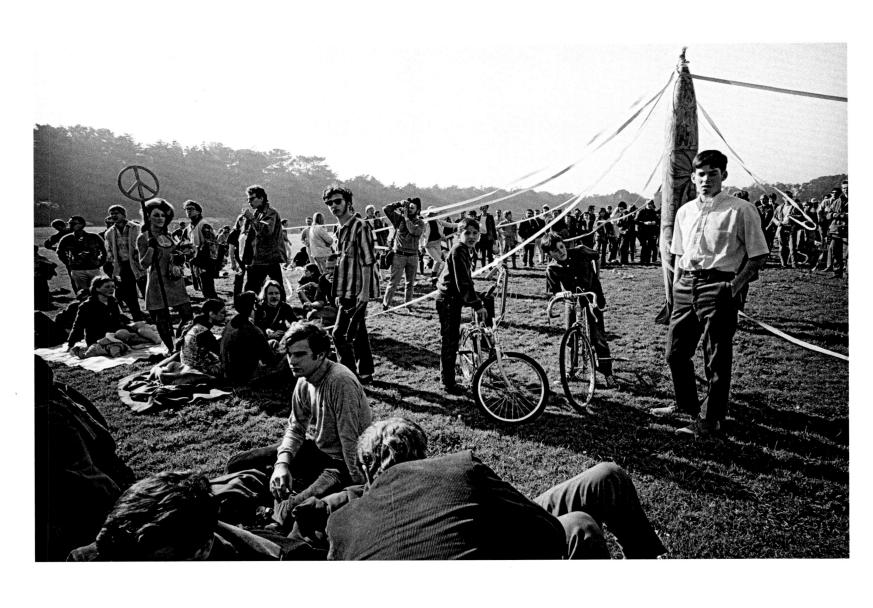

(THESE AND FOLLOWING PAGES) *Scenes from the*
Human Be-In in Golden Gate Park, 1967

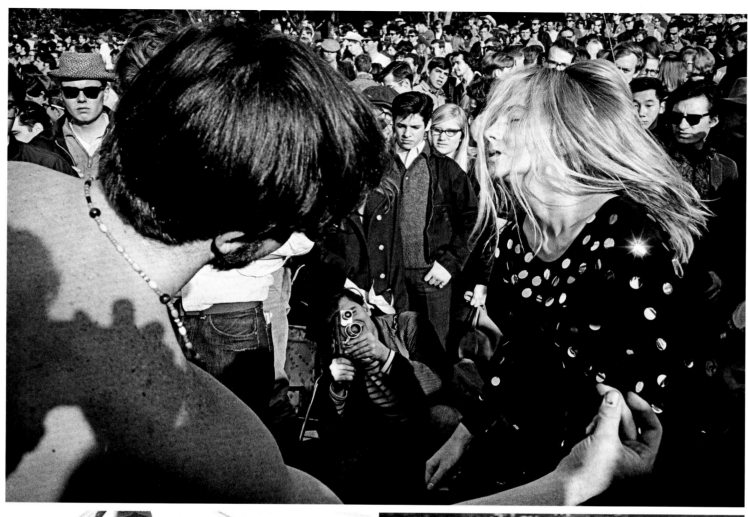

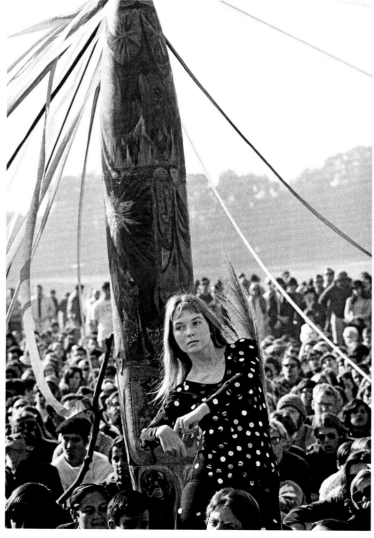

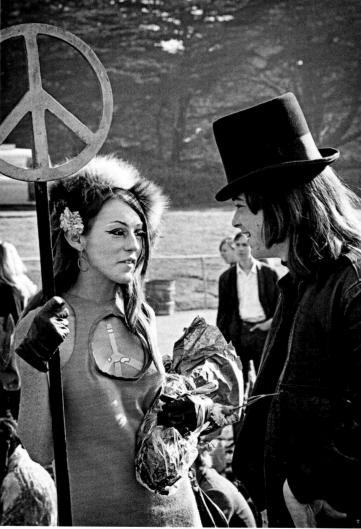

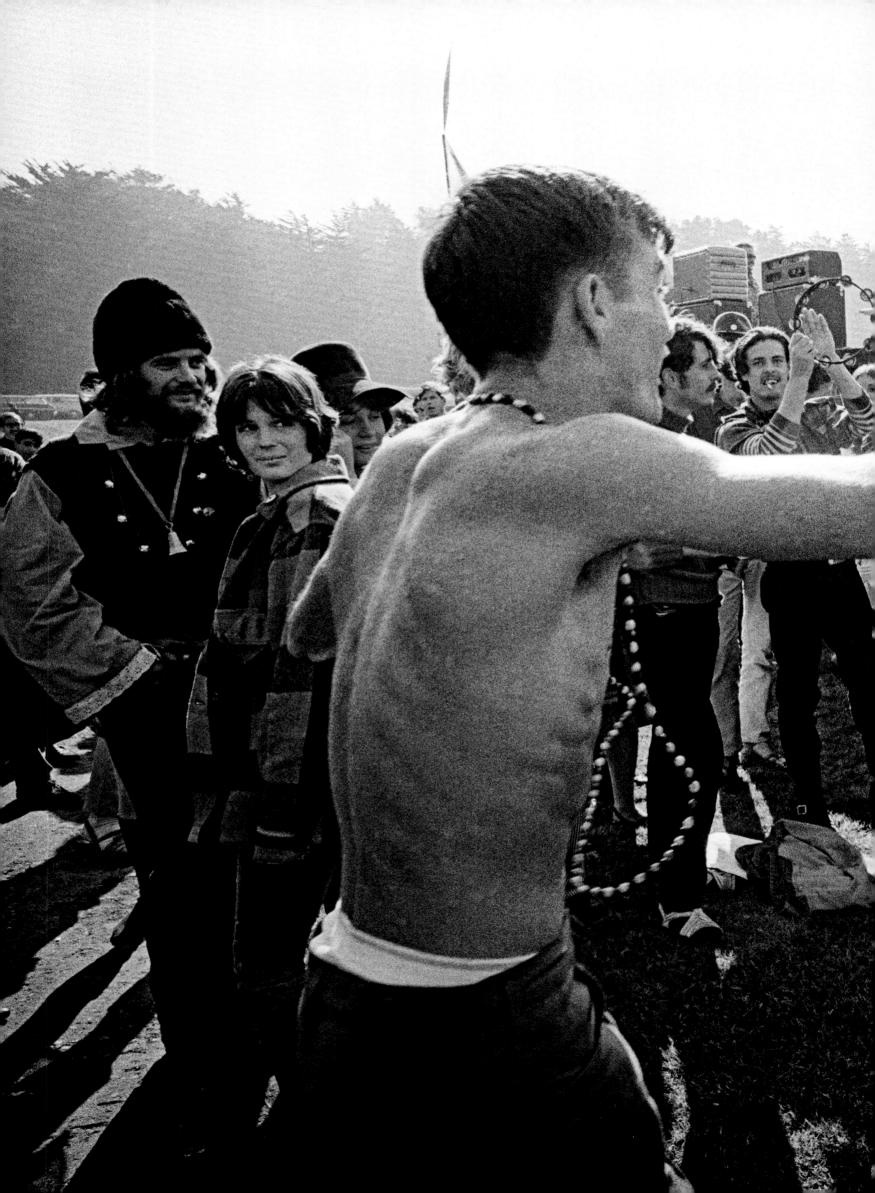

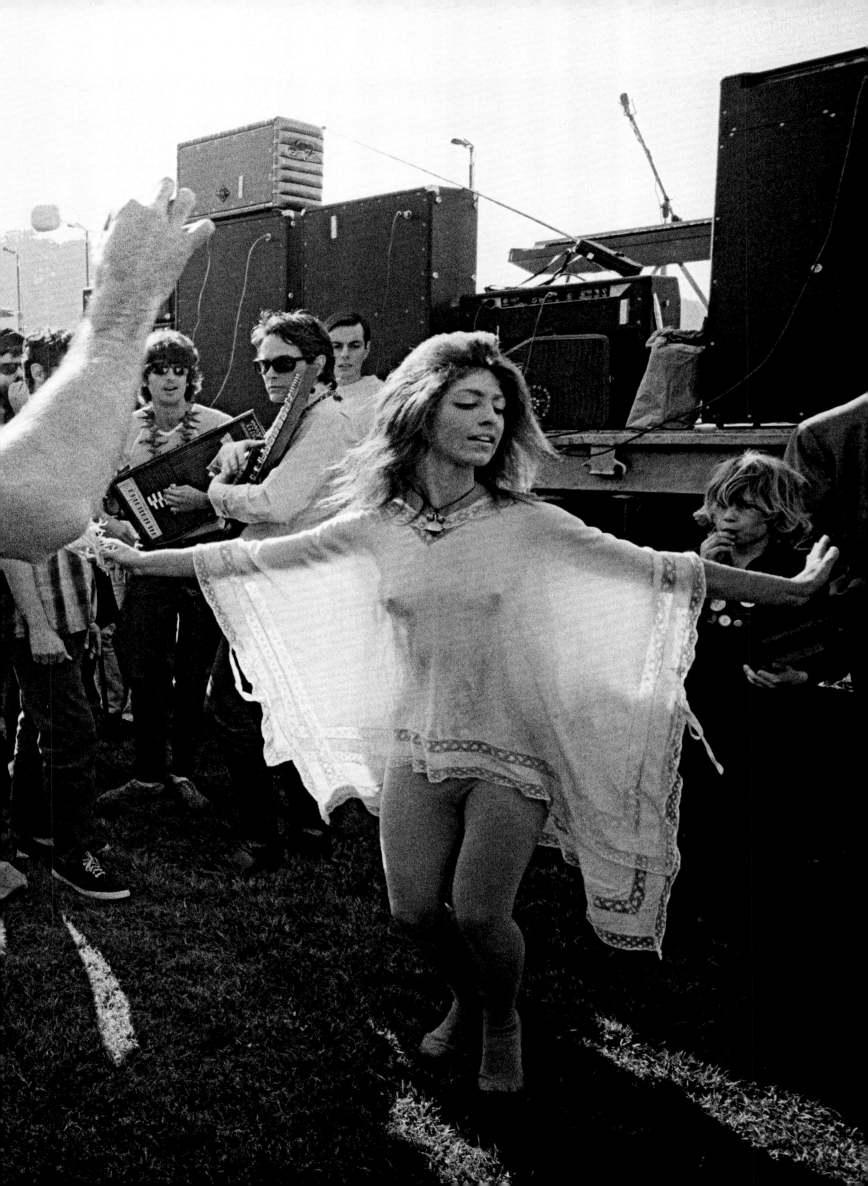

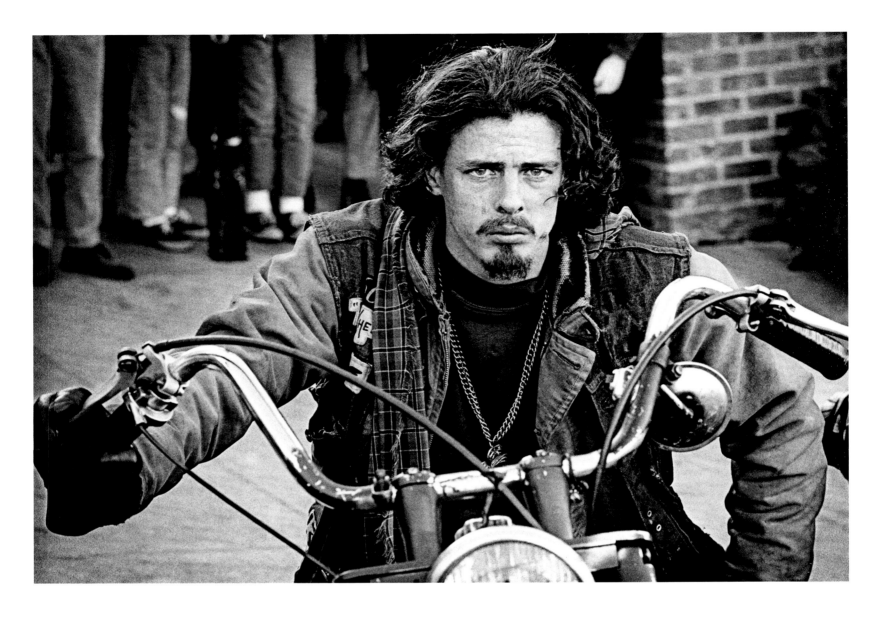

HELL'S ANGELS AND THE HIPPIES THE HELL'S ANGELS FIRST MET THE HIPPIES AT KEN
KESEY'S LA HONDA PLACE, WHERE THE REBEL MOTORCYCLE CLUB FOUND THE COMPANY HOSPITABLE
and some even sampled the LSD. Oakland chapter chief Sonny Barger quite enjoyed the psychedelic experience, but kept it secret
from his brothers because he feared the effect its widespread use would have on the club. The Angels could distinguish the serious
left-wing Berkeley politicos from the San Francisco hippies, who liked to get high, have sex, and party. The Angels were not only
social outsiders by choice—something the hippies admired—but they wore their hair long before the hippies did. It was a strange,
tenuous bond, but a number of the Angels became prominent figures around the Haight.

Terry the Tramp was a key link in Owsley's supply
chain, so the Angels always had plenty of acid. Gut was
an Oakland member who came from San Bernardino
and grew close to the bands, especially the Airplane. He
helped start and manage the San Francisco power rock
trio, Blue Cheer. Chocolate George—so-called because
of his fondness for chocolate milk at Tracy's Donuts
on Haight—was well known for the dances he threw,
but he became an instant *cause célèbre* on Haight Street
during a Death of Money parade staged by the Diggers
in December 1966. Cops pulled over Hairy Harry for
riding with a Digger woman standing on the back of his
motorcycle holding a sign that said NOW, a violation of the
vehicle code. A check on his driver license revealed Harry
to be out on parole and, when the police prepared to take
him into custody, his brother Angel, Chocolate George,

stepped up in his defense. The police arrested George for
interfering and took the pair to the Park Police station
for booking.

The Diggers followed the police and surrounded
the station, chanting for the Angels to be released. The
hippies passed around the coffin that was being used
in the Death of Money parade and raised bail money
for the Angels. This spontaneous display of loyalty
impressed the Angels.

Club members flying their colors were present at all
the Haight rock shows. They could get into the Avalon
and Fillmore for free. Angels like Sweet William, Fu,
and Badger became close friends with the Grateful
Dead, who were especially welcoming to the motorcycle
club. Oddly enough, the Angels were as much a part of
the Summer of Love as the hippies.

(ABOVE) *Freewheelin' Frank, secretary of the San Francisco chapter of
the Hell's Angels, 1967;* (OPPOSITE TOP AND BOTTOM) *Hell's Angels, 1967*

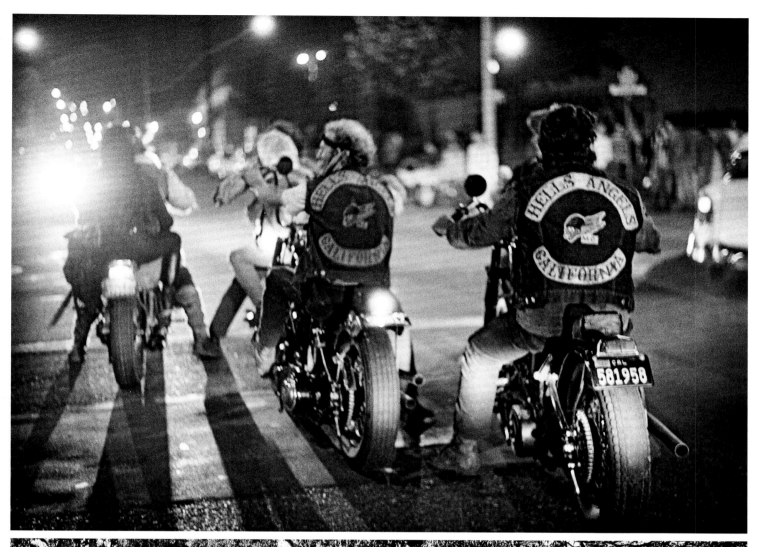

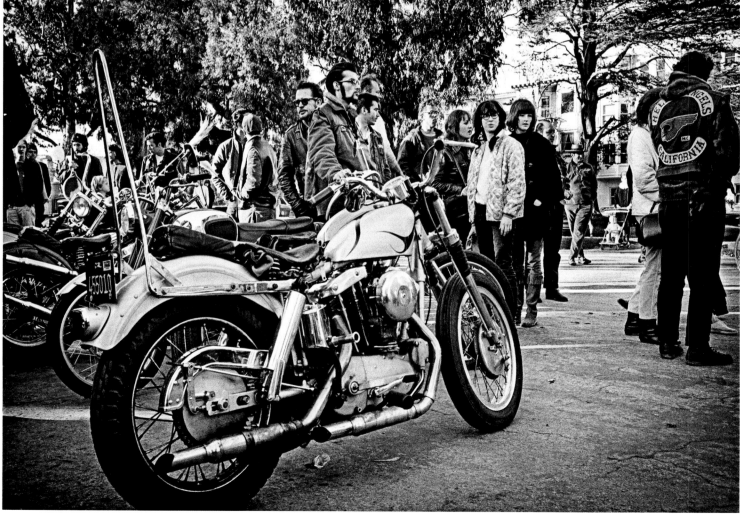

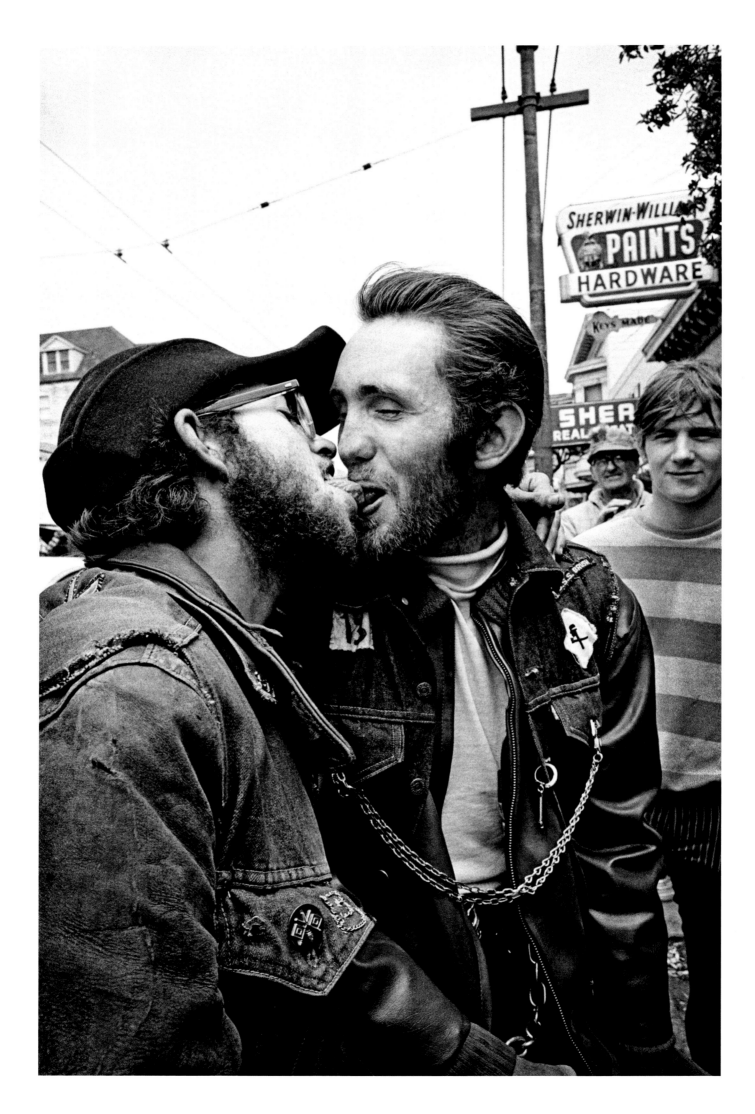

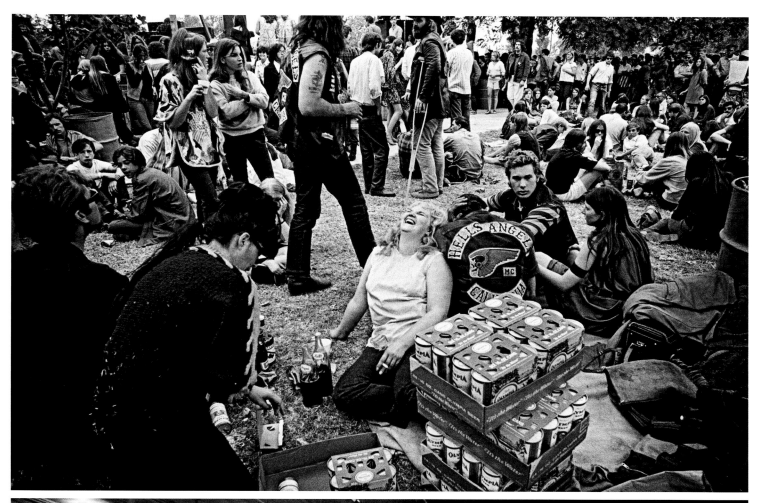

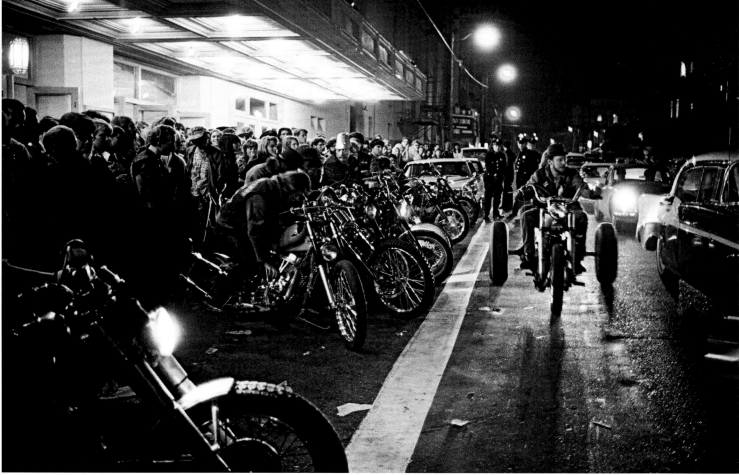

(OPPOSITE) *Two members of Hell's Angels kiss. This image was featured in* Look *magazine's "Hippie Story," 1967;* (TOP) *Hell's Angels in Golden Gate Park, 1968;* (ABOVE) *Motorcycles line the street, 1967*

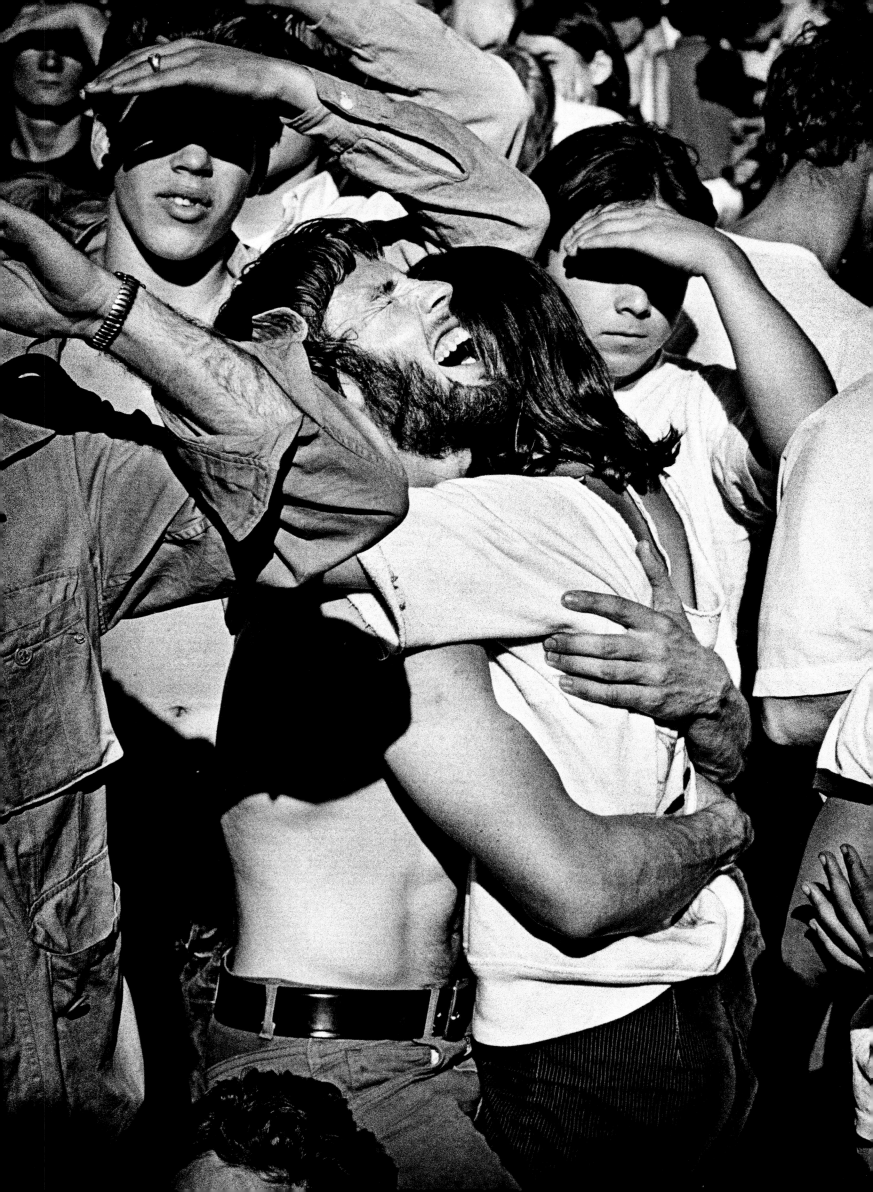

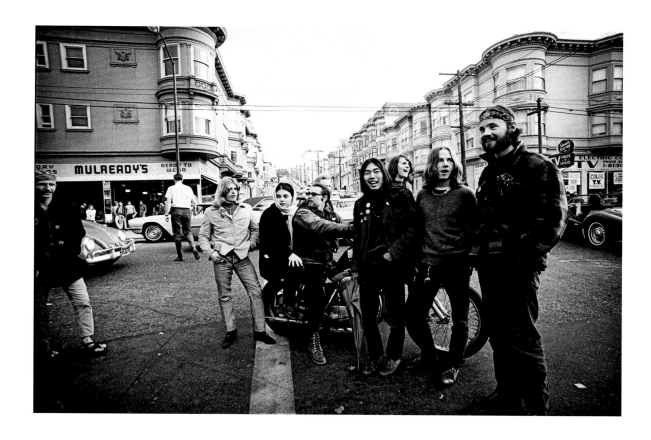

It was kind of a nice time in the beginning of '67, before the influx of all those people. It was still manageable. People knew each other. You could go down to a place like Haight Street and see your friends, walk around, go to the different dances. —DAVID GETZ (BIG BROTHER AND THE HOLDING COMPANY)

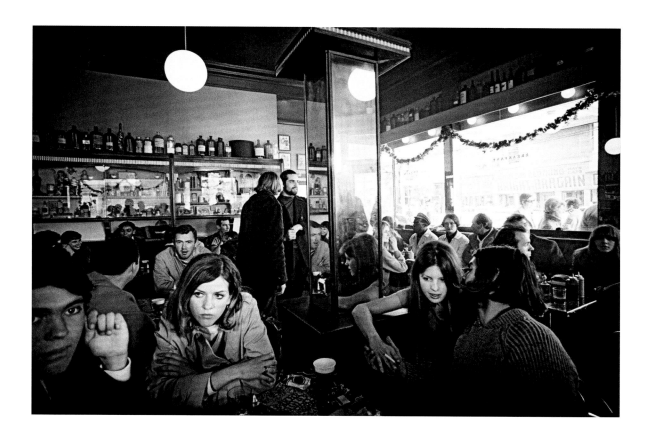

(OPPOSITE) *A man and woman find each other in the Panhandle,*
1967; (TOP) *A group of friends gather at Haight and Masonic, 1967;*
(ABOVE) *The Drogstore Café, 1967*

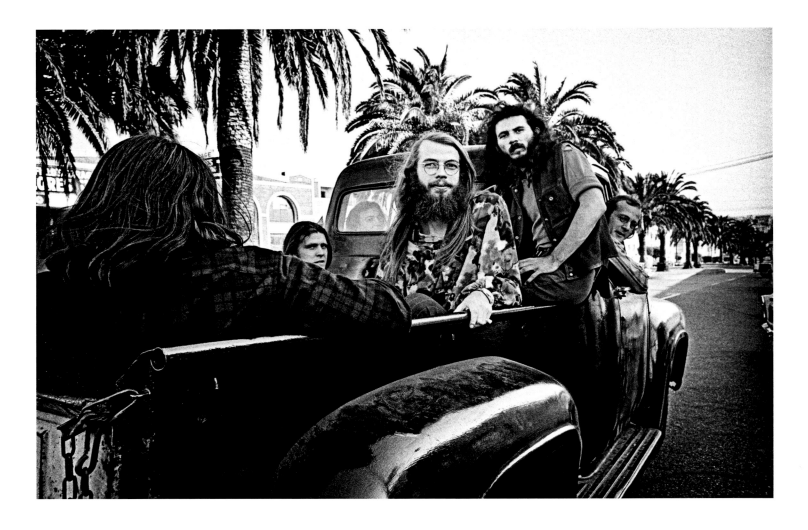

THE MUSIC BEGINS TO SPREAD

THE NEW ROCK COMING FROM THE HAIGHT WAS LARGELY A RUMOR AT THIS POINT, BUT IT WAS A RUMOR THAT WAS SPREADING. THESE BANDS HAD GROWN UP AS part of an emerging LSD culture in San Francisco, but the ideas they were introducing would have far-reaching impact on the rest of the music world. In January 1967, as the year of the Summer of Love dawned, the Haight was already a semi-mystical place in the minds of millions of people everywhere.

Chet Helms made a state visit to the London underground that January, ostensibly to scout locations for a Family Dog operation in London, the land of the Beatles and the Rolling Stones, although that hardly proved feasible. He went to a happening staged by the staff of the underground newspaper *IT* at the Roundhouse where fifty gallons of Jell-O was dumped at the feet of partygoers. John Lennon and Paul McCartney also attended. He caught the leading London psychedelic band, Pink Floyd—whose members outside vocalist Syd Barrett did not take LSD—but was disappointed in the light show. Ray Anderson of San Francisco's Holy See Lights would introduce liquid projection to British light shows, but when Helms saw the band, Pink Floyd only had a slide show playing behind them. San Francisco was far advanced from the London scene.

The second Jefferson Airplane album, *Surrealistic Pillow*, came out in February. RCA Victor threw a lavish bash for the album's release at Webster Hall in New York City and introduced West Coast–style rock to the East Coast, complete with a light show and jam session with members of the Paul Butterfield Blues Band, plucked out of the audience for the occasion. The album hit the charts the next month. "Somebody to Love" crashed the Top Forty in April, followed quickly by "White Rabbit." The Airplane was suddenly the progenitor of the psychedelic rock movement. When Owsley produced his next brand of LSD, Orange Sunshine, the band took bags with them on tour and threw handfuls into the crowds. Grace Slick had brought a soft, feminine

touch to the band, but she was no shrinking violet. She could swear, drink, smoke, and do drugs with the best of the guys. She was a smart-mouthed babe with a barbed wit and a beautiful face. Her vocals blended smoothly with the aching tenor of vocalist Marty Balin, and her songs were making the band famous. Marshall loved photographing her. She was his kind of gal.

Paul McCartney flew into town on Frank Sinatra's Learjet and walked in unannounced to an Airplane rehearsal at the abandoned synagogue next to the Fillmore in April. He was carrying a test pressing of the new Beatles record. Band members and the Beatle repaired to the Oak Street apartment shared by Marty Balin, Jack Casady, and road manager Bill Thompson. The musicians smoked some DMT, a powerful psychedelic, and McCartney played them "A Day in the Life." McCartney needed to check out the scene firsthand, and he then went back to L.A. on his borrowed plane.

The Airplane was only the beginning. Record companies started to line up for the other bands. As new rock musicians expanded boundaries everywhere daily, they all looked expectantly to San Francisco for direction, even if they could only imagine what the bands actually sounded like. Luria Castell's absurd prediction that "San Francisco could be the next Liverpool" was coming true.

The Grateful Dead signed with Warner Brothers Records. Tom Donahue dragged Warner Brothers' Vice President Joe Smith, who looked like the man on top of the wedding cake, out of a swanky dinner with his wife at the tony Ernie's Restaurant straight to the Avalon Ballroom.

(ABOVE) Chet Helms & the Family Dog, 1967; (OPPOSITE TOP) The Grateful Dead, lip-synching for a local television station. According to Marshall, they didn't even plug the instruments in, 1967; (OPPOSITE BOTTOM) Janis Joplin superimposed, 1967

Smith felt like he had fallen through a hole in the earth. The Dead hired Kesey's drug case attorney to represent the band, even though he had no experience with the music business. The lawyer met with an older attorney who represented jazz pianist Dave Brubeck and advised the Dead's attorney to keep the publishing. He negotiated an unprecedented deal with Warner Brothers that not only maintained publishing rights but redefined how royalties would be paid. The band was also guaranteed creative freedom.

The Dead went to Hollywood and recorded the first album in a three-day Benzedrine haze. The record, released in March, drew from the band's ballroom songbook—guitarist Jerry Garcia's folk-rocky "Morning Dew," organist Pigpen's blues workup "Good Morning Little Schoolgirl," the raga rock of "Viola Lee Blues" with the crashing, electric crescendo.

The San Francisco sound had not traveled much. The Dead played a run at Hollywood's Whisky a Go Go to coincide with the release of the album in March, the band's first out of town date since returning from the Acid Test in Los Angeles the year before. Big Brother and the Holding Company took a watershed engagement at a Chicago nightclub, where the band was stranded after nobody came to see the show and the club owner refused to pay them. In a panic, the group made a hasty, ill-advised record deal with a small label, cut a couple of sessions in Chicago, and drove back to San Francisco chastened and defeated.

Janis Joplin was coming out of her shell. No longer the homely country girl, she dressed in hippie chic, beads, bracelets, and patterned stockings, and her extravagant personality began to emerge. She was also becoming an electrifying presence in the Big Brother sound. Not only were her solo numbers turning into the band's big numbers, but her harmony vocals often threatened to overwhelm the lead vocalist, as on Sam Andrews' ode to the San Francisco dance halls, "Combination of the Two," when Joplin stepped on the gas singing nothing more than "whoa-whoa-whoa" and stole the scene.

She posed for a coyly nude photo with photographer Bob Seidemann, her bare breasts poking out between

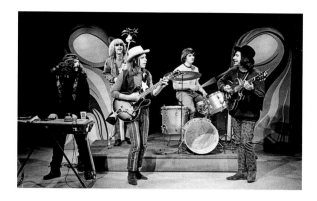

strands of glass beads, which became a top-selling poster at the Print Mint and made her the first hippie pin-up girl. Marshall photographed Joplin in various poses on her bed in her Lyon Street apartment, where she lived for a while with Joe McDonald of Country Joe and the Fish (who also had an album coming out on Vanguard Records). Like all her relationships, the romance with McDonald was short-lived, but the song he wrote about her, "Janis," appeared on his band's first album and helped contribute to her growing underground reputation.

The little known Big Brother landed a plum part in a major Hollywood motion picture, *Petulia*, being filmed in San Francisco. Starring Julie Christie and Richard Chamberlin, the film was directed by Richard Lester, who had directed the Beatles in *A Hard Day's Night* and *Help*. Big Brother supplied music for a party scene shot at the Fairmont Hotel, and Joplin wrote home excitedly, a little Texas girl who couldn't believe she was going to be in the movies.

Big Brother and the Holding Company finished their album for Mainstream Records in Los Angeles, and although the repertoire included songs by bassist Peter Albin and guitarist Sam Andrew, it was Joplin numbers like "Women Is Losers," "Call on Me," and "Down on Me" that stood out, even with the ham-fisted production from the jazz-inclined engineers, who turned Gurley's growling guitar down to a whimper. It was around this time that Joplin went to see Big Mama Thornton in a club and heard her sing "Ball and Chain."

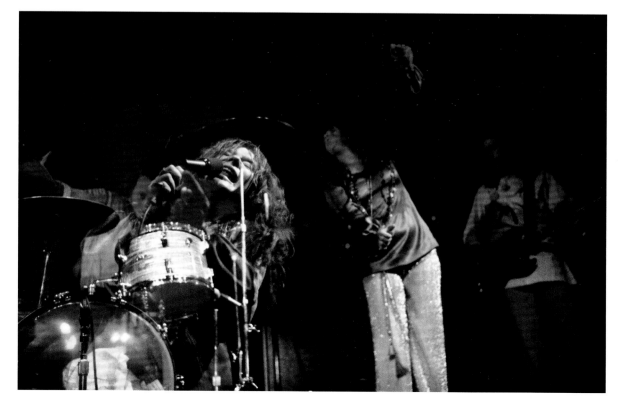

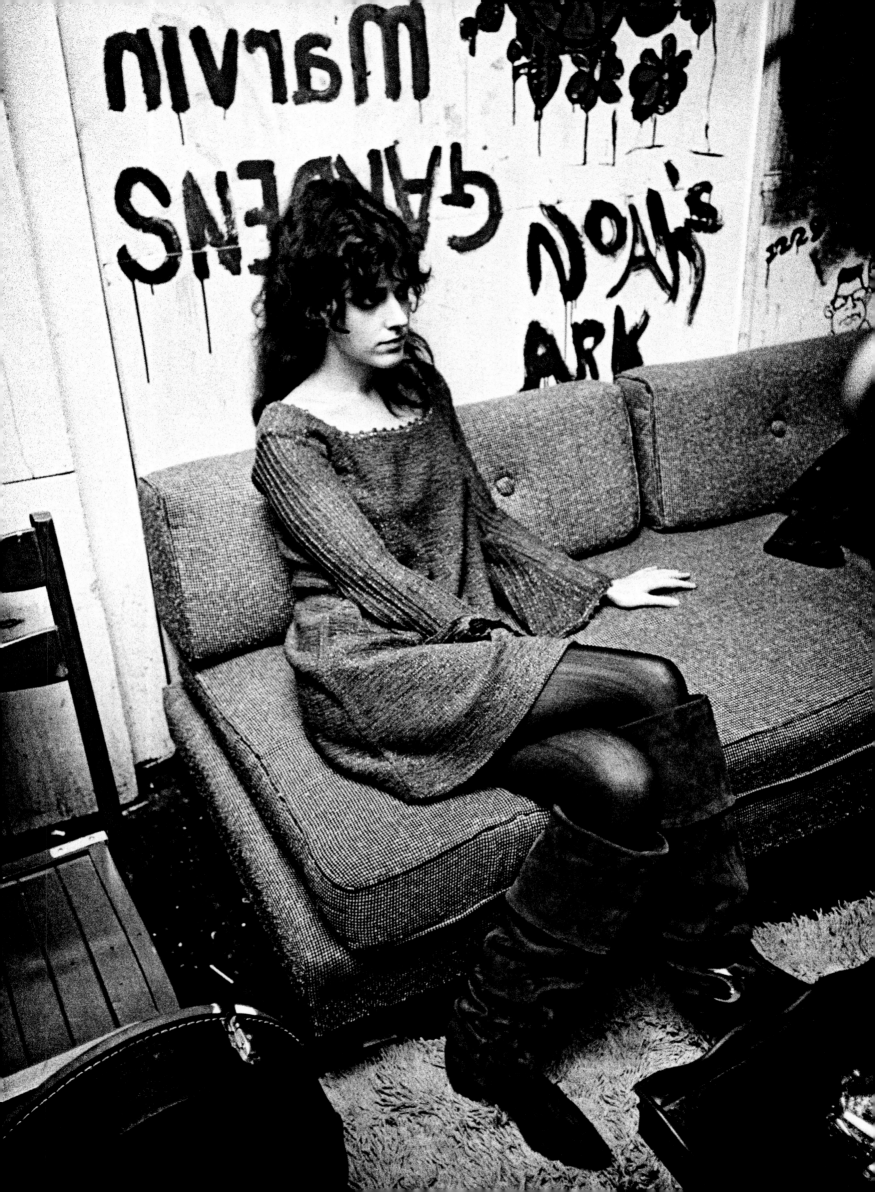

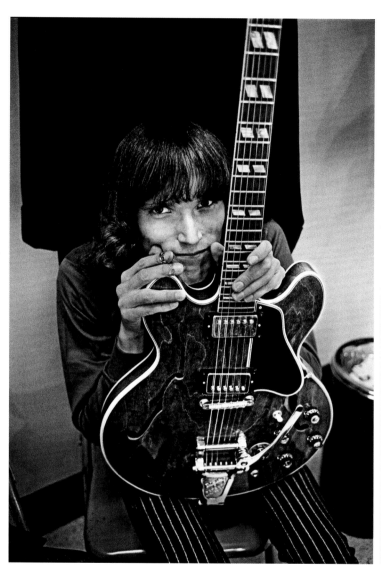

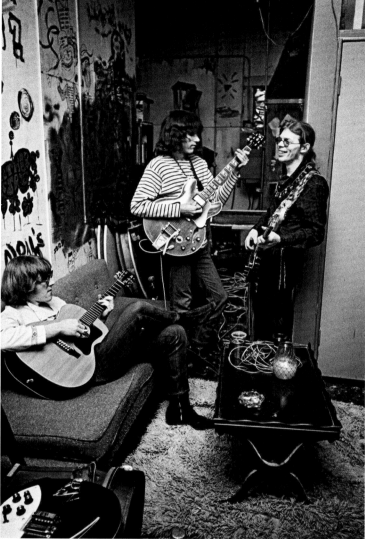

(THESE PAGES) *Jefferson Airplane backstage at the Matrix, 1968*

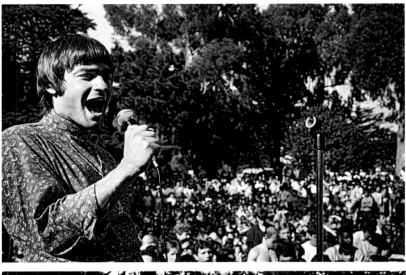

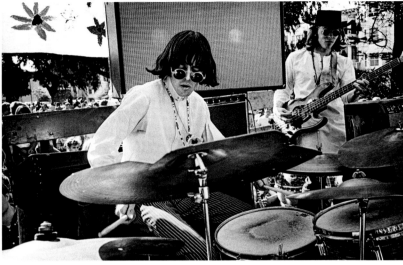

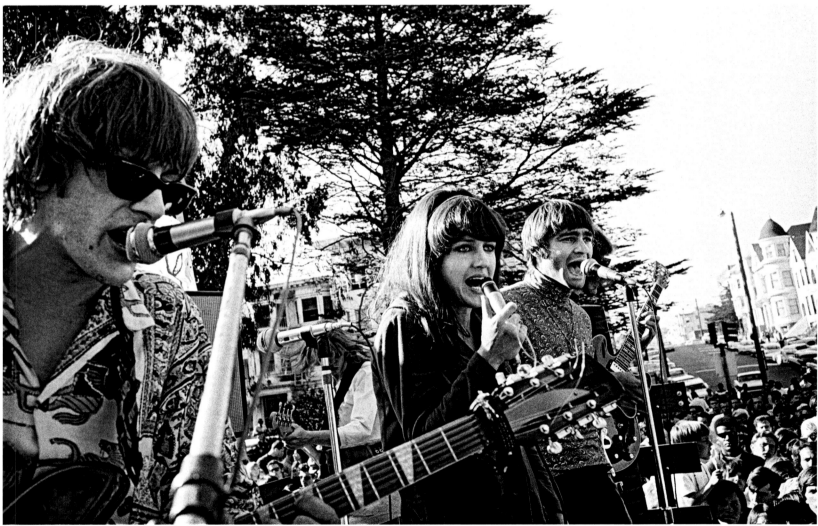

(TOP LEFT) *Marty Balin of Jefferson Airplane performing in the Panhandle, 1967;* (TOP RIGHT) *Drummer Spencer Dryden of Jefferson Airplane, 1967;* (ABOVE) *Paul Kantner, Grace Slick, and Marty Balin of Jefferson Airplane in the Panhandle, 1967;* (OPPOSITE) *Jefferson Airplane, 1967;* (FOLLOWING PAGES) *Jorma Kaukonen, Jerry Garcia, Jack Casady, and Pigpen onstage, 1967*

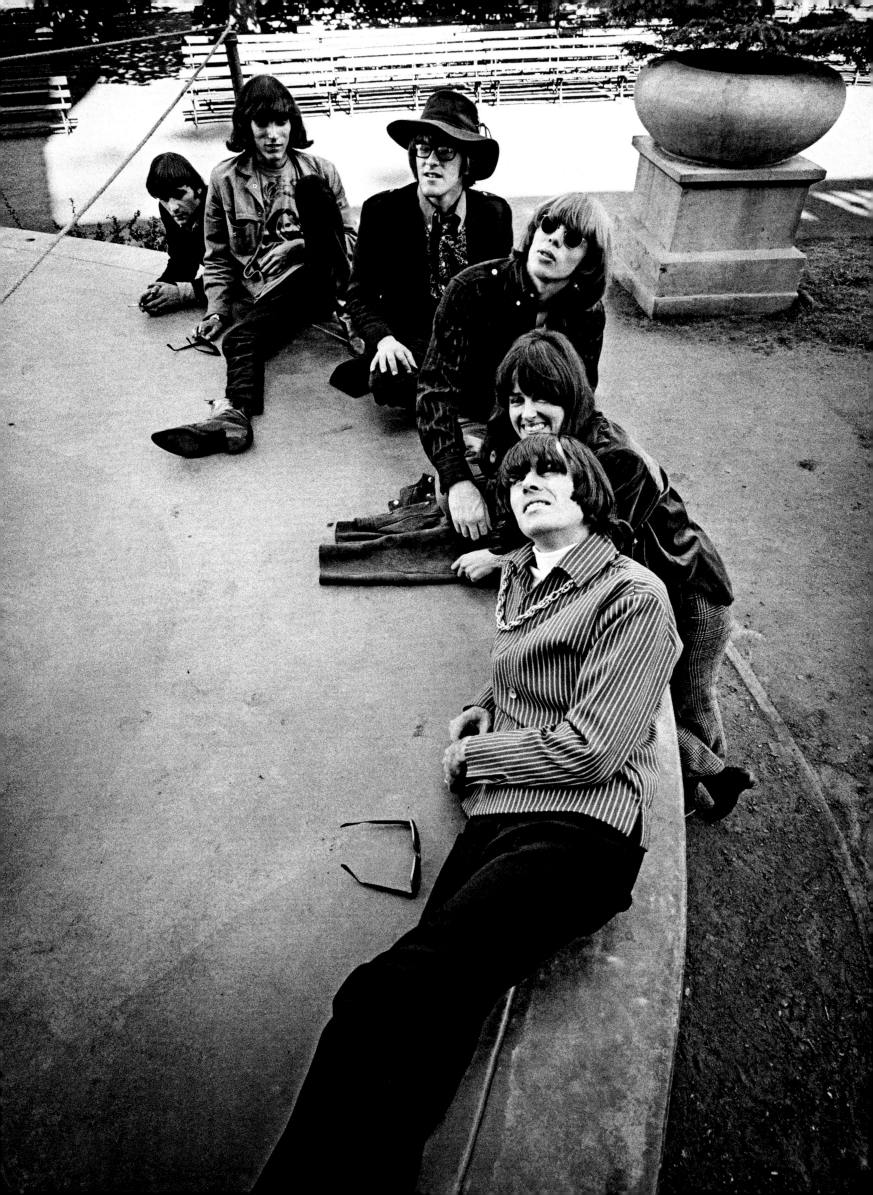

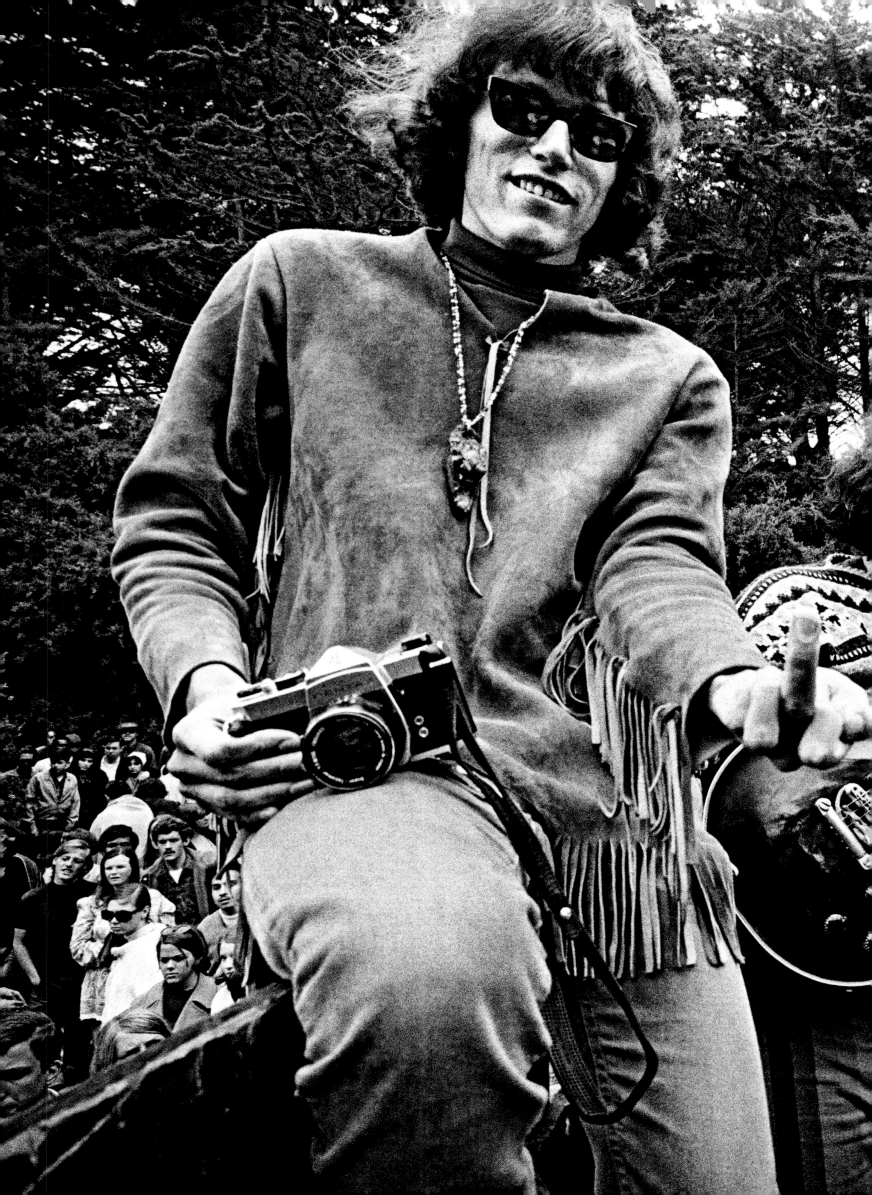

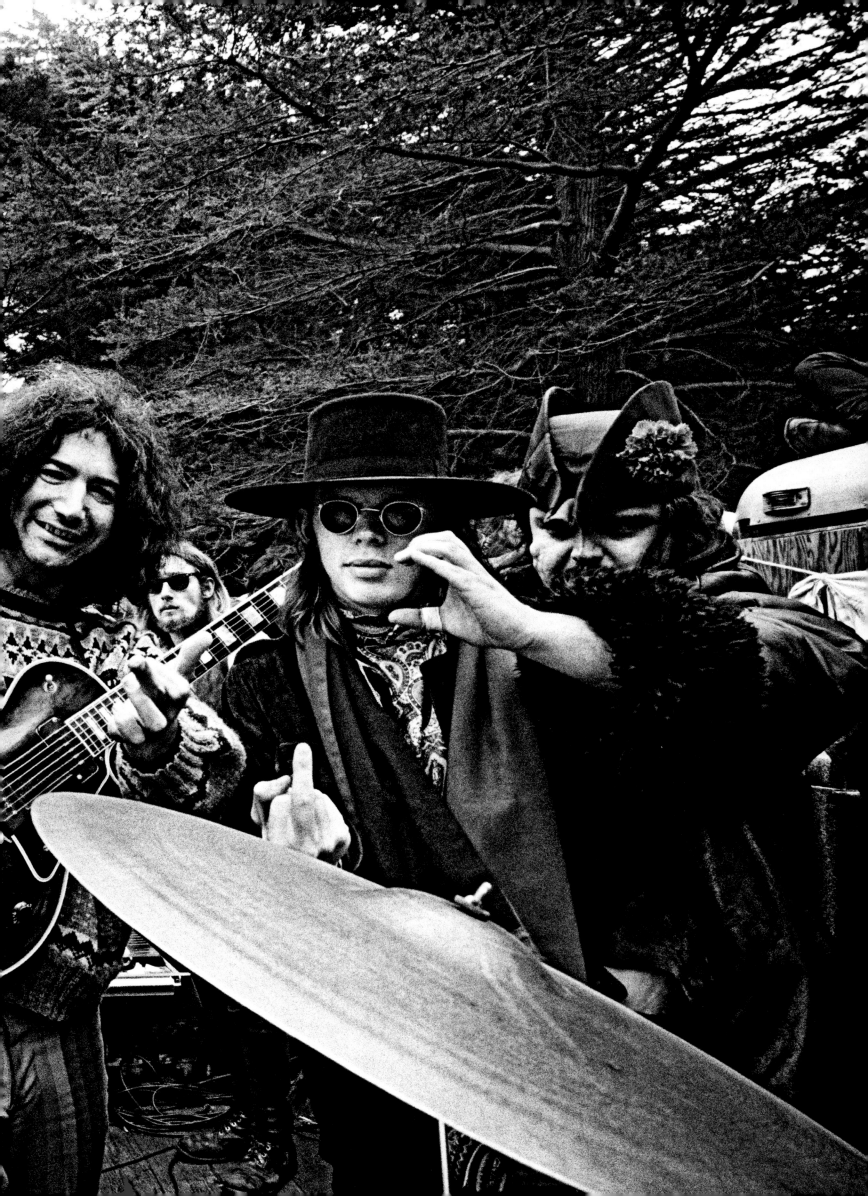

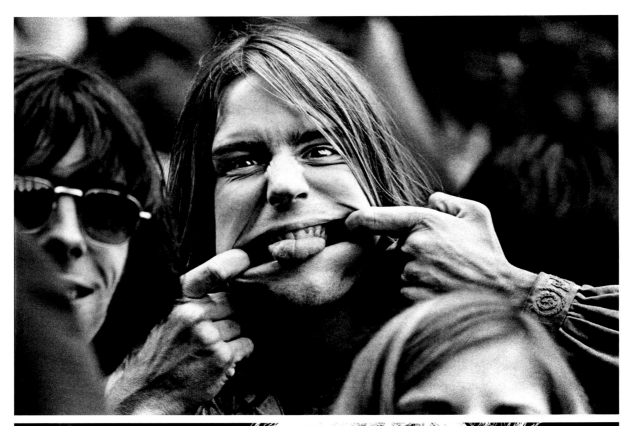

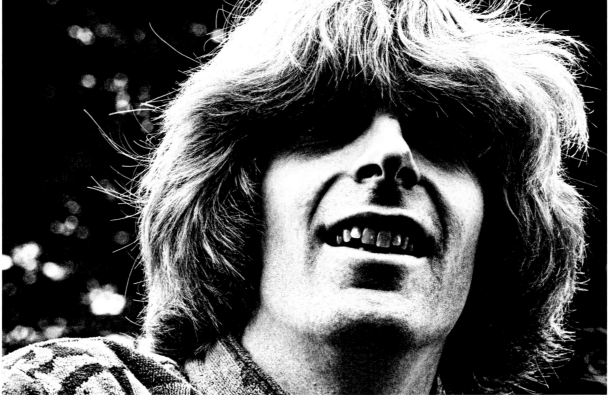

(TOP) *Bob Weir, 1967;* (ABOVE) *Phil Lesh, 1967;*
(OPPOSITE) *Jerry Garcia and "Mountain Girl," 1967*

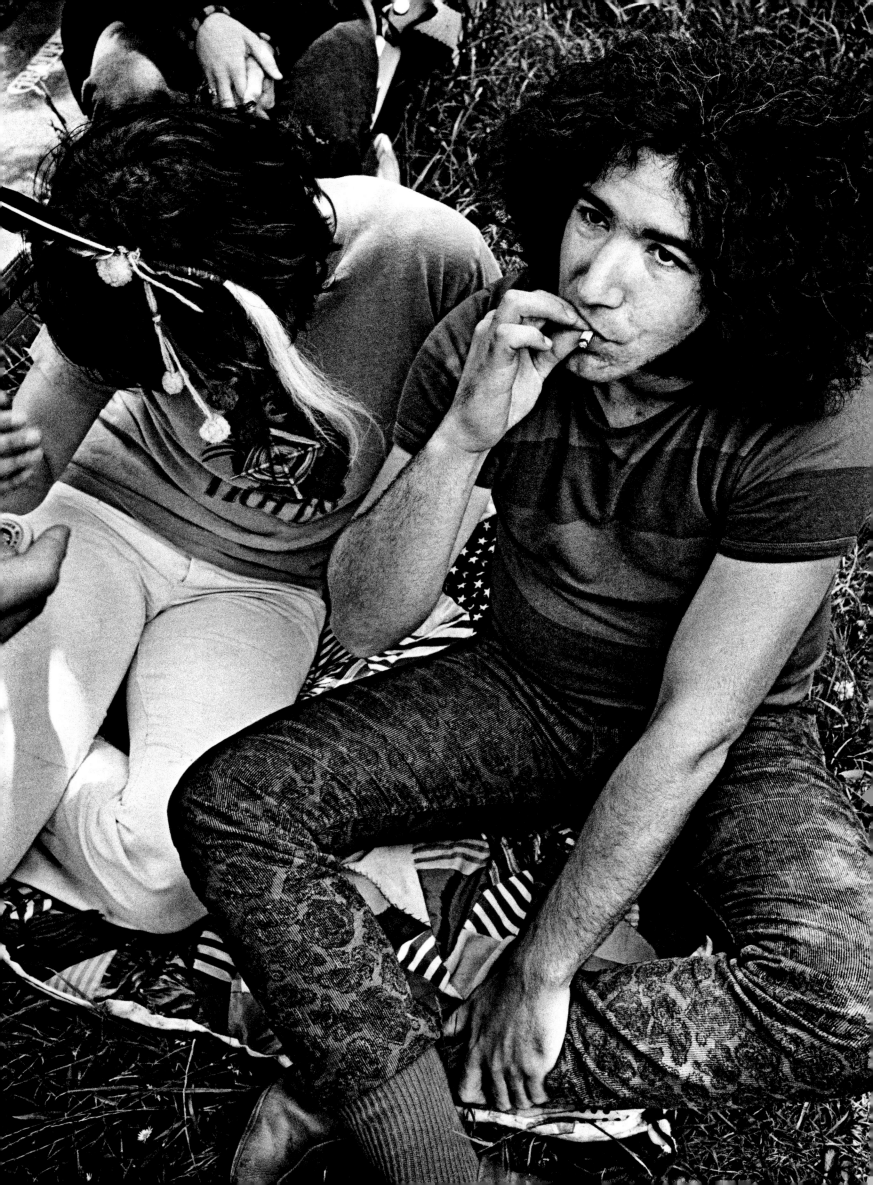

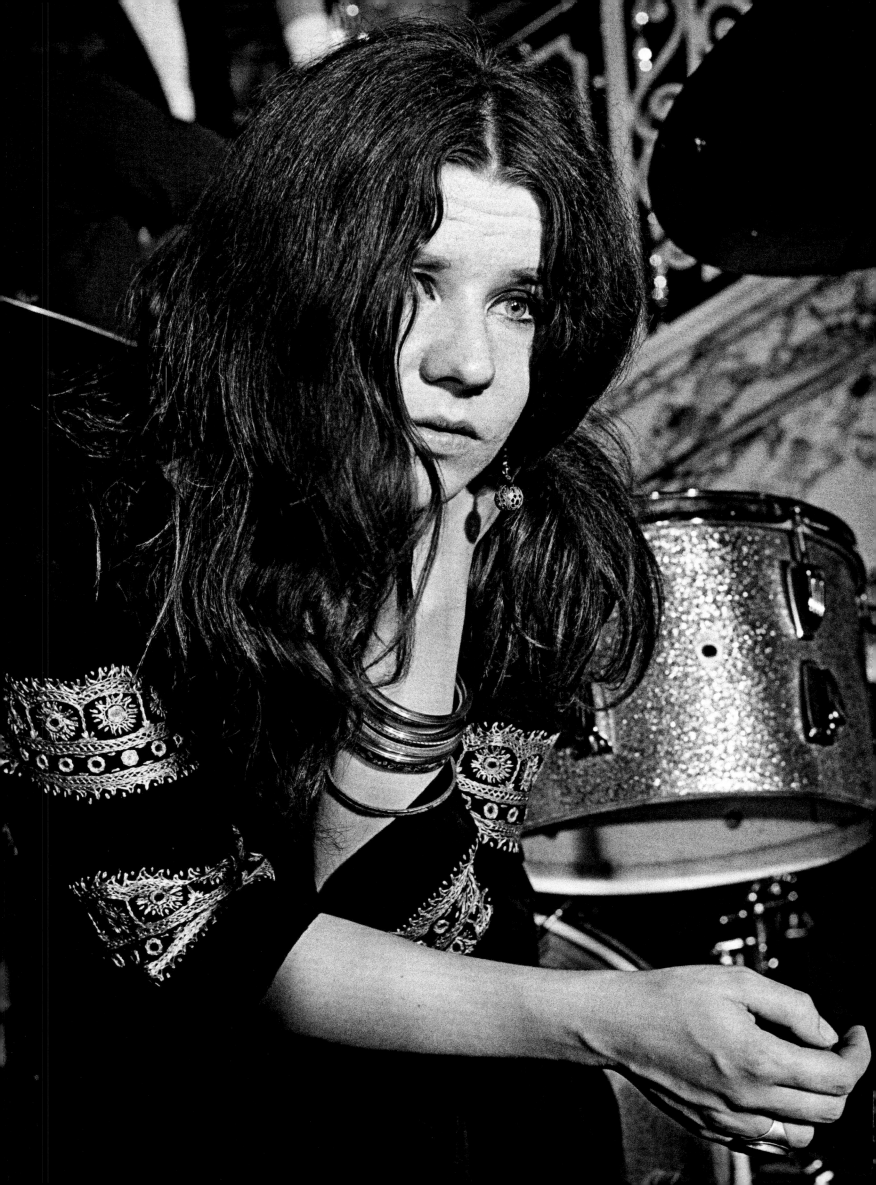

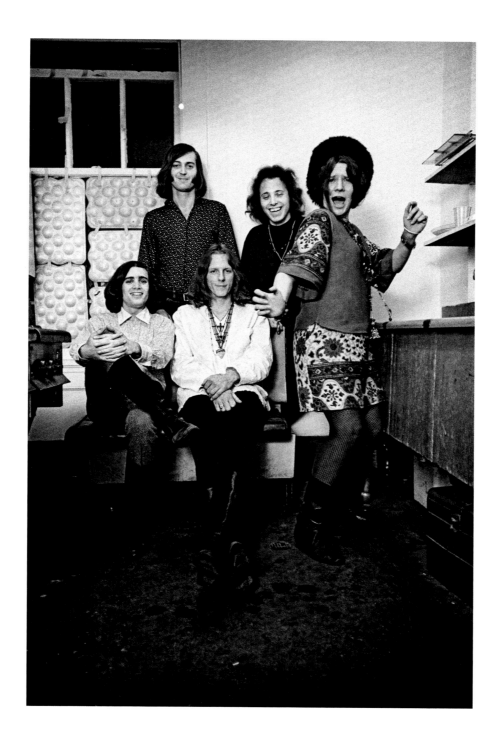

(OPPOSITE) *Janis Joplin filming* Petulia, *1967*; (ABOVE) *Big Brother and the Holding Company, 1967*; (FOLLOWING PAGES) *Janis Joplin performing a sound check at Winterland, 1968*

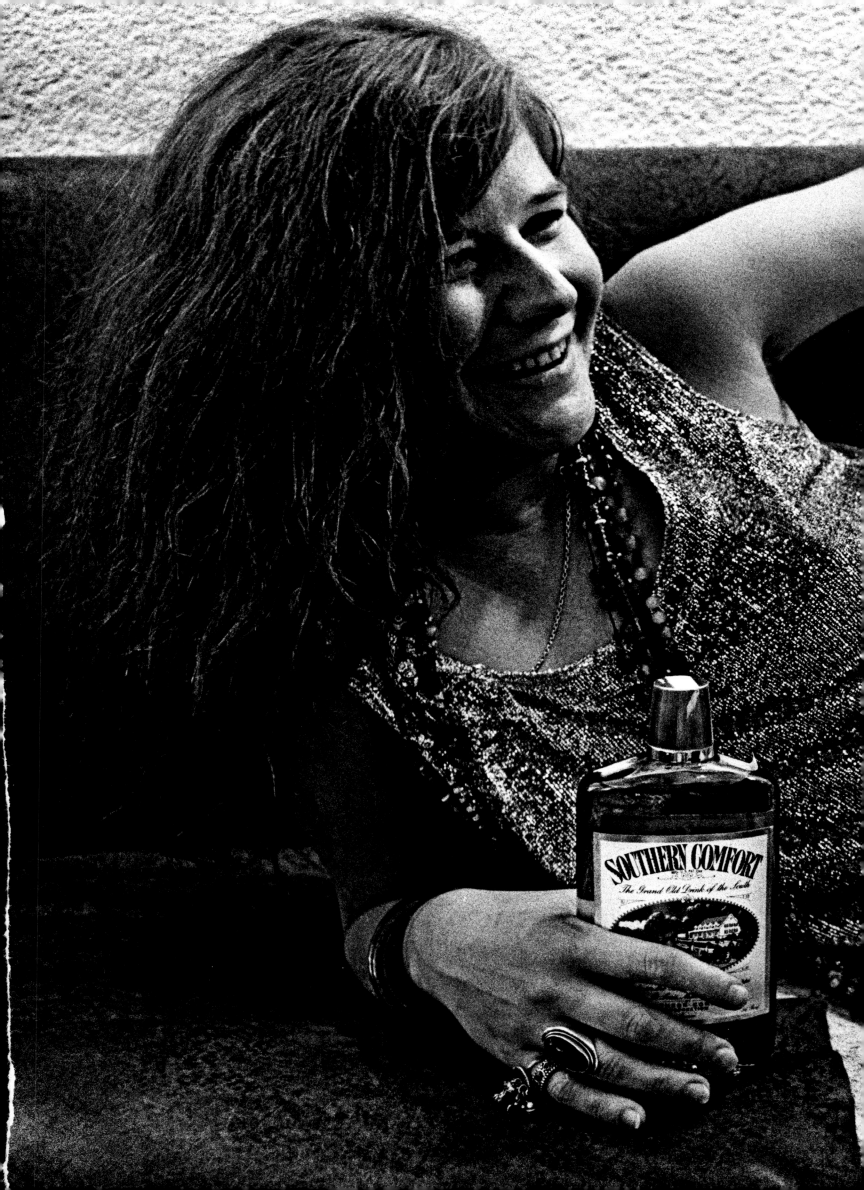

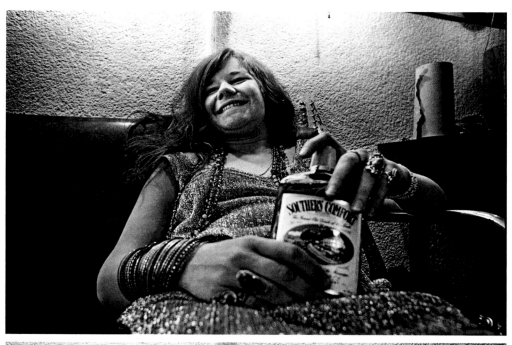

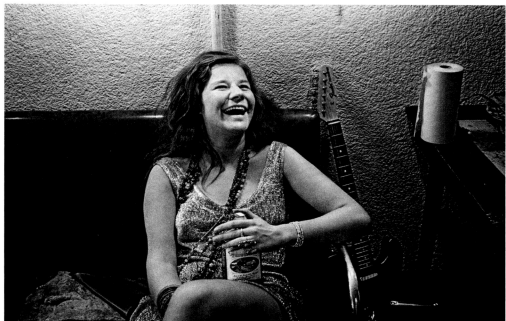

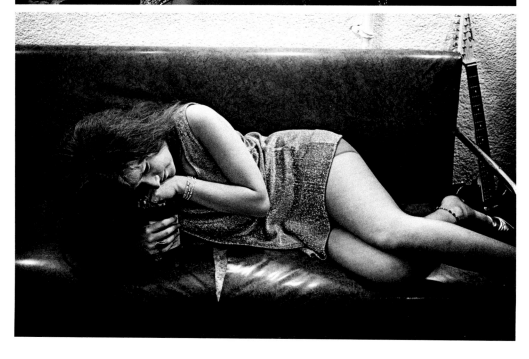

(THESE IMAGES) *Janis Joplin backstage at Winterland, 1968*

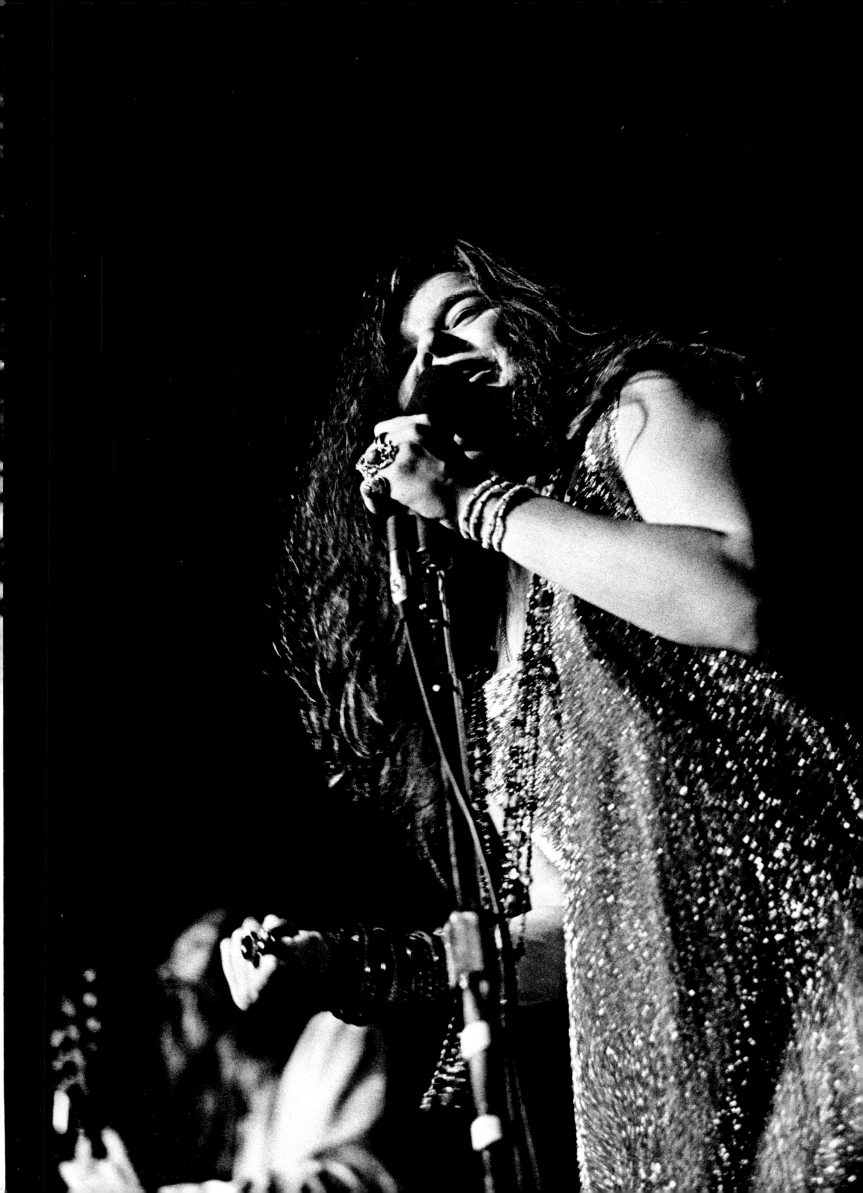

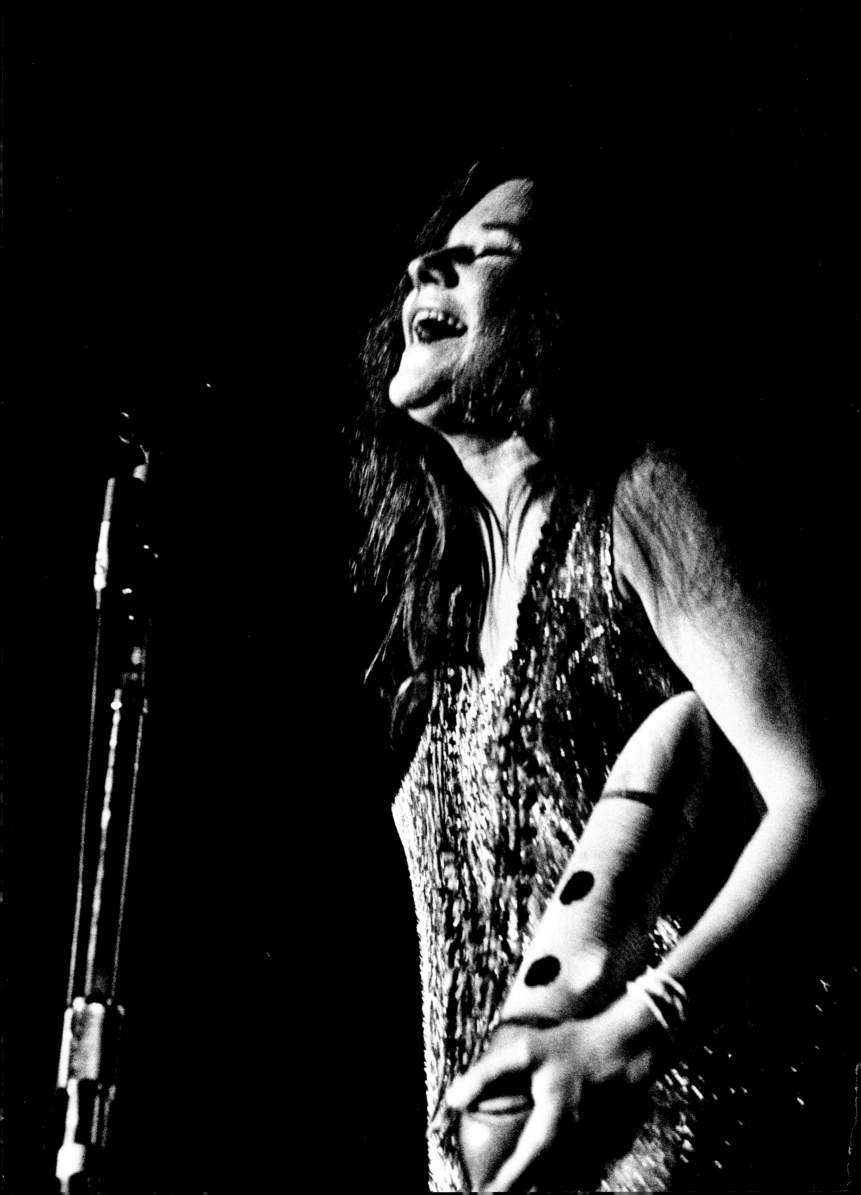

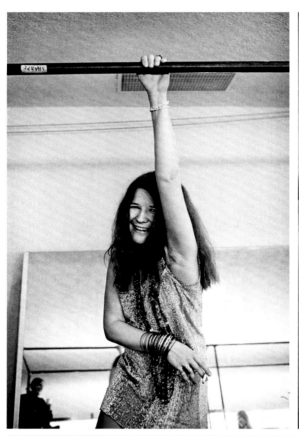
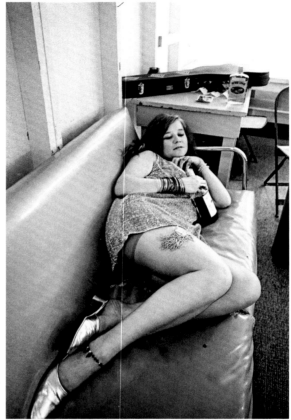
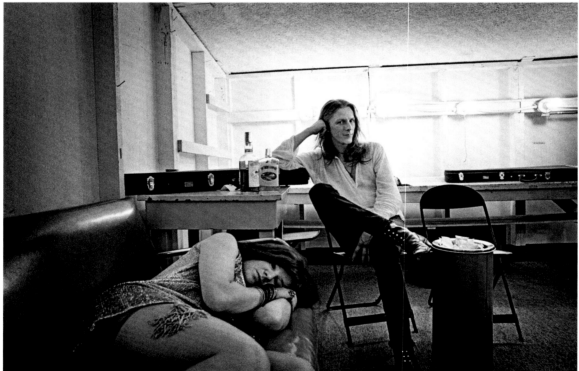

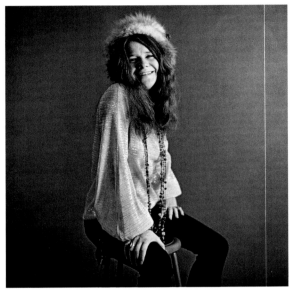

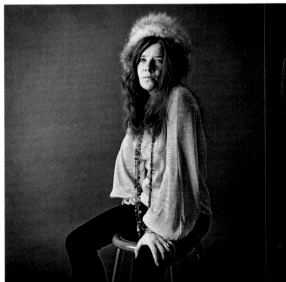

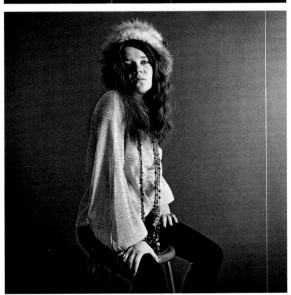

(ABOVE IMAGES) *Studio portraits of Janis Joplin, 1967. Images from this shoot* appeared in TeenSet *magazine.*

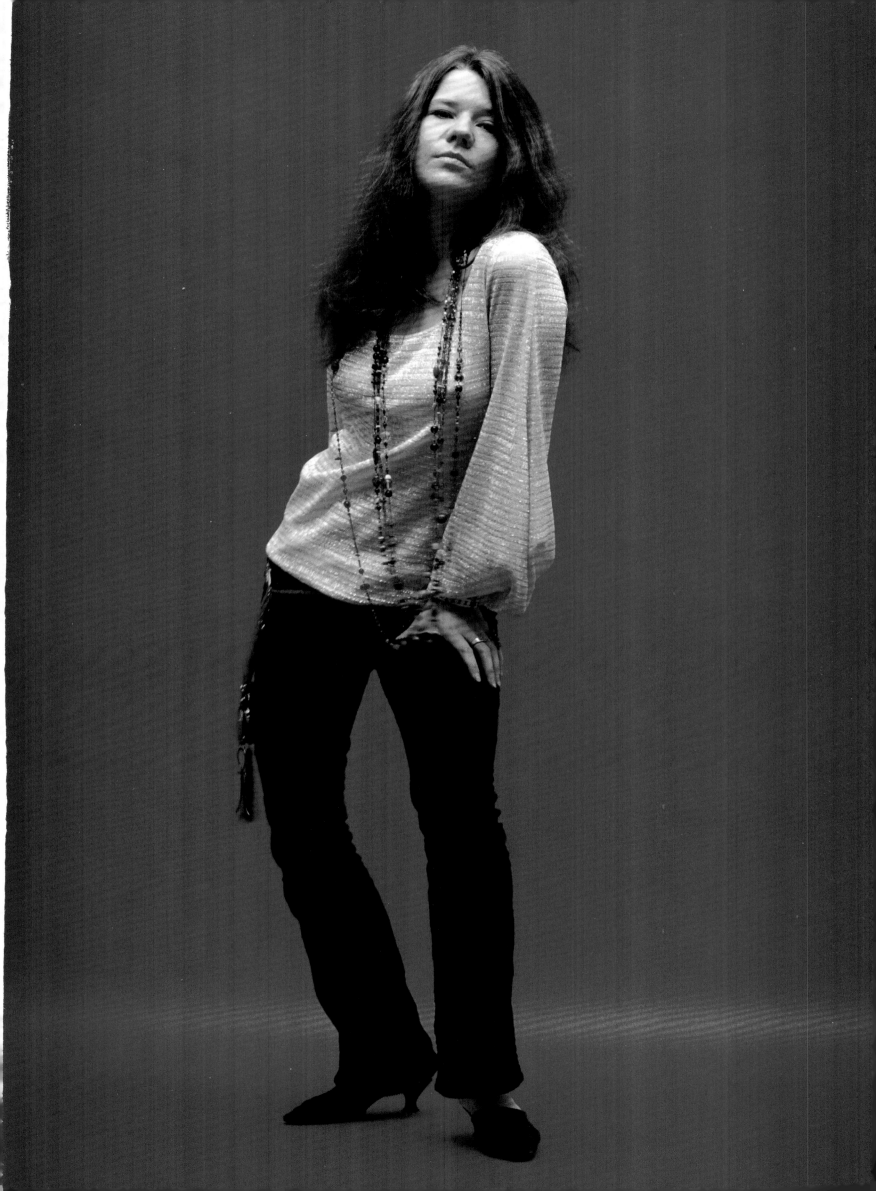

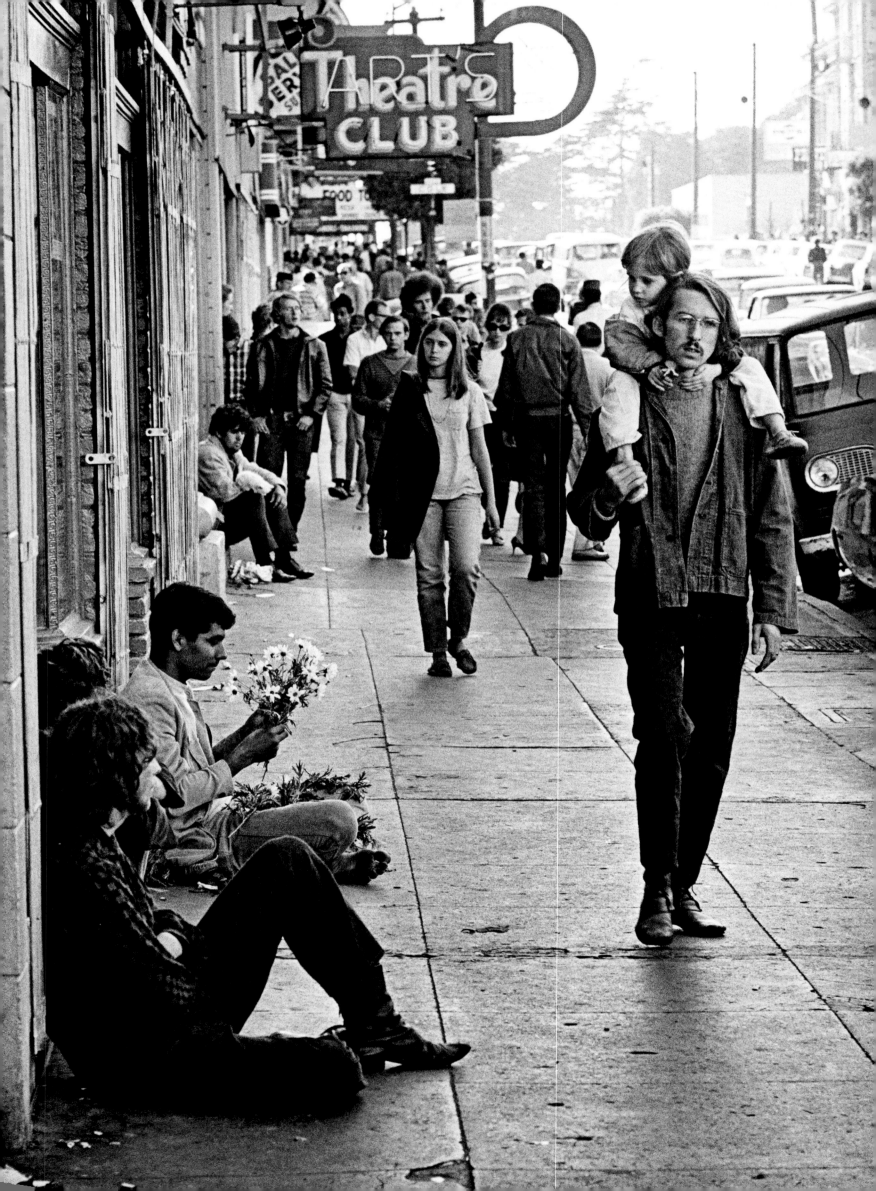

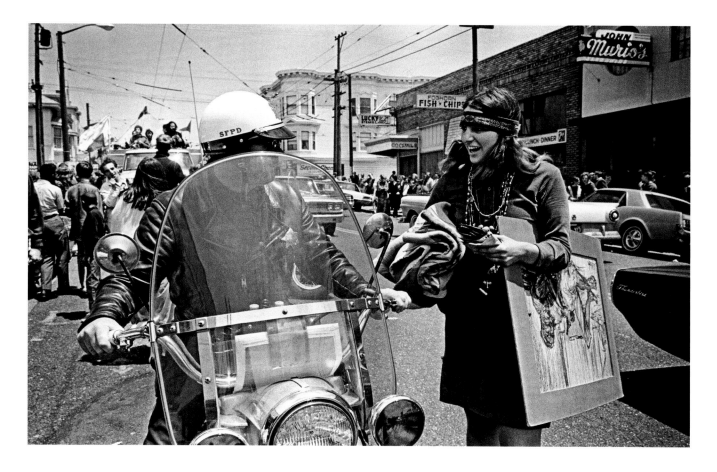

GIRDING FOR THE SUMMER OF LOVE THE HAIGHT HAD CHANGED SINCE BIG BROTHER

MOVED BACK FROM MARIN COUNTY THE PREVIOUS SUMMER. CROWDS FILLED THE STREETS. RUNAWAYS mingled with dealers. Everybody was dressed as something. All the clowns wore costumes. Hell's Angels roamed the streets. Tourists caused traffic jams as they rubbernecked their way down Haight Street, taking photos of the hippies from their car windows. When the Gray Line tourist buses started routing their tours down Haight Street, the hippies ran alongside the bus holding mirrors up to the gawking tourists. More youths from around the country flooded the scene every day. There was talk that one hundred thousand people would be headed for the Haight in the summer when school was out.

The hippies had struck a nerve in the national breast. Not only were some people outraged by the outlandish behavior and what they assumed was moral degeneracy, but other, less close-minded people warmed to the message of love. Some people instinctively gravitated toward the gentle appeal of these fresh young people, their music, their new values and peaceful ways. And their drugs. Fashion designers and graphic artists began to adopt the bright colors and psychedelic designs directly inspired by the LSD experience. What started out as second-hand clothing bought on the cheap to be worn festively had been transformed into fashion in New York and London.

The onslaught began in April. The community tried to take action. The Council on the Summer of Love featured representatives from the Diggers, Family Dog, the *Oracle*, and elsewhere. A job co-op was formed. A switchboard was established. Dr. David Smith, who lived in the area during his residency and watched with amusement and compassion the changing nature of his neighborhood, established the San Francisco Free Clinic to provide free health services for the sprawling new community.

There was also a stronger police presence on the street, and cops were routinely making busts. Eight teams of city health inspectors swept the Haight and issued five-day warning citations to thirty-nine buildings. Only sixteen were hippie pads, but the Digger house at 848 Clayton Street was cited for fifteen violations.

The Diggers delighted in sudden, spontaneous street closures. They would pull STREET CLOSED signs out of their headquarters, raise a crowd, and stop traffic. More often than not, the police looked the other way.

One afternoon, after the police halted an impromptu performance by a rock band at the corner of Haight and Ashbury, the Dead were hastily summoned to set up and play in the Panhandle as Diggers swept the street with a bullhorn redirecting the crowd down the street, and the Dead played for the rest of the day.

(OPPOSITE) A child observes hippies on the street, 1967; (ABOVE) A police officer and a hippie woman interact, 1967; (RIGHT) Healthcare is administered at the Haight-Ashbury Free Clinic, 1967; (FOLLOWING PAGES) Hippies and tourists meditate in the park, 1967

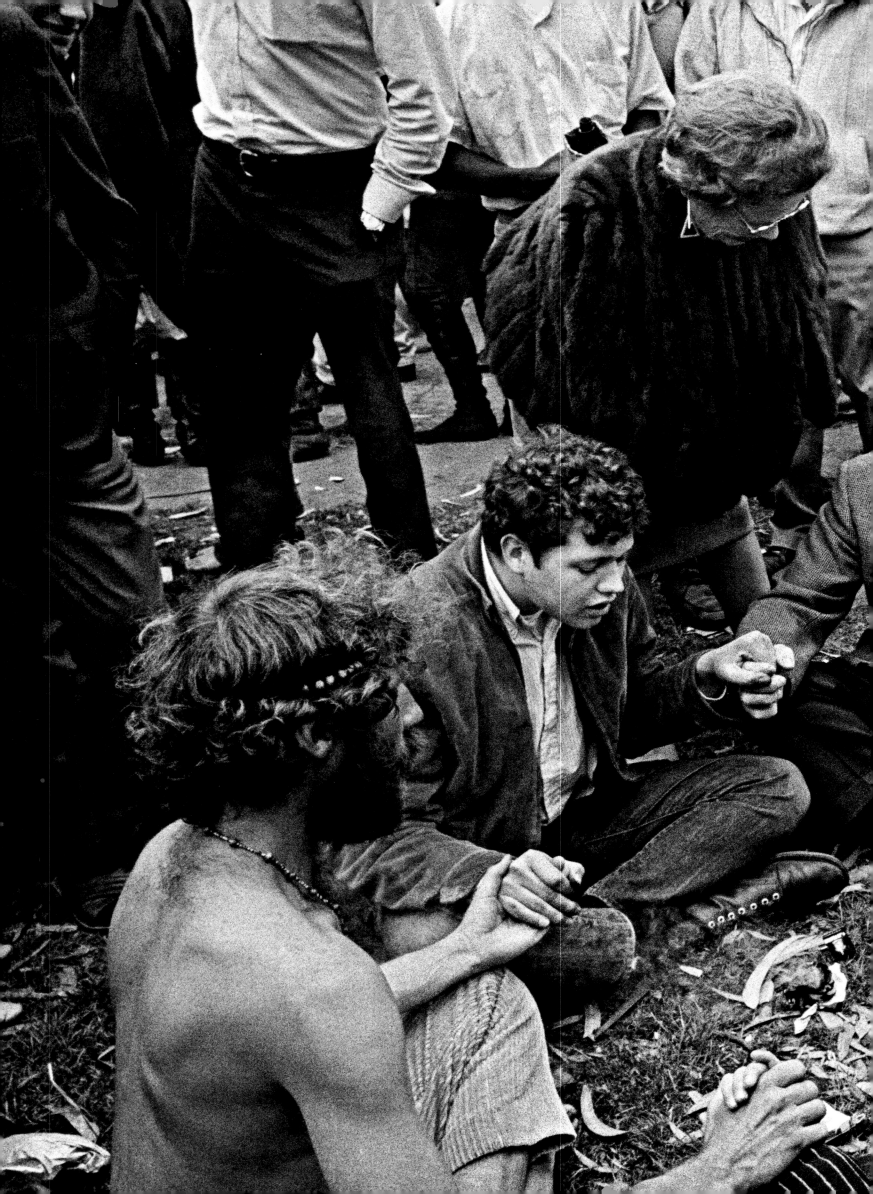

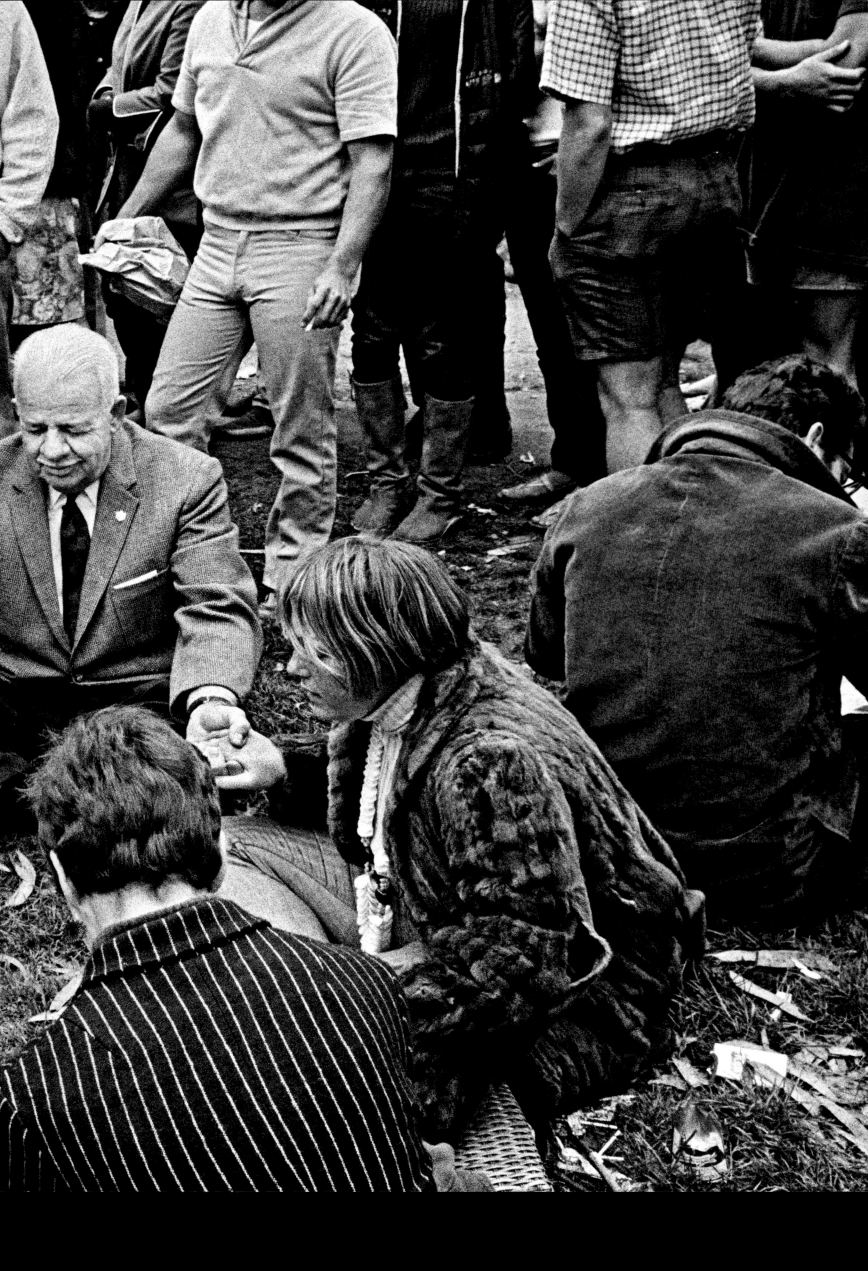

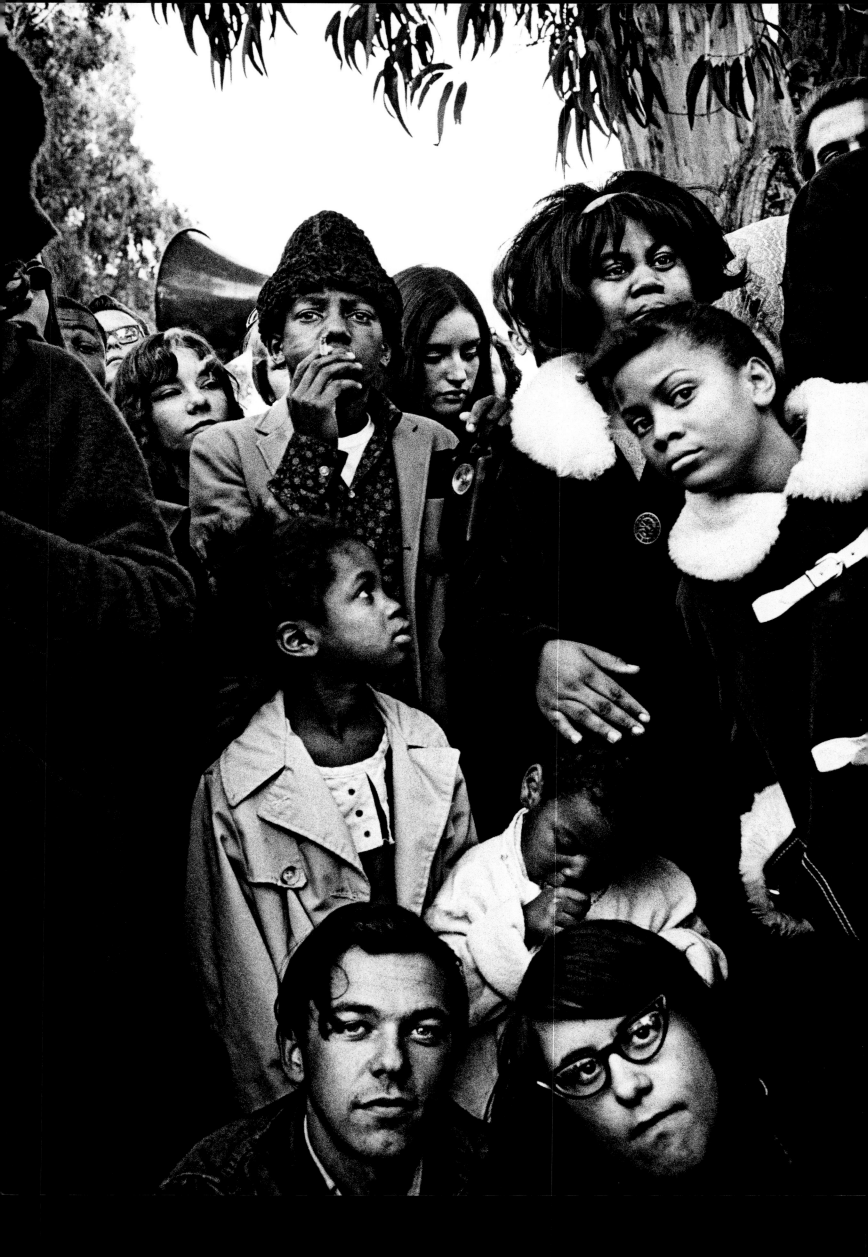

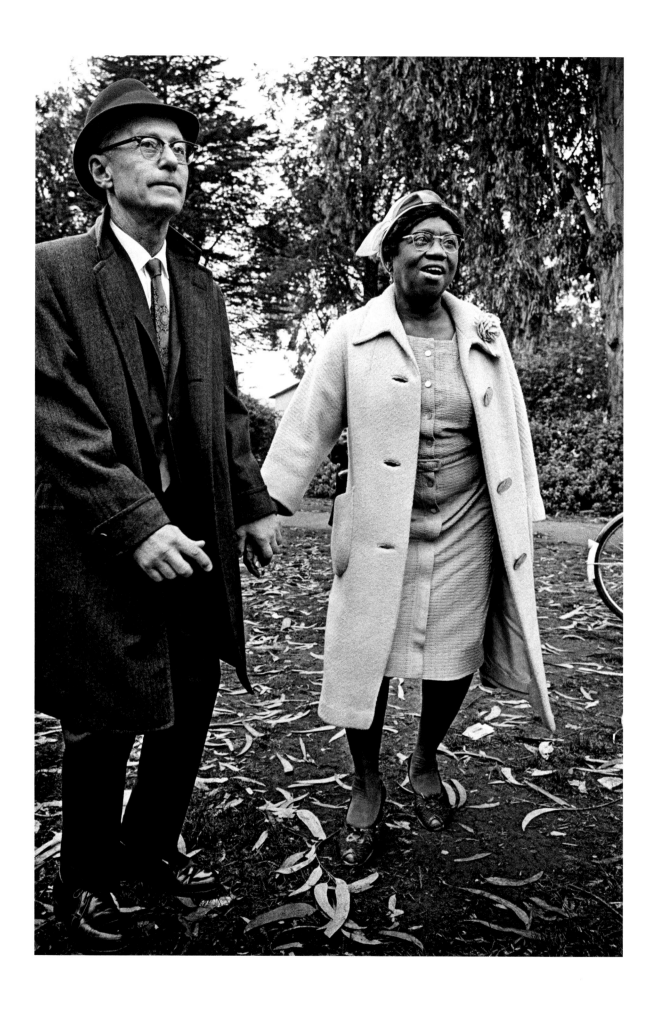

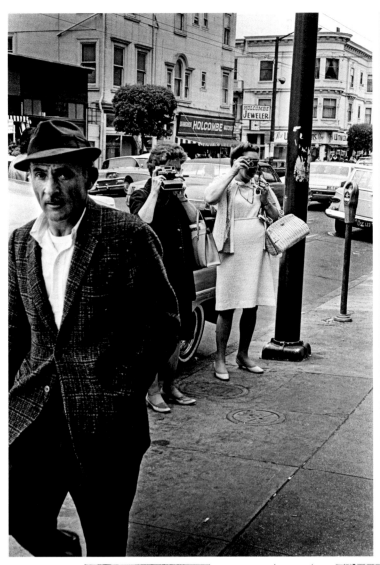

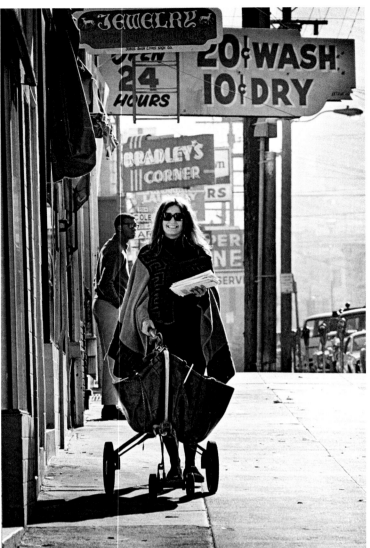

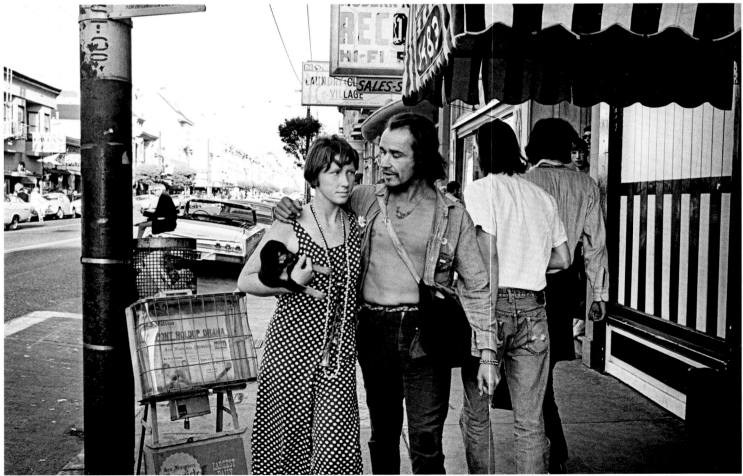

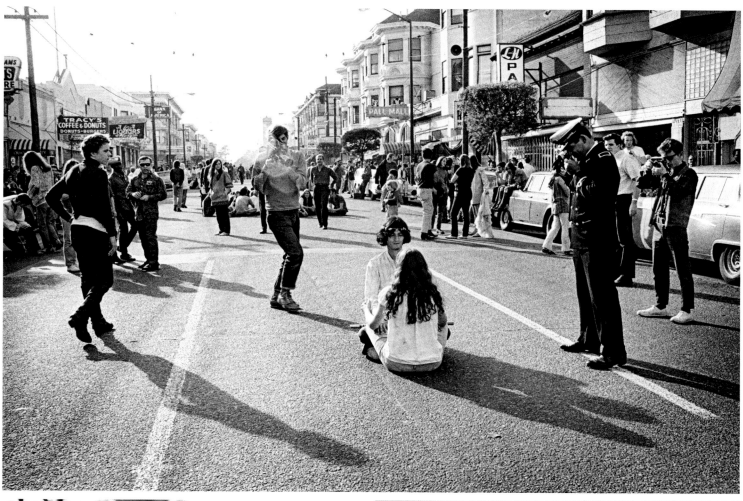

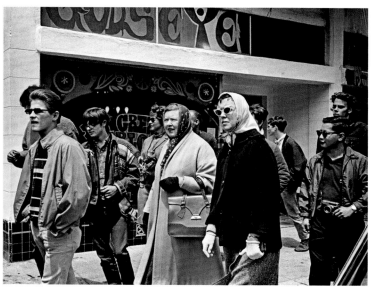

(PRECEDING PAGES AND THESE IMAGES) *Various scenes of protests, tourism, love, and diversity in the Haight, 1967–1968;* (OPPOSITE RIGHT) *A hippie postal worker delivers mail. In San Francisco in particular, the U.S. Postal Service clashed with employees who pushed back against the uniform.* (FOLLOWING PAGES) *A man and woman observe a war protest in Oakland, 1965*

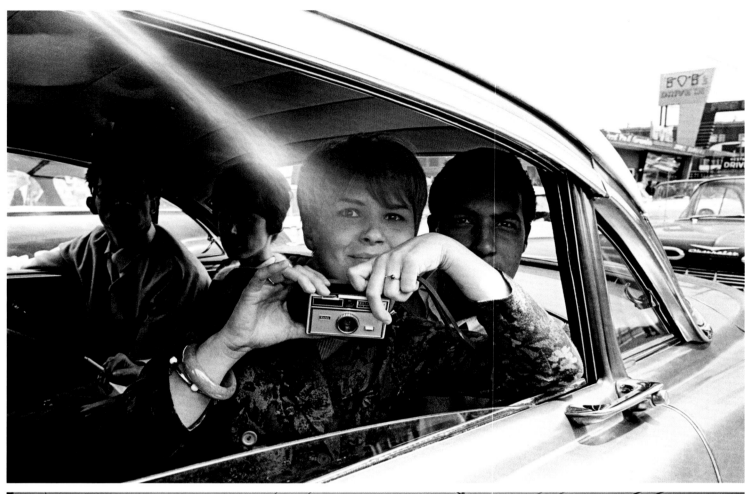

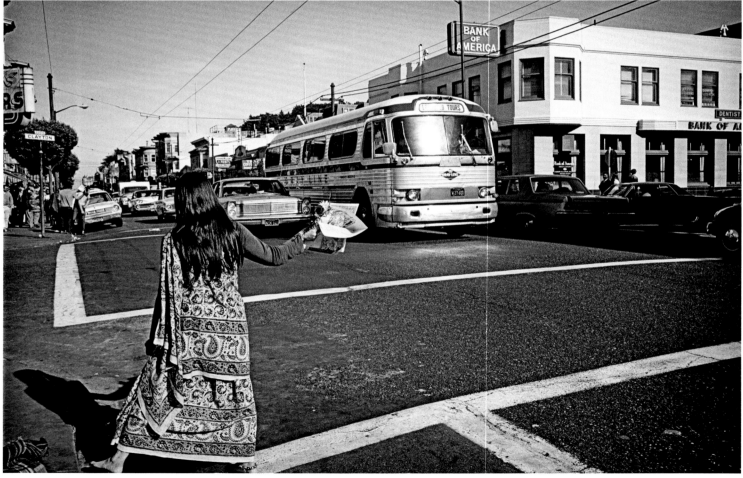

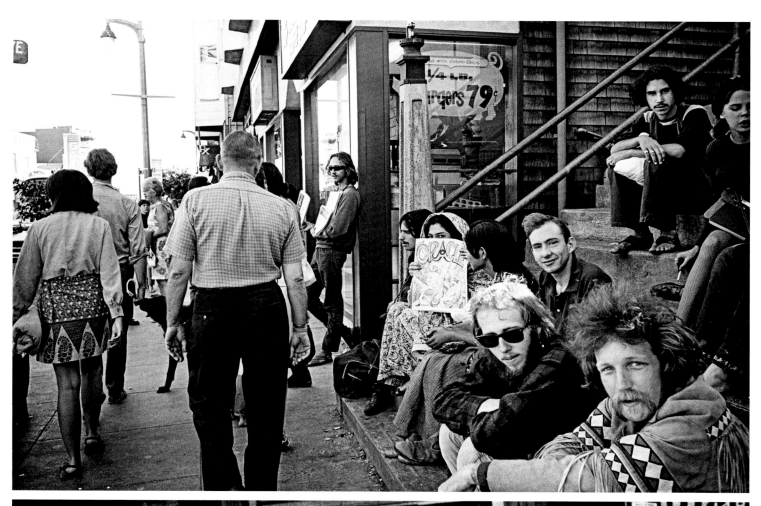

(THESE AND FOLLOWING PAGES) *Tourists observe the Haight from their cars, 1967;* (OPPOSITE BOTTOM) *A woman distributes the underground newspaper the San Francisco Oracle as a tour bus drives by, 1967*

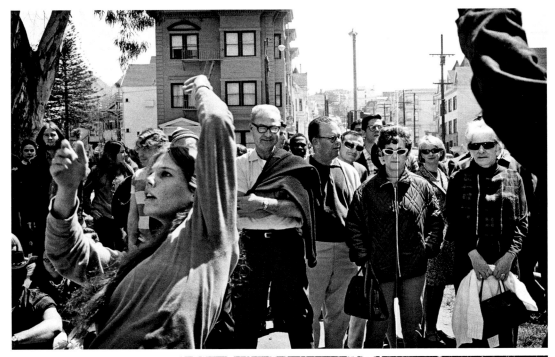

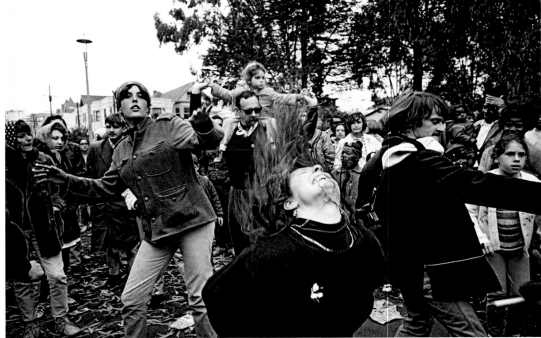

(THESE PAGES) Curious onlookers and tourists observe dancers in the Panhandle, 1967.

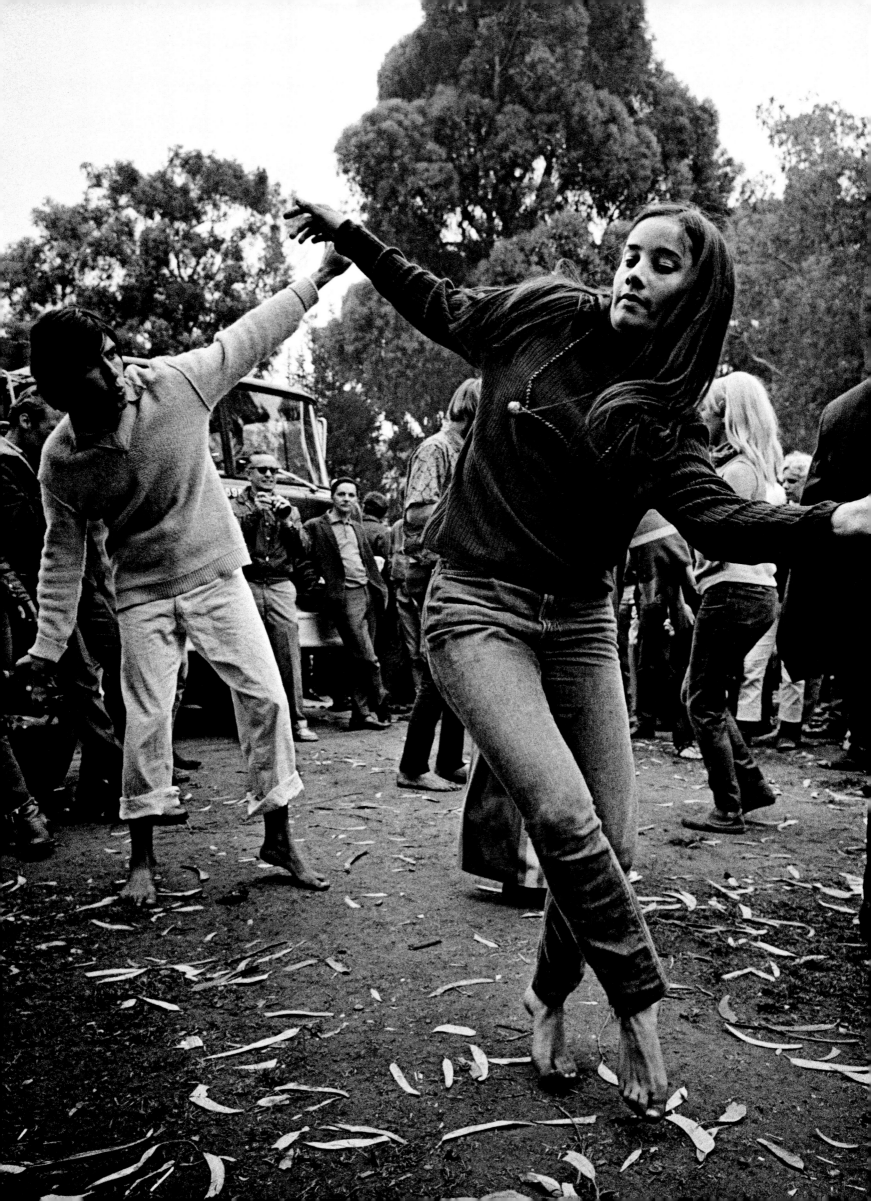

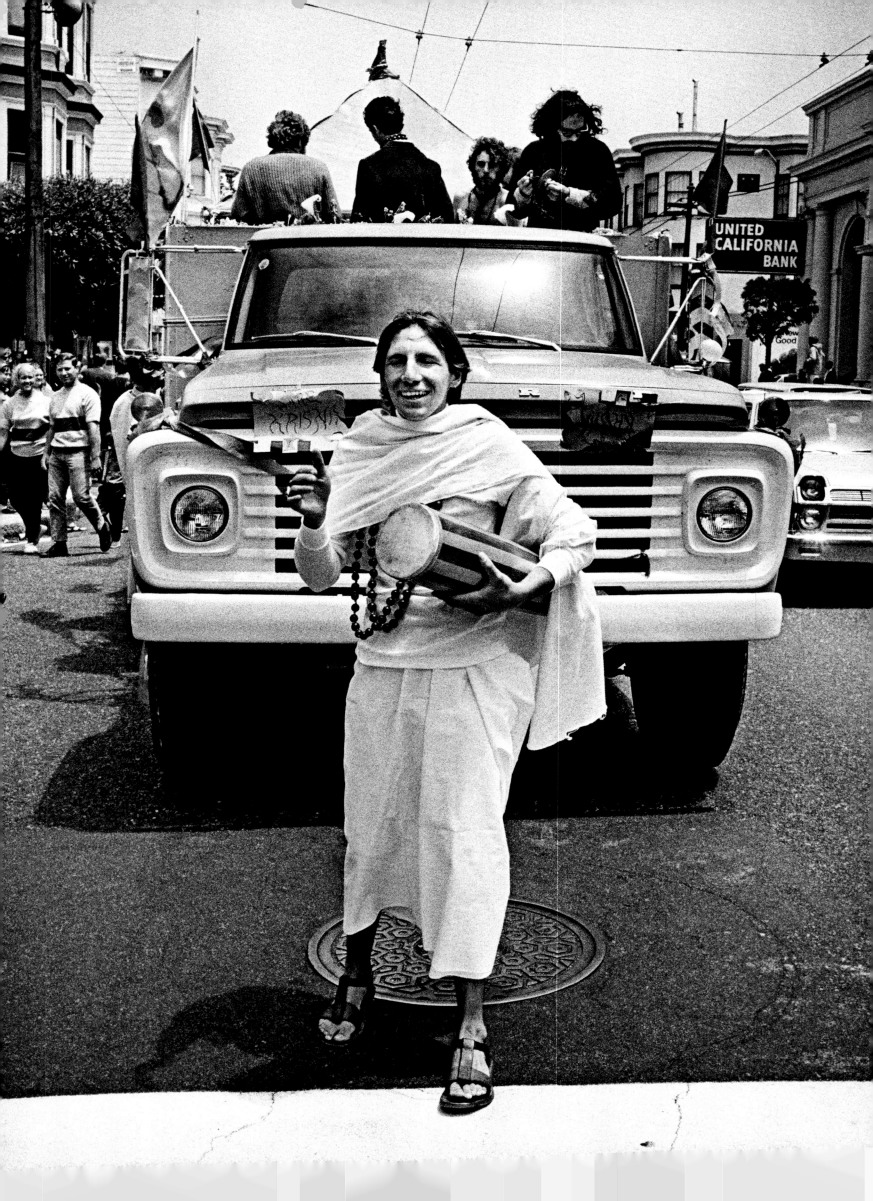

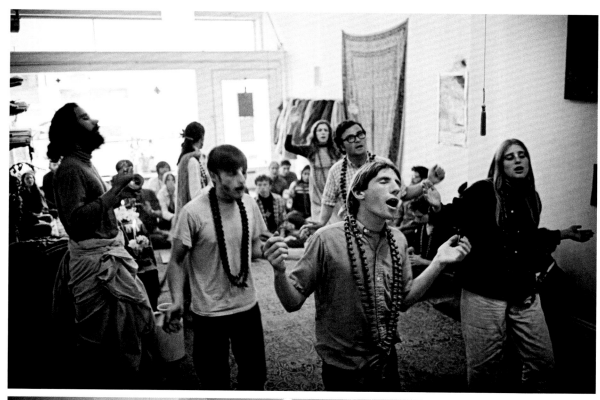

(OPPOSITE) *Subal Das (Steve Bohlert) leads the deities' float down the street during the Rathayatra Festival—the first outside of India—organized by the International Society for Krishna Consciousness (ISKCON), 1967;* (THIS PAGE) *Krishna devotees having kirtan (congregational chanting) at the ISKCON temple at 518 Frederick Street, 1967. The deities visible in the background are (left to right) Lord Balarama, Lady Subhadra, and Lord Jagannath (Krishna). Following an ancient Indian tradition, these Jagannath deities are taken to the beach in elaborate procession once a year.*

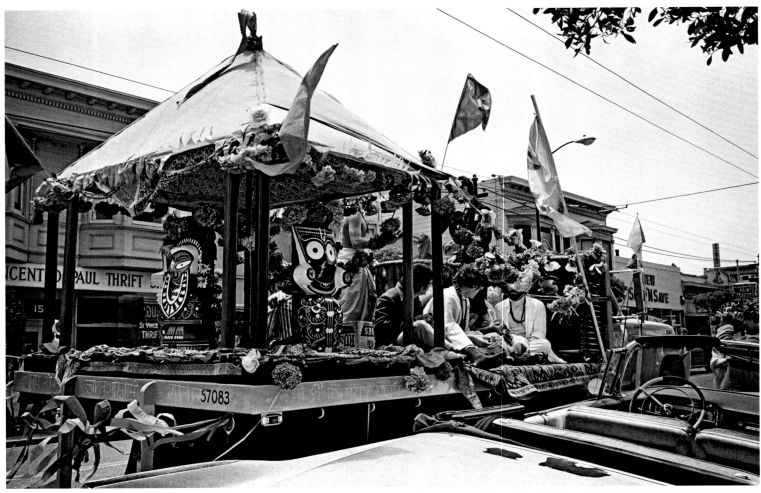

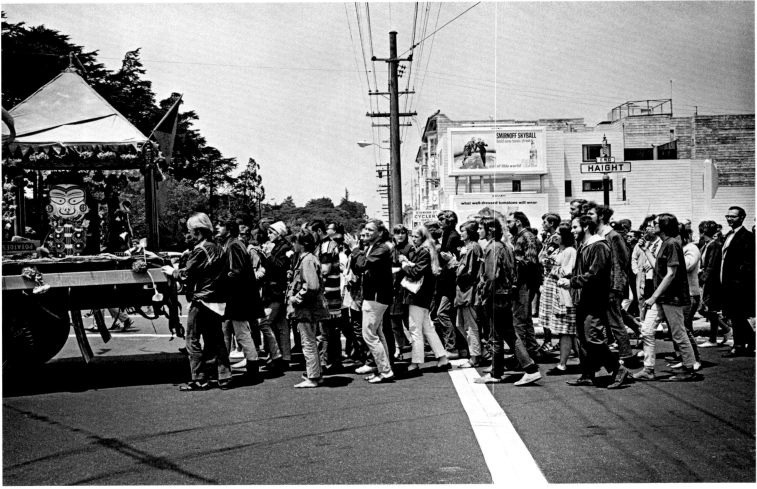

(THESE PAGES, CLOCKWISE FROM TOP LEFT) *The Rathayatra float; Chandrabali (left) and Yamuna (right) hand out prasad; Krishna devotees having kirtan on the Rathayatra float; the Rathayatra float and procession take a left at Haight and Stanyan en route to Ocean Beach with the statues of Lady Subhadra and Lord Jagannath.*

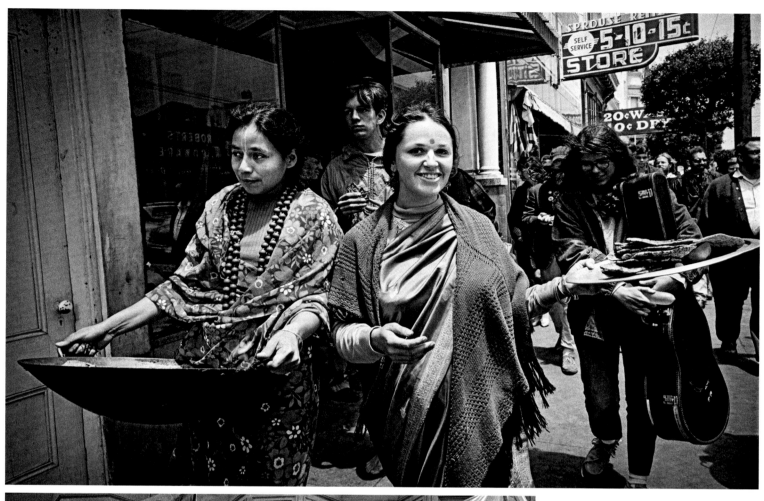

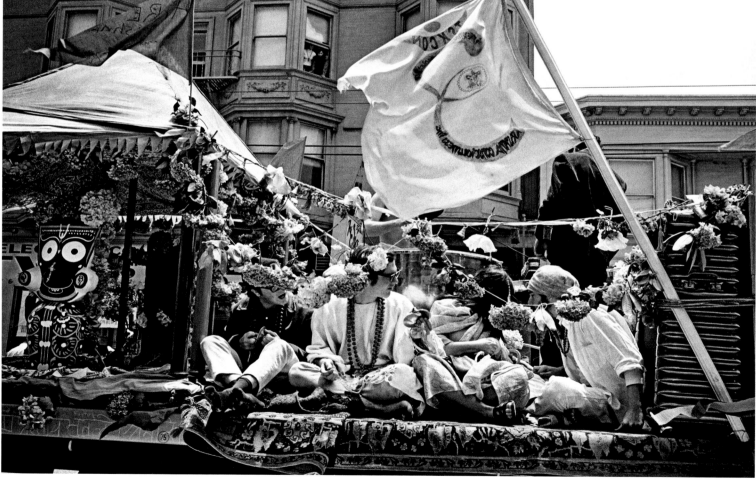

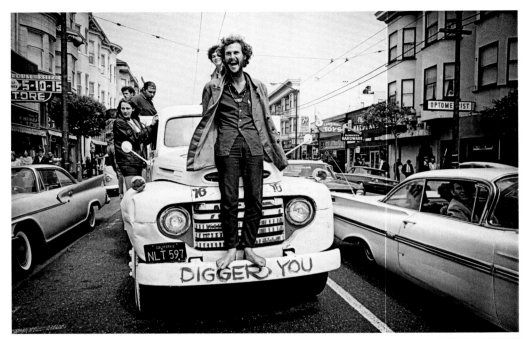

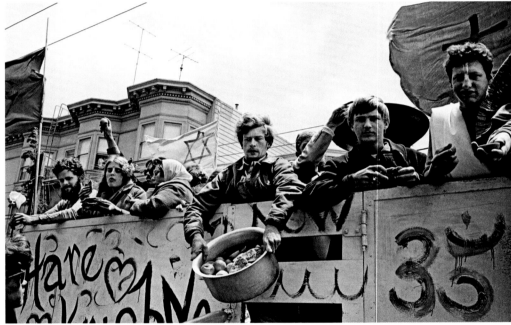

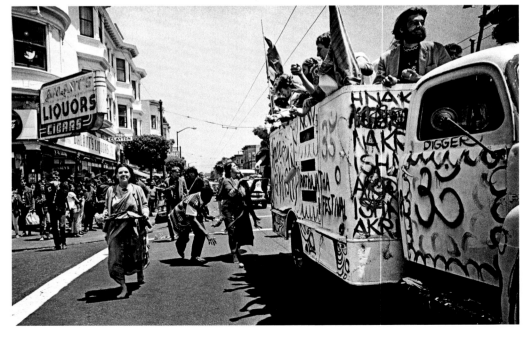

(THIS PAGE) *Devotees and well-wishers enjoying kirtan on the Diggers' truck, which followed the Rathayatra float, distributing prasad and good cheer, 1967;* (OPPOSITE) *Grateful Dead performing in Golden Gate Park, 1967*

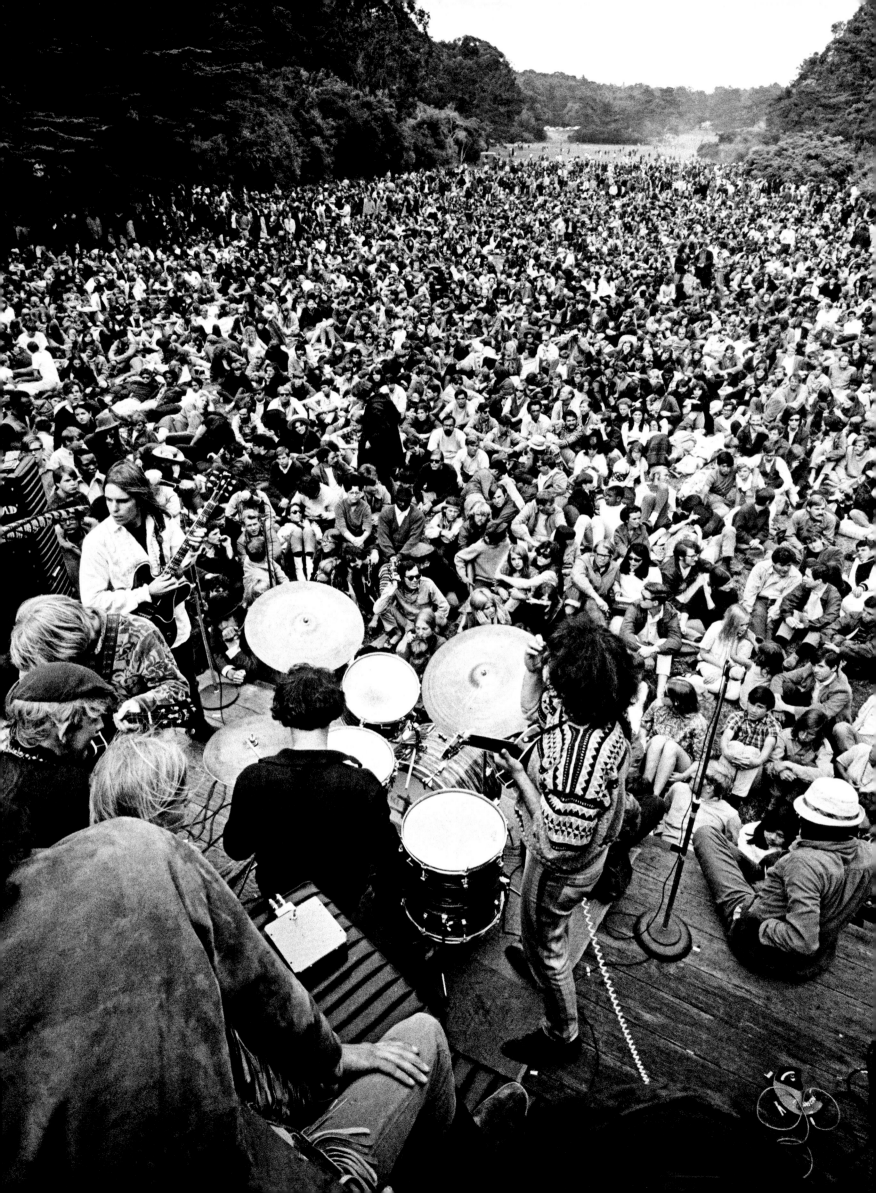

NEW ROCK RISING QUICKSILVER MESSENGER SERVICE MOVED TO AN ABANDONED DAIRY FARM IN THE OUTER REACHES OF MARIN, WHERE JOHN CIPOLLINA KEPT A WOLF AS A PET, BUT WERE STILL VERY much a part of the Haight scene, a fixture on the dance hall bills and concerts in the park, hip enough to dedicate the band's cover of the Del Shannon oldie, "Runaway," "to all our friends in the Haight-Ashbury." The band's repertoire mixed blues covers such as "Smokestack Lightning," extended Bo Diddley romps taking off from "Mona," and folk-flavored lyrical pieces such as "Dino's Song," written by Dino Valenti, by now out of jail and pursuing his own solo career. The band affected a kind of psychedelic cowboy look. Guitarist Duncan sometimes even wore a hunting knife on his belt.

The San Francisco rock scene was on fire. The Charlatans, the crazy Edwardian dandies who headlined A Tribute to Dr. Strange and started it all off, were still around, still living in the Haight. They were a luckless crew, headed by non-musician George Hunter, an architecture student who built his rock band like he did architectural models—made sure they first fit the specifications. The Charlatans had a practiced vintage look that combined turn-of-the-century men's wear with a Wild West look. Keyboardist Mike Ferguson ran one of the Haight's first head shops, which he also stocked with gorgeous Victorian knick-knacks (and other, less legal material under the counter). The music was a blend of folk-rock and blues capably driven by the lead guitar of Mike Wilhelm. The band recorded a disappointing single with producer Erik Jacobsen, who had supervised all the hits by the Lovin' Spoonful and managed to eke a Top Forty single out of another San Francisco group called Sopwith Camel ("Hello Hello") that usually appeared

further down the bills around town. After A Tribute to Dr. Strange, the Charlatans slowly descended to the bottom of the bills and never found firm footing on the scene again, although the band's dedication to style was a lesson not lost on the other San Francisco bands.

Exciting new bands appeared almost weekly. Skip Spence left his post as drummer for the Airplane—he also played guitar, sang, and helped write songs on *Surrealistic Pillow*—to put together a band with former Airplane manager Matthew Katz with a songwriter from Los Angeles named Peter Lewis (his mother was movie star Loretta Young) and some musicians from Seattle who had been playing the local go-go scene doing the Top Forty hits of the day. With three guitarists and three vocalists, and a passel of great songs from Spence, the band became a dance hall favorite from day one and was instantly snapped up by Columbia Records. They called the group Moby Grape.

The Grape played a splashy album release concert at the Avalon in May—Janis Joplin joined the group to

sing "Murder in My Heart for the Judge"—and were arrested in their cars later that night in Marin County for having sex with teenagers. The album bristled with sterling tracks—"Omaha," "Listen My Friends," "Hey Grandma"—and the band was mowing them down at Fillmore and Avalon shows.

Mike Bloomfield, the new avatar of rock electric guitar, left the Paul Butterfield Blues Band and moved to Marin County to start a new group with an old associate from Chicago named Nick Gravenites. They found a twenty-two-year-old drummer and vocalist who had been working with Wilson Pickett (among others) named Buddy Miles and put together a large, rhythm and blues–style outfit with a full horn section. They called the group Electric Flag.

Gravenites, who wrote the song "Born in Chicago" on the first Paul Butterfield Blues Band album, was a beatnik who grew up in Chicago, but had traveled back and forth between San Francisco frequently after reading *On the Road*. By the time Bloomfield split the Butterfield band and moved to Marin, Gravenites already had the place mapped out.

Another key piece of the puzzle fell in place in April, when disc jockey Tom Donahue began his nightly airshift on KMPX, a foreign language station on the little-used FM band that booked blocks of time to different ethnic groups. In February, a former classical music disc jockey from Detroit named Larry Miller had taken the 11 P.M. to 6 A.M. shift (immediately following the Turkish hour) and started underground FM radio. He played a mixture of the few underground rock albums that were available at the time and contemporary folk music, and assiduously avoided the commercial rock that could be heard between pimple cream advertisements on Top Forty radio.

Donahue had left his position at KYA, the town's most popular Top Forty outlet ("A man can only play so many Herman's Hermits records and still feel good about himself," he said). He had been taking plenty of LSD, sitting around Enrico's in North Beach every day and pondering his options. With Donahue onboard and in charge, the city's top disc jockey had moved to the FM band. He began to expand his air staff—and hired some of the first female engineers and broadcasters in the industry's history—as the foreign language contracts expired, and suddenly the new rock movement had found a voice on the airwaves.

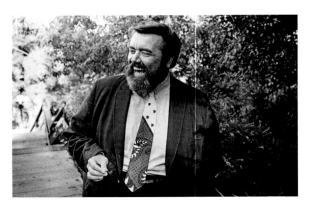

(TOP) *George Hunter of the Charlatans, 1967;* (LEFT) *Tom "Big Daddy" Donahue, 1966;* (OPPOSITE) *Quicksilver Messenger Service, 1968*

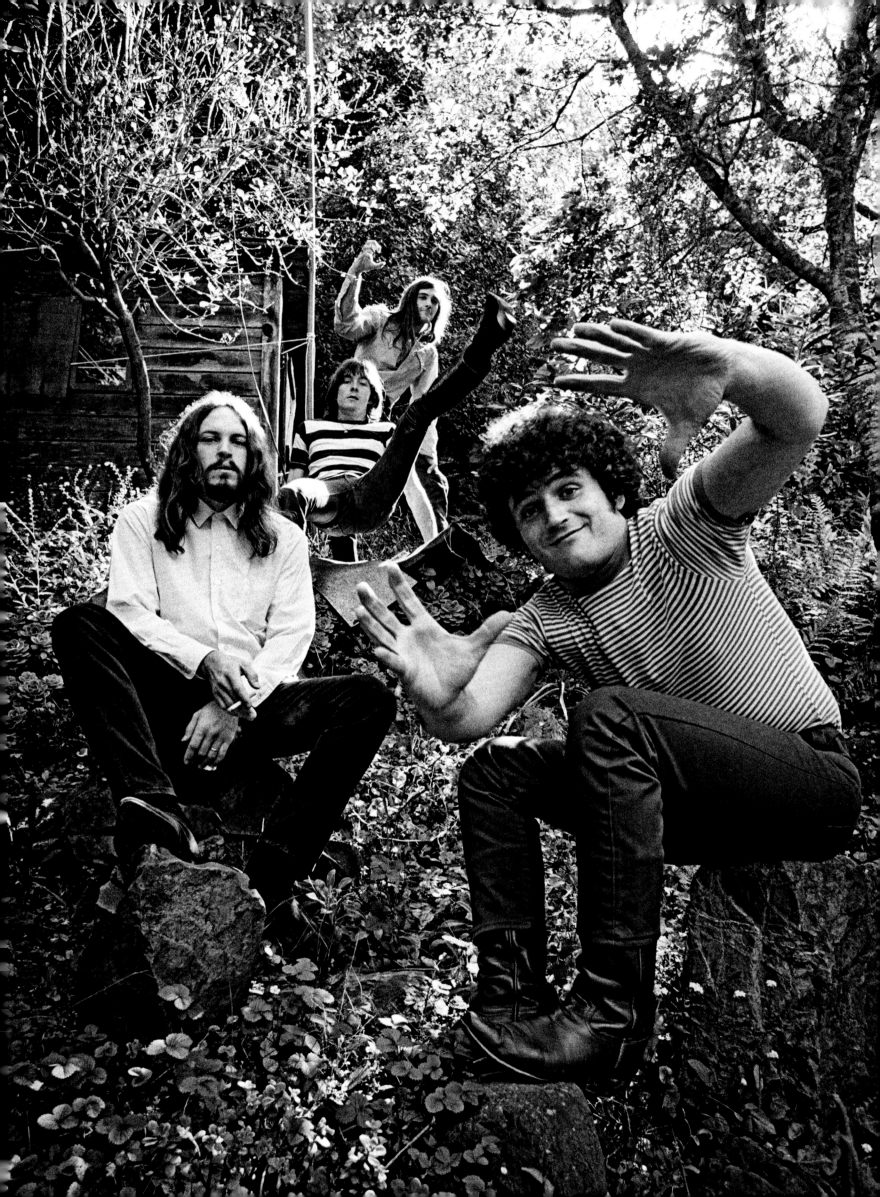

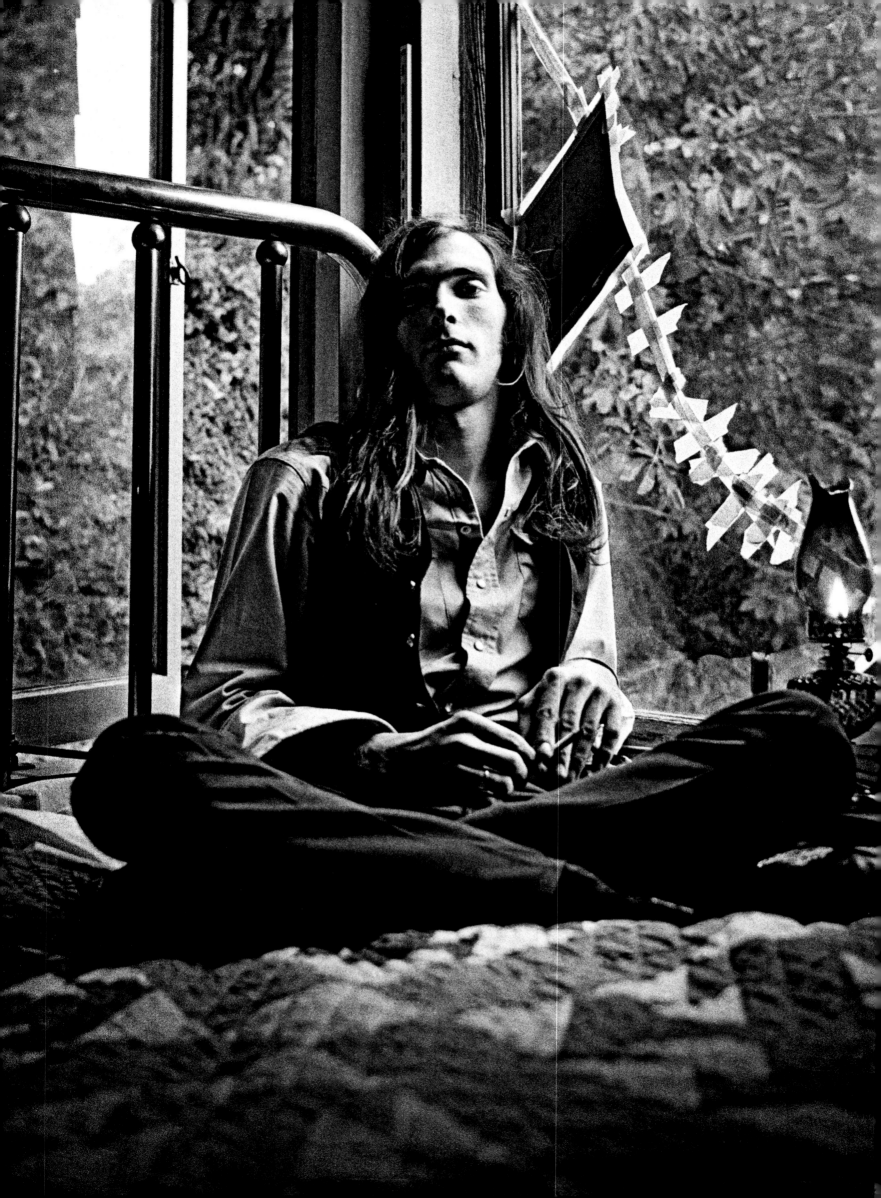

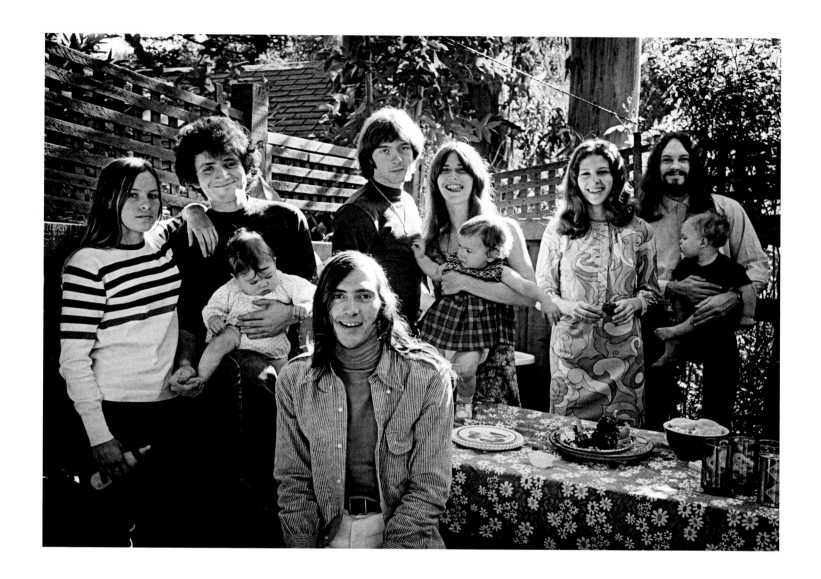

I had about two weeks that were really happy. After that, it faded pretty quickly as soon as the Haight turned into the, you know . . . The drugs changed. The Gray Lines were going up the street. It became one-way. By July, I'd moved to Marin. —DAVID FREIBERG (QUICKSILVER MESSENGER SERVICE)

(OPPOSITE) *Lead guitarist John Cipollina in his Marin retreat, 1968 ;* (RIGHT) *Members of Quicksilver Messenger Service with their families in Marin, 1968*

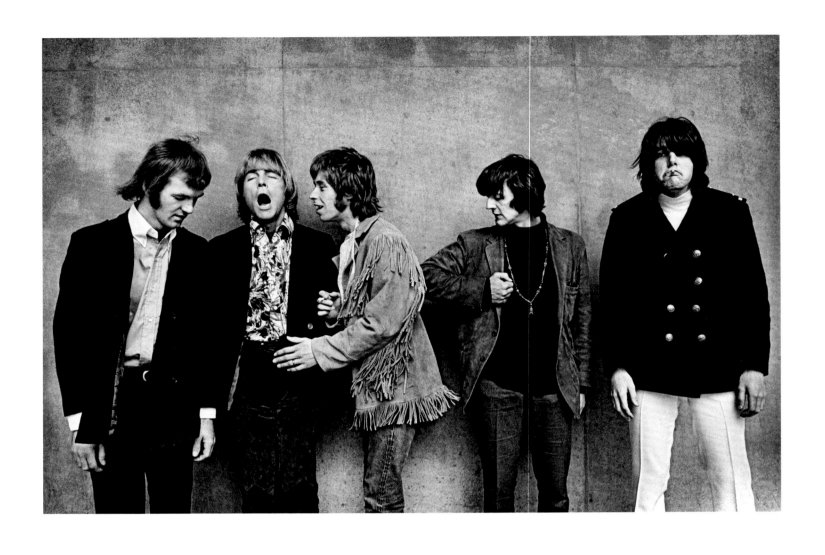

(ABOVE) *Moby Grape during a photo shoot in San Rafael for their debut album on Columbia Records: (left to right) Peter Lewis, Jerry Miller, Don Stevenson, Skip Spence, Bob Mosley, 1967;* (OPPOSITE) *The final cover image of the album, 1967. Stevenson's middle finger over the washboard was later removed from subsequent printings, following complaints.*

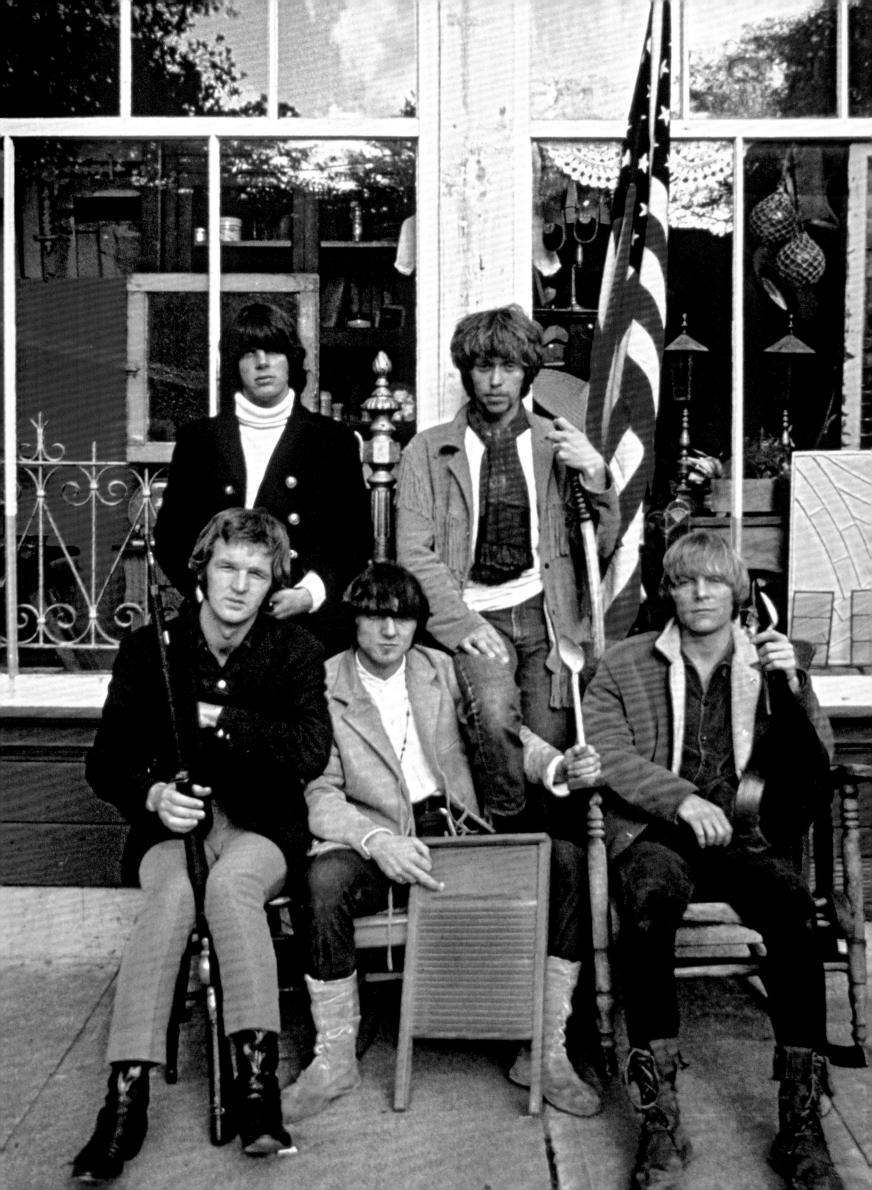

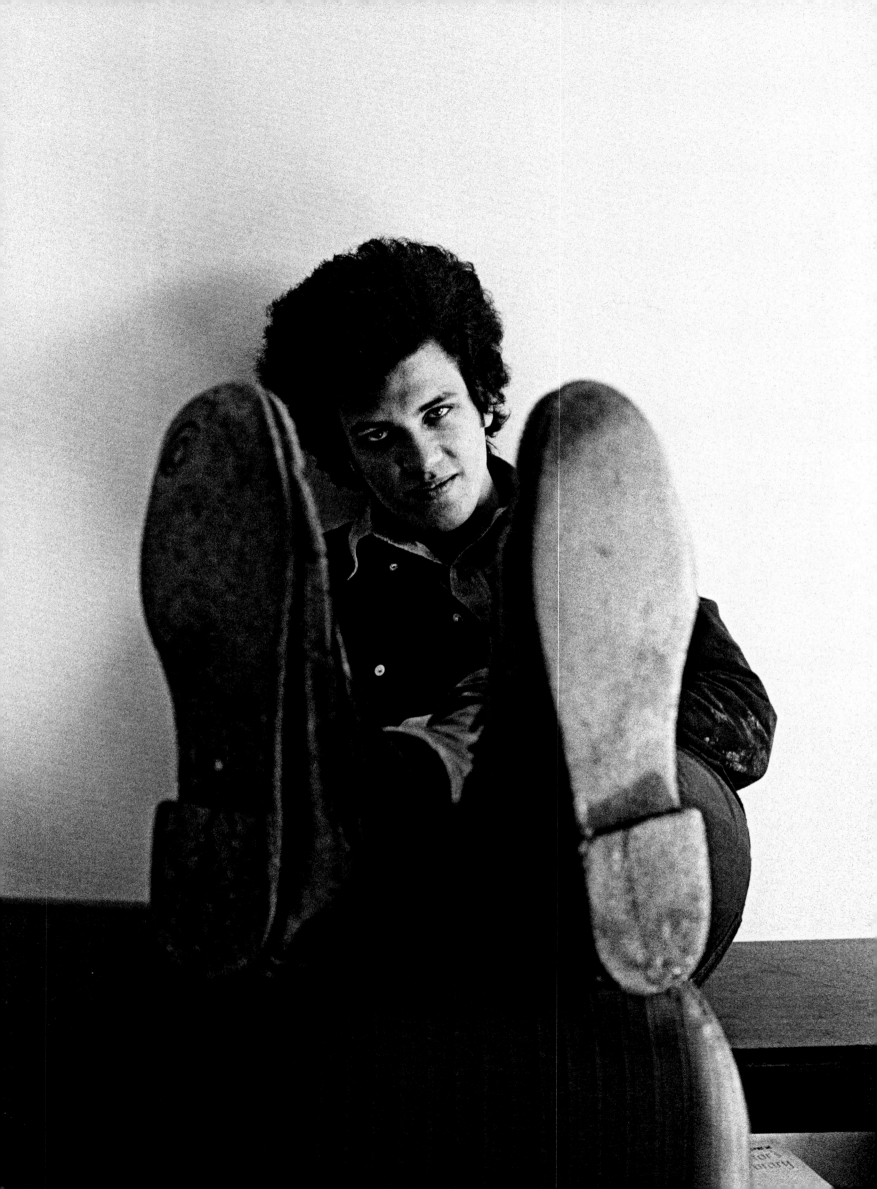

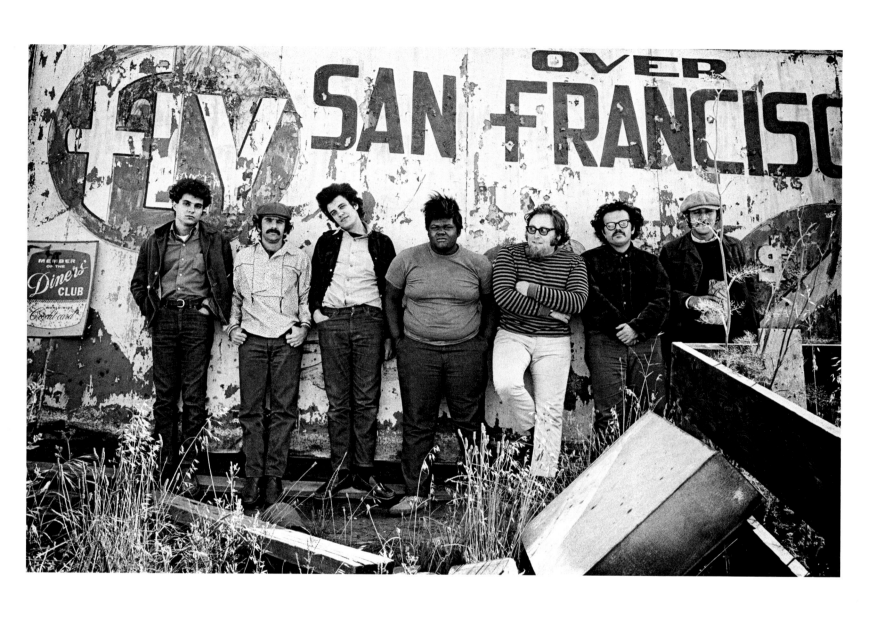

(OPPOSITE) *Mike Bloomfield of the Electric Flag, 1967;*
(ABOVE) *The Electric Flag, 1967*

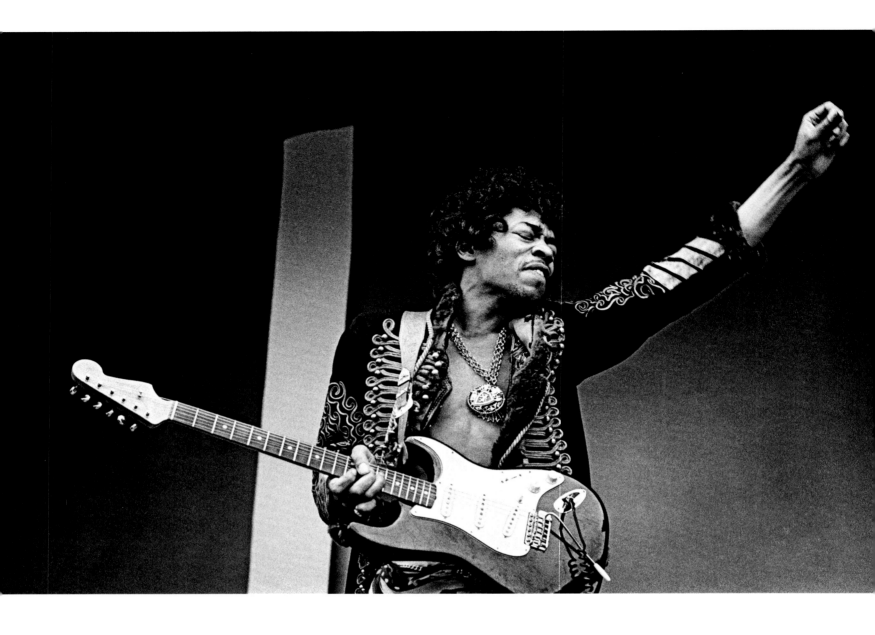

MONTEREY POP WITH THE CHART SUCCESS OF JEFFERSON AIRPLANE, NEW ALBUMS FROM THE
GRATEFUL DEAD AND COUNTRY JOE AND THE FISH, PLUS ALL THE WORD EMANATING FROM THE SAN
Francisco ballrooms of this brave, fresh rock sound, the pop music universe turned its eyes on San Francisco. In Hollywood, record producer Lou Adler and his partner, songwriter John Phillips of the Mamas and the Papas, hijacked plans to present a sweeping three-day showcase of the new rock at the Monterey County Fairgrounds, since 1958 site of the Monterey Jazz Festival in a small coastal town roughly halfway between Los Angeles and San Francisco. Adler and Phillips quickly turned the festival into a nonprofit enterprise, struck a deal with a TV network to film the event, and created a heavy-duty board of directors with their powerful associates in the rock world that included Paul Simon of Simon and Garfunkel, Paul McCartney, Jim McGuinn of the Byrds, Donovan, Rolling Stones manager Andrew Loog Oldham, and Mick Jagger.

The Monterey Pop Festival on June 16–18, 1967, was the signal event of the new rock music. In one weekend of five concerts before a reserved seat crowd of eighty-five thousand (surrounded by grounds-only attendees and many thousands outside the gates), pop music changed gears. The kings of Top Forty that sailed into that weekend on top of the charts—the Association, Johnny Rivers, the Byrds, even festival producers the Mamas and the Papas—never had any more hits. The new acts that exploded on the Monterey stage that weekend—Jimi Hendrix, the Who, Otis Redding, Big Brother and the Holding Company, Jefferson Airplane—would come to define the pop music world in the coming months. The Sunday afternoon performance by Indian sitar master Ravi Shankar only underlined the pervasive influence of the Haight-Ashbury with the inclusion of Eastern music and philosophy that would have been unthinkable on the pop scene at any previous time.

The Mamas and the Papas' songwriter Phillips composed an advertisement for his festival, and he and Adler produced the record with vocalist Scott McKenzie, "San Francisco (Be Sure to Wear Some Flowers in Your Hair)," which shot up the charts to number one. This summer in San Francisco—already trumpeted as the

(ABOVE) Jimi Hendrix performing a sound check; (LEFT) John Phillips of the Mamas & the Papas; (OPPOSITE TOP) The Who; (OPPOSITE BOTTOM) Michelle Phillips of the Mamas & the Papas. All images from the Monterey Pop Festival, 1967.

Summer of Love—was a topic of interest around the world. The hippie mythology had struck a chord in the public breast. People were attracted by the promise of freedom, the shedding of inhibitions, and the sheer joy the hippies exuded. Other people were scornful of the lawlessness, drug use, and flouting of authority and conventional wisdom. Whatever the attitude, everyone had one, as the world watched the Haight.

The banner across the stage read LOVE, MUSIC, AND FLOWERS. The Monterey police, poised for an even worse bacchanal and free-for-all than the annual jazz festival craziness, were taken by surprise with these gentle, peaceful kids. Thousands camped out at a nearby football field where rock bands held forth all night—including some of the festival performers such as the Dead, Eric Burdon, and Steve Miller—from a flatbed truck. The shady grove that serves as the festival grounds was awash in colorful costumes, booths selling handcrafts, and the smell of incense and marijuana. Brian Jones of the Rolling Stones walked the grounds in all his peacock British rock star finery.

The Pop Festival programming carefully reflected the expanse of the new music. From England, Eric Burdon would be making the debut of his new, psychedelic Animals. British mod heroes who had yet to find purchase Stateside, the Who, would be playing, as would an unknown American guitarist who had been making a splash in London circles, Jimi Hendrix.

From Los Angeles came Johnny Rivers, the Association, the Byrds (on their last legs), Buffalo Springfield (with David Crosby of the Byrds substituting for guitarist Neil Young, who had quit the band only days before), and the festival closing act, the Mamas

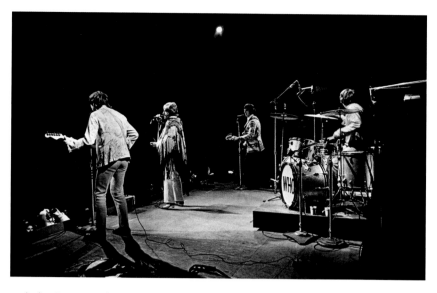

and the Papas, riding a string of six consecutive Top Ten hits. The only new Los Angeles underground rock band included was Canned Heat, who was featured on the Saturday afternoon program, which was otherwise entirely devoted to new San Francisco bands. The Beach Boys were supposed to appear, but backed down at the last minute, fearful they would sound old and out-of-date amid all the latest groups.

To represent the rhythm and blues side, the producers failed to convince any of the Motown acts to appear for free like Smokey Robinson and the Miracles, and settled for the supper club soul of Lou Rawls and the up-and-coming Memphis soul singer Otis Redding.

But it was the San Francisco bands that attracted the most attention, especially Jefferson Airplane, the

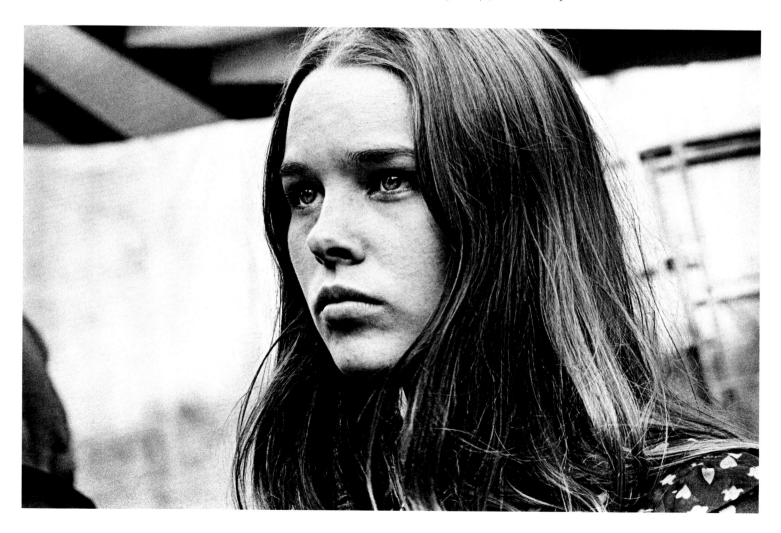

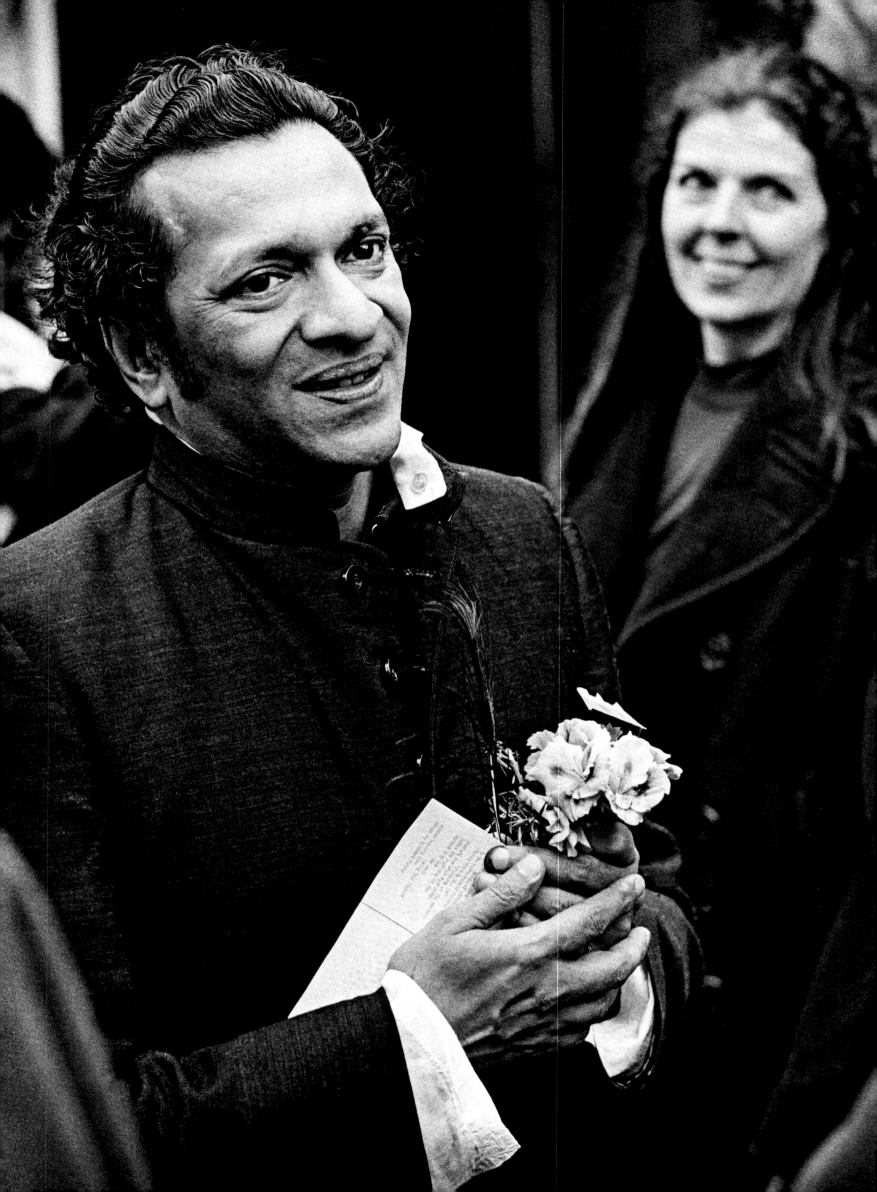

big draw on the Saturday night bill. Adler and Phillips had to travel to San Francisco to convince the dubious managers of the San Francisco bands to cooperate. They kissed the ring of *Chronicle* columnist Ralph Gleason, and he gave their enterprise his blessing, which opened the door to booking the San Francisco groups.

In addition to Jefferson Airplane, they presented Big Brother and the Holding Company, Quicksilver Messenger Service, Country Joe and the Fish, Moby Grape, and a relatively new band on the San Francisco scene that had vaulted through the ranks in the past six months, the Steve Miller Blues Band. In addition to the Paul Butterfield Blues Band, the new band with former Butterfield guitarist Mike Bloomfield, Electric Flag, also made the band's public debut.

Janis Joplin made a tremendous impression on the crowd in the Saturday afternoon performance by Big Brother and the Holding Company, but a bitter fight broke out among the band backstage immediately after the set. Suspicious of the Hollywood motives and show business associations of the festival producers, Big Brother's hippie manager had ordered the cameras filming the shows for the prospective TV special turned off during the Big Brother show. Backstage, Bob Dylan's manager Albert Grossman told Joplin that filming the set would have made her a star. She threw a tantrum. She berated the manager and her bandmates until they relented; festival officials quickly arranged a second appearance on the Sunday evening bill, which would be filmed. Grossman was right; the version of Joplin singing "Ball and Chain," which filmmaker D. A. Pennebaker captured for his documentary, did make Joplin a star.

Otis Redding followed the supposed climax of the Saturday night show, the Airplane, hitting the stage with a double-time, amped-up version of Sam Cooke's "Shake," backed by Booker T. and the MGs, that stopped the exiting masses in their tracks in an instant and sent them scurrying back to their seats. Redding had them in the palm of his hand from the moment he stepped onstage. "This is the love crowd, right?" he said, introducing his second number. He walked on the stage a minor figure in rock circles and he left a giant. Six months later, he was dead in a plane crash at age twenty-six.

The Sunday night finale was a duel between the Who, with guitarist Pete Townshend smashing his guitar to pieces at the explosive end of his performance, and Jimi Hendrix, who went Townshend one better and set *his* guitar on fire. The two had sparred before at a concert in London, but at Monterey, Hendrix would prevail. Dressed in yellow frilly silk shirt, toreador vest, and red pants, a headband through his improbable mop of unruly hair, he crushed the audience, opening with the title track from the new Beatles album, *Sergeant Pepper's Lonely Hearts Club Band.* He blew the doors off Dylan's "Like a Rolling Stone," and brought the epic performance to a fiery close with "Wild Thing," climaxed by Hendrix drenching his guitar in lighter fluid and setting it ablaze. Marshall's photo of Hendrix kneeling over his burning guitar may be the single most famous image in rock history. Hendrix, who was loaded on a double dose of Owsley Purple, had warned Marshall before taking the stage to be sure and bring plenty of film.

The Grateful Dead, sandwiched between the Who and Hendrix, found their set interrupted by Peter Tork

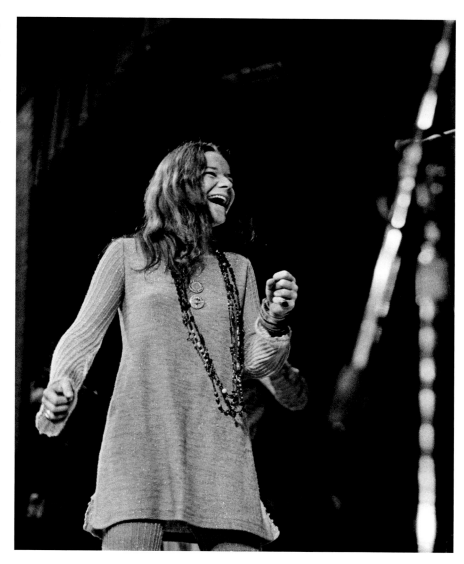

of the Monkees, a fabricated rock band that currently had their own network TV series, at the request of the producers. Sent out by festival producers, Tork wanted to assure the crowd that rumors that the Beatles were in attendance were false. Bassist Phil Lesh of the Dead took a grim view of the phony Hollywood hippie busting in on their scene. He looked at the crowd massed beyond the chain-link fence and invited them into the arena. They flooded past the ushers and filled the aisles. The Dead played one elongated improvisation for the rest of the band's set.

Following Hendrix, the closing performance by the Mamas and the Papas was something of an anti-climax. When they brought out Scott McKenzie to sing "San Francisco (Be Sure to Wear Some Flowers in Your Hair)," Country Joe McDonald, sitting in the audience still reeling from a new powerful designer psychedelic Owsley debuted that weekend called STP, couldn't handle that. *We've been had*, he thought.

The event was attended by many major record company executives getting their first look at this new rock. Festival press agent Derek Taylor, a former Fleet Streeter who handled publicity for the Beatles, gave press credentials to virtually anyone who asked, and news of the event was carried on an ever-expanding network of underground newspapers and magazines across the country. Marshall photographed the weekend. The mainstream media largely ignored the festival, but the yawning underground press swamped the scene. Word spread in an instant. Monterey Pop was the stuff of legend by Monday morning.

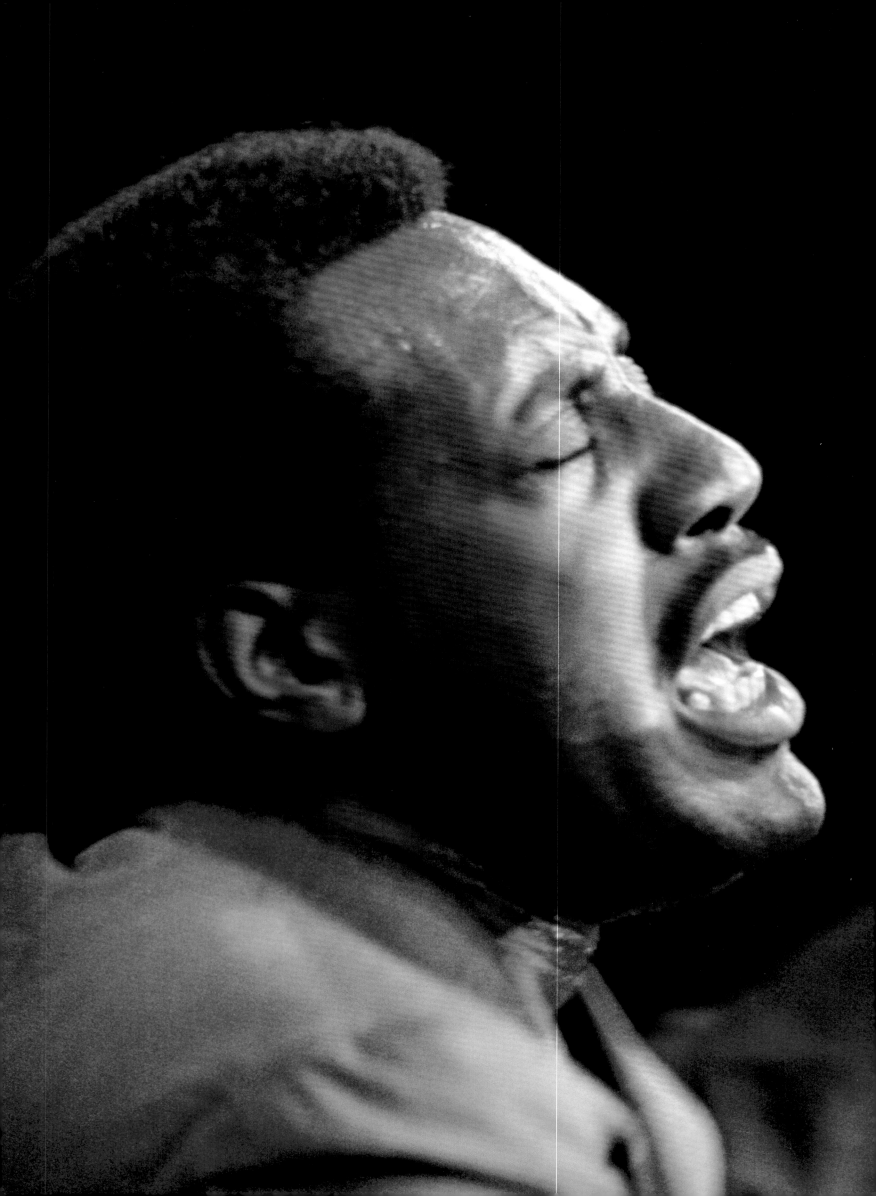

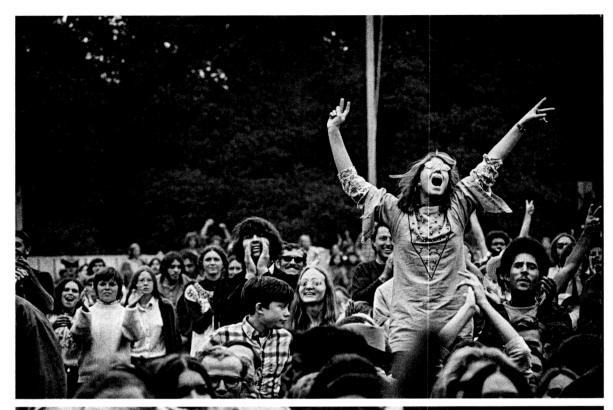

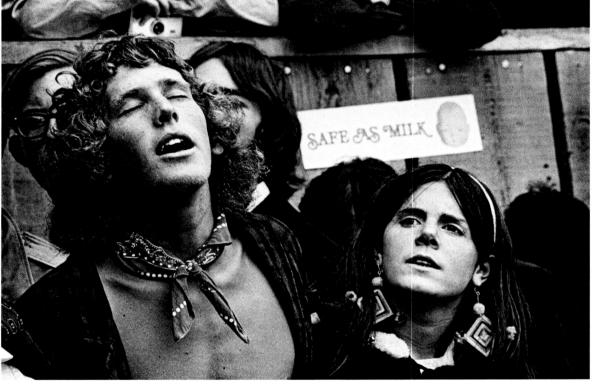

(THESE PAGES) *Concertgoers at the Monterey Pop Festival, 1967. The* Safe as Milk *sticker in the background (above) refers to the debut album of Captain Beefheart and His Magic Band, 1967*

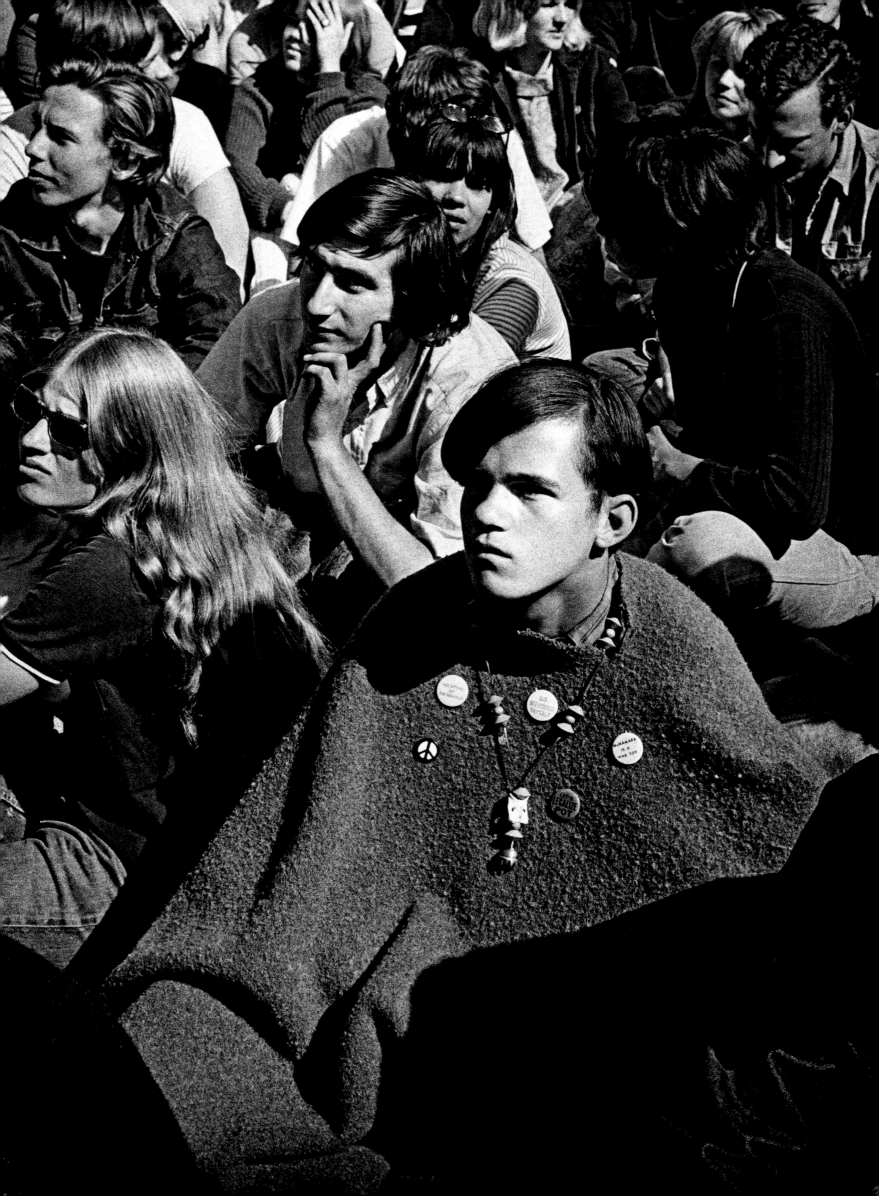

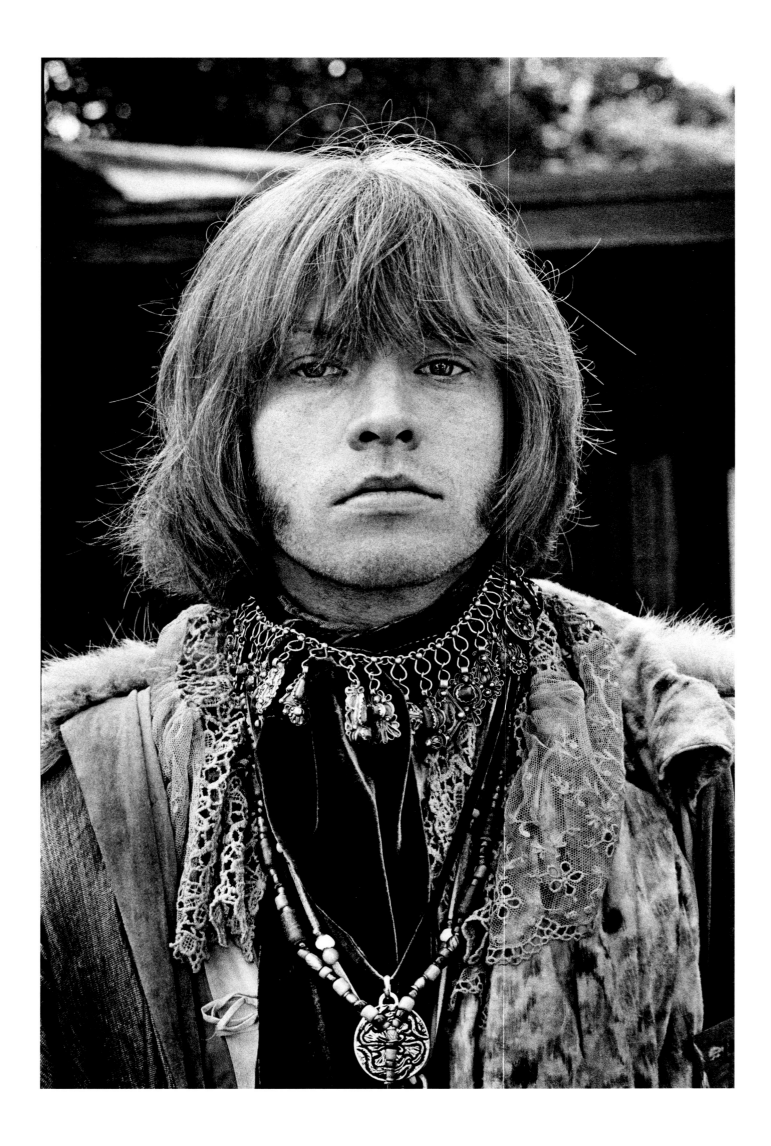

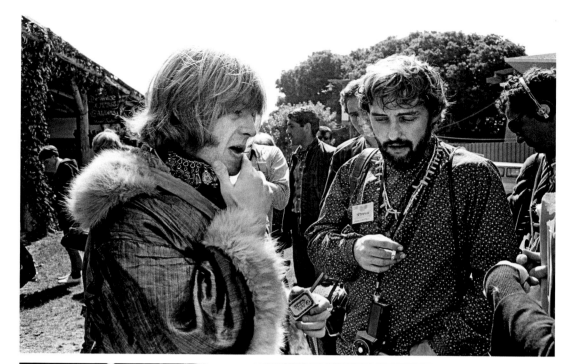

(OPPOSITE) *Brian Jones, founding member of the Rolling Stones;* (TOP) *Brian Jones and Dennis Hopper;* (CENTER) *Dennis Hopper;* (BOTTOM) *Brian Jones, Nico, Judy Collins, and Dennis Hopper. Hopper based his character in* Apocalypse Now *on Marshall;* (FOLLOWING PAGES) *Brian Jones and Jimi Hendrix backstage. All images from the Monterey Pop Festival, 1967.*

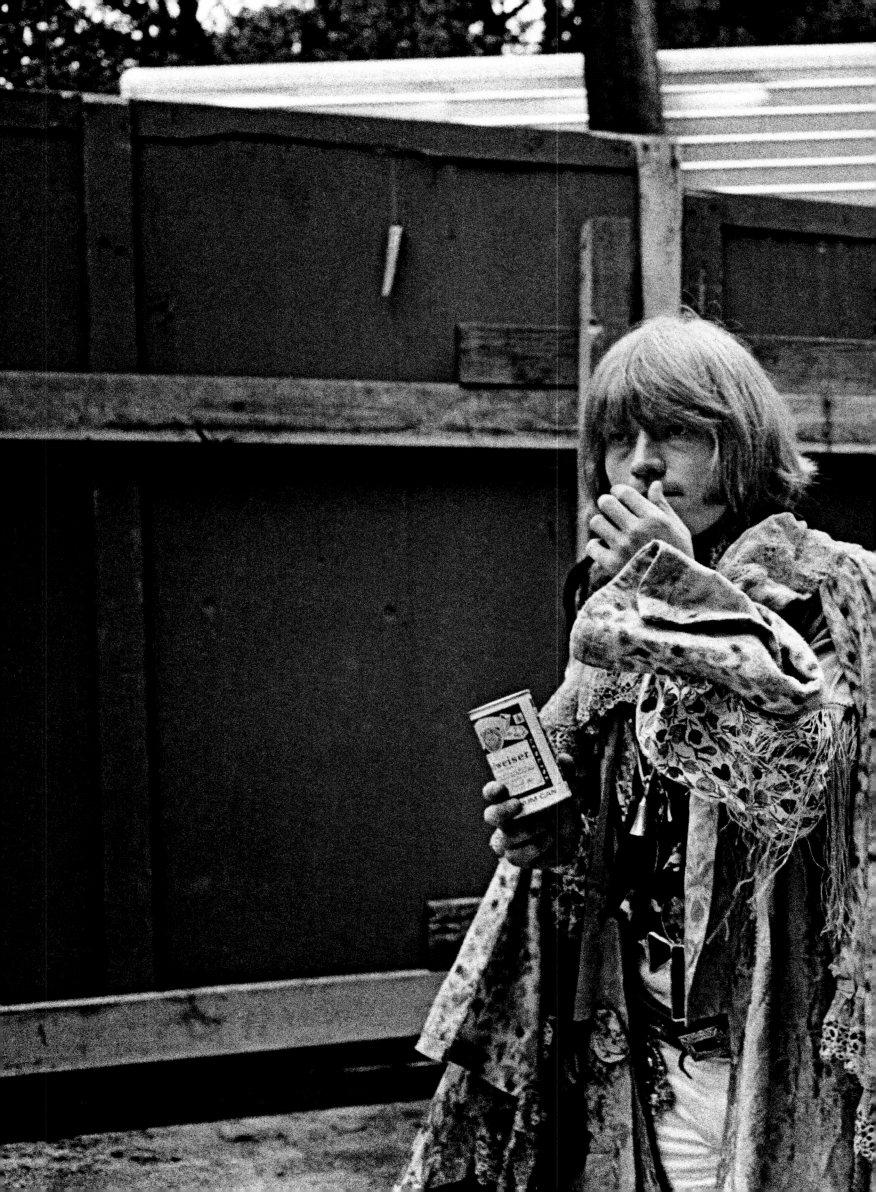

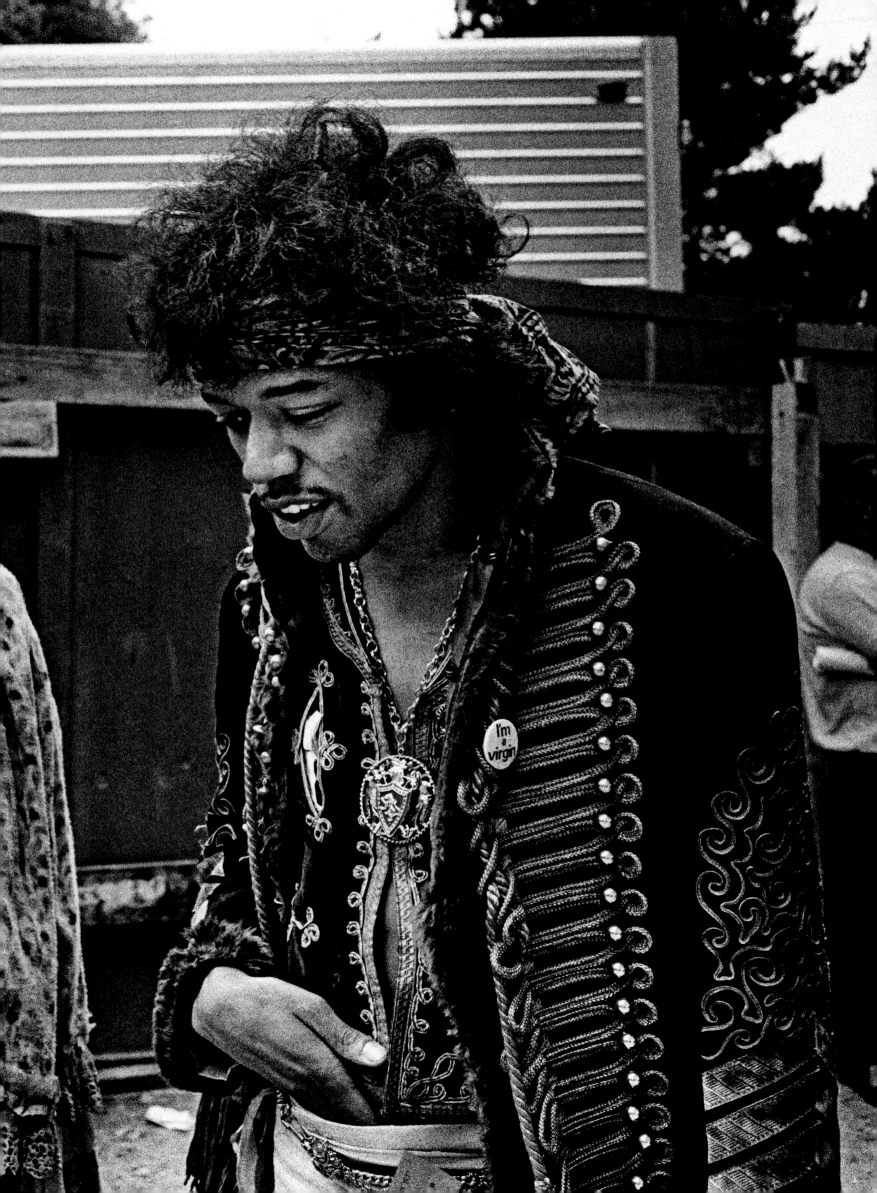

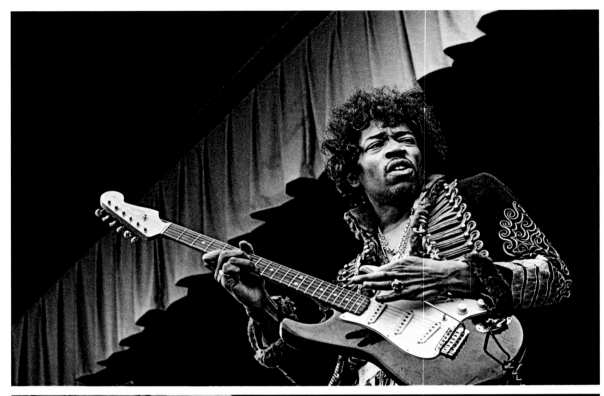

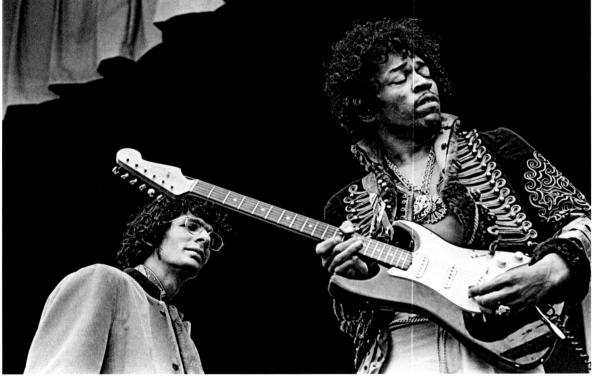

(THESE PAGES) *Jimi Hendrix sound check at Monterey Pop;* (FOLLOWING PAGES) *Jimi Hendrix famously lights a guitar on fire onstage. Before taking the stage, Hendrix told Marshall to stand by and "have a lot of film ready."*

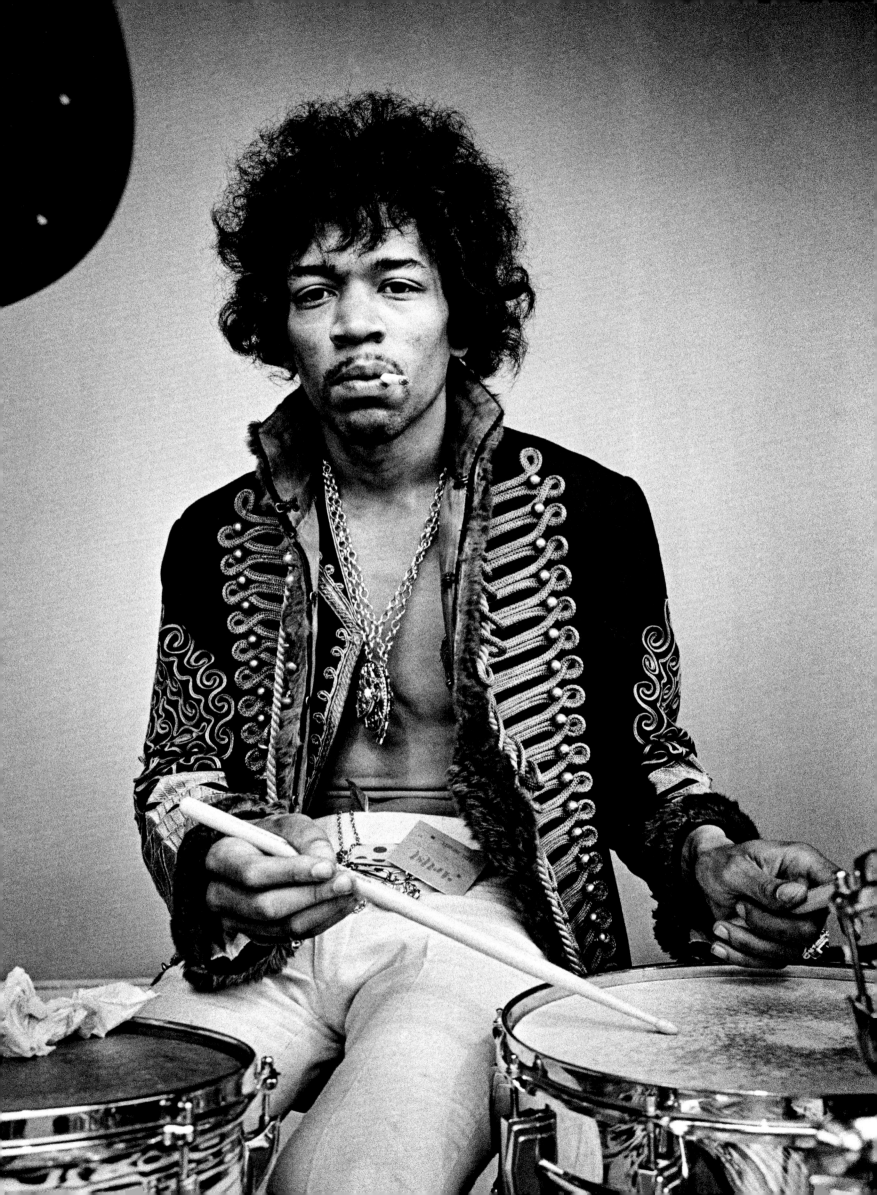

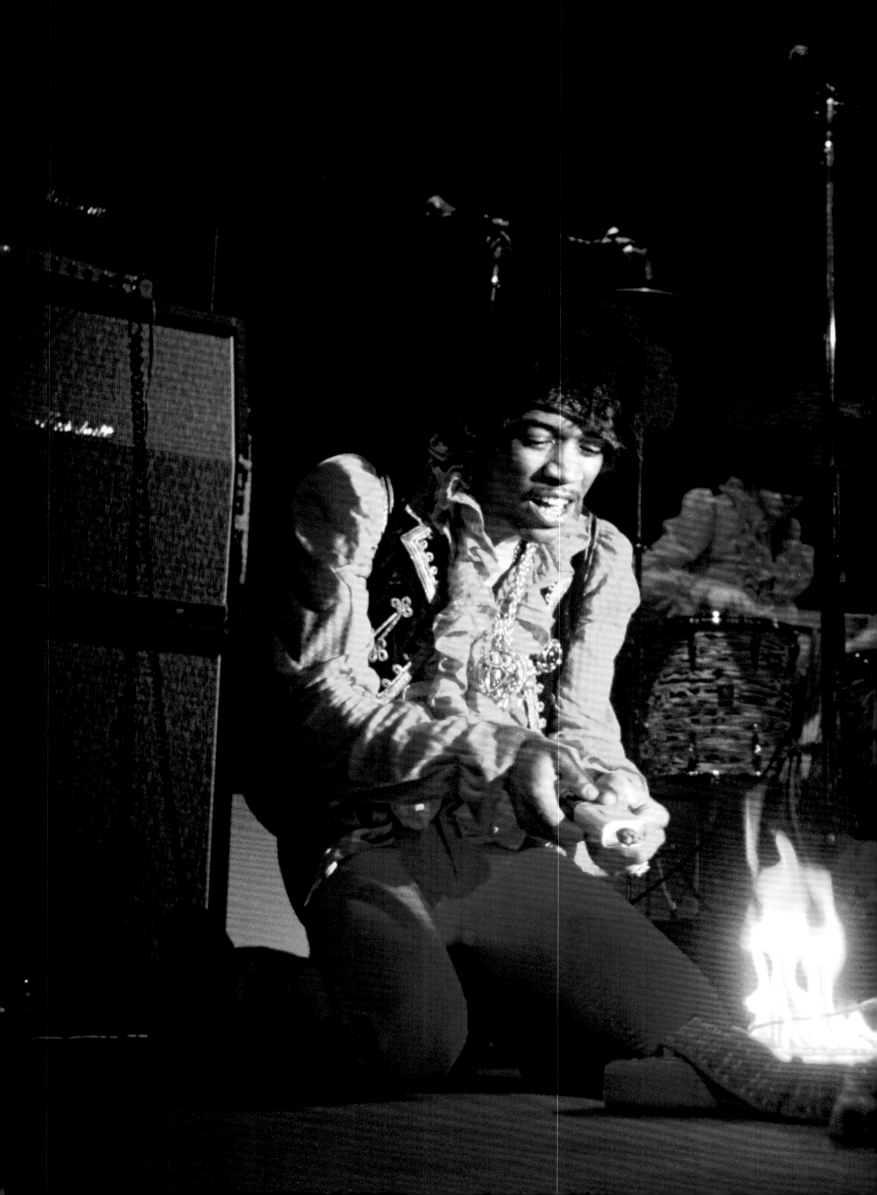

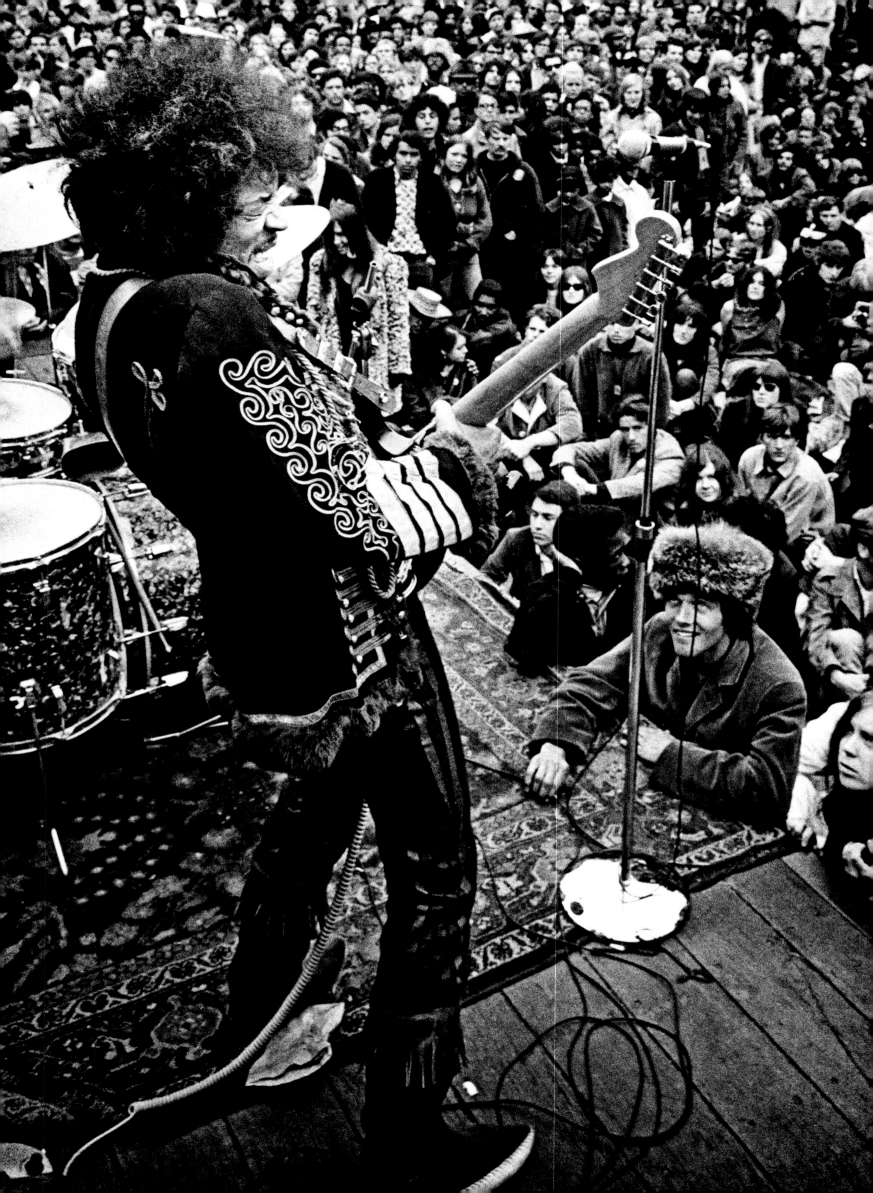

HENDRIX IN THE PARK
MARSHALL SENSED SOMETHING SPECIAL IN HENDRIX. EVEN BEFORE MONTEREY, THE BRITISH RELEASE OF THE DEBUT ALBUM BY HIS BAND, THE JIMI HENDRIX EXPERIENCE, had been blasting for several weeks on KMPX in San Francisco (the album would not be released in the United States until August). At Monterey, Marshall photographed Hendrix at the Sunday morning sound check, standing on the stage eye-to-eye with Hendrix while he ran through his number or catching him sitting behind the kit. Hendrix was so passionate even at sound check, people have thought for years these famous photographs were taken during his performance, but, of course, they were shot under sunlight and Hendrix performed at night. Marshall was the only photographer there to capture the rehearsal. He knew it yielded an amazing shot. And it did.

The Jimi Hendrix Experience was scheduled to be the opening act for six nights at the Fillmore Auditorium the following week on a bill also featuring Jefferson Airplane and Hungarian jazz guitarist Gabor Szabo. With Hendrix's record pounding out of KMPX and expensive import copies disappearing out of the few record stores in San Francisco that carried them as fast as they could get them, the Hendrix appearance was highly anticipated. "Foxy Lady," "Purple Haze," and the blues "Red House," ironically not included on the U.S. edition, burned up the station's airwaves.

At the Fillmore, each band did two sets a night, which meant that the opener's second set immediately followed the headliner's first set. The first night, Hendrix so completely destroyed the Airplane following the band's first set, the audience had dwindled down by the time the Airplane came back for the second show. The Airplane immediately decided their time would be better spent in Hollywood, working on the follow-up to *Surrealistic Pillow*, and decamped to the recording studio the next morning. To finish the run, Bill Graham brought in the other star of the Monterey Pop Festival, Big Brother and

the Holding Company, the first time he ever hired the former Avalon Ballroom house band. Hendrix and Joplin became quite friendly, and some of her band members think they had sex in a backstage dressing room during the engagement.

On Sunday afternoon, Hendrix played a free concert in the Panhandle. It was part of a regular series of shows presented by one of the employees of the Psychedelic Shop. The Airplane brought the band's flatbed truck, already set up with their gear, and the Jimi Hendrix Experience initiated the Summer of Love in the Haight a week early before a few hundred people. Bill Graham, fooling around backstage, gave Marshall the finger, which turned into another famous photograph and poster—a precursor of one of Marshall's most famous photos of Johnny Cash (though Cash gave the finger to a warden, not Jim). Hendrix went from San Francisco to Los Angeles to do some recording, then, in one of rock's great mismatches, he spent most of the summer touring as opening act for the Monkees, at the insistence of Peter Tork and bandmate Micky Dolenz, who both saw Hendrix at Monterey.

(OPPOSITE) *Jimi Hendrix performing at a free concert in the Panhandle, 1967;* (BELOW) *Jimi Hendrix and Buddy Miles, 1967;* (FOLLOWING PAGES) *Mitch Mitchell and Noel Redding of the Jimi Hendrix Experience, 1967*

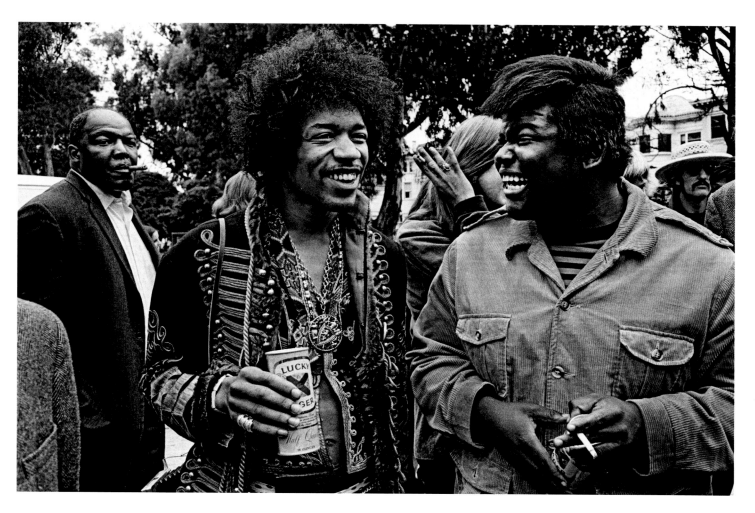

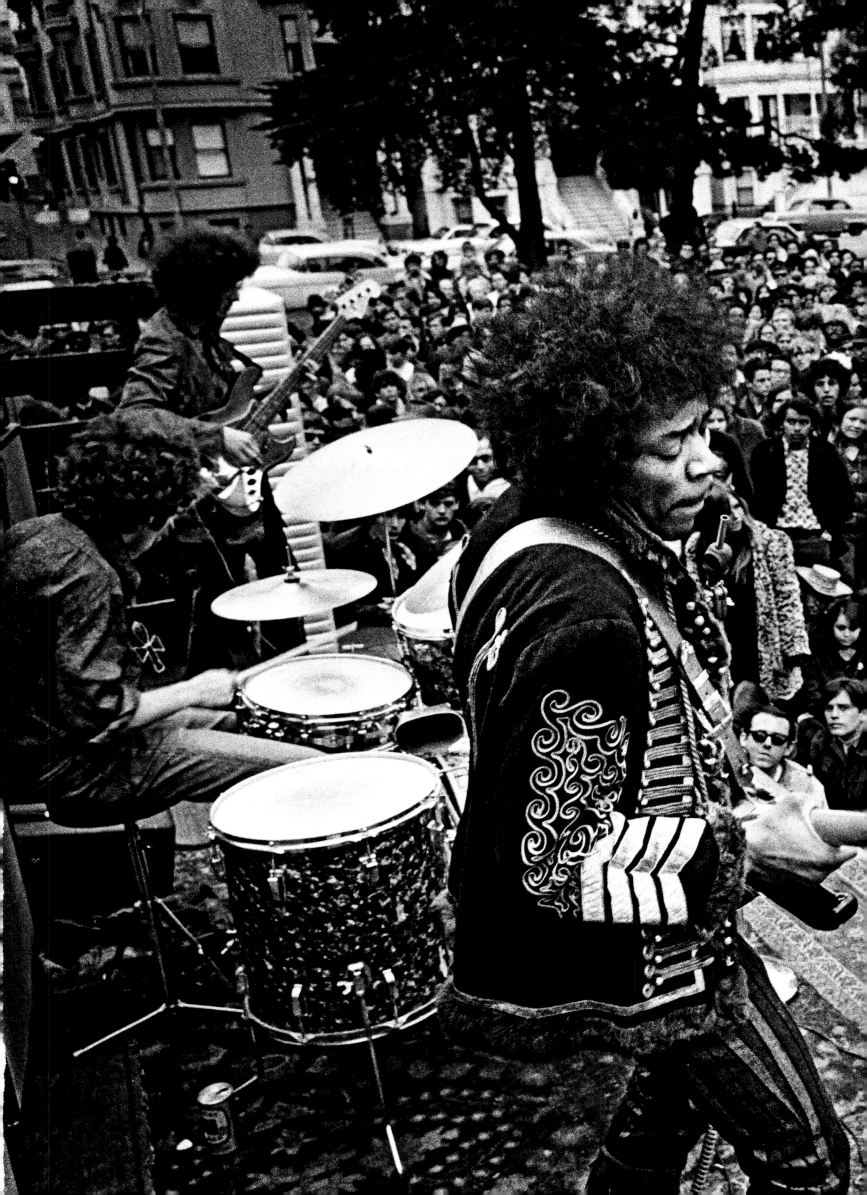

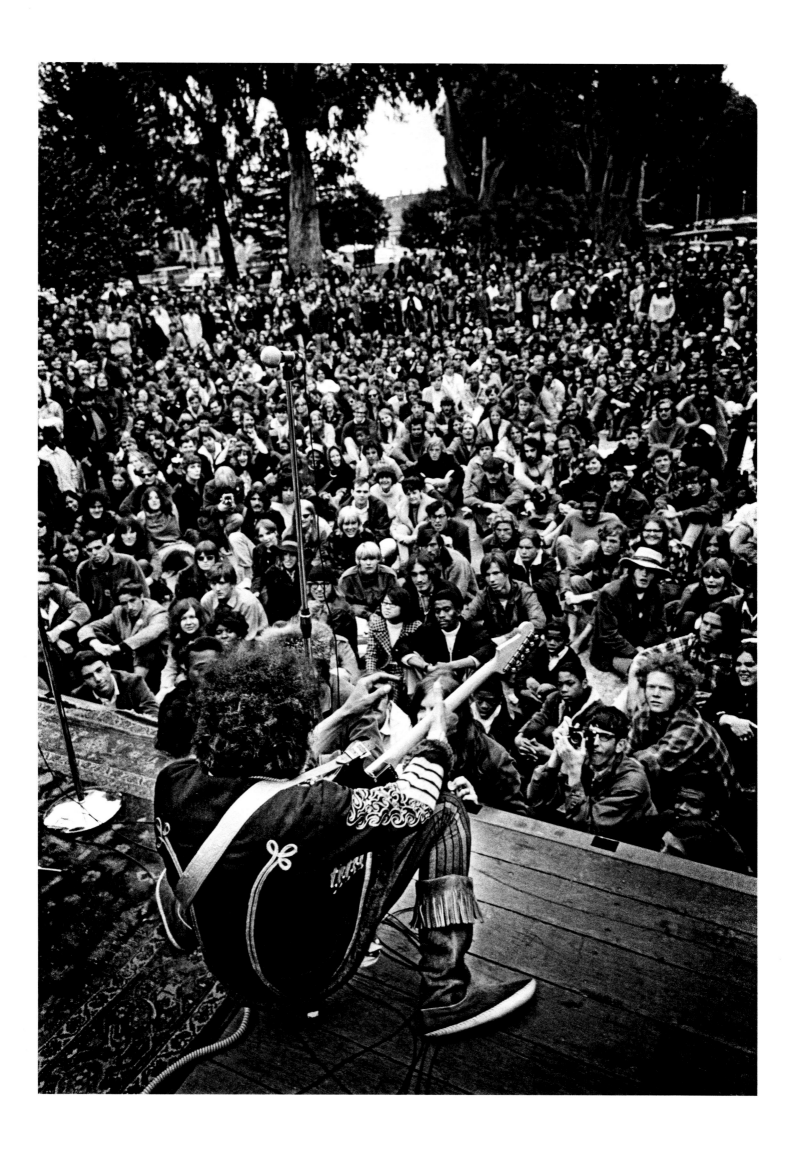

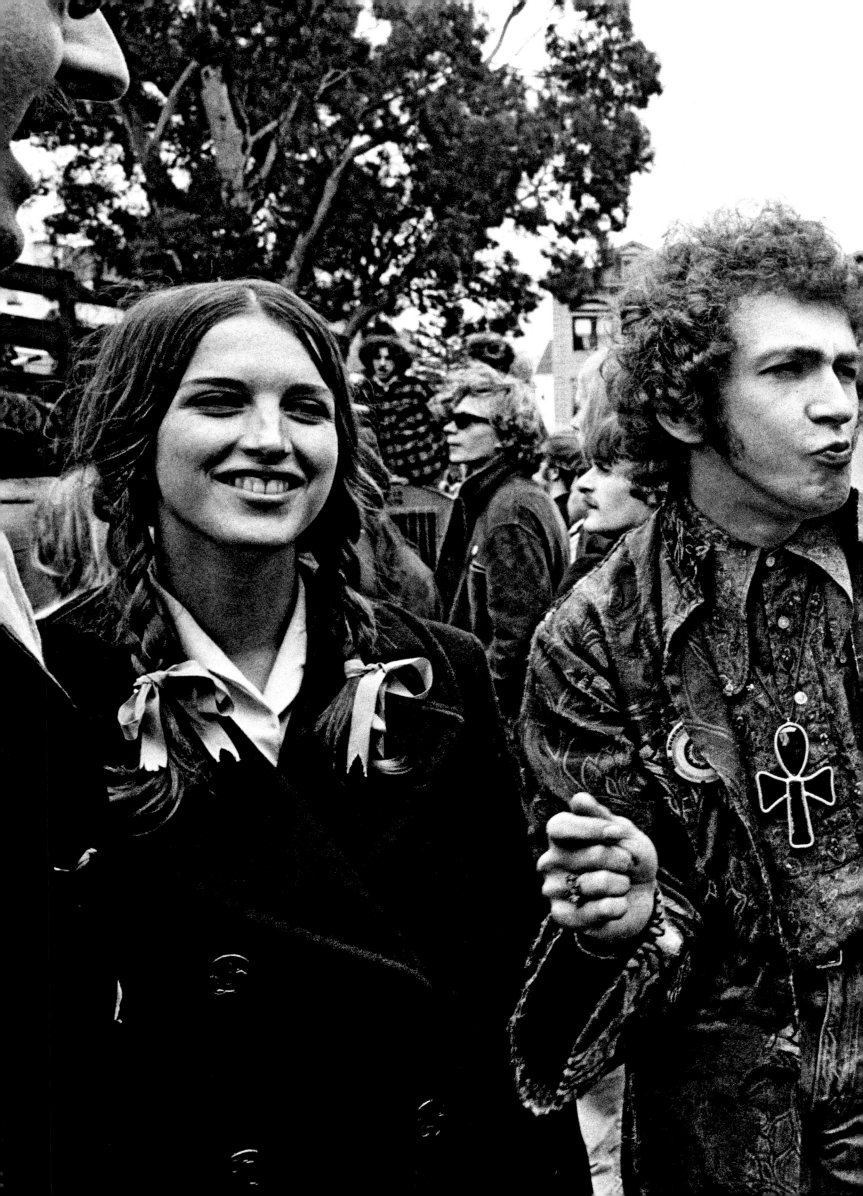

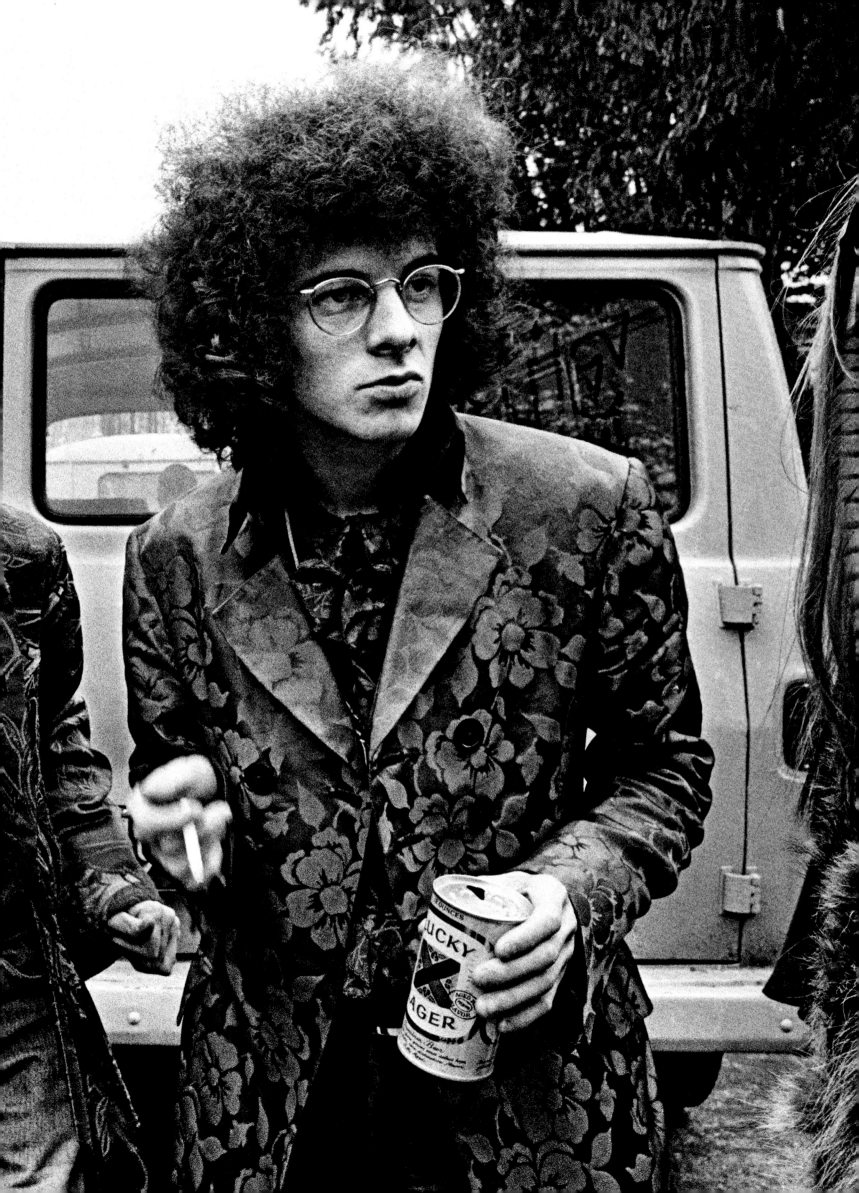

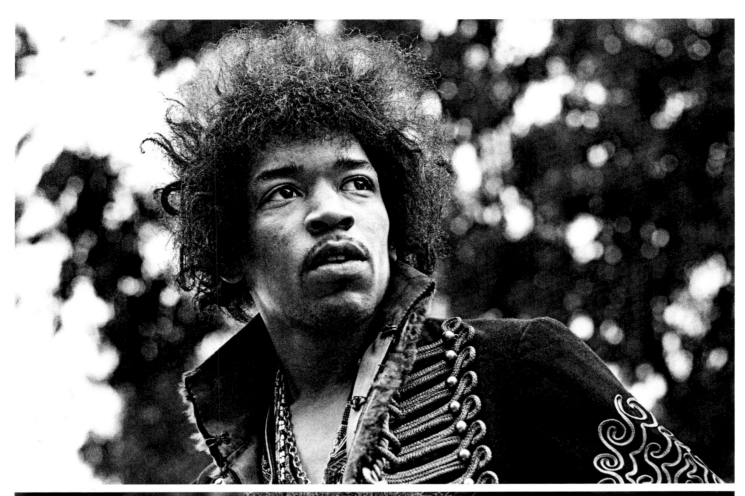

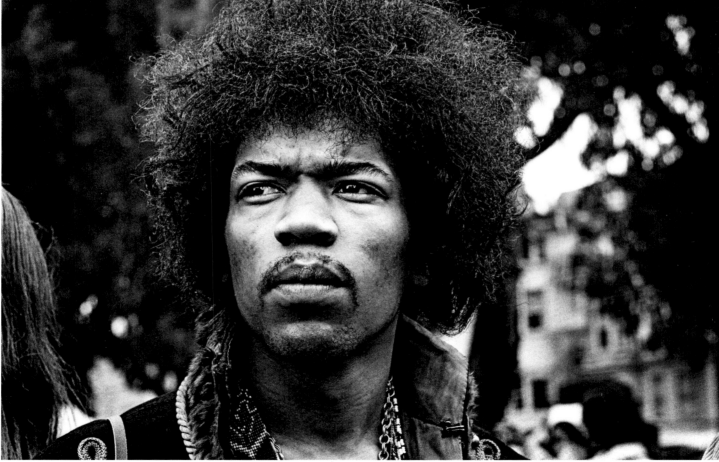

(THESE IMAGES) *Scenes from Jimi Hendrix's iconic Panhandle concert, 1967*

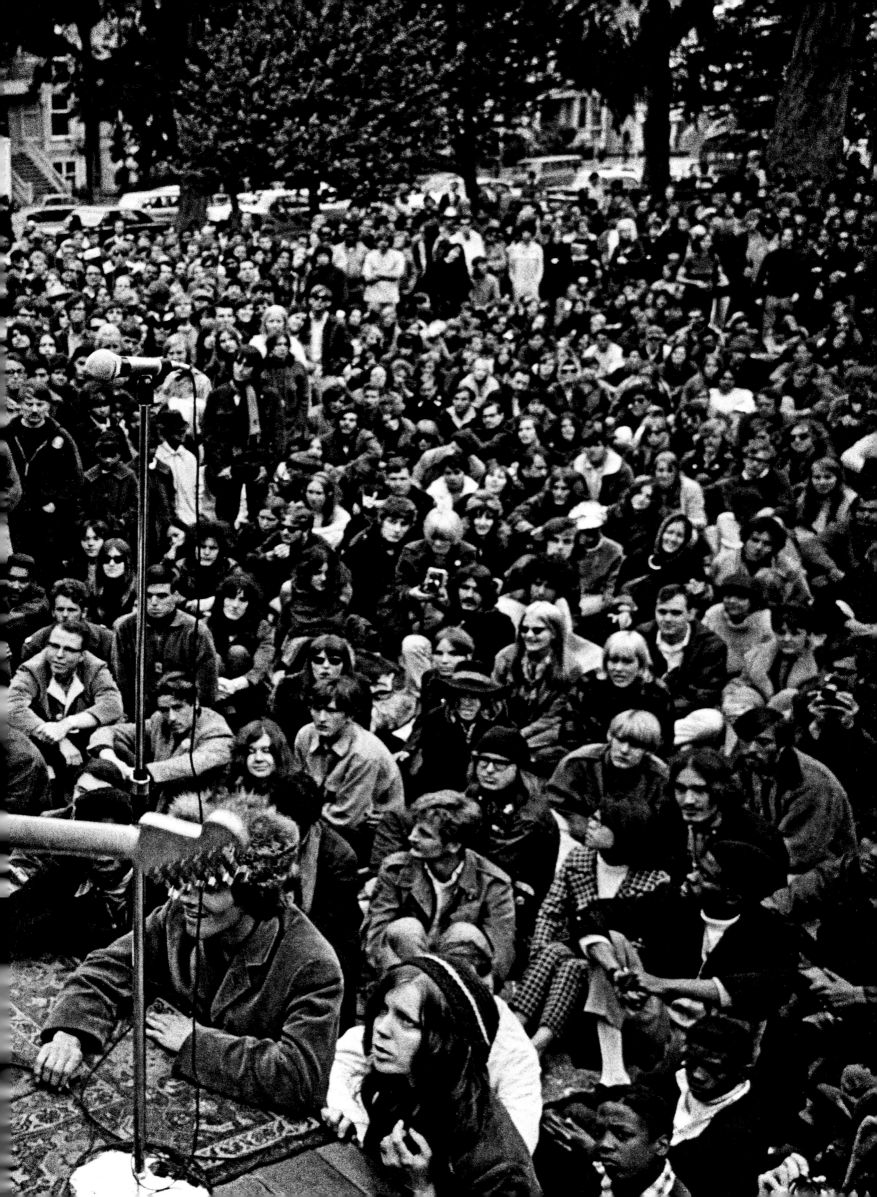

THE CARDBOARD BEATLES THE MONKEES WERE THE TEENYBOPPER SENSATION OF THE MOMENT, STARS OF A HIT TV SERIES THAT MADE A CAST OF FOUR ACTORS INTO a cardboard Beatles, propped up with actual hit records written and produced by music business professionals. It was the exact kind of show business that the Haight bands utterly rejected. While the San Francisco bands— except the Airplane—were largely unheard outside a few adjacent zip codes, the big rock music tour of the Summer of Love was the Monkees, with Hendrix largely ignored as the opening act.

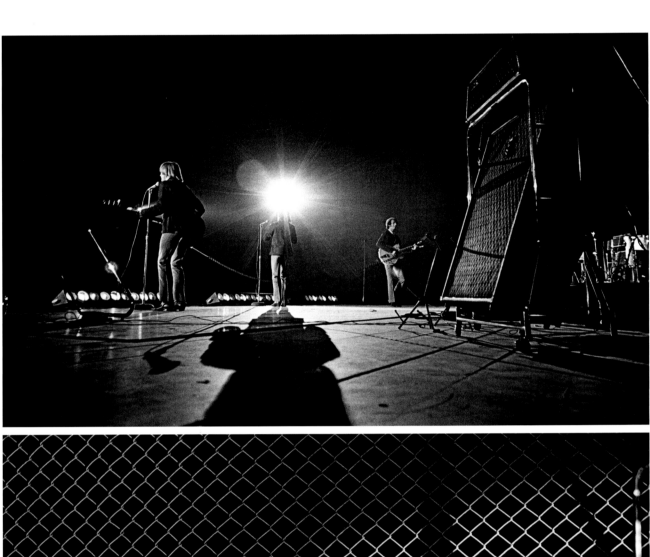

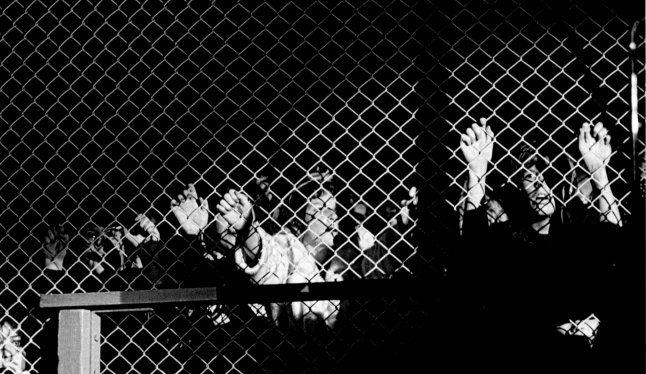

(ABOVE IMAGES) *The Monkees performing at Cow Palace to rabid fans during their U.S. tour, 1967;* (OPPOSITE, CLOCKWISE FROM TOP LEFT) *Davy Jones, Michael Nesmith, Micky Dolenz, and Peter Tork of the Monkees, 1967*

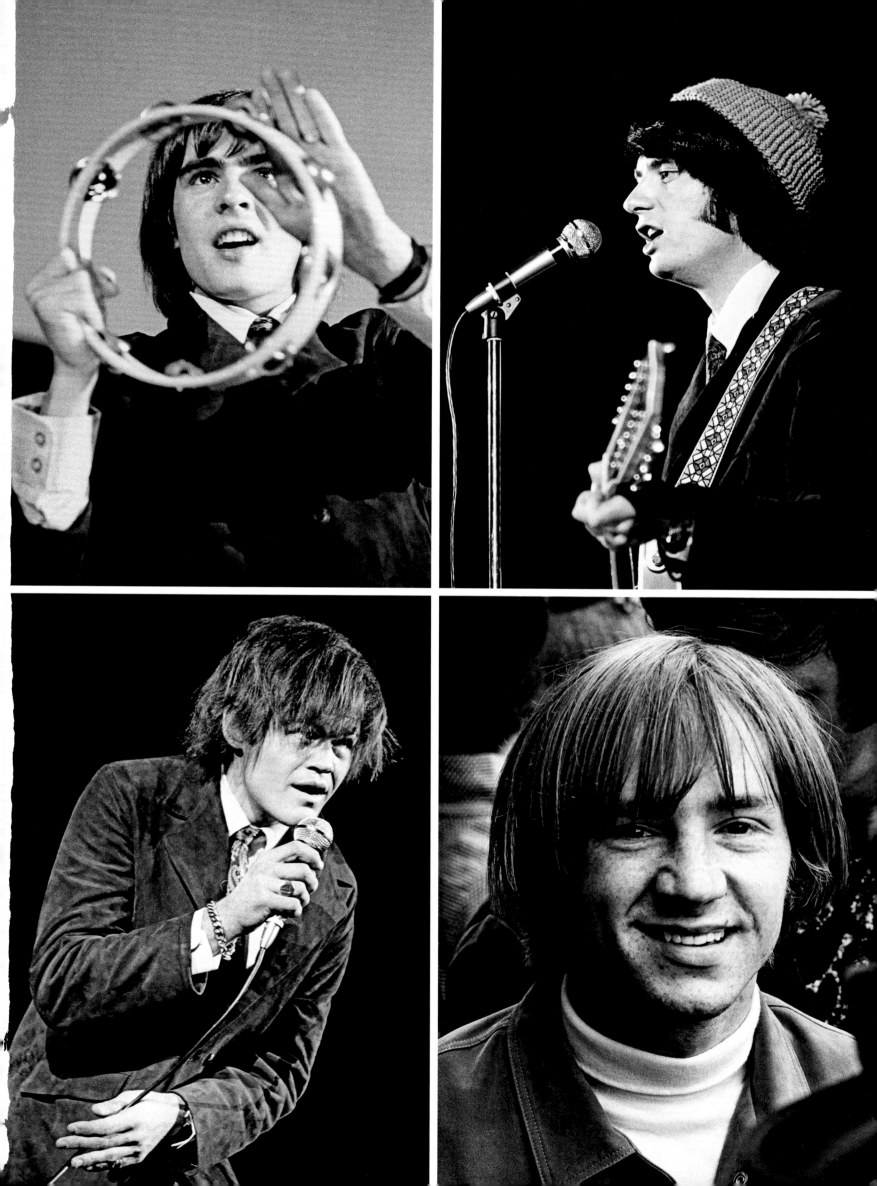

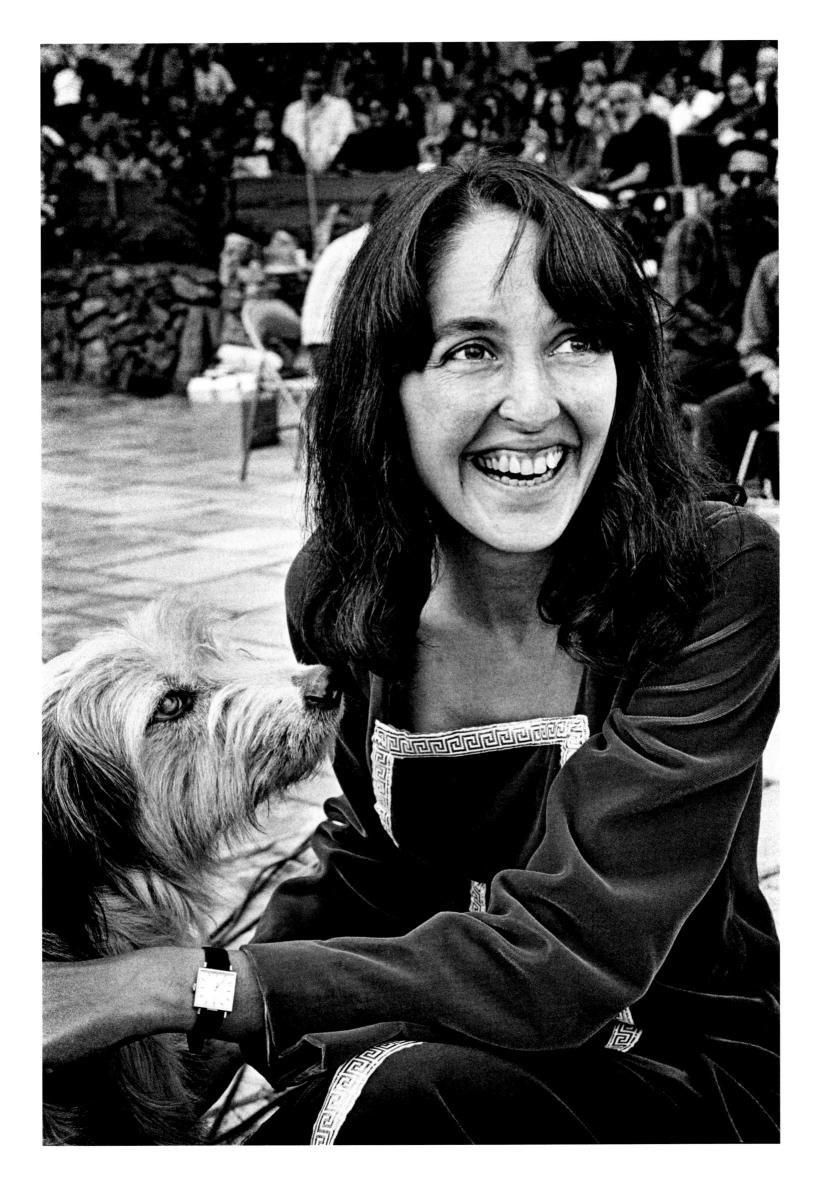

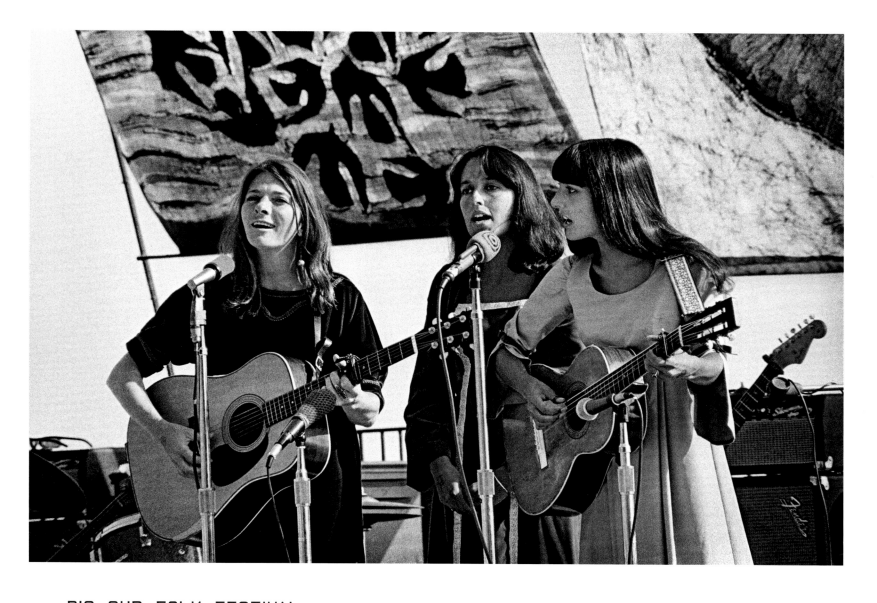

BIG SUR FOLK FESTIVAL
ALMOST THE POLAR OPPOSITE OF THE HOT SHOW BUSINESS SPOTLIGHT OF MONTEREY POP WAS THE HANDMADE BIG SUR FOLK FESTIVAL, just down the road from Monterey a couple of weeks after the pop festival. Held on the grounds of the Zen Buddhist retreat the Esalen Institute, poised on cliffs above the Pacific Ocean, the tiny, intimate gathering grew out of a folk music workshop Joan Baez gave at the institute three years before. The festival site held only a small crowd, and the concert was promoted virtually by secret.

Baez was probably Marshall's greatest subject. Throughout his career, over the dozens and dozens of long-lasting relationships he developed with his subjects, Marshall would return time and time again to Baez. He loved her through his lens.

For the little celebration at Big Sur that June, Baez invited her sister Mimi Farina and their friend Judy Collins. The Chambers Brothers, a gospel group yet to have their souls psychedelicized, joined the bill, along with folksinger Mark Spoelestra and Al Kooper, who had quit the Blues Project and, while at loose ends, taken a job as stage manager for the Monterey Pop Festival. Also fresh from Monterey, Paul Simon and Art Garfunkel made a surprise, unannounced appearance before the audience of a couple hundred, where the performers played on the slope of a hill, separated from

the small crowd by the swimming pool. There was no electric rock, only lots of singing, acoustic guitars, and informal performances with festival guests joining each other onstage.

Baez reigned over the proceedings like a gorgeous, glowing queen, even donning a crown of flowers at one point. The Esalen Institute provided a serene and remote setting. Many of the people attending the concert were guests at the retreat, which features outdoor communal baths and unparalleled ocean vistas. The entire event was more like a private party than a folk festival, a fitting tribute to Baez, an admirable down-to-earth musician—not a star—who stood for nonviolent principles and ideals and used her popularity to advance humanitarian goals. The Big Sur Folk Festival was her little clambake.

(OPPOSITE) *Joan Baez;* (TOP) *Judy Collins, Joan Baez, and Mimi Fariña onstage;* (ABOVE) *Festival attendees dancing by the shore. All images from these pages, as well as pages 212–215, were taken at the Big Sur Folk Festival, 1967.*

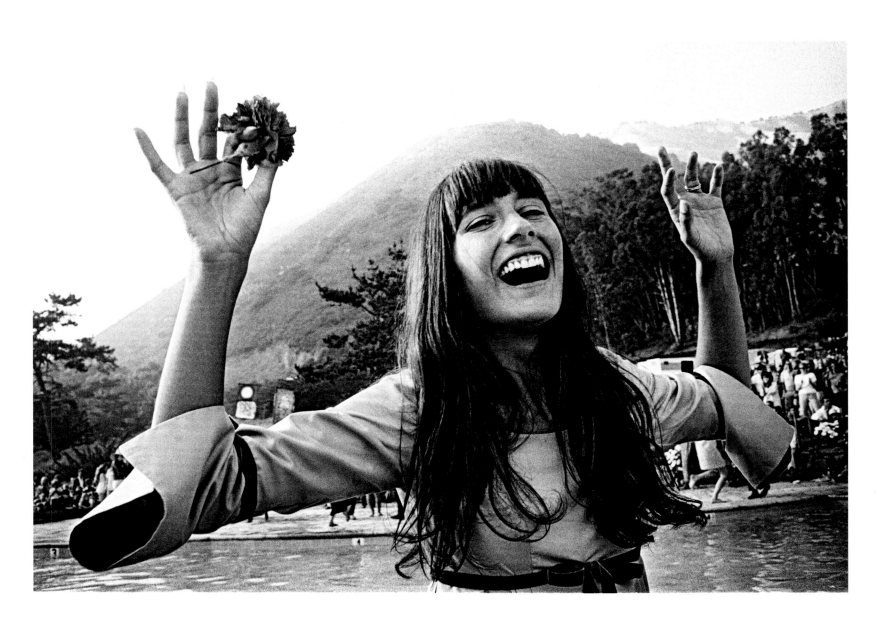

(ABOVE) *Mimi Fariña;*
(OPPOSITE) *Joan Baez*

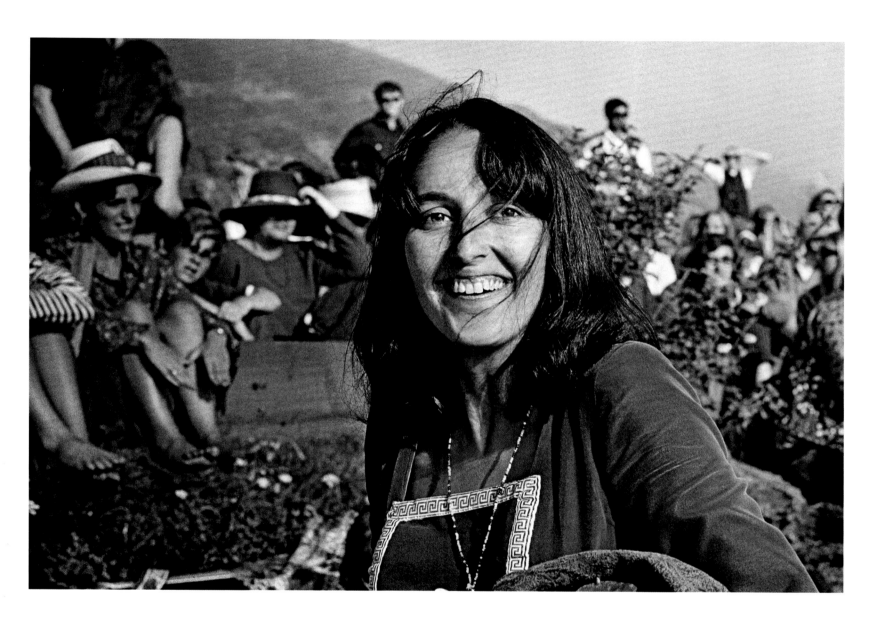

You know what I call it? The perfect storm. There was the music, the songwriters. Everything was coming together toward this implosion in the middle—there was a civil rights movement, there was the war. There was a feeling of cohesiveness, which is the main thing that's missing now. There's plenty of activity, plenty of heart, plenty of people thinking. . . . There just isn't the glue to bring them together in any lasting way. —JOAN BAEZ (FOLKSINGER, PEACE ACTIVIST)

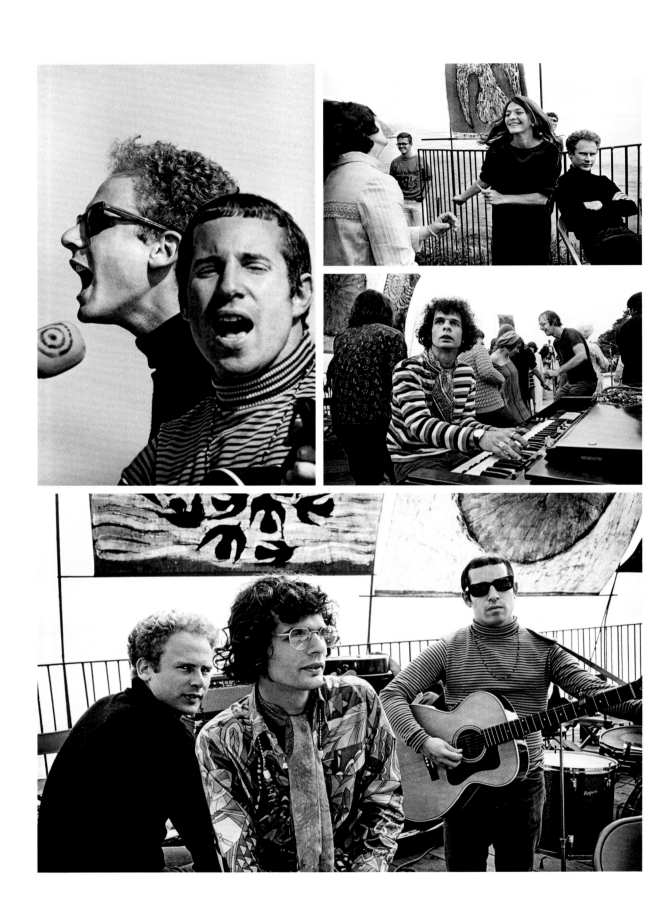

(THIS PAGE) *Al Kooper, Art Garfunkel, and Paul Simon;*
(RIGHT) *Ralph Gleason with Simon and Garfunkel*

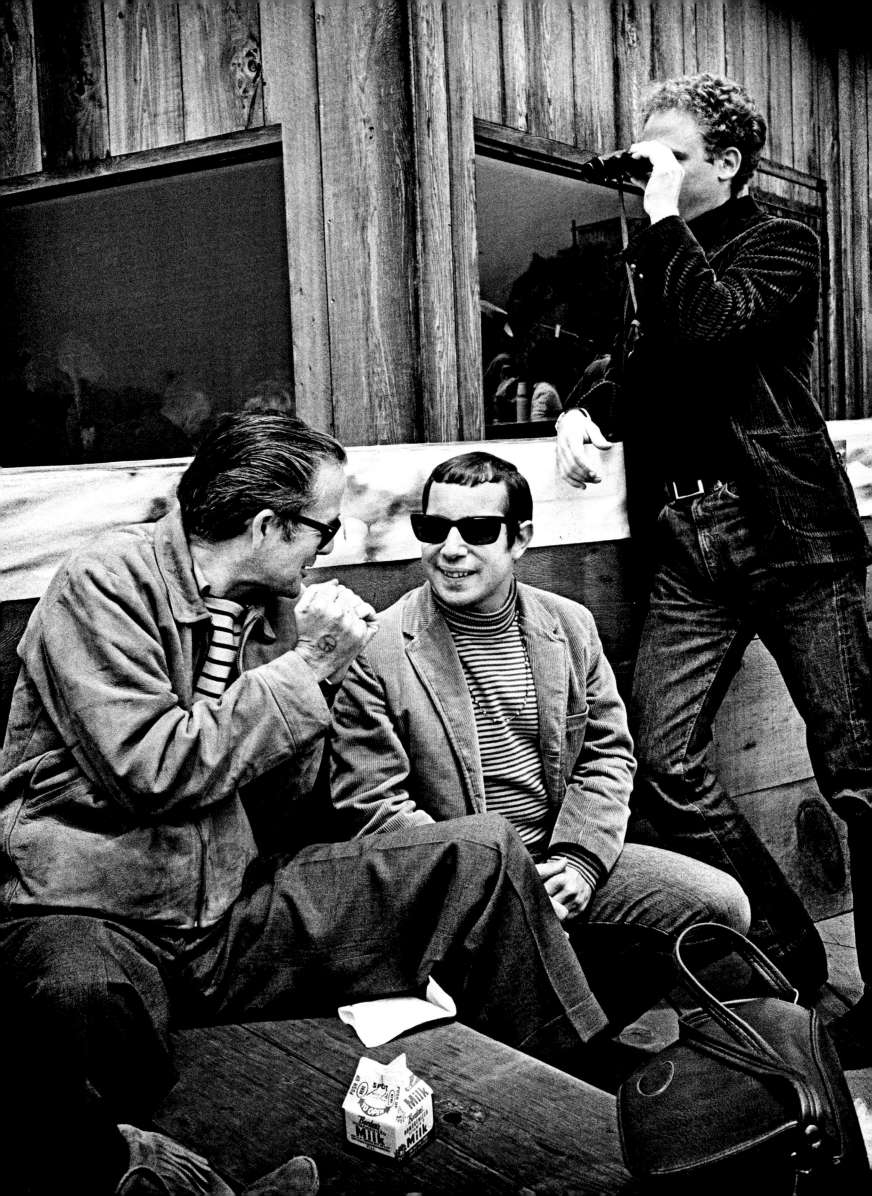

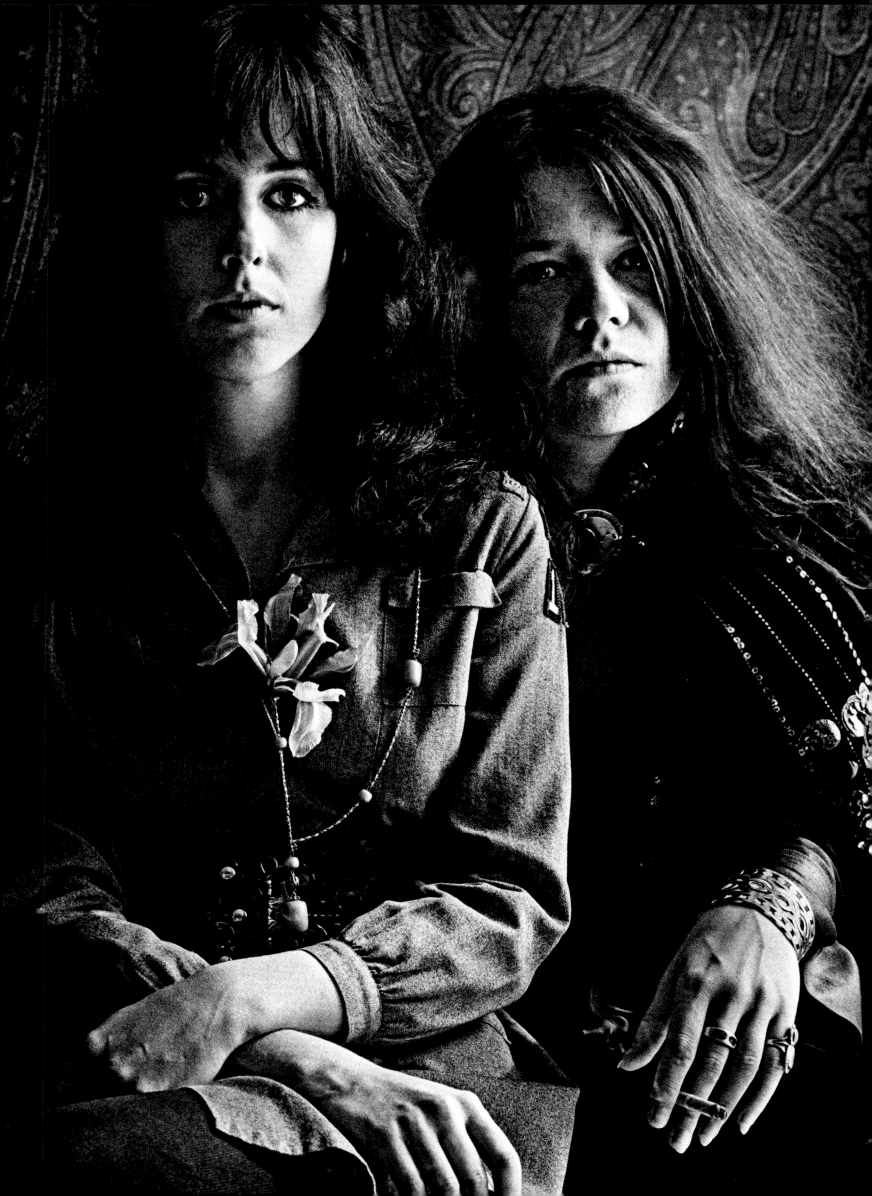

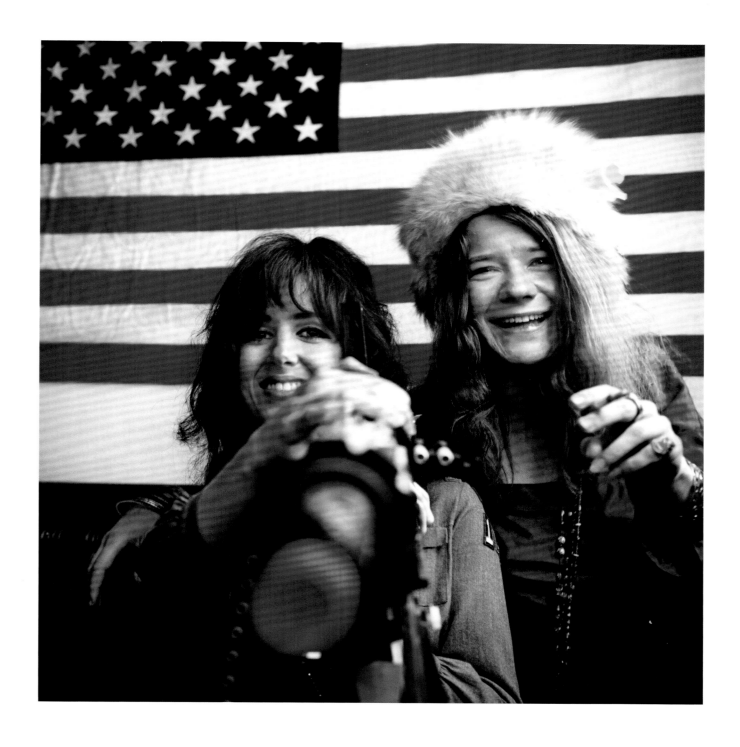

THE QUEENS: JANIS AND GRACE SHORTLY AFTER MONTEREY POP, MARSHALL TOOK JANIS
JOPLIN FOR A PHOTO SESSION OVER TO THE WASHINGTON STREET DUPLEX WHERE GRACE SLICK
lived with Airplane drummer Spencer Dryden downstairs (and Airplane guitarist Kaukonen lived upstairs with his wife). Slick
kept a wooden wheelchair by the fireplace and an American flag hung on the wall. They were not really friends, but the two
women knew each other from backstages around San Francisco. They had a lot in common besides both being the only females
in otherwise all-male rock bands. They both liked to drink out of the bottle. Joplin preferred bourbon, either Wild Turkey or
Southern Comfort, and Slick stuck with vodka. Glasses were always so hard to find backstage.

Joplin grew up in working-class Port Arthur, Texas, and attended the University of Texas in Austin. Her father worked at the Texaco plant. Slick was raised in the suburban splendor of Palo Alto and went to the elite private women's school Finch College. Her father was an investment banker. But both were rowdy babes, untamed and wild at heart.

Marshall wanted to photograph the two queens of San Francisco rock. Grace Slick was the unequivocal leading lady of the new rock, and Joplin had just knocked everybody dead at Monterey and was clearly the next contender. Marshall and Joplin were buddies—he could often be found hanging out at her apartment—and Slick was also fond of Marshall, who had shot her with the

Airplane since she first joined the band. Marshall asked them to smile, and without conferring, they both gave him stony looks.

Slick was wearing a Girl Scouts uniform she bought in a thrift store. Because it was a little girl's size, she belted it around the middle and turned it into a miniskirt. She didn't belong to the Girl Scouts when she was a girl and she liked the dress because it was so not her. She was anything but a Girl Scout.

There were no stylists, no hair and makeup people, no wardrobe mistresses. Just a couple of young women goofing around for a friend with a camera. It was the only time those two would pose together.

(THESE AND FOLLOWING PAGES) *Grace Slick and Janis Joplin. Images from this shoot appeared in TeenSet, 1968*

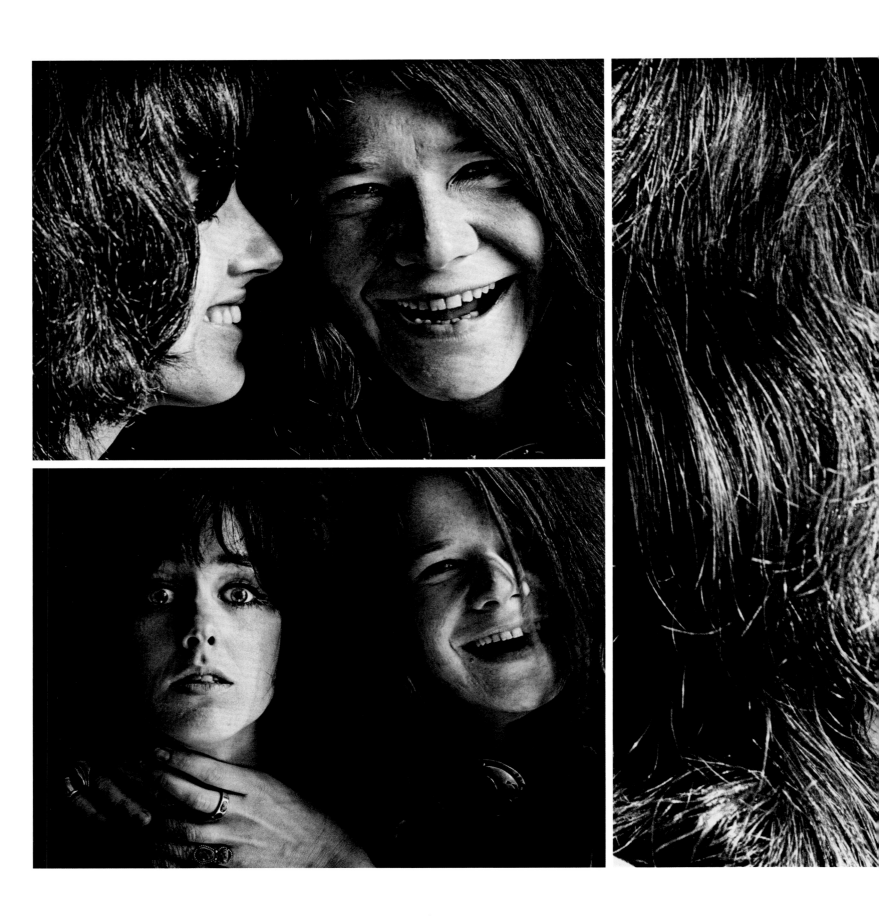

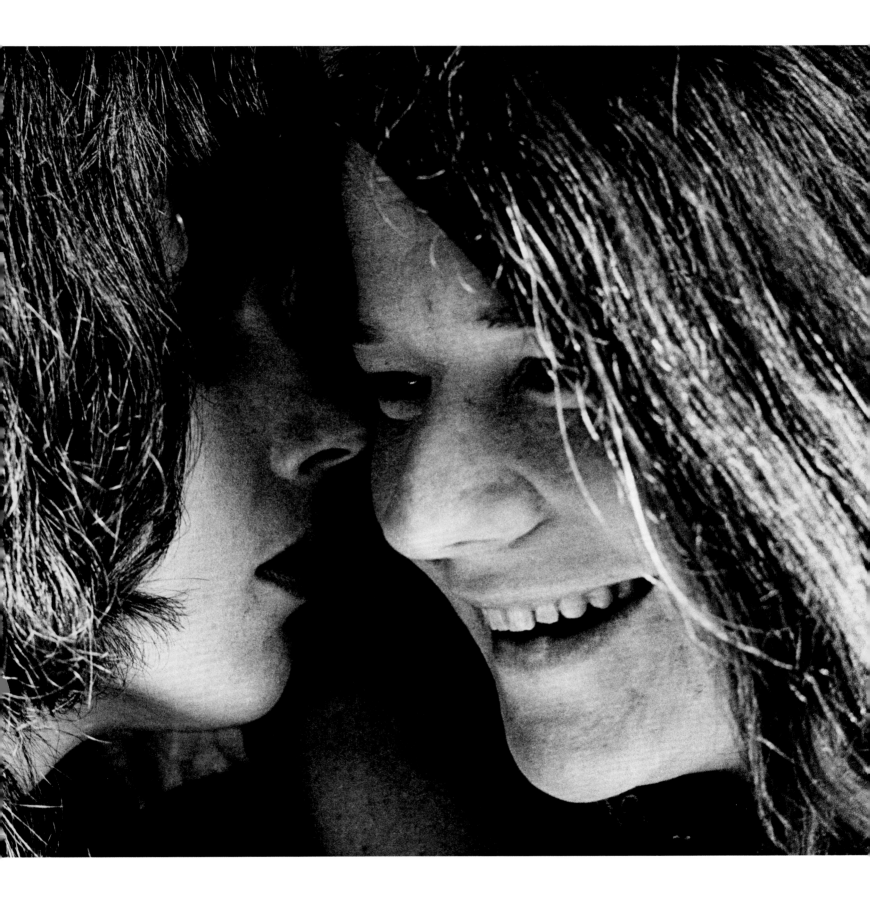

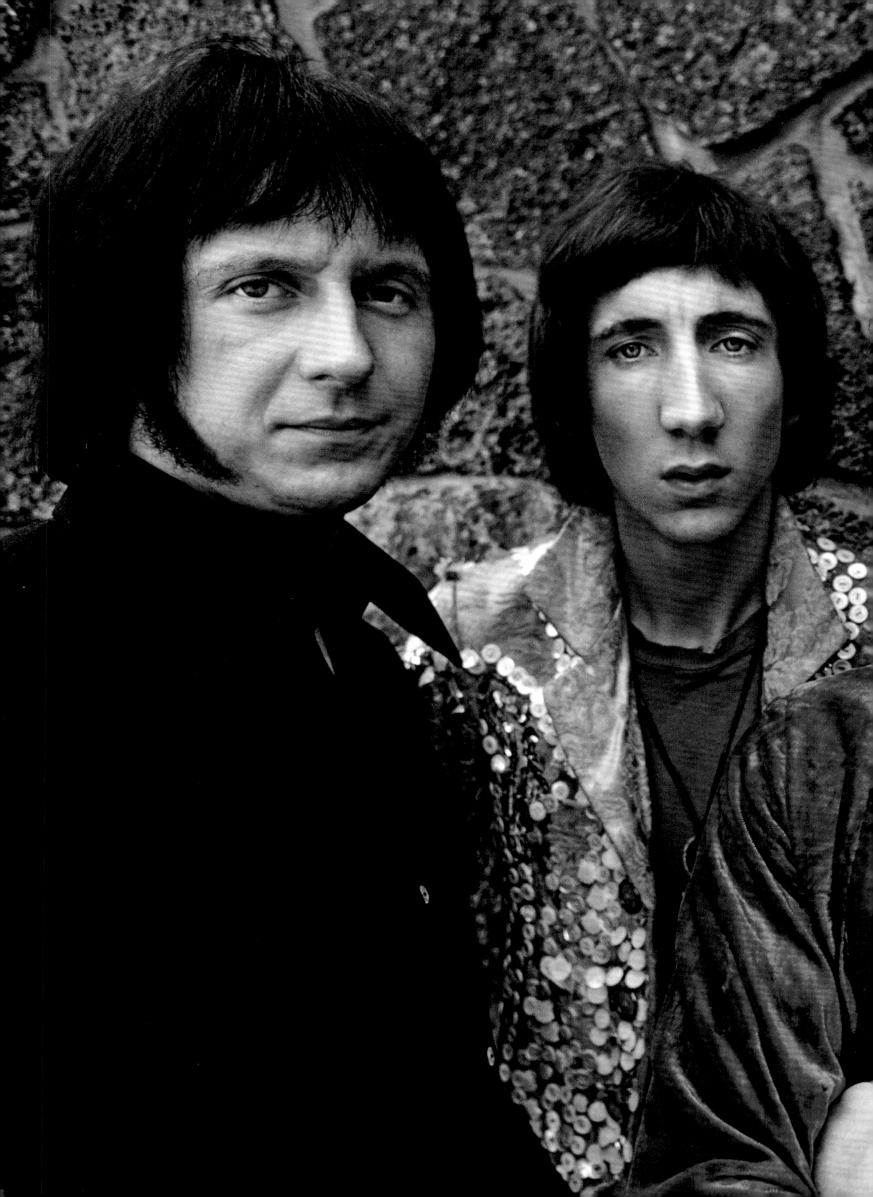

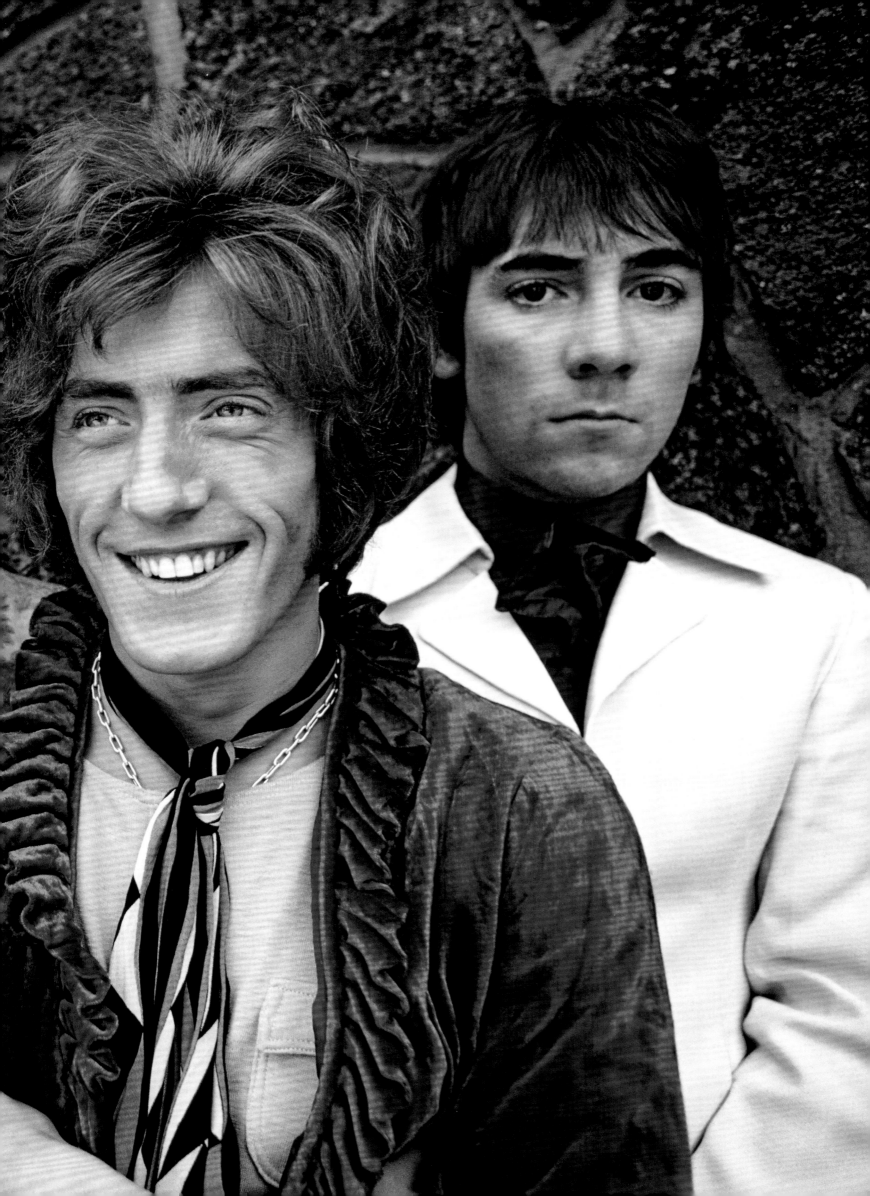

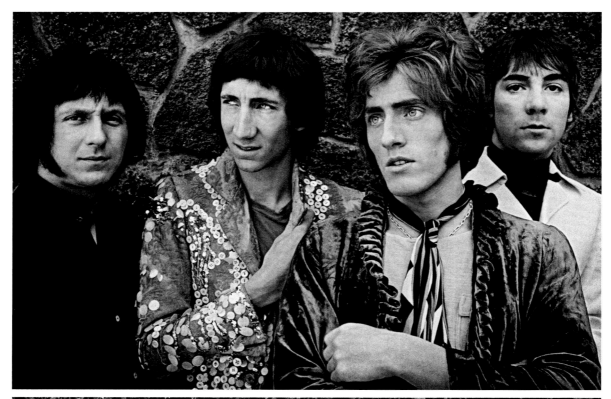

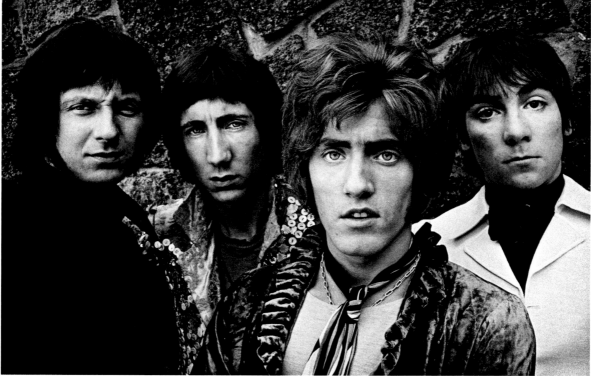

(PRECEDING PAGES AND THESE IMAGES) *The Who on the San Francisco stop of their first U.S. tour, 1967*

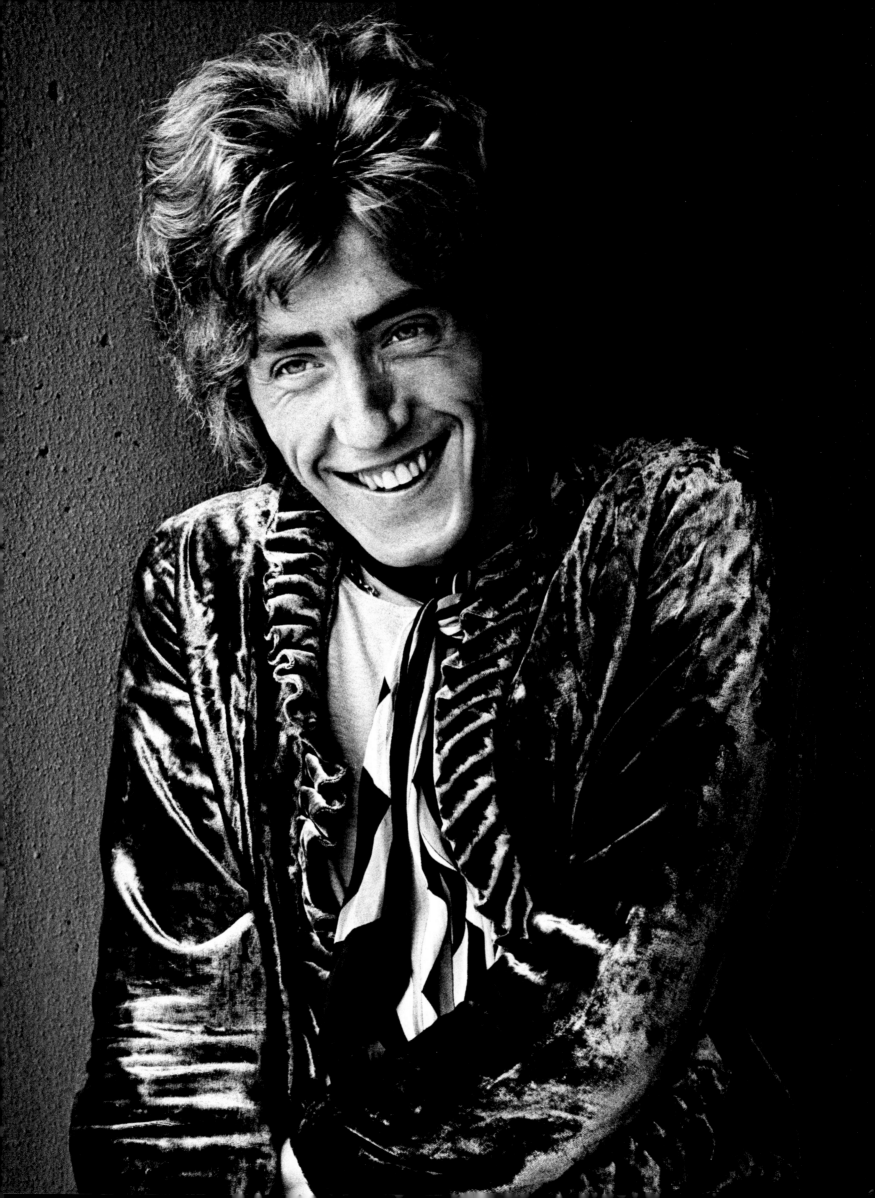

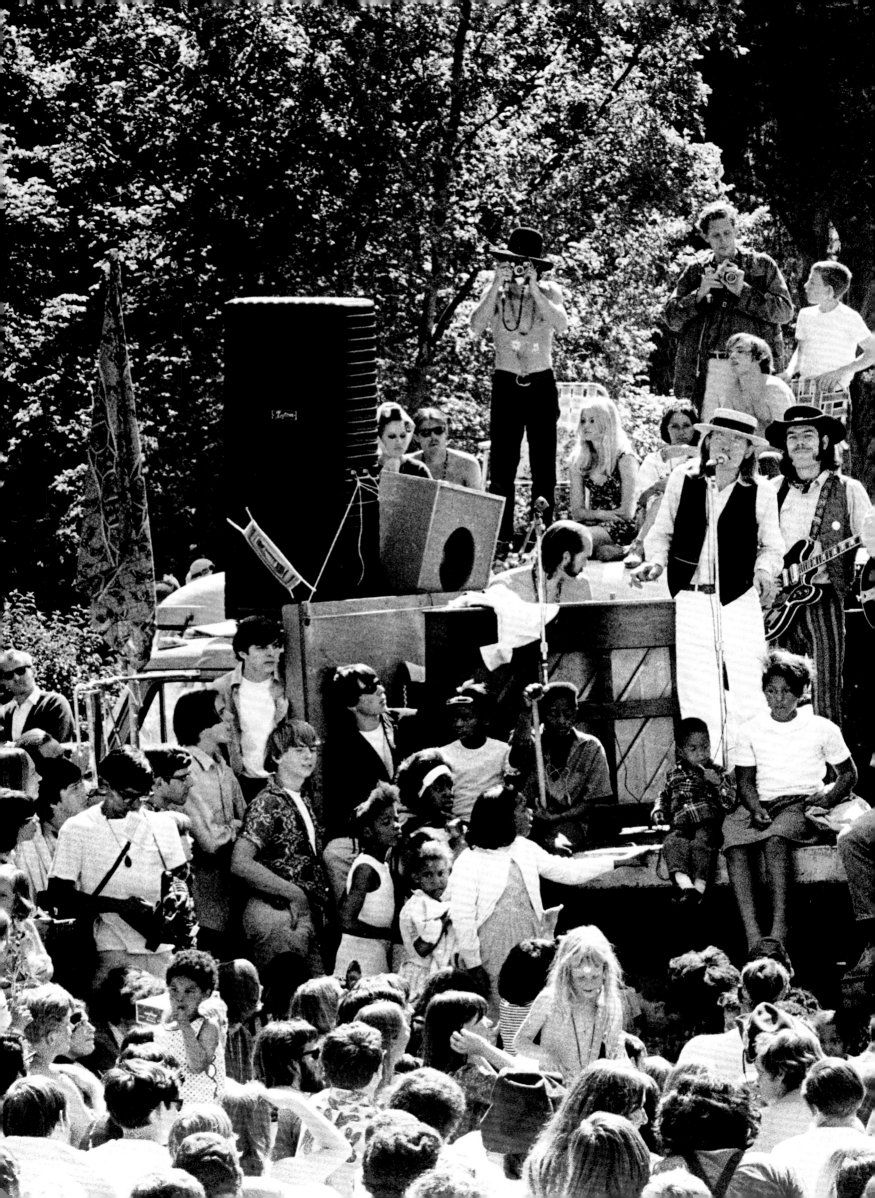

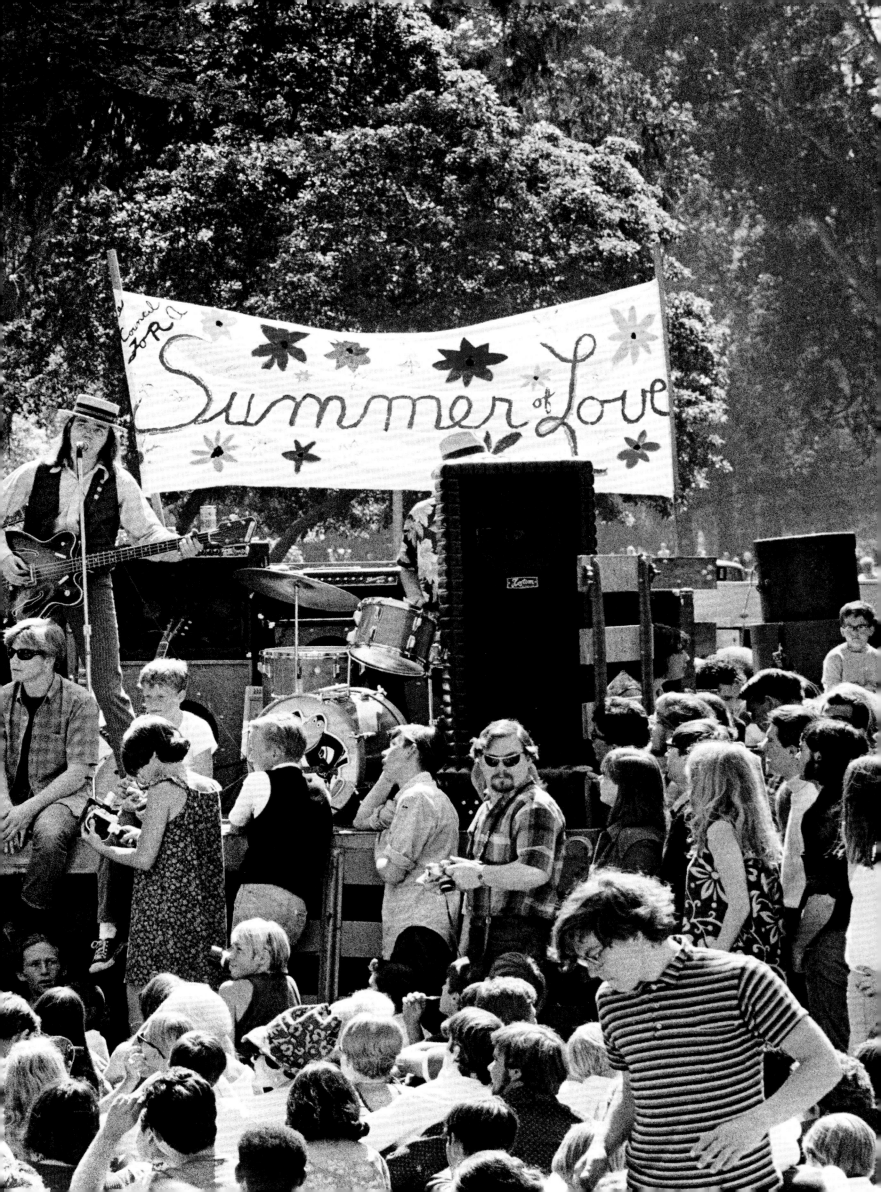

SAN FRANCISCAN NIGHTS THE SUMMER OF LOVE CAME TO THE HAIGHT. ON JUNE 21,

A THOUSAND PEOPLE GATHERED AT THE TOP OF TWIN PEAKS TO GREET THE DAWN OF THE Summer Solstice. That afternoon, a couple of thousand more gathered at Speedway Meadow in Golden Gate Park, a smaller glen than the massive Polo Fields. The Grateful Dead, Big Brother, Quicksilver, the Charlatans, and others played in a free concert welcoming the Summer of Love. The sound equipment had been "borrowed" from the Monterey Pop Festival. The crowd was filled with jugglers, people playing tin whistles, strumming guitars, stars painted on their faces. It was the Be-In writ small, a neighborhood celebration. While the Be-In was a massive event, an awakening, the Summer of Love concert was more of a leafy footnote, almost an anti-climactic gathering two weeks after Monterey Pop.

(PRECEDING PAGES) *The Charlatans perform in Golden Gate Park, 1967;* (ABOVE) *Graffiti on Haight Street, 1968;* (BELOW AND OPPOSITE) *Drug addicts and a tourist recording hippies on a stoop. Both of these images appeared in* Look *magazine's "Hippie Story," 1967*

The Haight had become world famous. The new single by Eric Burdon and the Animals, "San Franciscan Nights," toasted the Haight (Burdon experienced a memorable LSD experience during his visit to the Dead house earlier that summer). The community was overrun with young people from out of town. Crash pads overflowed. People were sleeping in the park. Huckleberry House was established as a home for runaways. Traffic on Haight slowed to a crawl, as cars clogged the street. Tourists made the sidewalks impassable. Out-of-towners mixed with the kids playing congas, begging for change, or just sitting around talking. These street urchins were not the flower children of the summer before. A lot of seedier, more insidious drugs than LSD and pot—speed, heroin, animal tranquilizers—began to seep into the scene. Cops swept the streets for runaways. There were skirmishes between the hippies and police, some near riots. The street was turning ugly.

In July, *Time* magazine featured a cover article on "The Hippies." In August, CBS News broadcast "The Hippie Temptation," a scornful, condescending news special that featured skeptical newsman Harry Reasoner interviewing the Grateful Dead. "They make you uncomfortable," Reasoner said about the hippies, "because there is obviously something wrong with

the world they never made if it leads them to these grotesqueries. But granting the faults of society, you can say three things about them. They, at their best, are trying for a kind of group sainthood, and saints running in groups are likely to be ludicrous. [Second,] they depend on hallucinations for their philosophy. This is not a new idea and it has never worked. And finally, they offer a spurious attraction of the young, a corruption of the idea of innocence. Nothing in the world is as appealing as real innocence, but it is by definition a quality of childhood. People who can grow beards and make love are supposed to move from innocence to wisdom."

But the appeal of the hippie scourge proved irresistible, even to the merely curious. No visit to San Francisco was complete without a Haight-Ashbury tour. Ballet stars Rudolph Nureyev and Dame Margot Fonteyn were rousted from a Haight-Ashbury rooftop when a noise complaint about a party turned into a drug bust that made headlines around the world. The crowning moment came in August, when, wearing heart-shaped sunglasses and accompanied by his wife Pattie Boyd, George Harrison of the Beatles took a walking tour through the Haight, trailing a gathering throng like the Pied Piper, an impromptu visit reported worldwide. Mohammed had truly come to the mountain.

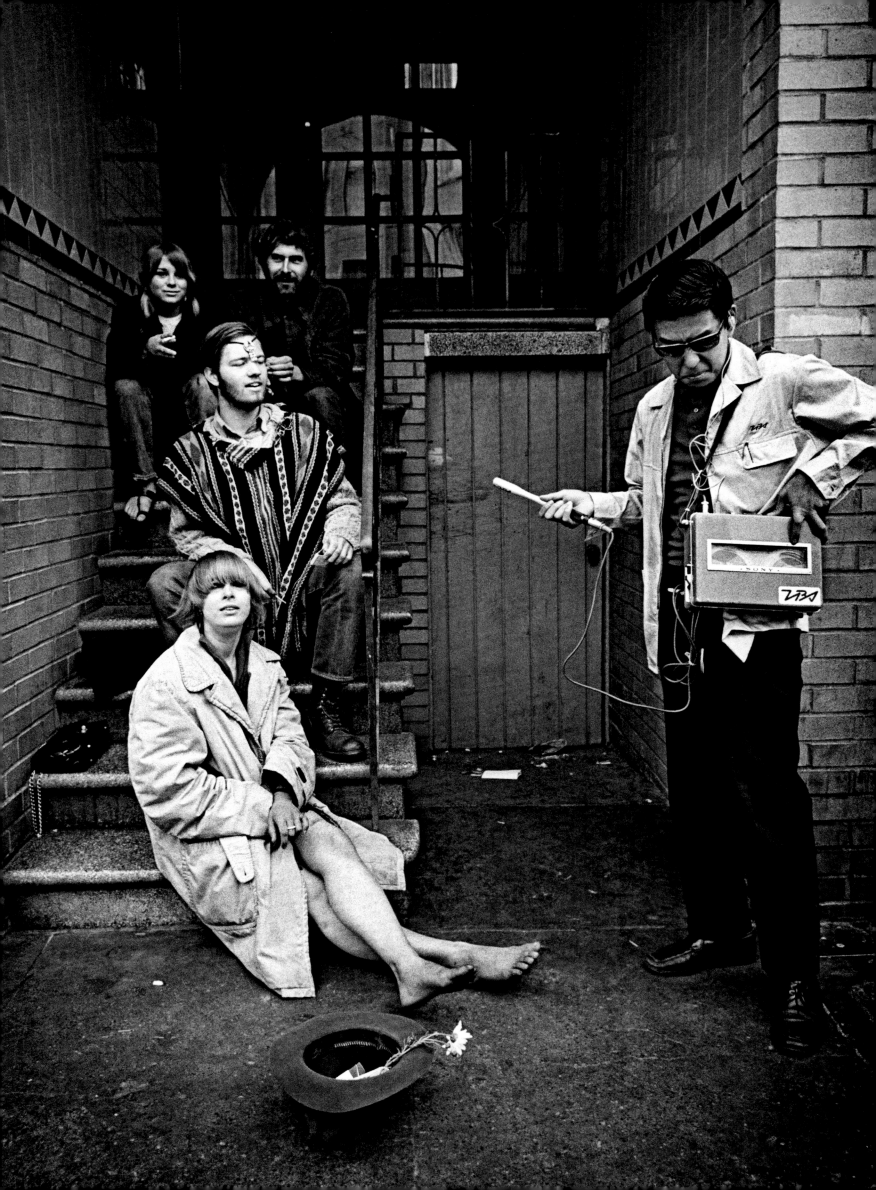

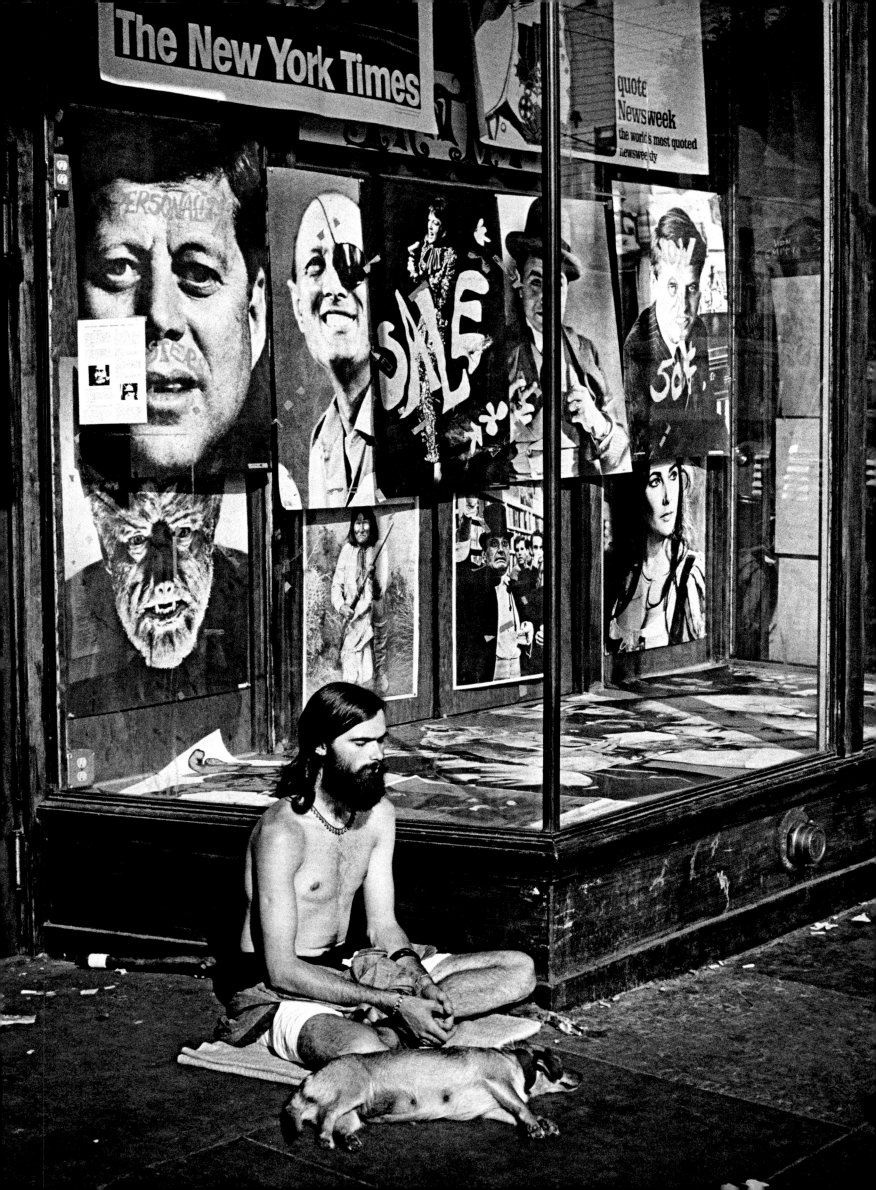

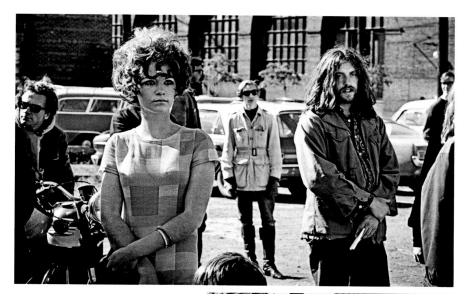

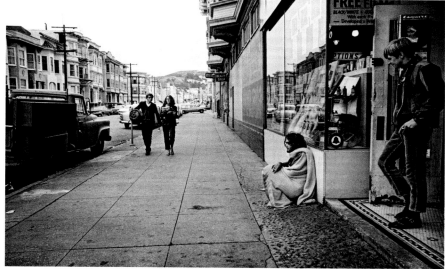

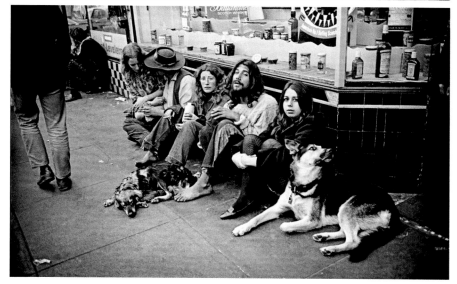

(THESE PAGES) *Street scenes in the Haight, 1967–1968,*
the darker side of the streets apparent; (FOLLOWING PAGES)
Drug den behind a storefront on Haight Street, 1967

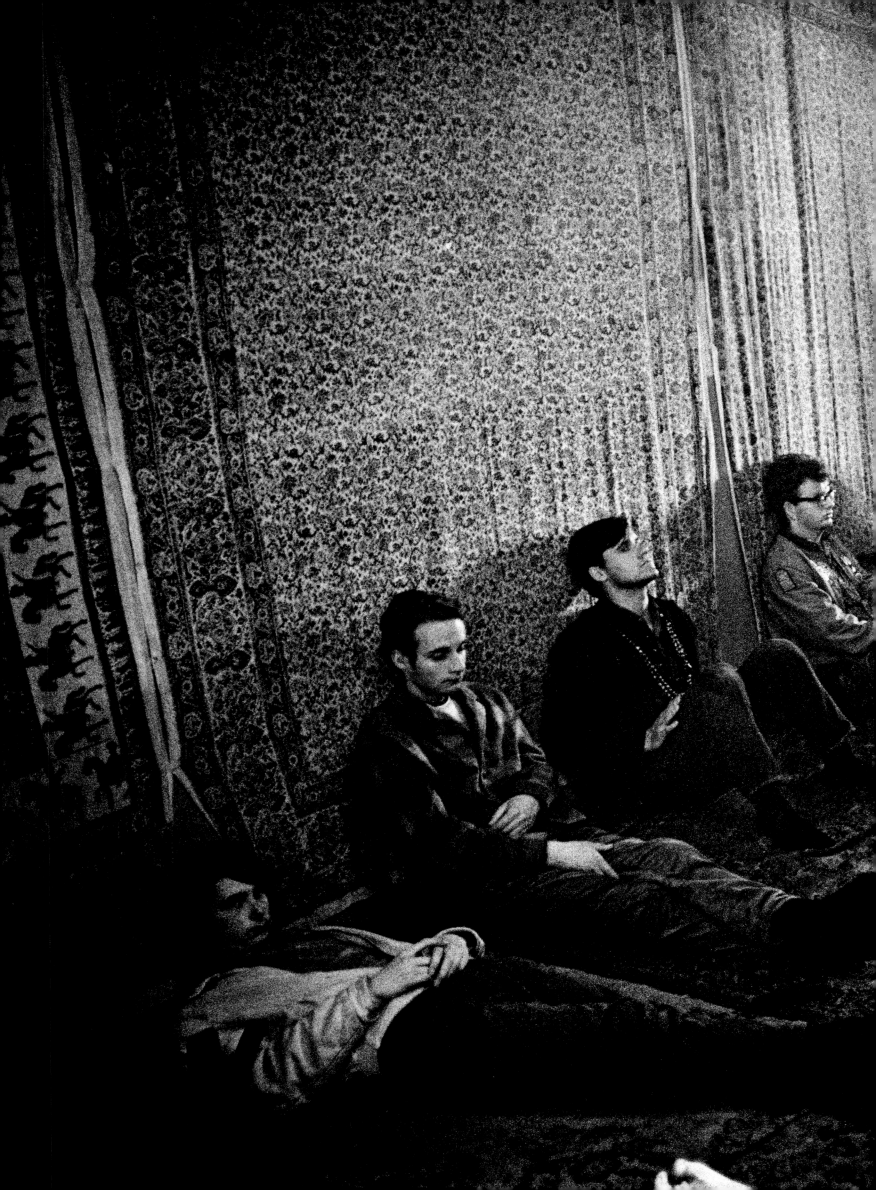

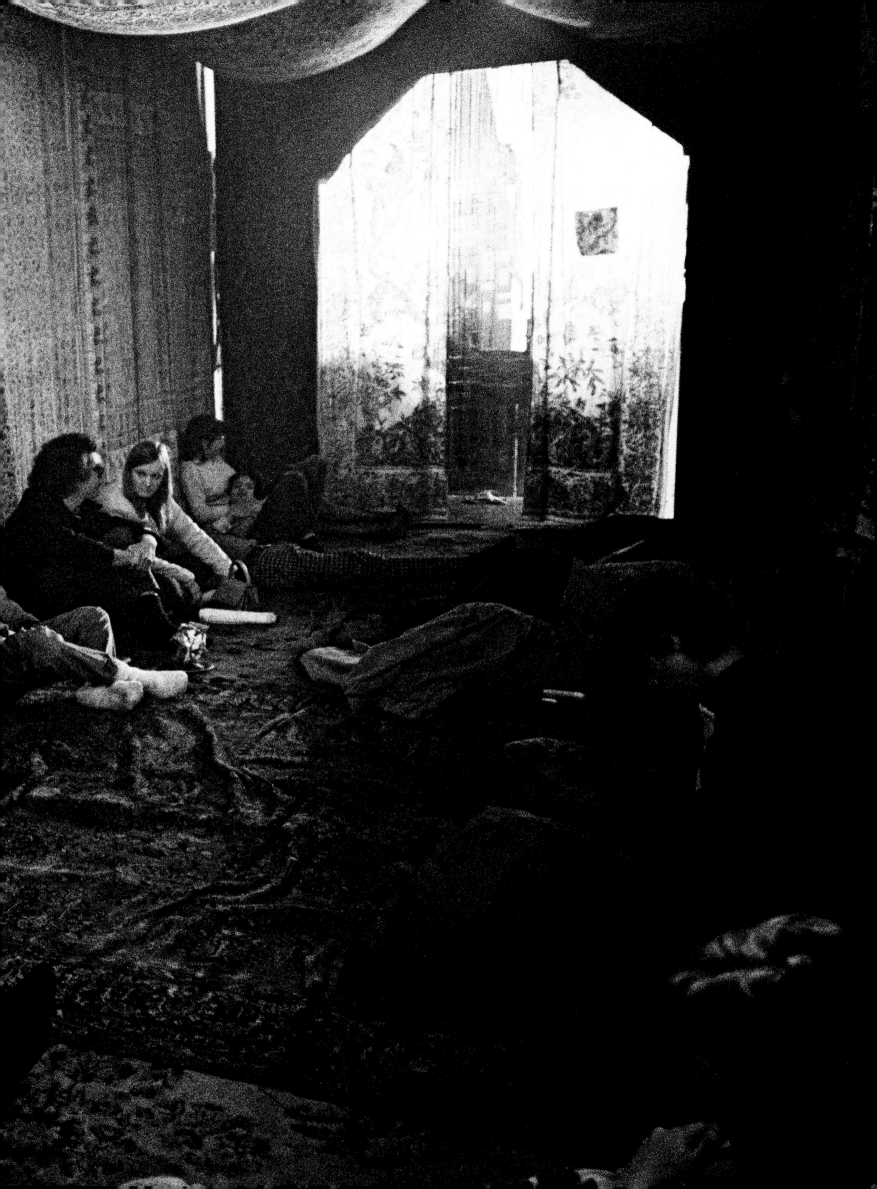

AIRPLANE: HIGH-FLYING BIRD JEFFERSON AIRPLANE HUDDLED THAT SUMMER IN THE PINK
MANSION IN THE HOLLYWOOD HILLS WHERE THE BEATLES STAYED AND GEORGE HARRISON WROTE
"Blue Jay Way," recording the band's next album at RCA Studios. The contract called for unlimited studio time, and the label was
paying the rent on the mansion, so the band was in no hurry. The Airplane didn't mind success, but they hated show business.
Relations were tense and strained with manager Bill Graham, who complained he couldn't hum any of the new songs. He got into
screaming matches with band members. Grace Slick yelled back. It was a band without a leader. Guitarist Jorma Kaukonen and
his old friend from high school in Baltimore, bassist Jack Casady, became like a group within the group. With Grace Slick and
drummer Spencer Dryden forming a personal relationship, Marty Balin was becoming increasingly marginalized in the band he
had founded. Oddly enough, guitarist Paul Kantner flourished under all the contention and wrote most of the songs for the new
album, *After Bathing at Baxter's*, the first truly psychedelic album by the Airplane.

Surrealistic Pillow made the Top Ten and—along with the two hit singles—transformed the band into a phenomenon. *Look* magazine featured the group ("Jefferson Airplane must love you. Can you love Jefferson Airplane?"). The band produced a couple of weird radio ads for Levi's. The new album progressed haltingly; Graham kept the band busy with a heavy schedule of concert appearances and little regard for routing. If he could find a flight that would make it in time, he would take the booking.

Bill Graham arranged for Jefferson Airplane to play in August in Toronto, the first international excursion by the new sound, and the Grateful Dead went along. After the Airplane warmed up the town with a free concert before forty thousand people, the two bands attracted good crowds to their shows at the O'Keefe Center. Outside

of a week at New York's Café Au Go Go just before the Monterey Pop Festival, this was the Dead's first real road trip. The two bands brought everybody: wives, girlfriends, cast, and crew—and booked adjoining rooms on the same floor of the hotel, redecorated the rooms with Indian bedspreads and candles, threw open all the doors, and partied. They followed the Toronto shows with a concert at the Youth Pavilion of Expo '67 in Montreal. The Airplane left the Dead, with all the band's luggage and gear, on a sidewalk in Montreal. Somebody in the Dead traveling party had a credit card, and rental cars were acquired. The group drove to Millbrook, New York, for a summit meeting with Timothy Leary. In New York City, the band played a memorable show for the Diggers on the roof of the Chelsea Hotel and stopped on the way home for a weekend at the Grande Ballroom in Detroit.

*(ABOVE) Grace Slick and Spencer Dryden
of Jefferson Airplane at the San Francisco
Airport, 1967; (OPPOSITE TOP) Cream, 1967*

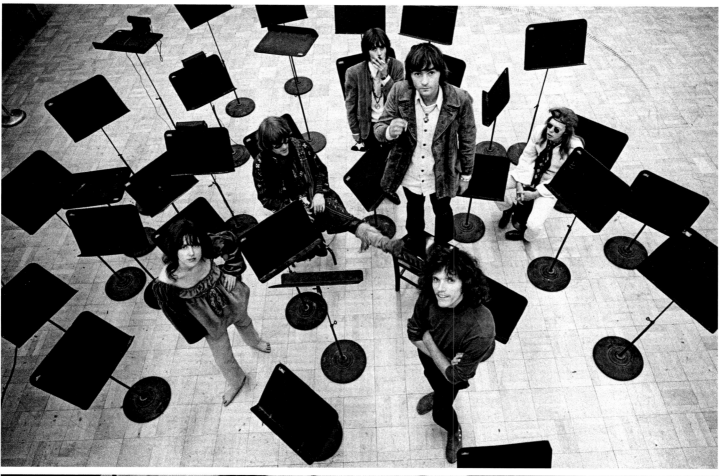

(ABOVE) *Jefferson Airplane at RCA Studios in Los Angeles, 1967;*
(FOLLOWING PAGES) *Jefferson Airplane in Golden Gate Park, 1967.*
Taken during a photo shoot for their album Volunteers.

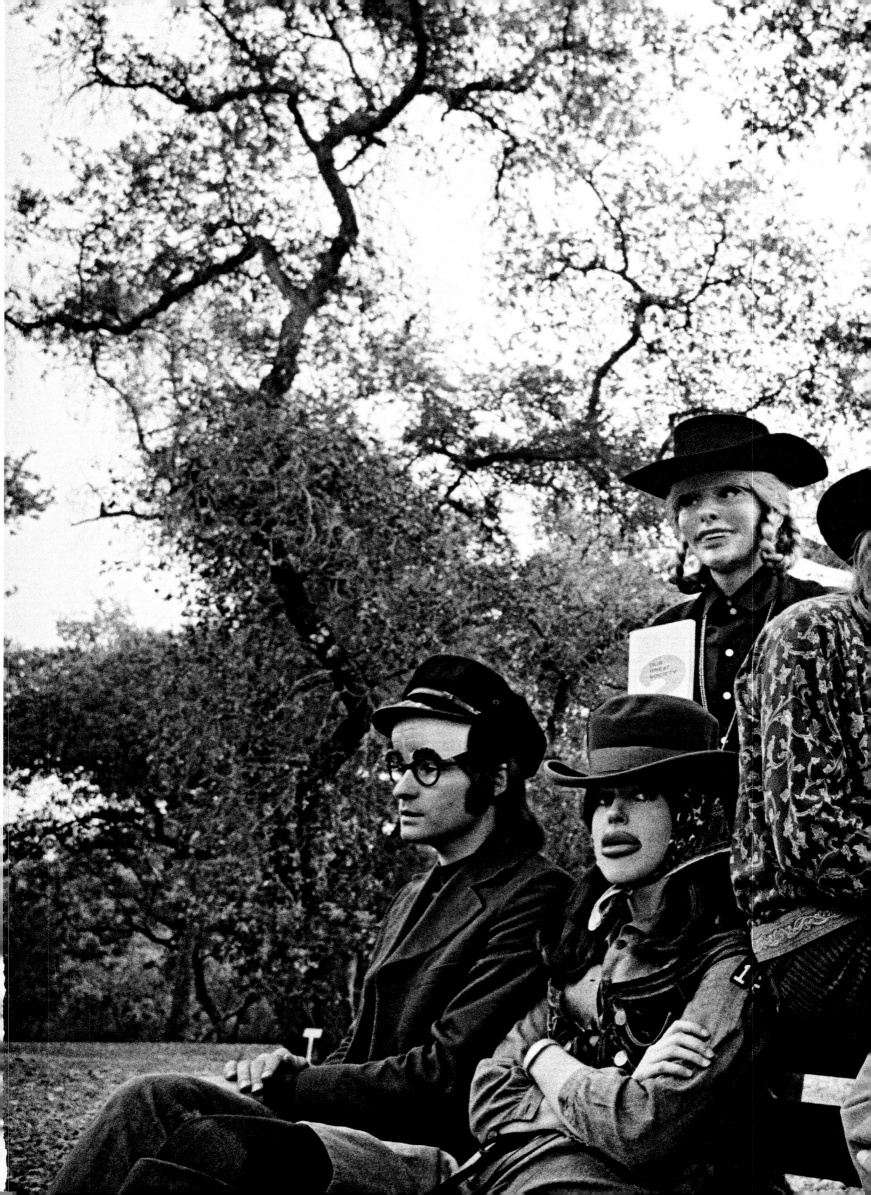

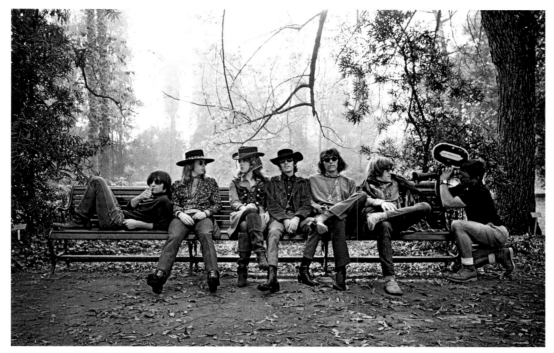

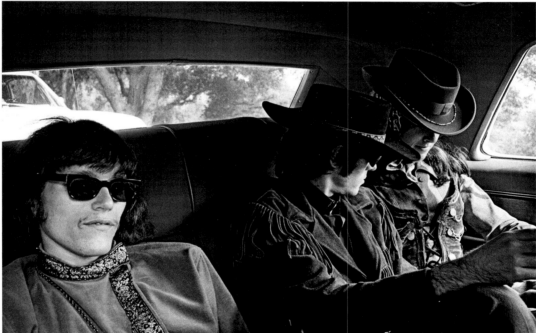

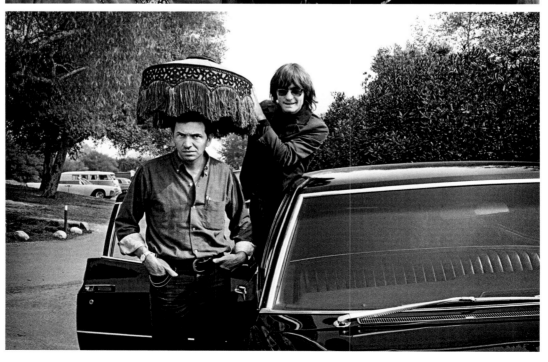

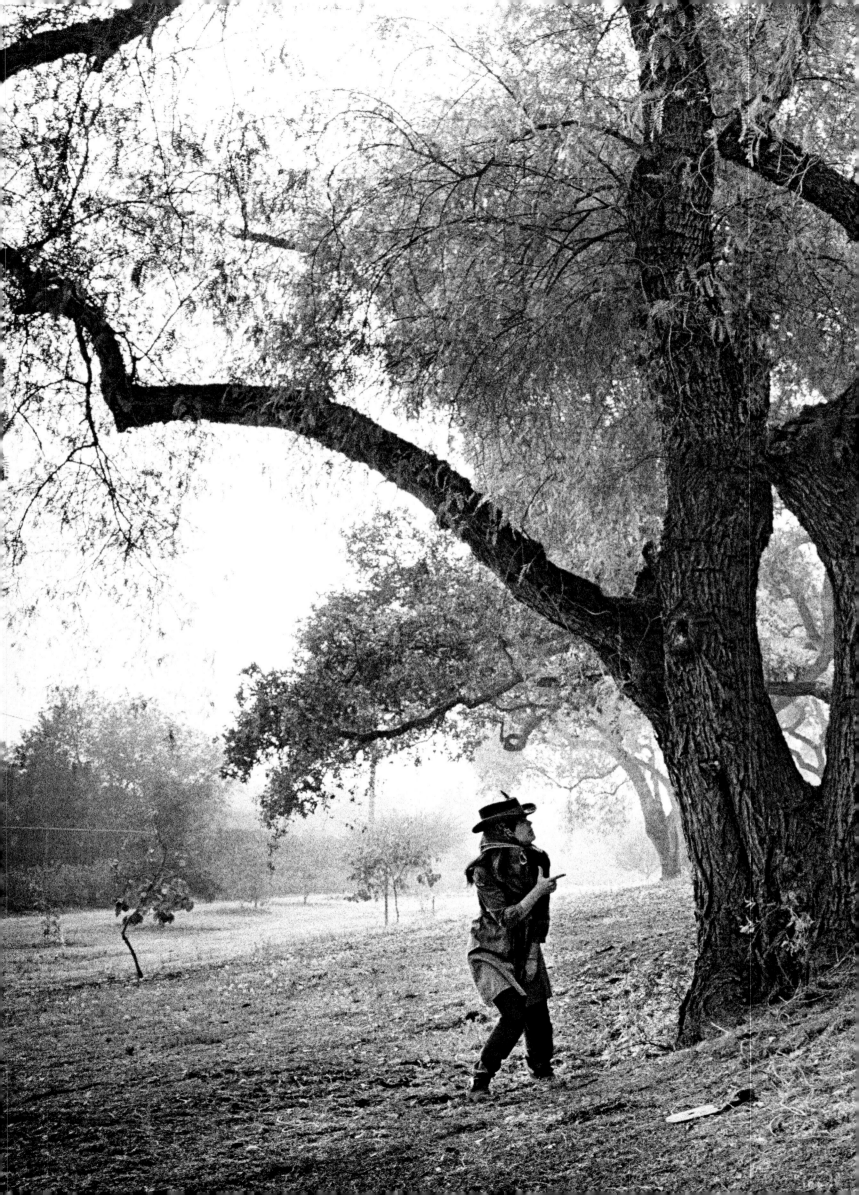

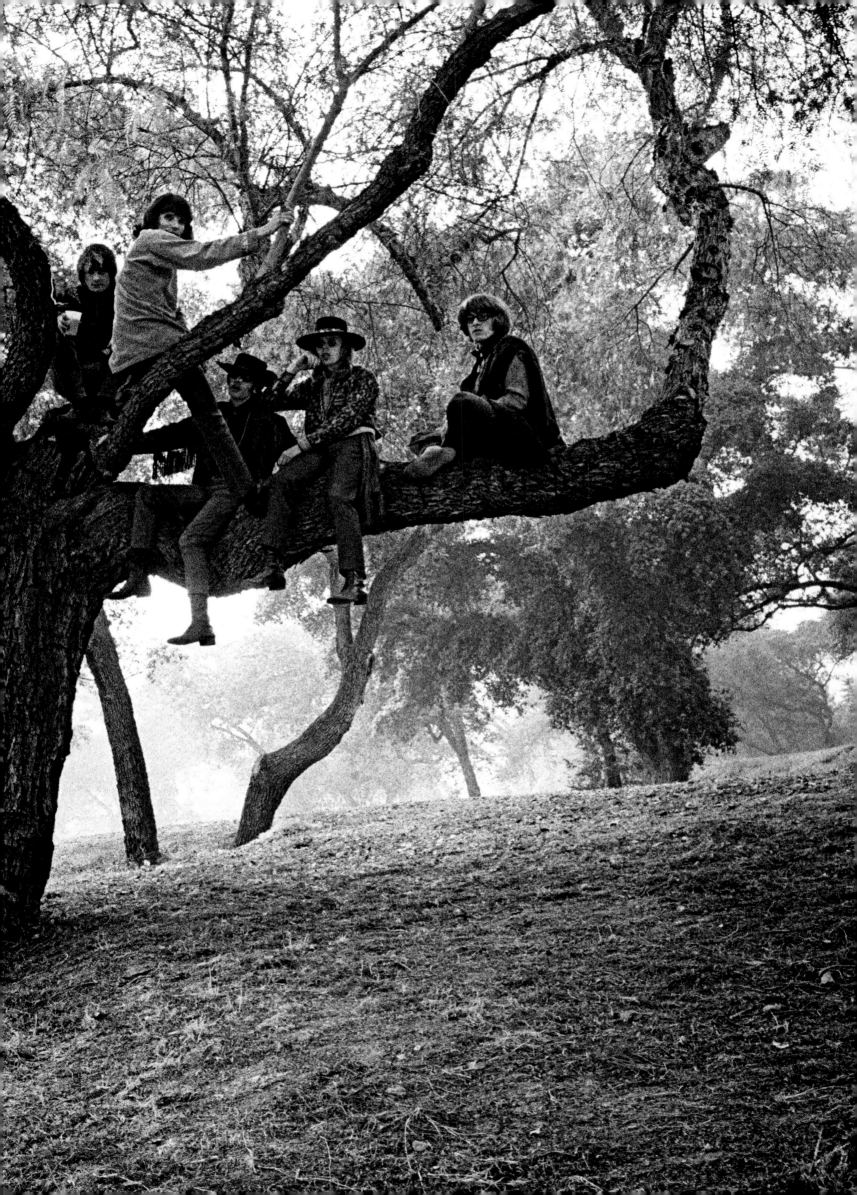

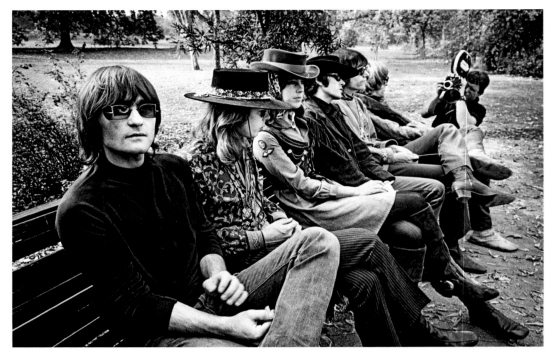

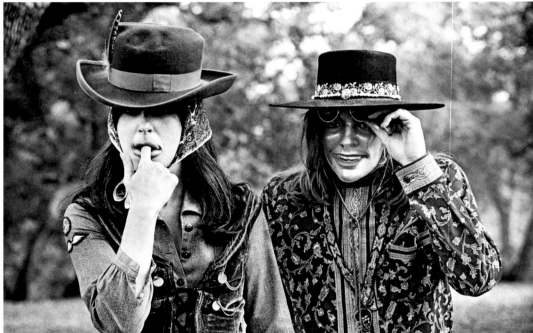

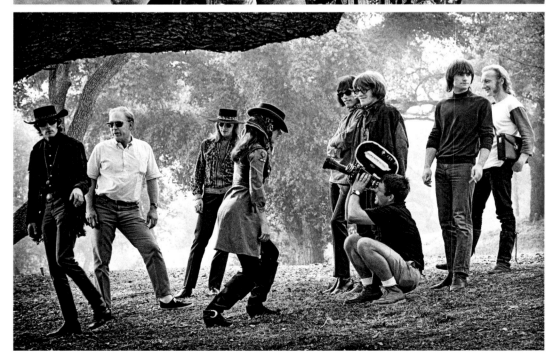

(THESE PAGES) *Images from
the* Volunteers *shoot;*
(CENTER) *The* Volunteers
album cover

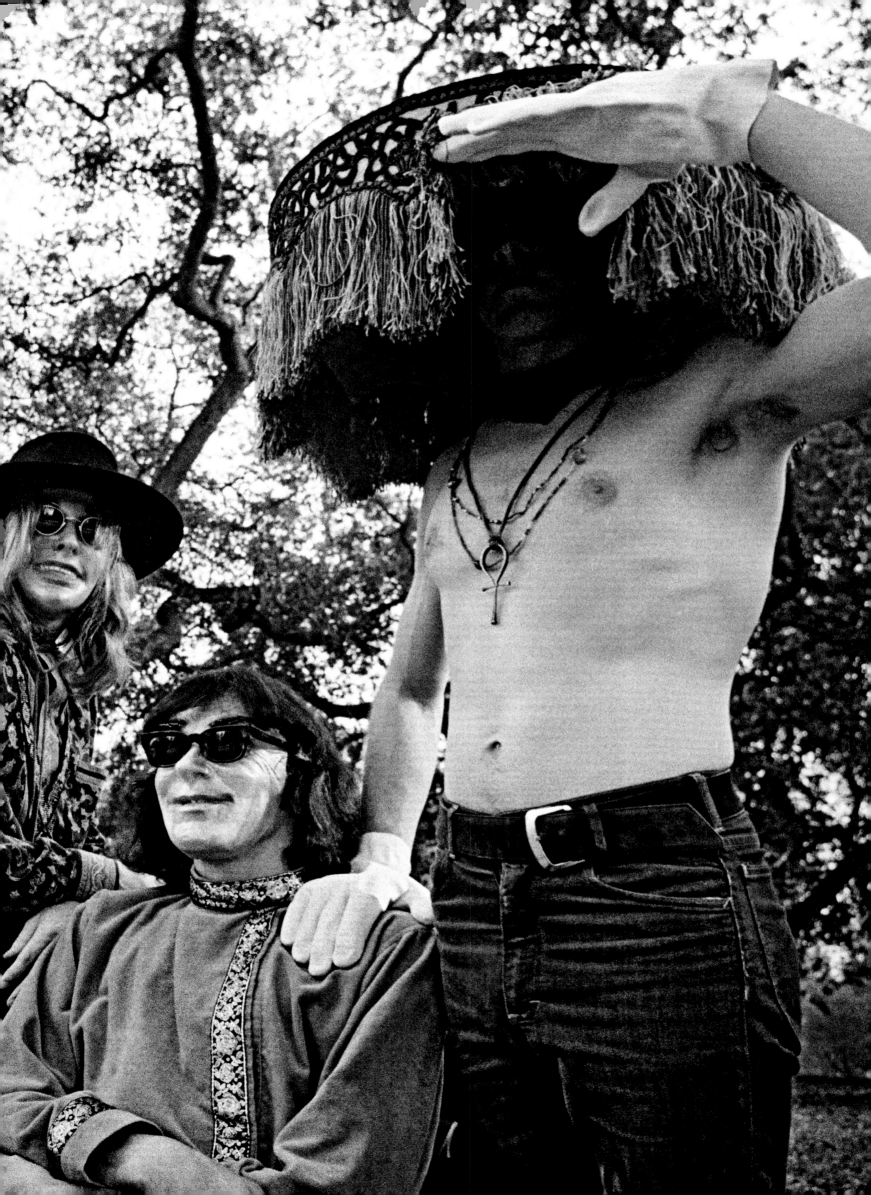

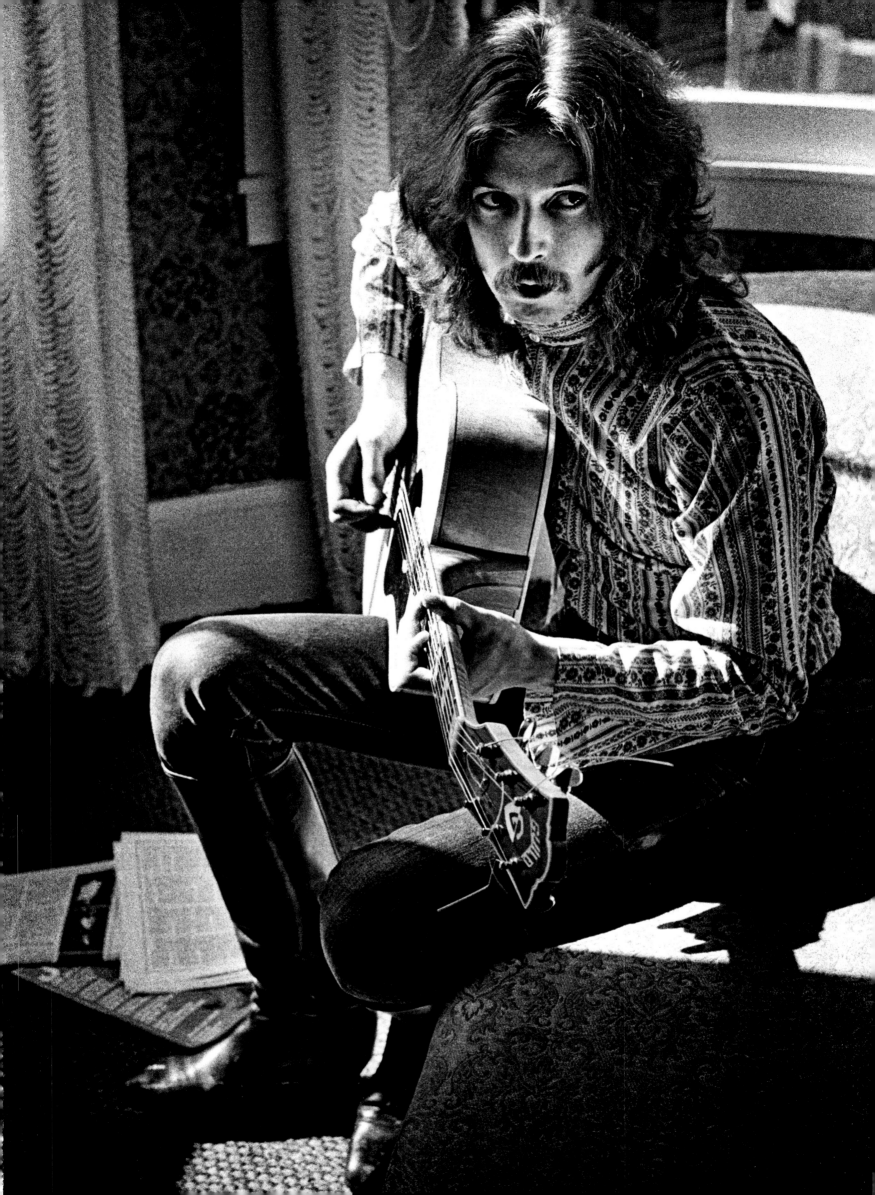

CREAM: BRITISH ROCK ROYALTY

THE MEMBERS OF THE AIRPLANE—ESPECIALLY KAUKONEN AND CASADY—HAD FALLEN UNDER THE SPELL OF A NEW BRITISH ROCK BAND CALLED CREAM, and they chartered a private plane to ferry the band back from a concert in Southern California to see Cream at the Fillmore in August. The Airplane was not alone. The debut album called *Fresh Cream* had been a staple on KMPX since the station first got copies of the English album ahead of its U.S. release at the beginning of the year. A supersonic trio led by guitarist Eric Clapton, a key figure in England's blues-rock revival through his work with the Yardbirds and John Mayall's Bluesbreakers, Cream adopted the improvisational ethos of the San Francisco bands and through the sheer virtuosity of the three musicians—also including bassist Jack Bruce and drummer Ginger Baker—pushed the music to new levels. They cracked open the blues and filled the spaces with buzzing, driving, hyper-intense psychedelic energy. They arrived in San Francisco hailed in hip circles as the latest and greatest.

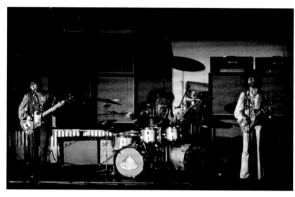

Graham, who booked the band for eleven shows over two weeks, told the musicians they could play as long as they wanted. They dispensed with the typical forty-five-minute set and stretched out. Buried onstage beneath the light show, frequently under the influence of LSD supplied by Owsley, they lost themselves in the music like never before.

Almost every musician in town was in the house. Red lights blinked on stacks of Marshall amplifiers, unlike anything previously seen on the Fillmore stage, in the darkened hall as Clapton struck the opening chord of "Tales of Brave Ulysses." As quickly as Hendrix had surged to the forefront of the modern music movement, Cream stepped up right behind him. The band arrived in San Francisco expecting some modest interest, stirrings from the underground, but was utterly unprepared to be received as conquering heroes and was encouraged to play their greatest music. Years later, Clapton would describe those two weekends at the Fillmore—when the British band arrived in the heart of the pop music universe and took it by storm—as the height of the band's brief, incendiary career.

Marshall photographed the three men in the stairwell of the Sausalito Inn, where they were staying, jamming and smoking weed with visitors like Jerry Garcia, David Crosby, and Mike Bloomfield. He took them to the waterfront park in front of the hotel and took more shots, as well as shooting the concerts at the Fillmore. Decked out in fashionable Edwardian wear, Clapton's hair curling glamorously around his neck, they looked every bit the hero British rock stars they were.

(OPPOSITE) *Eric Clapton, August 1967;* (THIS PAGE) *Cream, August 1967;* (FOLLOWING PAGES) *Jack Bruce, Ginger Baker, and Eric Clapton of Cream in the lobby of the Sausalito Hotel, 1967*

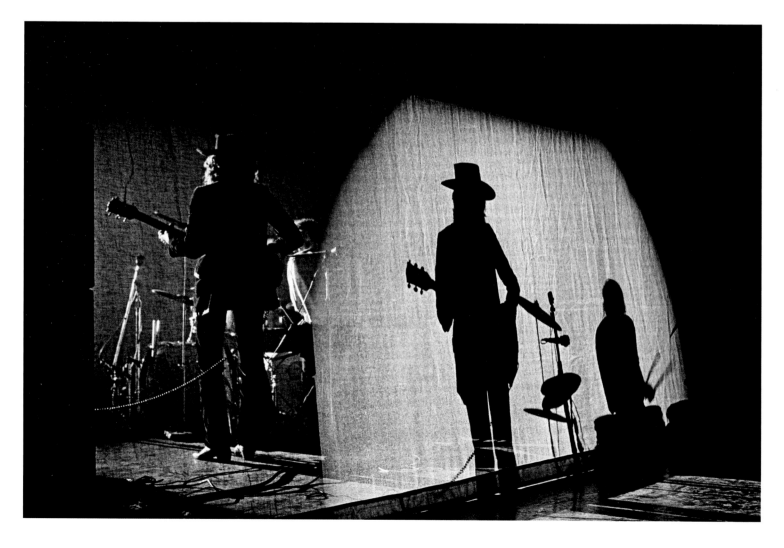

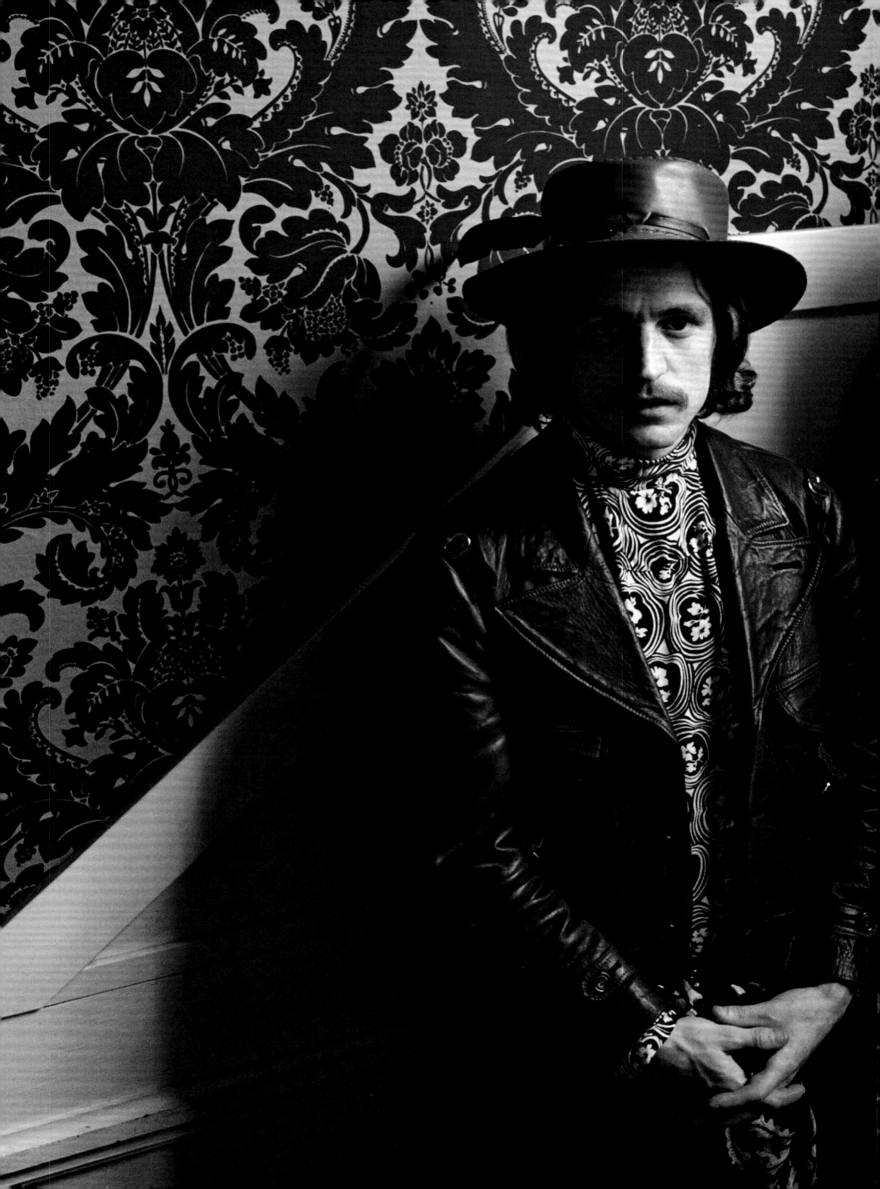

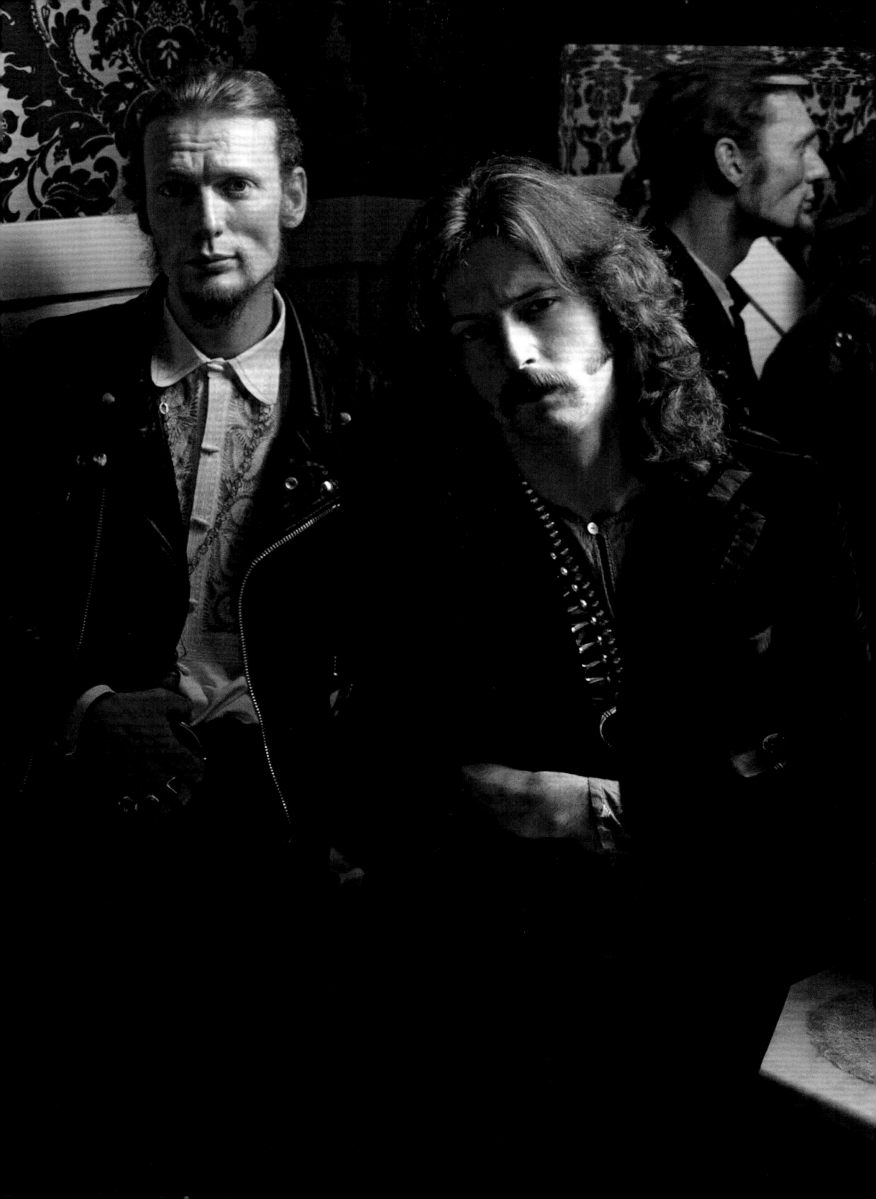

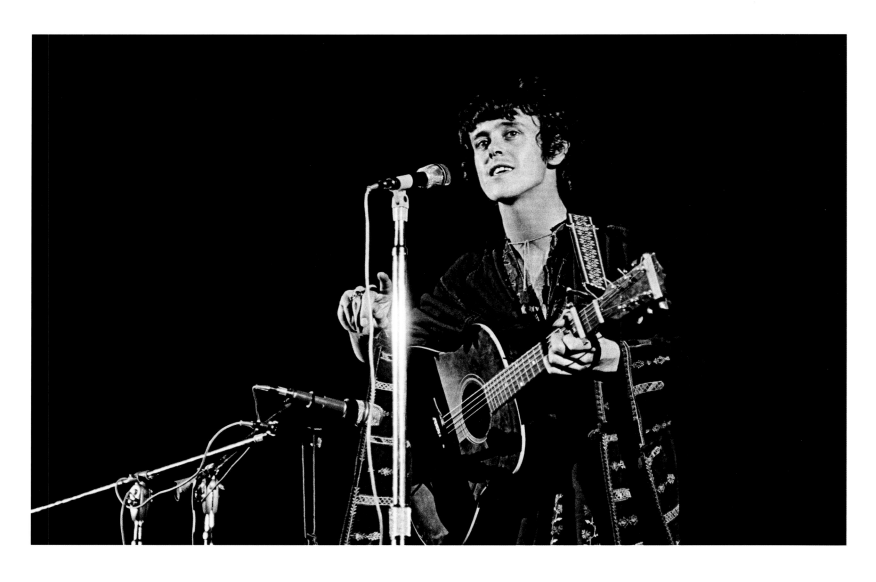

DONOVAN: CARNABY STREET FLOWER POWER DONOVAN COMING TO SAN FRANCISCO
THAT YEAR WAS PRE-ORDAINED. HE HAD ALREADY CONTRIBUTED TO THE GROWING HAIGHT MYTH
with his song the previous year, "Fat Angel," where he urged listeners to "fly Jefferson Airplane—get you there on time." His
Gaelic-flavored folk-rock found favor on the underground radio—songs beyond his hit singles such as "Sunny Goodge Street"
and "Young Girl Blues"—and his flower-power, Carnaby Street hippie-naïf look struck the perfect note for the moment. His
September concert at the dank, cavernous Cow Palace was so unsatisfactory that he returned for a full weekend run the next month
at Winterland. The imaginative new psychedelic British rock scene would be on full display that fall at the Fillmore with the first
U.S. appearances by Pink Floyd and a weekend with Procol Harum, whose "A Whiter Shade of Pale" was swamping the airwaves.

The entire pop music world was turning on a London–San Francisco axis. As soon as the San Francisco bands introduced an idea, the fashion-conscious English rock scene turned it into a trend. New British acts like Cream got their first breaks in the States on San Francisco radio and bills at the dance halls, where the audience was already primed for more highly evolved rock music.

Chocolate George died from a skull fracture after his motorcycle crashed into a car at Haight and Schrader Streets in August. The popular Hell's Angel was known around the Haight for dances he threw that featured bands like the Grateful Dead and Big Brother and the Holding Company. More than a hundred motorcycles paraded down Dolores Street in a four-block-long

funeral cortege to the Daphne Funeral Home, where the chapel was filled to overflowing for George. Reporters covering the event were surprised to learn that George earned a living handing out volleyballs at a neighborhood recreation center.

The Dead and Big Brother played a wake for Chocolate George in Lindley Meadow deep in the park. A thousand or more hippies danced but didn't mingle with George's brothers from the Angels and friends from other clubs, Gypsy Jokers, Nomads, Vagabonds, Satan's Slaves, and others. The Angels put a quick stop to the hippies having snowball fights with ice from the beer wagon. It was a sign of the relatively peaceful rapprochement that, when the wake was over, only four hippies had been stomped.

(ABOVE) *Donovan, 1967;* (OPPOSITE) *Donovan, superimposed with marigolds, 1967*

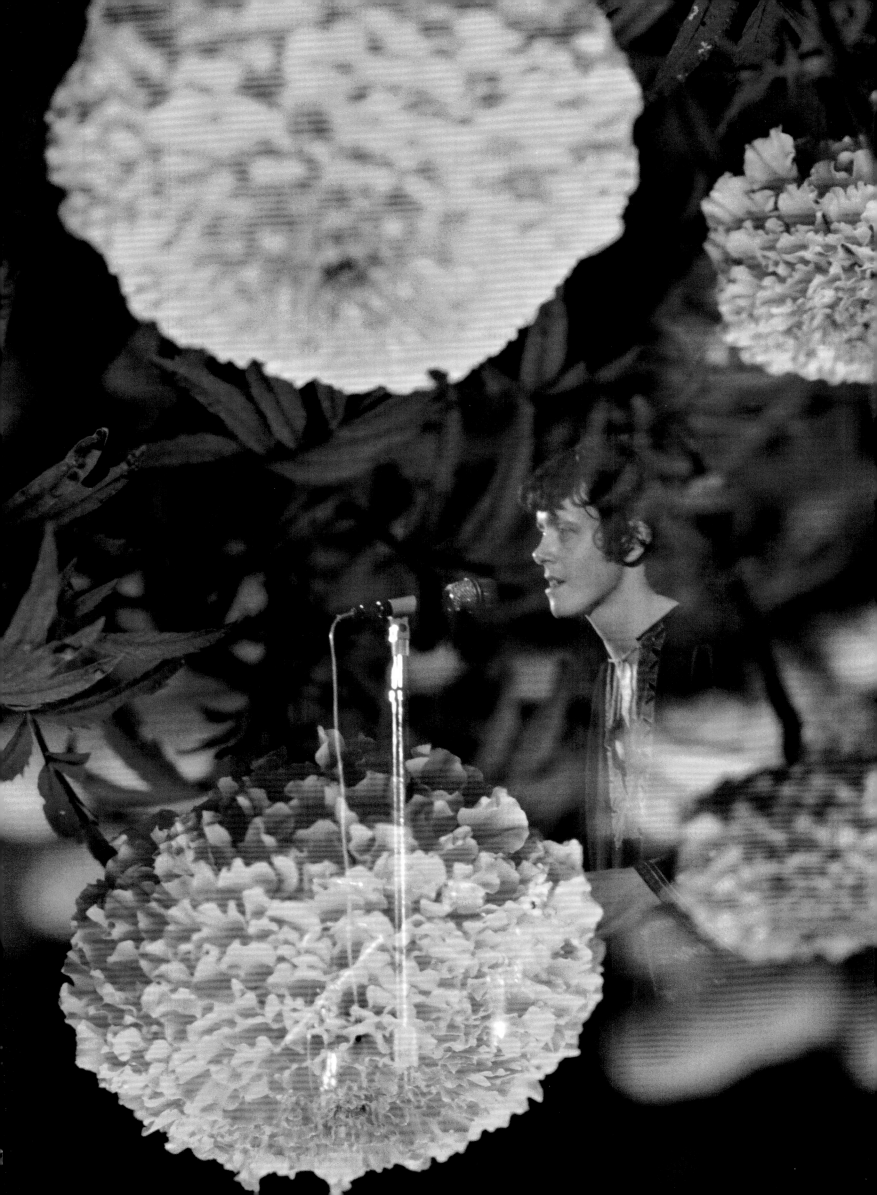

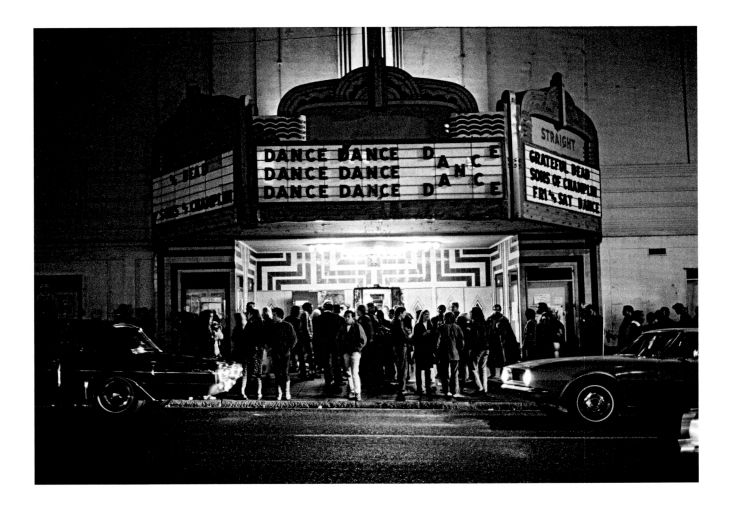

DANCE CLASSES AT THE STRAIGHT THE STRAIGHT THEATER WAS A QUINTESSENTIAL HIPPIE

ENTERPRISE. THE CONVERSION OF THE OLD MOVIE THEATER ON HAIGHT STREET INTO A DANCE HALL
had taken months, run through piles of money, been a boondoggle from the start, and was turning into a community project with
many investors. One of the original hippie partners dumped his entire trust fund into the operation. They talked another young
heir into parting with his. Some of the bands gave money, as did Owsley. They had big plans that called for a four-thousand-foot
dance floor with a seated balcony. The capacity was larger than the Fillmore and Avalon combined, plus it was located right in the
heart of the Haight.

The partners envisioned a vast cultural center, expanding beyond the theater and taking over the entire block. With posters from the Fillmore and Avalon proving to be a cottage industry almost entirely separate from the dances themselves, selling by the thousands in head shops springing up in every town in the country, the Straight partners outlined an ambitious poster program. They planned for the rock dances to fund less popular programs, like Shakespearean dramas or modern dance. Even before the theater was opened, there was a Straight Theater Dance Company in rehearsal next door at the Masonic Hall. The hippie wood butchers working the remodel were often on drugs. The people using the electric sander on the dance floor took so much speed, they sanded waves into the floor. The proprietors also had no idea the operation would require any city permits.

After four months of hearings and appeals, including an appearance on behalf of the Straight by actress Dame Judith Anderson, aunt of one of the partners, the city finally turned down the Straight's permit to throw dances in September. The Straight immediately announced that the Straight Theater School of Dancing would move from next door to the theater and begin offering public dance classes. It turned out that dance schools did not require permits. The poster read: *The Board of Permit Appeals Presents . . .*

Professional Dance Lessons—5 hours for only $2.50. Instructors include Jerome Garcia, Dr. P. Pen.

More than two thousand "student body cards" were sold. Dance instructors included Neal Cassady of the Pranksters (and model for Dean Moriarty of the Jack Kerouac novel *On the Road*) and the famous dancer and choreographer Ann Halprin. The Permit Board surrendered; it would be too much trouble to change the rules around dance schools.

Joining the Grateful Dead for the first time that night was a former Marine Corps drummer named Mickey Hart, who set up his drum kit alongside the Dead's regular drummer Bill Kreutzmann. Hart would bring to the band a restless creative enthusiasm and a penchant for exotic time signatures, often drawn from world music. Garcia's old Palo Alto pal Robert Hunter had recently found his way back to San Francisco and was ensconced in the Dead camp turning out Joycean lyrics for songs. A friend of Phil Lesh's with a classical background named Tom Constanten joined on keyboards, freeing Pigpen to concentrate on his role as the band's resident bluesman. The Dead was rapidly evolving beyond the electric folk and blues band they were.

The band's headquarters at 710 Ashbury had turned into a kind of community center. Attorney Michael Stepanian set up the Haight-Ashbury Legal Office (HALO) in the front room. There was usually a kilo of pot in the pantry and plenty of people hanging out.

Mountain Girl and friends from the neighborhood often congregated on the front stoop in the late afternoon, as the cool Mediterranean breeze blew in from the sea.

Two days after the Straight gigs, while Garcia and Mountain Girl were away shopping, two police cars swooped down on 710 Ashbury and police bullied their way into the house, trailing newspaper photographers and TV cameramen. They found a small amount of marijuana on the kitchen table in a colander, where somebody had been separating seeds and stems (and missed an unopened kilo in the pantry). The police arrested eleven people who happened to be there, including managers Danny Rifkin and Rock Scully as they walked up the front steps happening on the bust. Neighbors alerted Garcia and Mountain Girl as they came home and diverted them from arrest. Ironically, the two band members arrested—Bob Weir and Pigpen—were the only two who didn't smoke pot. Pen was strictly a juicer and Weir, on a macrobiotic diet, was abstaining from the evil weed for the duration. They arrested Scully a second time a couple of days later for running a place where drugs were used.

After the bust landed the band on the front page of the paper, the Dead convened a press conference at 710 Ashbury. Rifkin and attorney Stepanian attacked the cops. Stepanian said that a bust like this would never happen in Russian Hill or Pacific Heights. Rifkin criticized the media for creating "the so-called hippie myth." "If all the lawyers, doctors, and political officeholders who use marijuana were arrested today, this law might well be off the books by Thanksgiving," he said.

The assembled newsmen were not impressed. Rifkin opened the floor to questions. "How long did it take for you to grow your hair, Danny?" said one.

After threatening the poor fellow with a cream pie in the face and producing a bowl of whipped cream, the band instead served refreshments and, after the straight media had retired, pulled out some of Pigpen's antique firearms and posed for photographs with a new magazine preparing its first issue for the next month called *Rolling Stone*.

The Dead returned to Hollywood in October to continue work on the band's second album, which had started more than a year before. They filled half the studio with rented instruments and equipment, but made little progress. They returned to San Francisco to play a Halloween show called "Trip or Freak" and Marshall photographed Bob Weir backstage in full-face clown makeup.

The next month, the band's straightlaced record producer, assigned by the label, walked out of sessions in New York for the new album after Bobby Weir asked if he could make the sound of "heavy air." The producer had enough problems putting up with contentious bassist Phil Lesh.

(OPPOSITE) *The Straight Theater, 1967;* (BELOW AND FOLLOWING PAGES) *The Grateful Dead press conference, 1967*

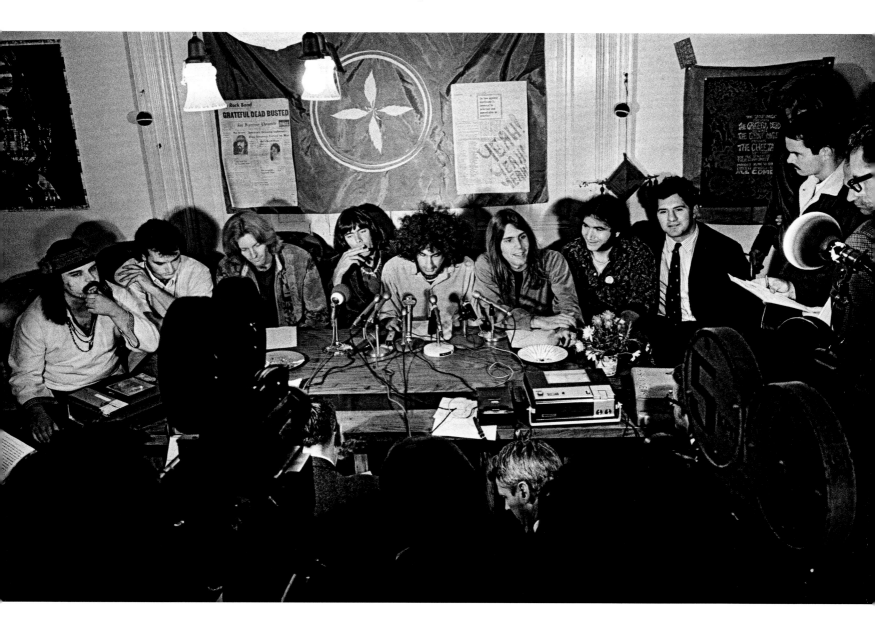

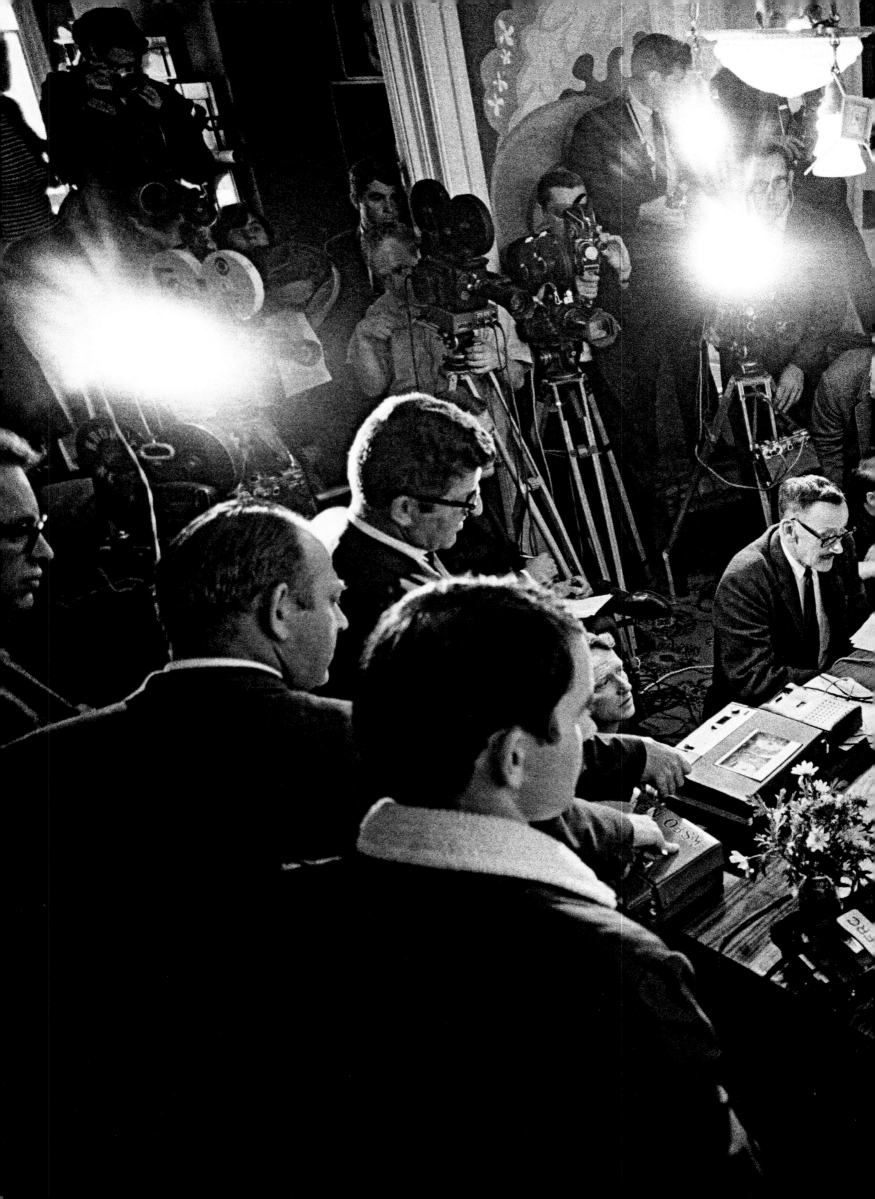

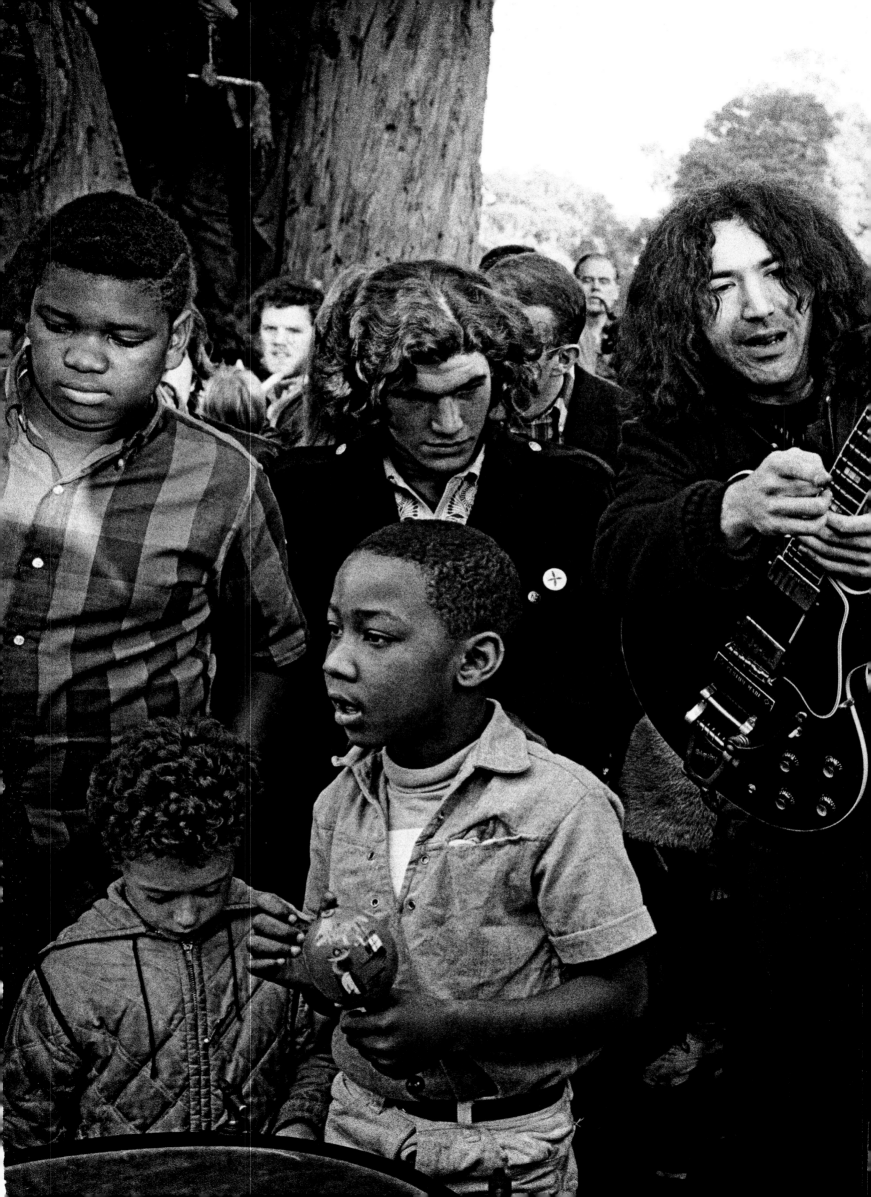

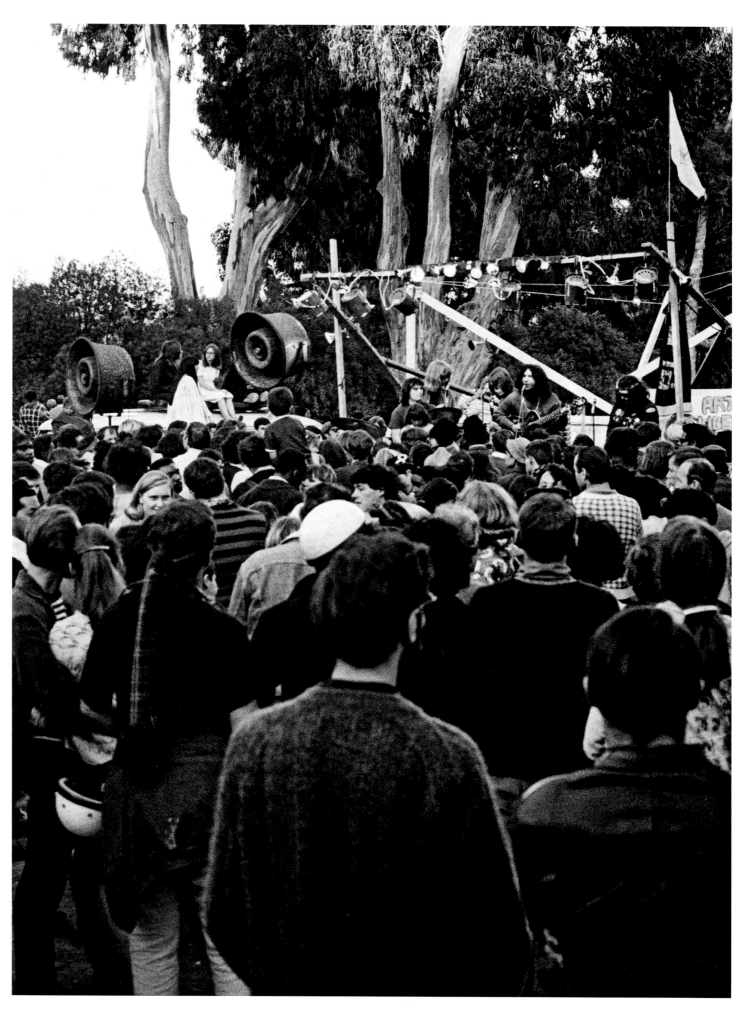

(PRECEDING AND FOLLOWING PAGES) *Pigpen (left) and Bill Kreutzmann (right) during a studio shoot of The Grateful Dead, 1967. Images from this shoot appeared in* TeenSet; (ABOVE) *The Grateful Dead perform in the Panhandle, 1967;* (CENTER AND OPPOSITE TOP) *Jerry Garcia, 1967;* (OPPOSITE BOTTOM) *Members of the Hell's Angels at the Dead's Panhandle performance, 1967*

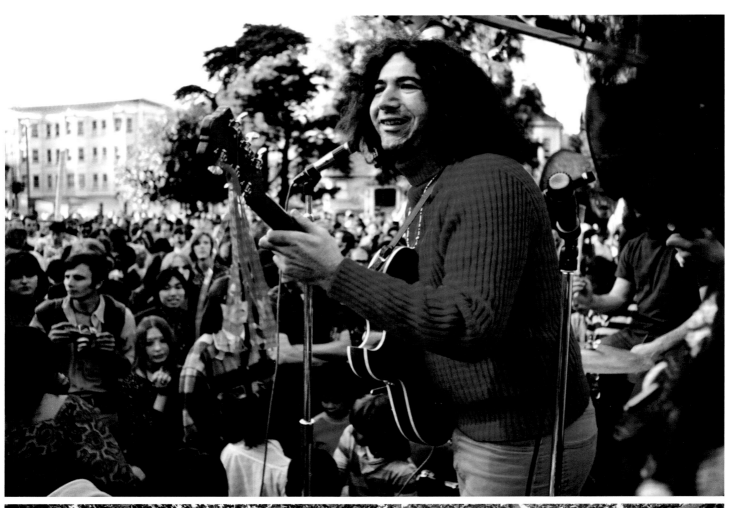

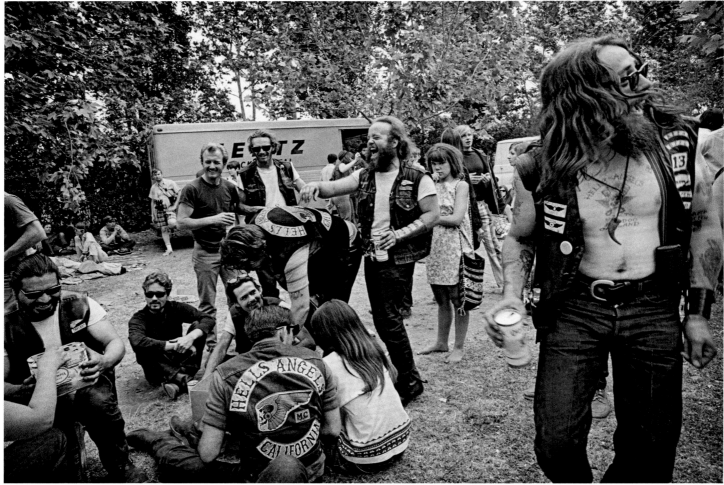

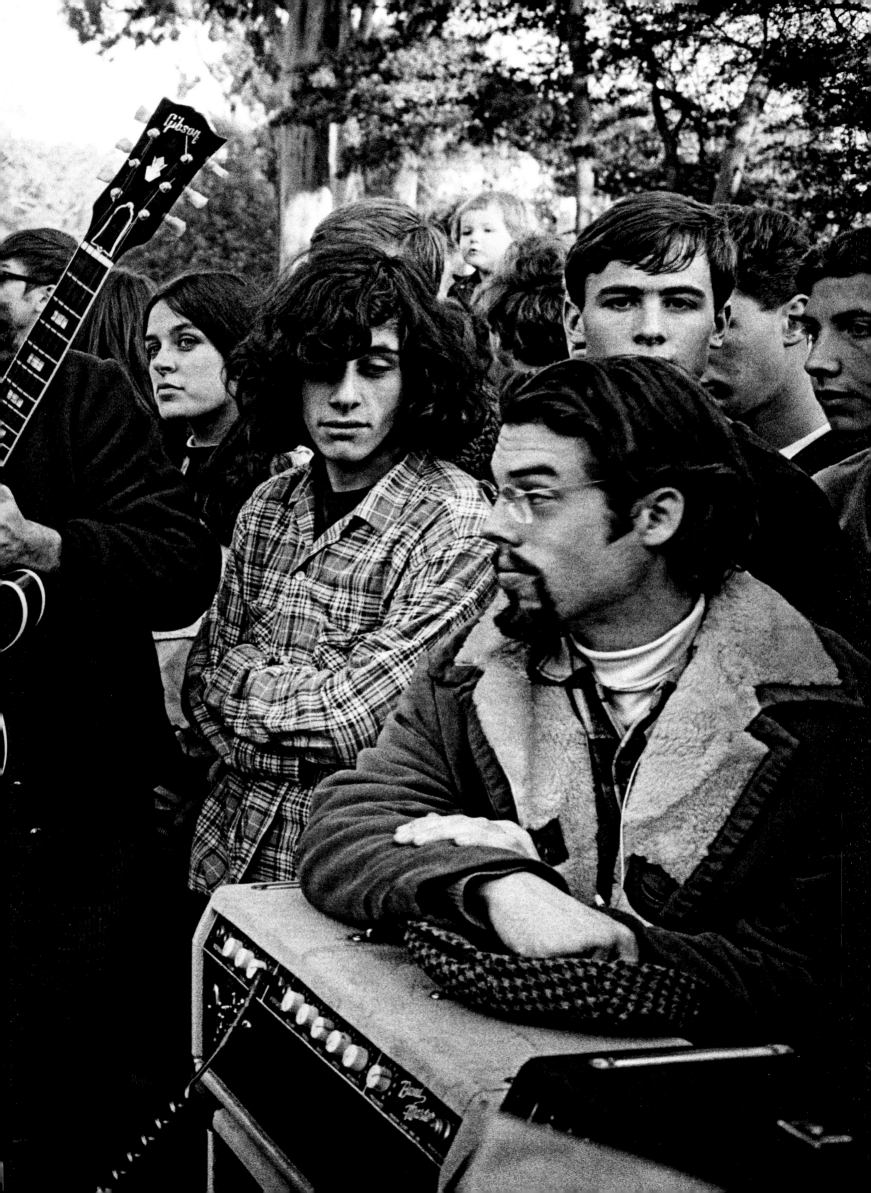

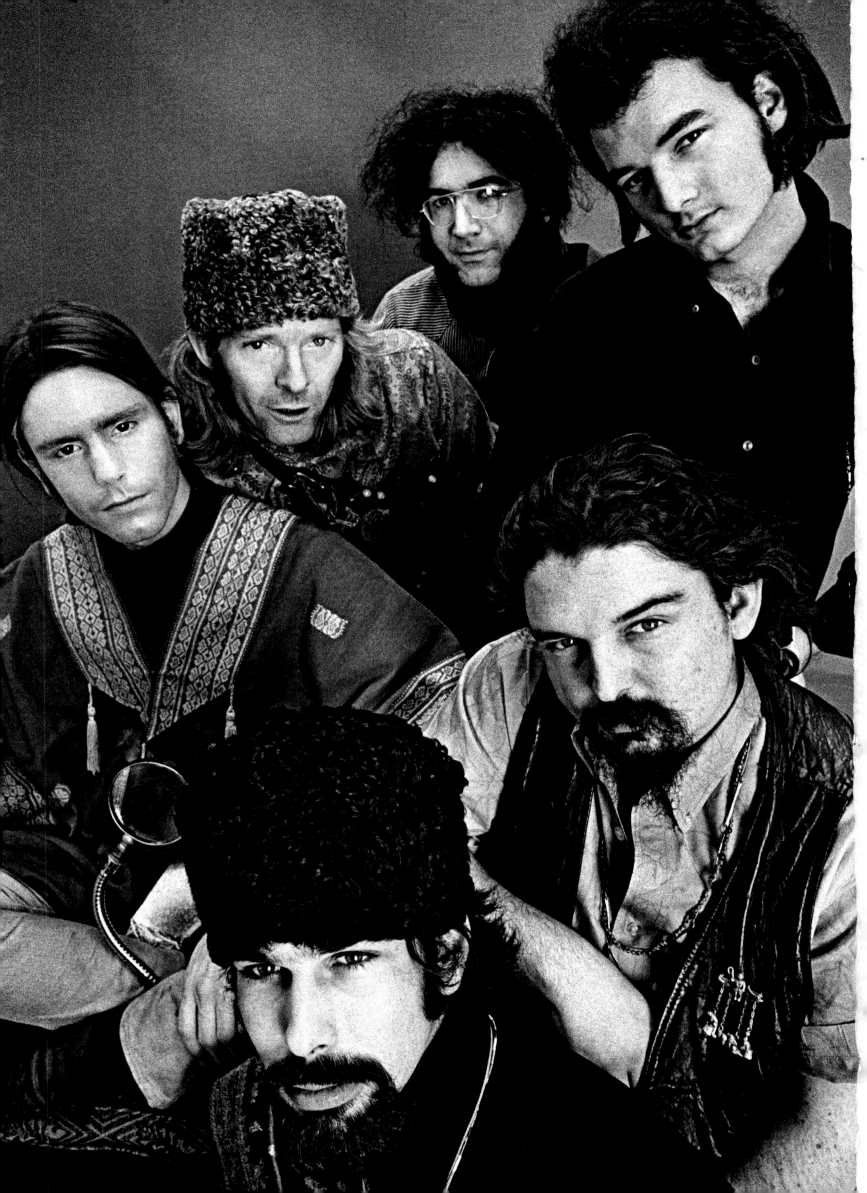

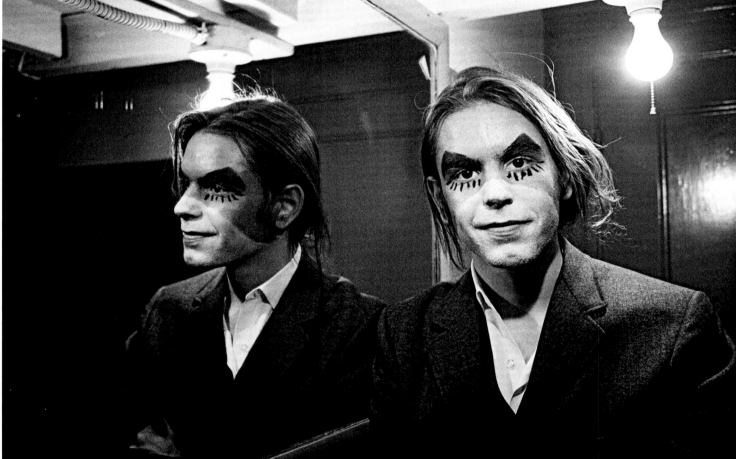

(OPPOSITE) *Studio shot of the Grateful Dead, 1967. Members of the band "dosed" Marshall with acid during this shoot;* (ABOVE) *Bob Weir of the Grateful Dead at the Trip or Freak Psychedelic Art Exchange, Winterland, 1967*

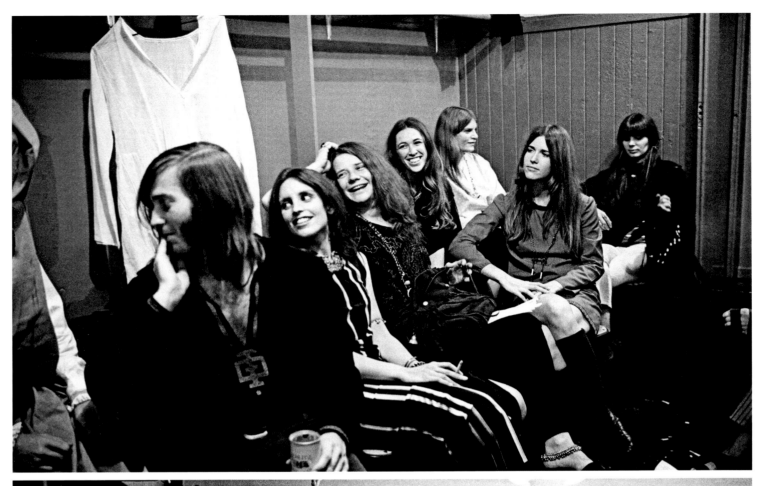

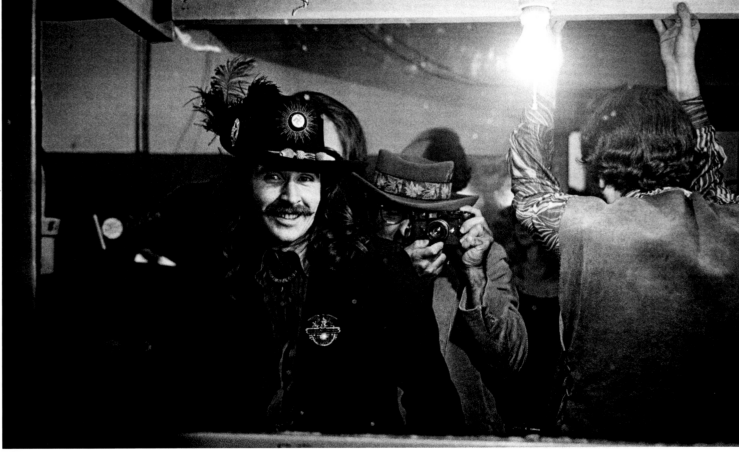

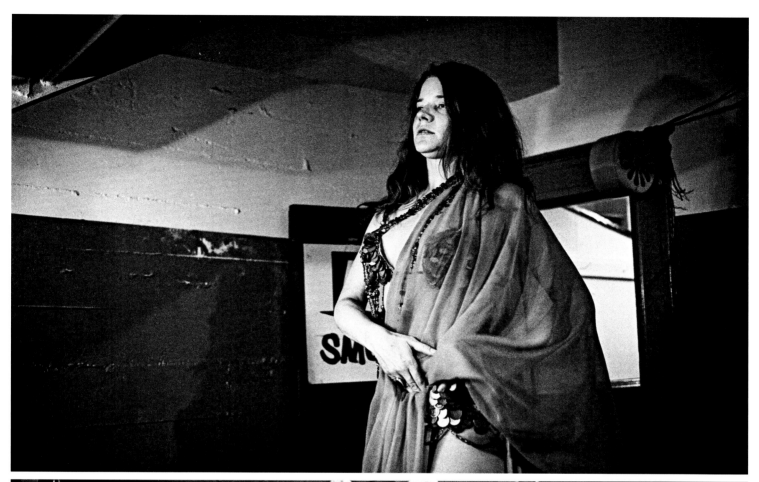

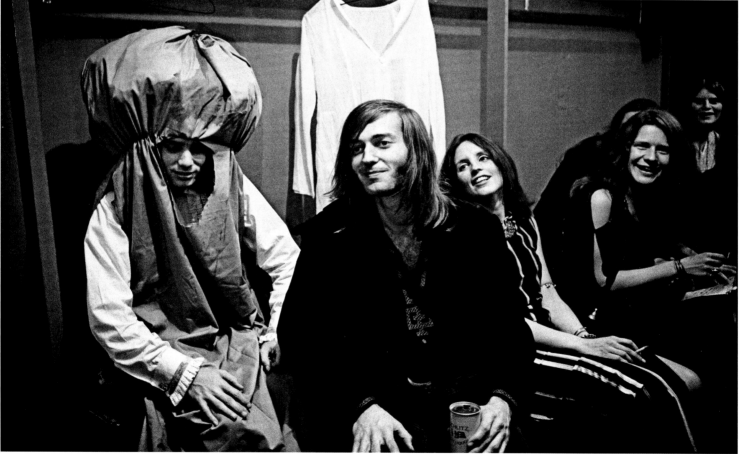

(THESE PAGES) *Backstage at Trip or Freak.*
Among the attendees were Alton Kelley
with Jim Marshall (opposite bottom) and
Janis Joplin (opposite top and above)

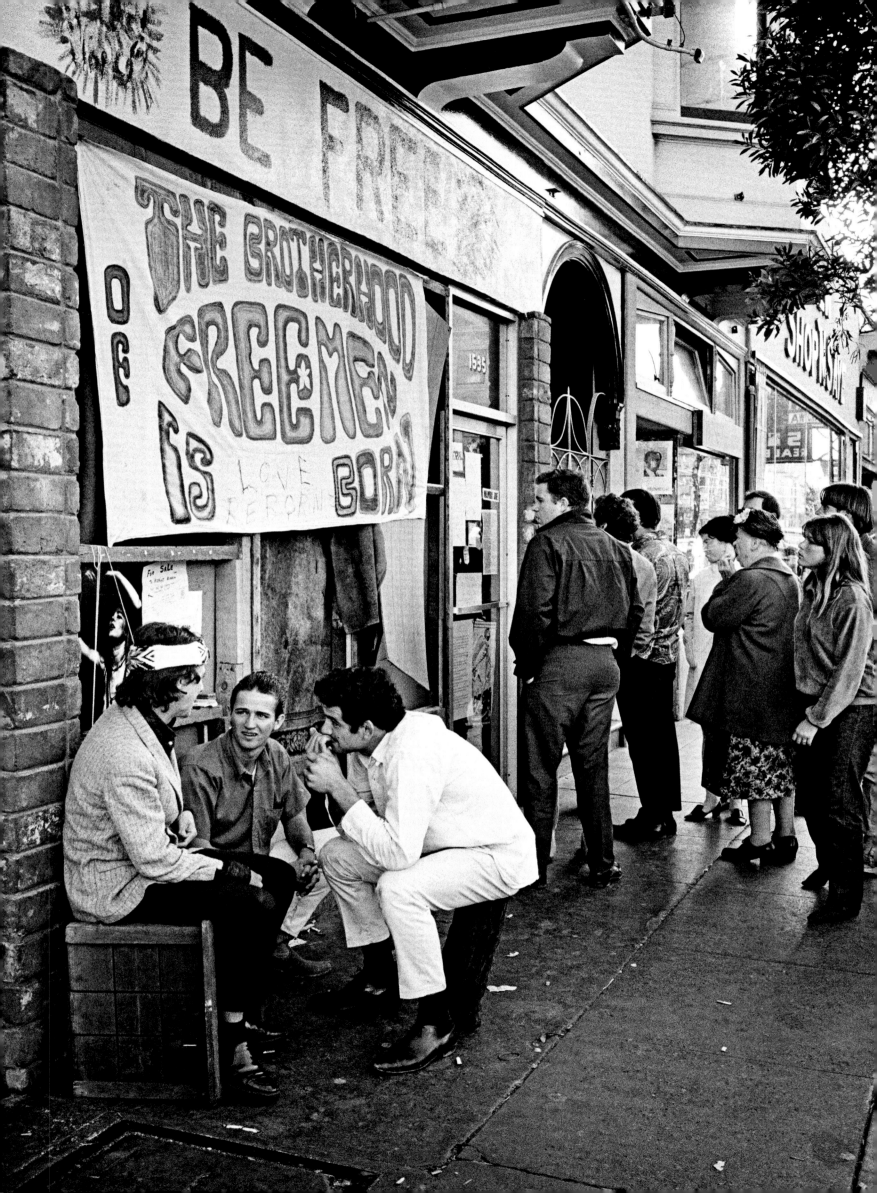

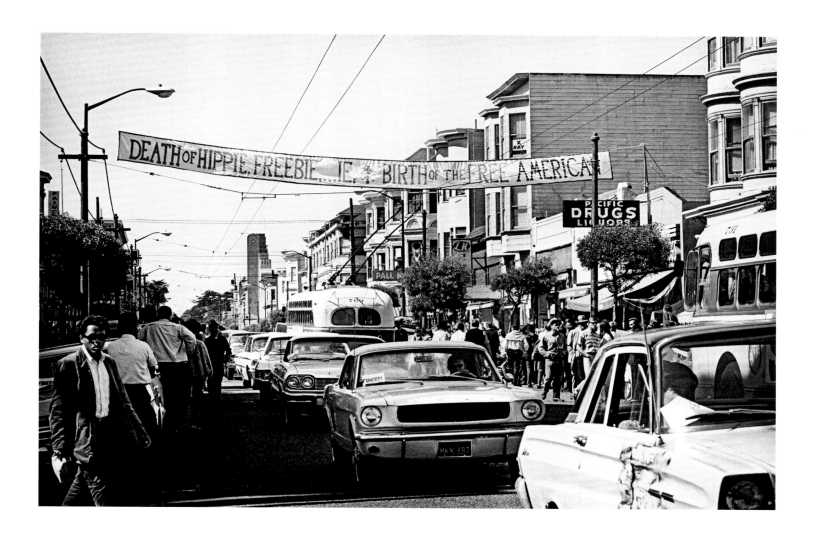

THE DEATH OF HIPPIE
THE HAIGHT WAS GETTING TOUGH. THERE WAS A RAPE ON THE STREET. THE FREE CLINIC WAS FORCED TO CLOSE ITS MEDICAL DEPARTMENT AFTER THE CITY DENIED FUNDING, saying there was no medical emergency in the neighborhood. In response to the Dead's press conference, the police noted that only 40 percent of the recent drug bust had been for pot—the rest had been speed and heroin. Speed freaks, spare-changers, and other flotsam and jetsam of humanity mobbed the sidewalks. The Psychedelic Shop announced it would close, staying open all night and giving away the remaining merchandise. Many of the tribal elders were urging people to move out of the neighborhood. Many did. They spread out from Mendocino to Mexico. Kesey, having served his jail sentence, relocated to an old dairy farm in Oregon. In a year, the place had gone from a happy hippie paradise to drug-infested, debauched hell on earth. The Utopian experiment had failed, and those most closely associated with the inner workings of the community knew it.

When a loose coalition—what other kind was there in the Haight?—of hippie old-timers issued a press release announcing the Death of Hippie celebration, the proclamation answered a growing need in the community to somehow purge the Haight of the excesses of the summer. They called for the emergence of something they called the Free Man. The date they picked—October 6—was the first year anniversary of the law making LSD illegal. So much had changed.

After a Wake for Hippie the night before, the procession began at sunrise at the top of Buena Vista Park hill. Underground newspapers were burned. Hippie gear was tossed in the bonfire. Somebody played "Taps." About a hundred people, many holding candles, took part in the parade down Haight Street, carrying a coffin containing a representative hippie. The banner across Haight Street read DEATH OF HIPPIE FREEBIE, I.E., BIRTH OF THE FREE AMERICAN. They held a brief "kneel-in" at the intersection of Haight and Ashbury. The parade wound its way to the Psychedelic Shop, where the window was covered with signs: DON'T MOURN, ORGANIZE; BE FREE; NEBRASKA NEEDS YOU.

That afternoon, the police began making regular sweeps of Haight Street, arresting any minor without proper identification as either a runaway or draft dodger.

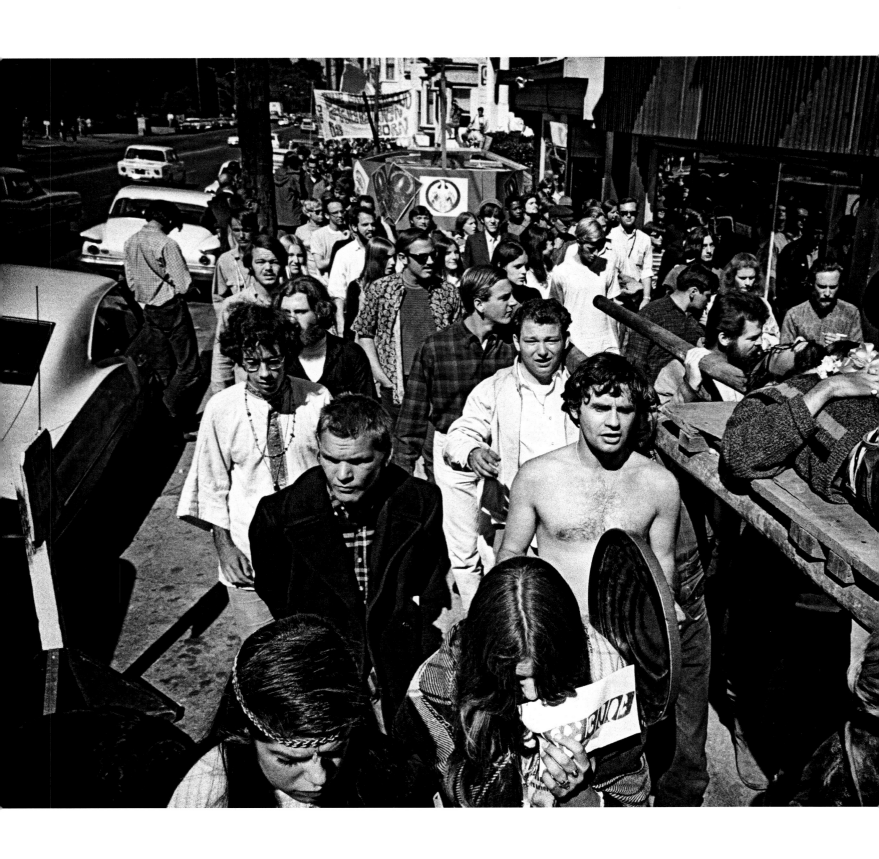

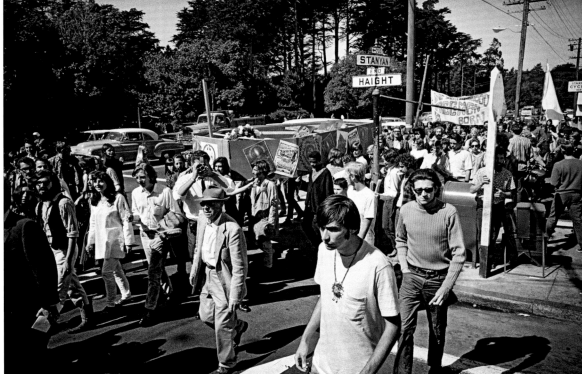

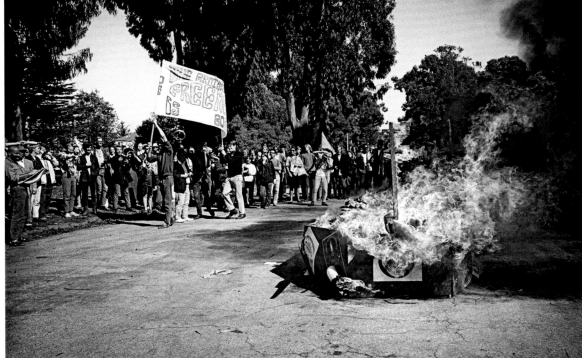

(THESE AND FOLLOWING PAGES) *The Death of Hippie march, 1967*

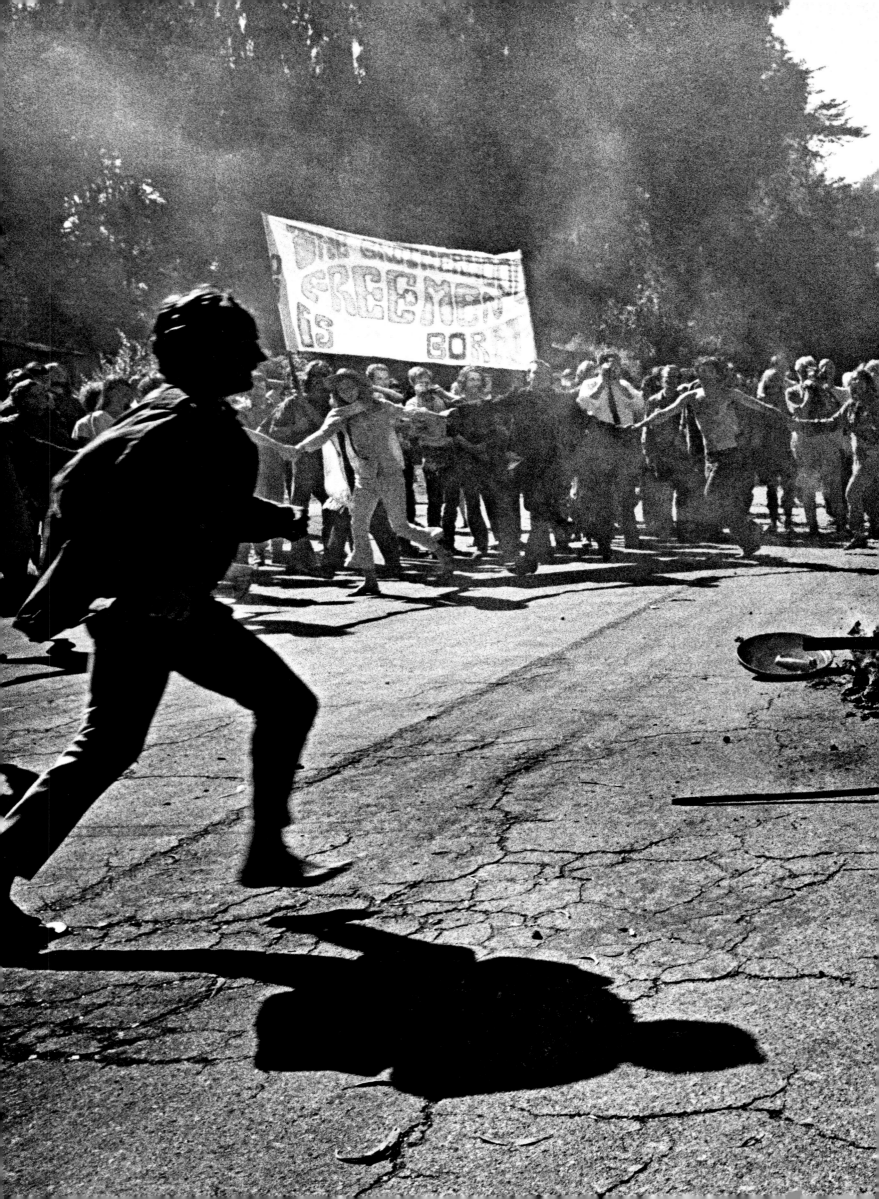

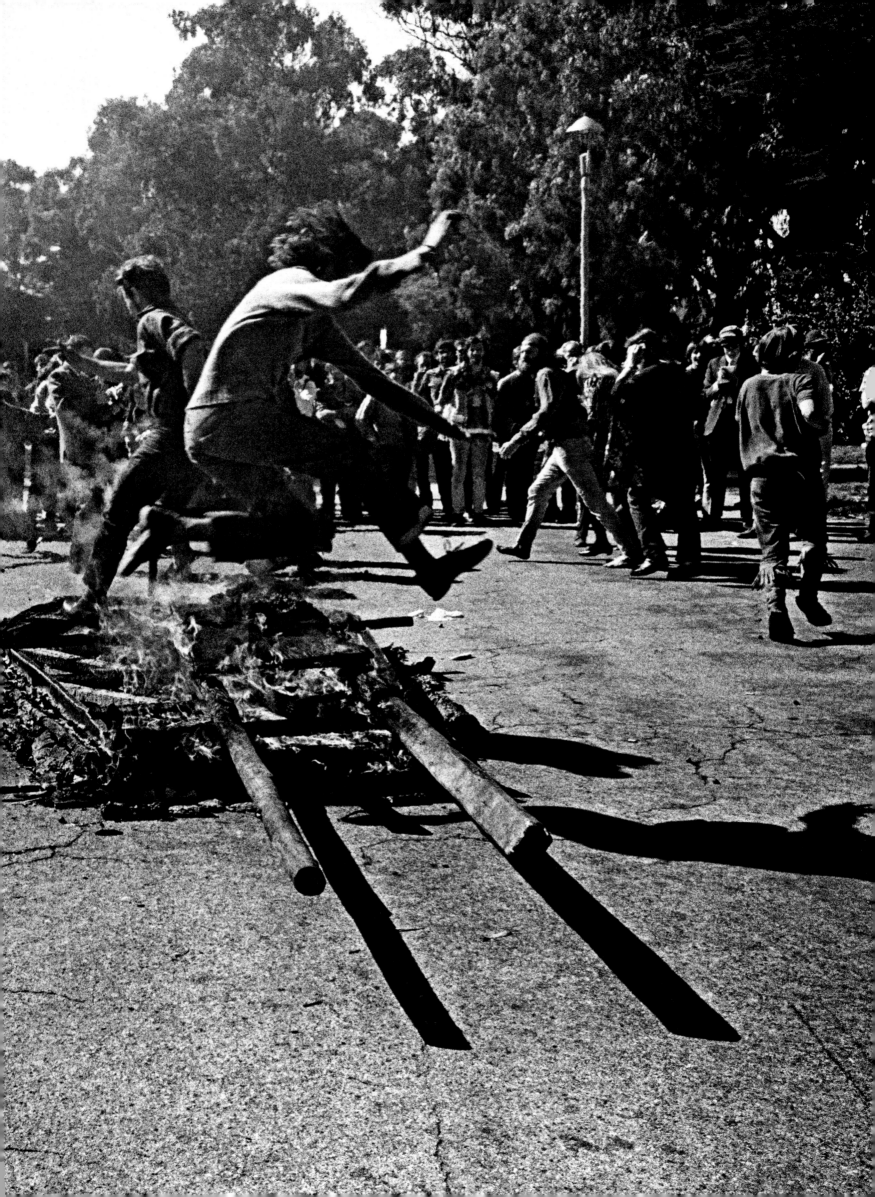

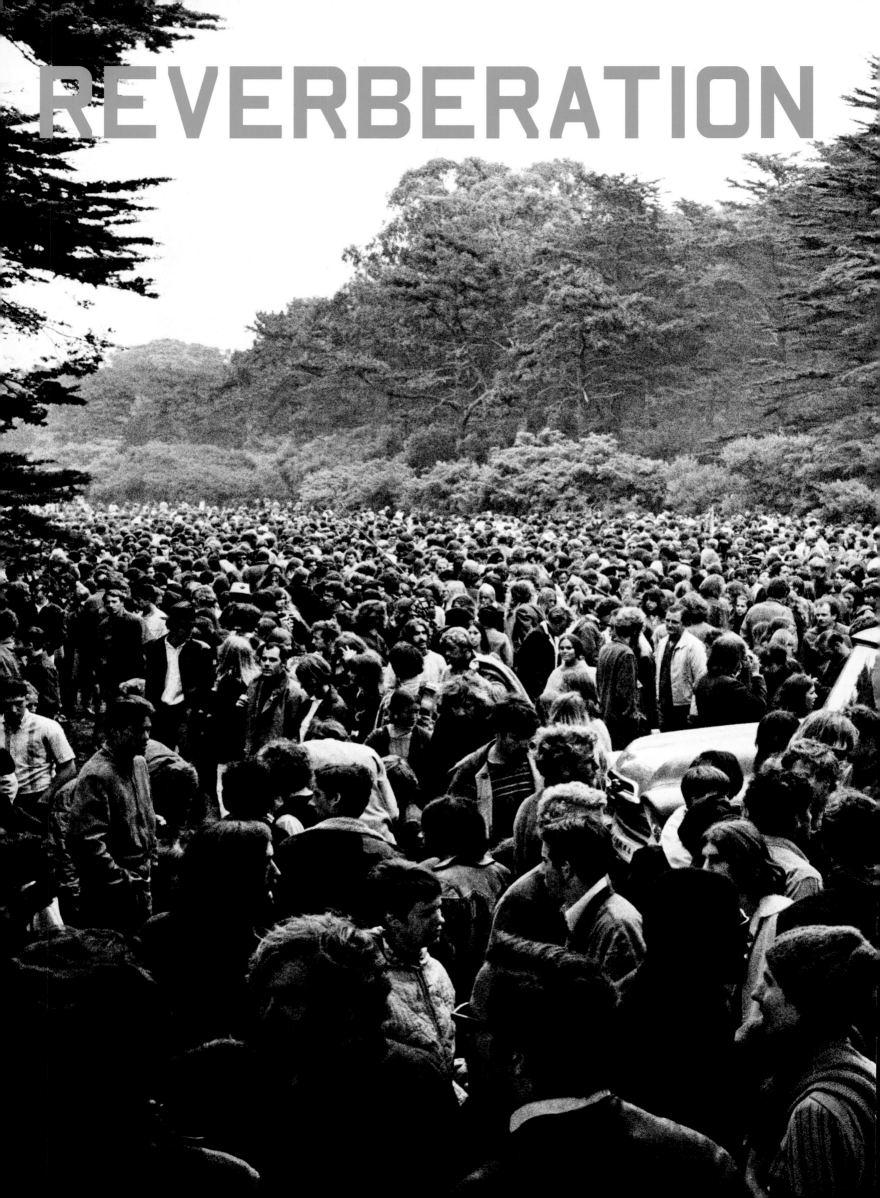

REVERBERATION

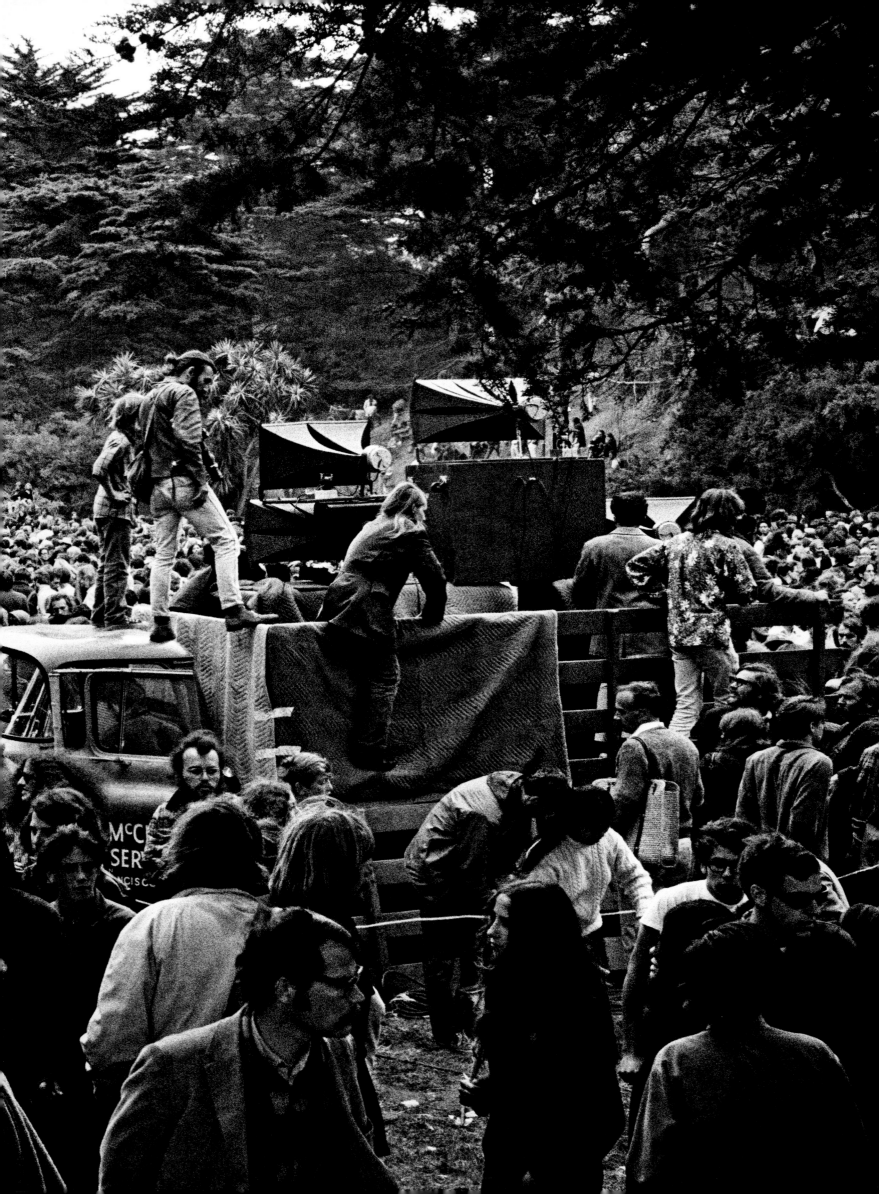

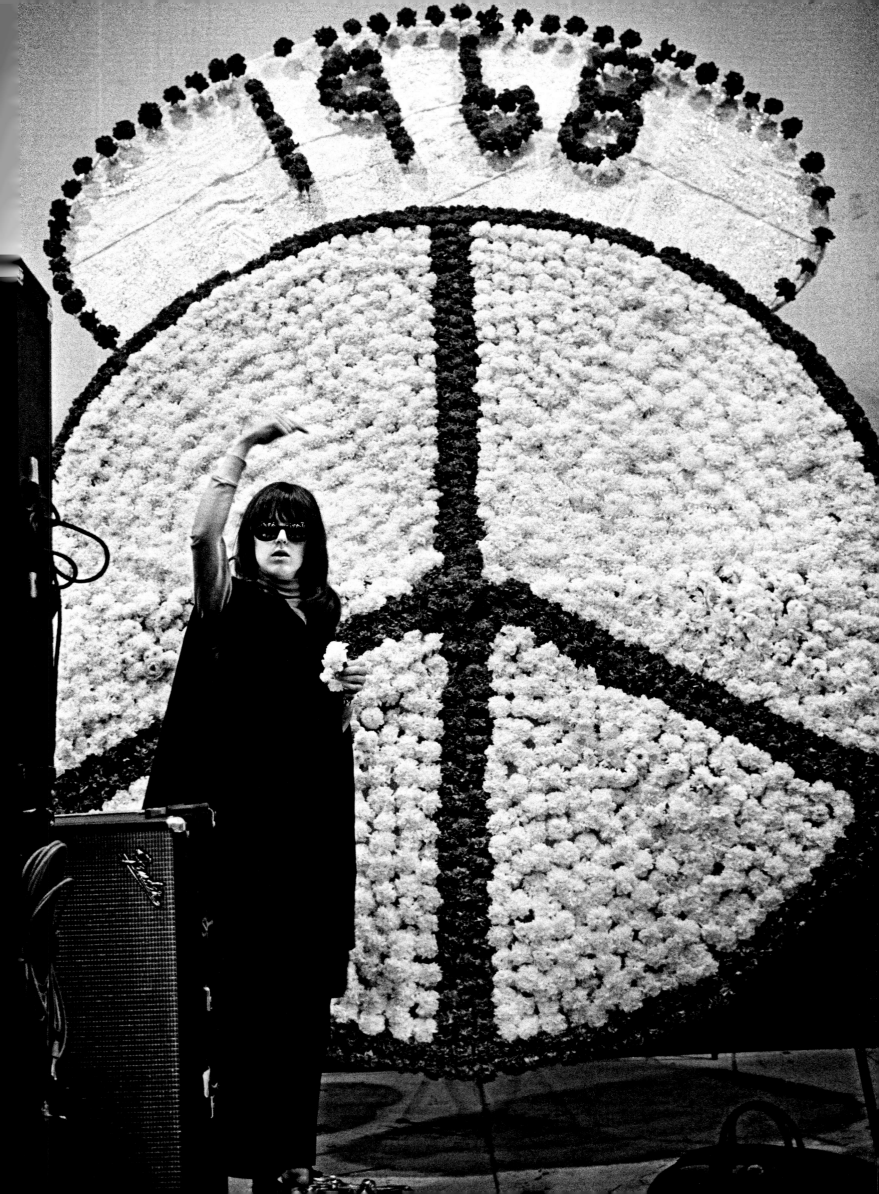

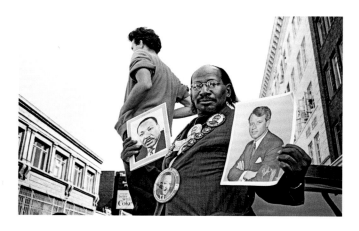

The North Vietnamese army launches the Tet Offensive in January, as protests against the war escalate around the world. President Johnson announces he will not seek re-election. In April, Martin Luther King Jr. is assassinated; in June, Robert F. Kennedy is killed. McDonald's introduces the Big Mac for forty-nine cents. The new record by the Beatles, "Hey Jude," is the first single on the band's Apple Records.

THE CAROUSEL BALLROOM OPENS Vocalist Jimmy Murray quit Quicksilver when the band moved back to the city and started rehearsing. That was too much serious work for the dedicated hippie, who moved to Hawaii. The new four-man Quicksilver played the lineup's first show New Year's Eve 1967–1968 at Winterland. The band had always been leery of the record business. They had done some demo recordings for Vanguard the year before, but nothing came of them. Quicksilver's manager negotiated an extraordinary deal with Capitol Records that called for one hundred thousand dollars in advance and gave the band complete artistic license. They scrapped the entire first attempt at a debut album recorded in the Capitol Tower in Hollywood with producer Nick Gravenites of Electric Flag and went about recording concerts to make the group's first album live.

Quicksilver guitarist John Cipollina was often sickly and wan, his long, black hair hanging past his shoulders like a cape. He draped himself in black and came off as some kind of Dickensian character, surrounded by adoring females, an air of fragile vulnerability hovering over him. He hot-rodded his gear, mounting custom-made treble horns on the top of his amplifier to give his sound extra screech. While the other Quicksilver guitarist, Gary Duncan, was a daring improvisationalist, Cipollina honed his often complicated guitar parts to perfection, rigorously polishing his playing at every performance. His slicing, shimmering tone gave Quicksilver the band's trademark sound.

In January 1968, Quicksilver and the Dead launched a string of dates in the Pacific Northwest called "The Quick and the Dead," along with a light show, bringing the San Francisco carnival to the hinterlands for the first time. Police dogged their moves every step of the way. Cipollina bought guns and hundreds of blank cartridges in Portland to continue the cowboys and Indians game the two bands had been playing with each other for more than a year, staging "raids" on one another and "shooting" each other "dead" with nothing more than a thumb and forefinger. Cipollina spotted Pigpen, Rifkin, and Scully in a car, stepped in front of its path, and blazed away with a carbine filled with blanks. As according to the rules, the car doors swung open and the "victims" fell out on the street. Shocked onlookers summoned the police, but by the time they arrived, sirens blaring, the "victims" had gotten back in their car and driven away. Cipollina returned from the tour with calluses on his fingers from so much gunplay.

On Valentine's Day, the Grateful Dead presided over the opening of the Carousel Ballroom, a second-

(PRECEDING PAGES) Crowds gather for a free concert in the park; a flatbed truck used as a makeshift stage, 1968; (OPPOSITE) Grace Slick, 1968; (TOP) A man remembers Martin Luther King Jr. and Robert Kennedy, 1968; (RIGHT) This shot of the Fillmore West, formerly the Carousel Ballroom, 1968, was used for Nick Gravenites and Mike Bloomfield's 1969 album, My Labors

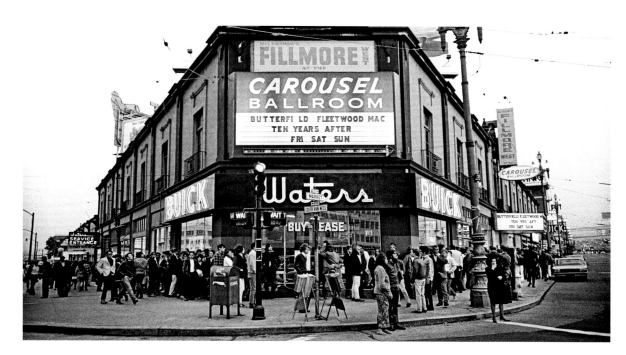

floor dance hall above the rug showroom at the corner of Market Street and Van Ness Avenue. An opulent relic of the swing era of the '30s, the Carousel was twice the capacity of the Fillmore. The Airplane had fired Graham as manager (road manager Bill Thompson assumed the duties), and his abrasive ways and greedy business practices had alienated the other bands as well. The Airplane, the Dead, and Quicksilver formed a partnership to run the Carousel in direct competition with Graham's operation (Chet Helms and the Family Dog were teetering on the brink of insolvency after losing huge amounts of money in an unsuccessful attempt to open a dance hall in Denver, largely undermined by one overzealous cop). Big Brother and the Holding Company, who had signed for management with big shot Albert Grossman, couldn't openly participate, but pledged their support. With these bands all agreeing to make regular appearances at the hall, success seemed assured, since the Airplane was currently the most popular rock band in the country, commanding an astronomical seventy-five hundred dollars per performance.

To emphasize how special the Carousel opening night was, the concert was broadcast live over KMPX-FM. Since going round-the-clock the previous August, the station had tied together the exploding San Francisco rock scene with the rapidly shifting sounds from around the country and England. Every week another great new record by another new band turned up on the station. The audience was paying careful attention. When some KMPX disc jockeys discovered an old track by folksinger Dave Van Ronk, "Cocaine," that hit the drug consciousness of the station's audience and became a smash hit, Van Ronk was able to sell out a triumphant

concert appearance at the Masonic Hall, a complete anomaly on the man's otherwise more pedestrian schedule. The underground station had established British bands such as Cream and Traffic in this country and the live broadcast of the Carousel opening, the station's first live broadcast, was heard throughout the community. A more effective advertisement could not have been found.

Of course, the operation soon foundered under typical hippie indolence and reckless irresponsibility. The bands all were swept up in the maelstrom of their own careers and left the management of the hall to deranged associates, who ran the place more as a social laboratory than a business. Big Brother played for a Hell's Angels benefit where they spilled so much beer on the floor, it soaked through to the rug store on the ground floor. One night admission was either five dollars or you had to burn a dollar bill. All musicians were admitted free and barter was accepted. One fellow left a raw leg of lamb at the box office one night in exchange for tickets.

In addition to firing Graham, who remained on friendly terms with the band because, after all, the Airplane was one of the biggest draws on the scene, the band was having other problems with success. The record label was not pleased with the new album. The singles weren't hits and the band spent more than eighty thousand dollars in recording, thanks to the unlimited studio time clause in the contract. The band members constantly argued, and Grace Slick, the voice of the band's hit records, contemplated an offer to go solo from another label that she eventually turned down. The Airplane was too busy and making too much money, even if they weren't getting along.

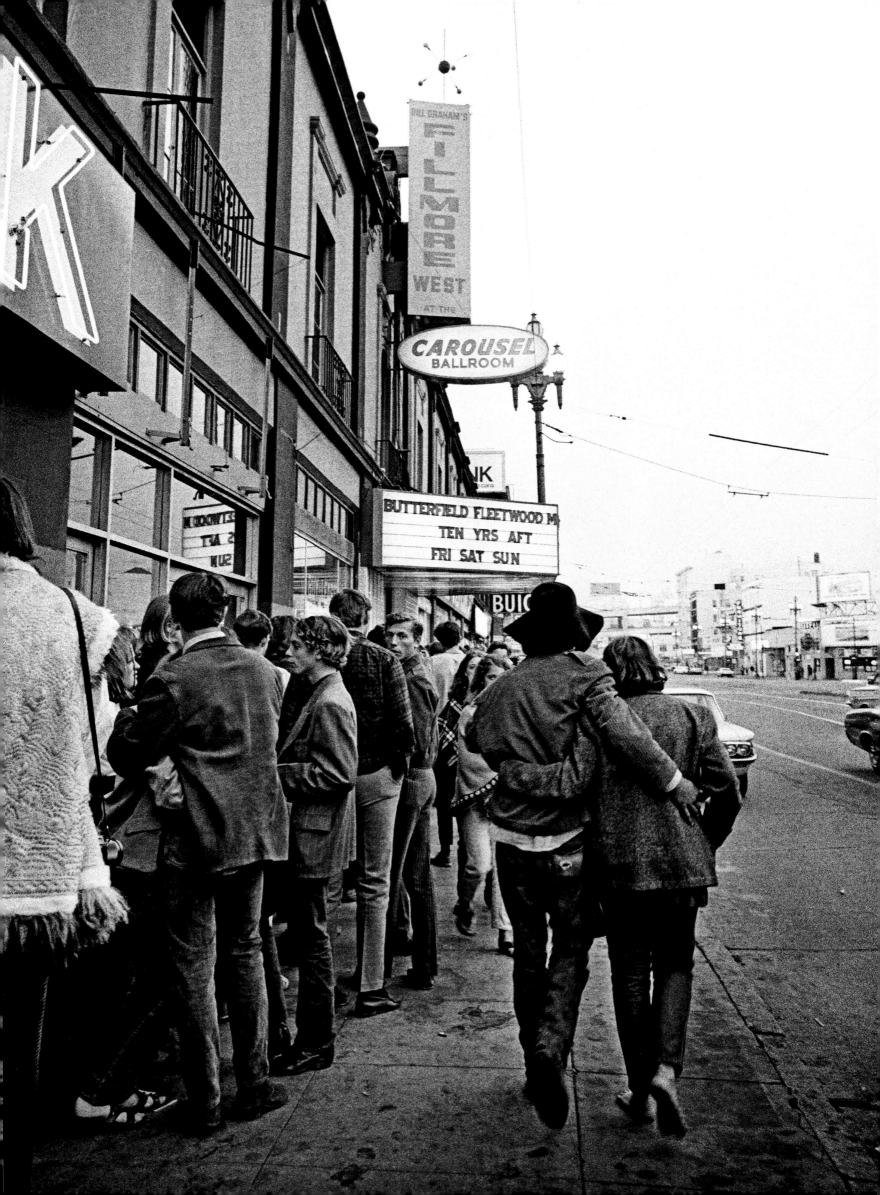

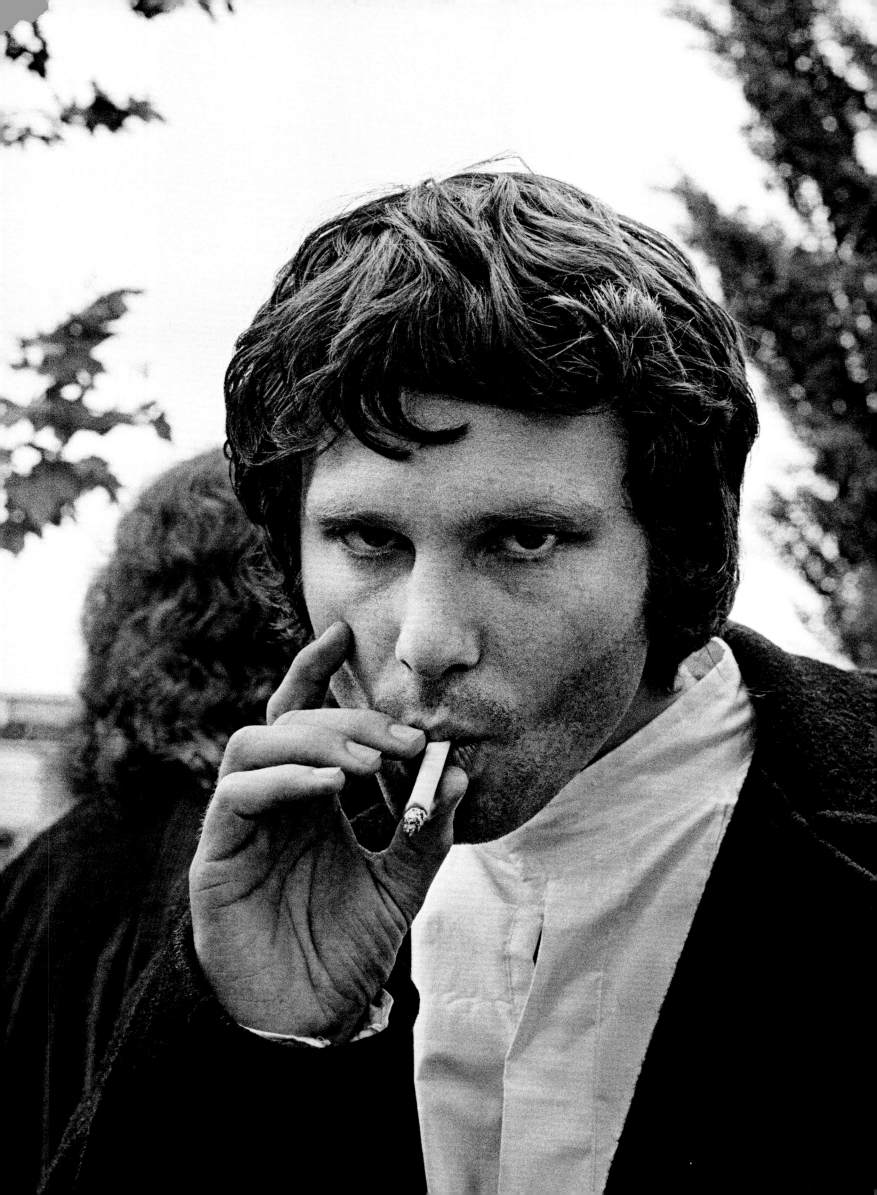

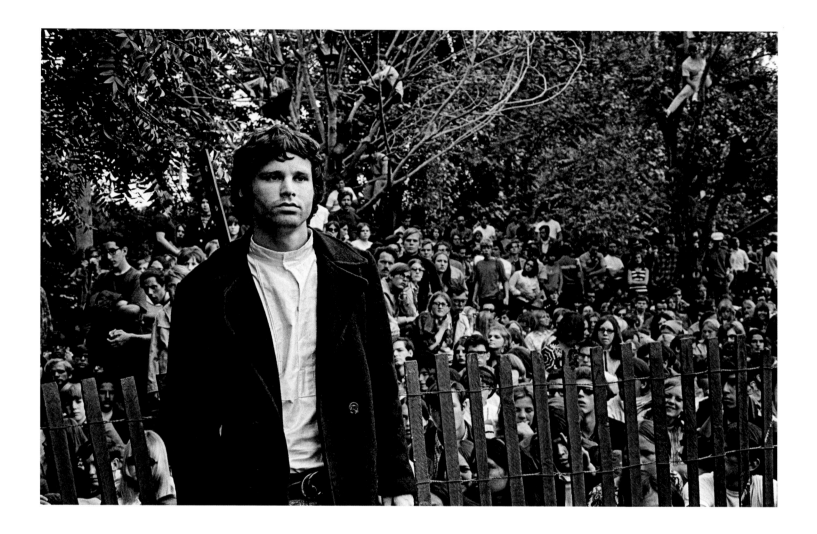

NORTHERN CALIFORNIA FOLK-ROCK THE DOORS ARRIVED AT THE NORTHERN CALIFORNIA FOLK-ROCK FESTIVAL THAT MAY AT THE SANTA CLARA COUNTY FAIRGROUNDS. THEY WERE ONE OF the big attractions of the two-day event, alongside Jefferson Airplane, Big Brother, Country Joe and the Fish, the Animals, the Youngbloods, and Taj Mahal. The band always felt uneasy appearing before San Francisco crowds with their healthy skepticism of Los Angeles hippies and their rock bands. The ground was cold and wet from rain during the night, and the sun blared down on the

field during the afternoon, which made the crowd uncomfortable to begin with. Vocalist Jim Morrison modeled his new "short" hair, cropped off a few days before. The band was in the middle of sessions for the third Doors album, *Waiting for the Sun*, and Morrison threw himself into getting across to the audience, falling onstage in the process. The show was far from a triumph and went a long way toward convincing

Morrison to avoid performing at outdoor daytime shows with his band in the future. That aside, Marshall did catch a timeless classic portrait of the maniacal vocalist sucking on a cigarette minutes before taking the stage. Before he snapped the shutter, Morrison had looked at him and given him the photograph with the words, "Hey, Marshall. Want a fucking shot?"

(OPPOSITE AND ABOVE) *Jim Morrison, 1968*

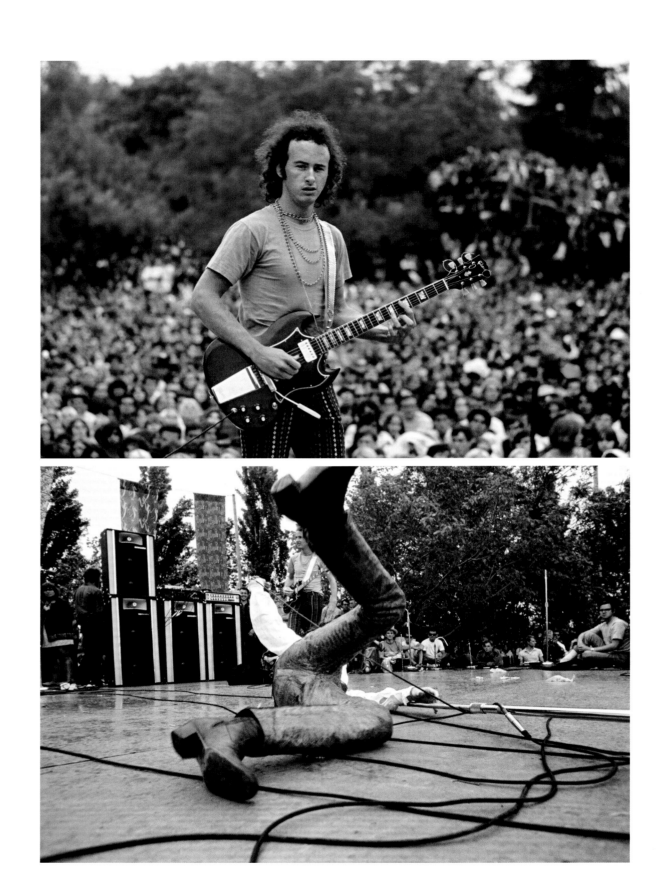

(THESE PAGES) *Members of the Doors, Robby Krieger (top),
Jim Morrison (above), and Ray Manzarek (right), perform
at the Northern California Folk Rock Festival, 1968*

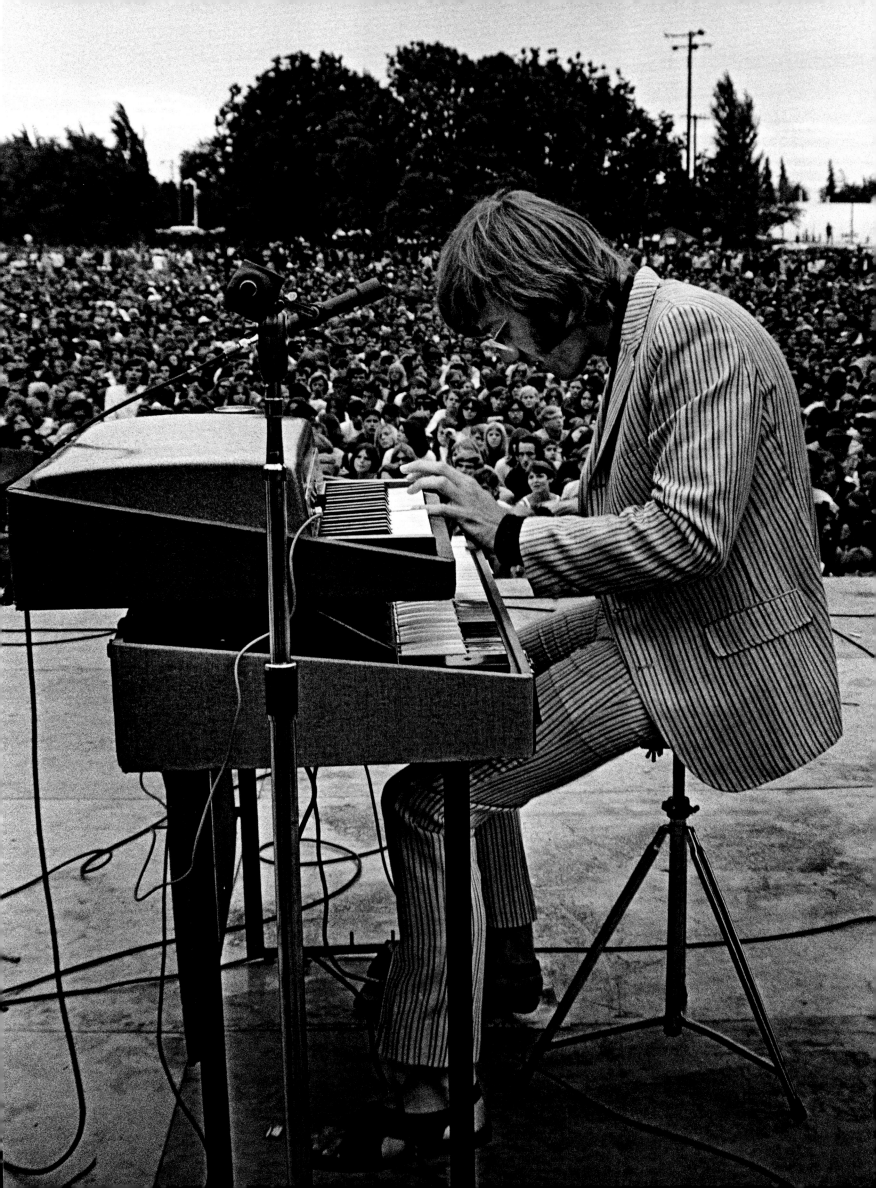

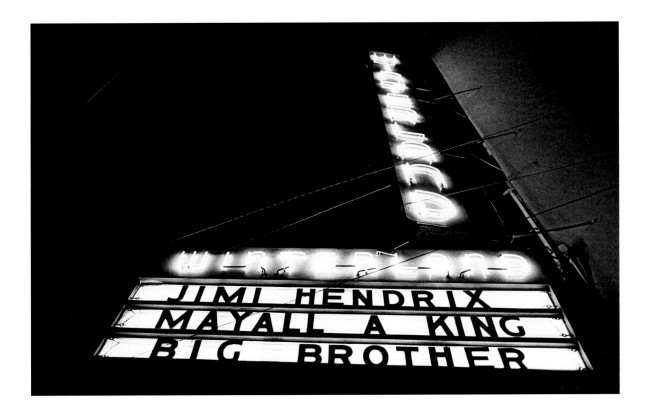

JIMI AND BIG BROTHER BIG BROTHER AND THE HOLDING COMPANY RELOCATED TEMPORARILY
TO NEW YORK CITY IN FEBRUARY. THE COMBINATION OF WORD OF MOUTH OUT OF MONTEREY AND
San Francisco, coupled with the widespread exposure of the band's Mainstream Records album, poorly recorded as it was, poised
Big Brother on the cusp of national success and Janis Joplin on the brink of stardom, heady stuff for a Texas girl fresh off the
streets of Haight-Ashbury in the big city. The band came to town to play shows and sign a new record deal with Columbia Records.
Columbia president Clive Davis had wanted to sign the band since he saw the group at Monterey. He paid two hundred and fifty
thousand dollars to Mainstream to acquire the contract.

The band brought an authentic West Coast cachet to Manhattan. The town took notice. The band members were taken to hang out at Max's Kansas City, the trendy nightclub where Andy Warhol liked to party, and as they walked in, the deejay played the Country Joe and the Fish song "Janis." All heads in the place swiveled toward Joplin. When Columbia announced the signing at a lavish press function at a Greek restaurant, the jaded journalists and scene-makers parted the way for the band when Joplin and company walked through the crowd. "I don't know what this is about," a flustered Joplin told her publicist. "I'm no star."

The band's New York debut at the Anderson Theater, an old Yiddish music hall in Greenwich Village, couldn't have gone better. The crowd rushed the stage at the first number. Joplin showed New York audiences what they'd only heard about—her crunching version of "Summertime," the rugged R&B of "Piece of My Heart," and the cataclysmic "Ball and Chain." The New York Times gushed about the concert on Monday morning. New York embraced Big Brother in an instant.

Bill Graham was in the crowd that night at the Anderson. San Francisco was no longer big enough for him. He had been considering opening a New York operation, and he had already met with the owner of the Anderson about going into business together and been abruptly refused. He found another place, the semi-vacant Village Theater, another old downtown Yiddish theater, and put together a partnership that included Dylan (and Big Brother) manager Albert Grossman to buy the place and get it back in shape. He booked Big Brother and the Holding Company for the first show on March 8 at the quickly renamed Fillmore East. The Joplin star was ascendant.

Big Brother was still in San Francisco when the Jimi Hendrix Experience returned to San Francisco to play four nights at Winterland in February. John Mayall and the Bluesbreakers and bluesman Albert King were the supporting acts. On the final night, Big Brother and the Holding Company also appeared, and Joplin and Hendrix joked around together backstage in front of Marshall's cameras. The Hendrix engagement was a big deal. The New York Times covered the show, and the headline read, "The Black Elvis?"

The first night, an indifferent opening set by Hendrix was immediately followed by Albert King, who poured on the blues guitar and whipped the audience into a frenzy. When Hendrix returned, he took charge and destroyed the crowd, piercing their ears with feedback to start "Foxy Lady," bringing out Airplane bassist Jack Casady to sit in, putting on a peerless display of his mastery. He even played the new hit by Cream, "Sunshine of Your Love." "Not that we play it better than they do," he said. It was the first stop on a U.S. tour following the release of his second album, Axis: Bold as Love, and with San Francisco firmly in his pocket, Hendrix definitely ruled the rock world.

At the end of the month, Cream returned for eight shows over two weekends. With "Sunshine of Your Love" pounding out of radios everywhere, Cream brought two eight-track recorders in a remote van to capture the performances for the band's next album, Wheels of Fire. At the height of their popular acclaim, the group was already shot. The musicians were tired after months of touring, and Clapton was beginning to feel frustrated at both the personal and musical limitations of the three-man band, but the tapes caught his finest vocal performance with the group on the Robert Johnson blues "Crossroads."

(ABOVE) *John Mayall, Albert King, Jimi Hendrix, and Big Brother split the bill at Winterland, 1968;* (RIGHT) *Jimi Hendrix, 1968*

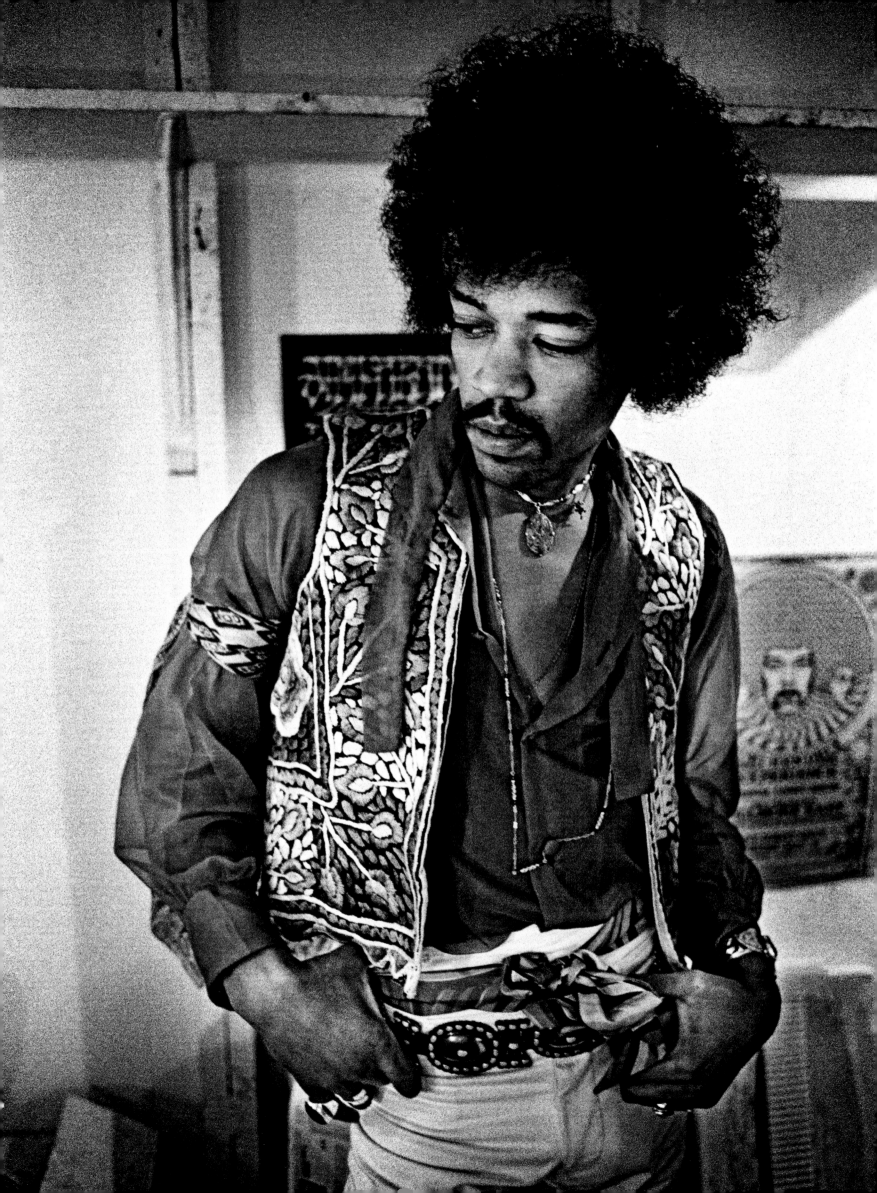

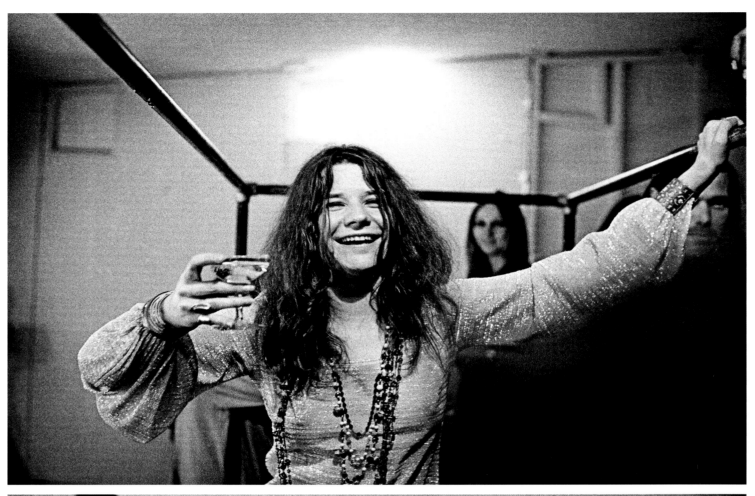

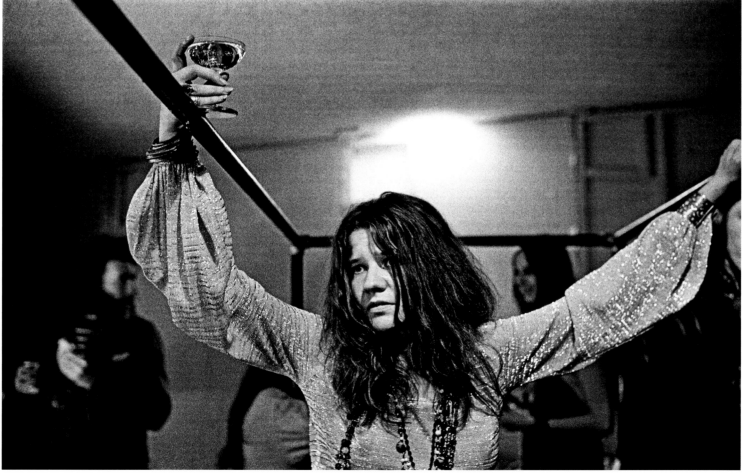

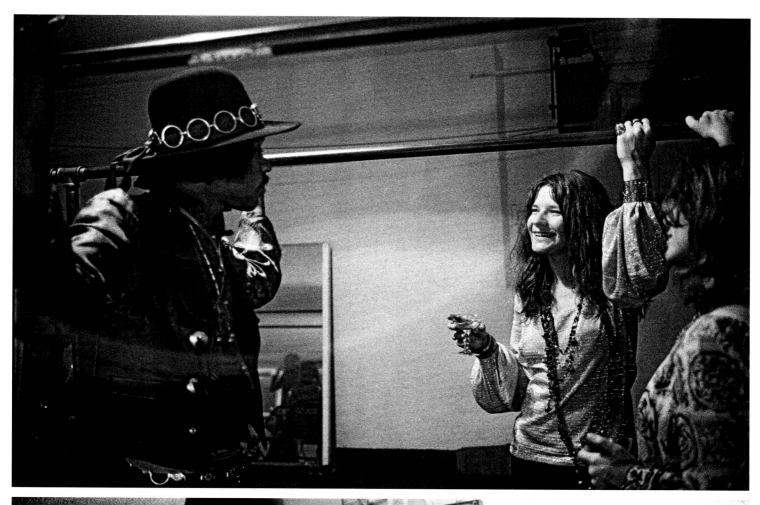

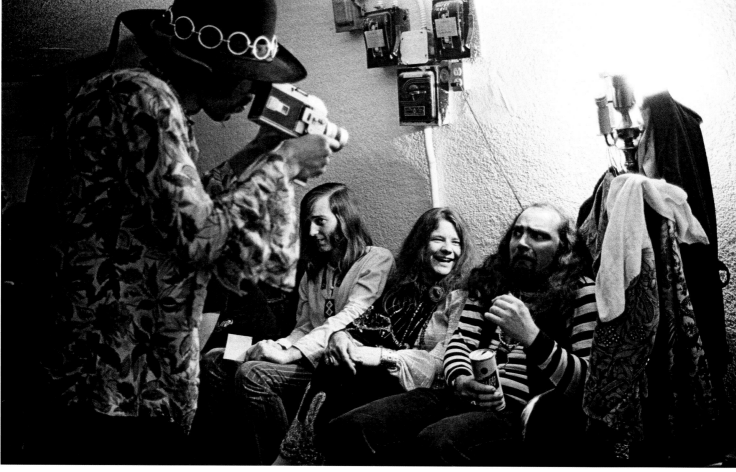

(THESE PAGES) *Jimi Hendrix and Janis Joplin, backstage at Winterland, 1968;* (FOLLOWING PAGES) *Jimi Hendrix on stage, 1968*

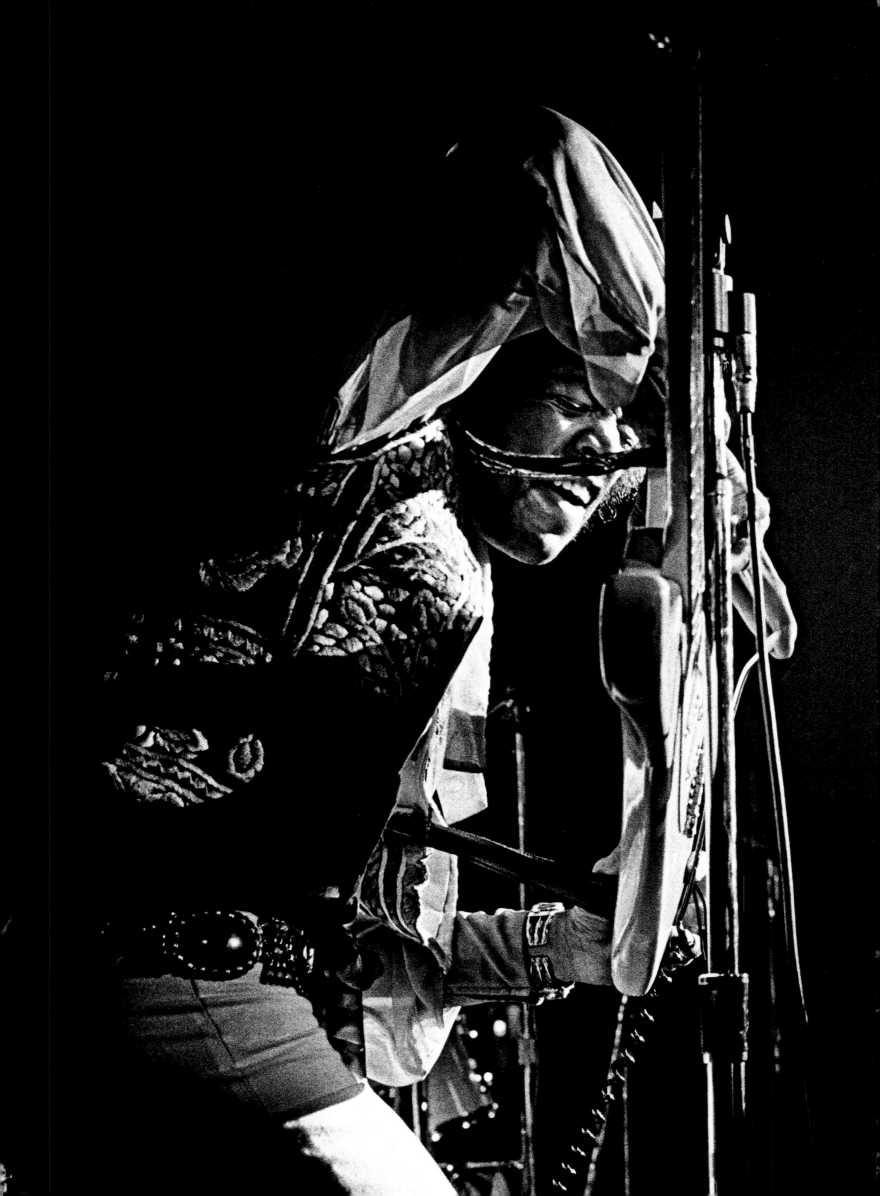

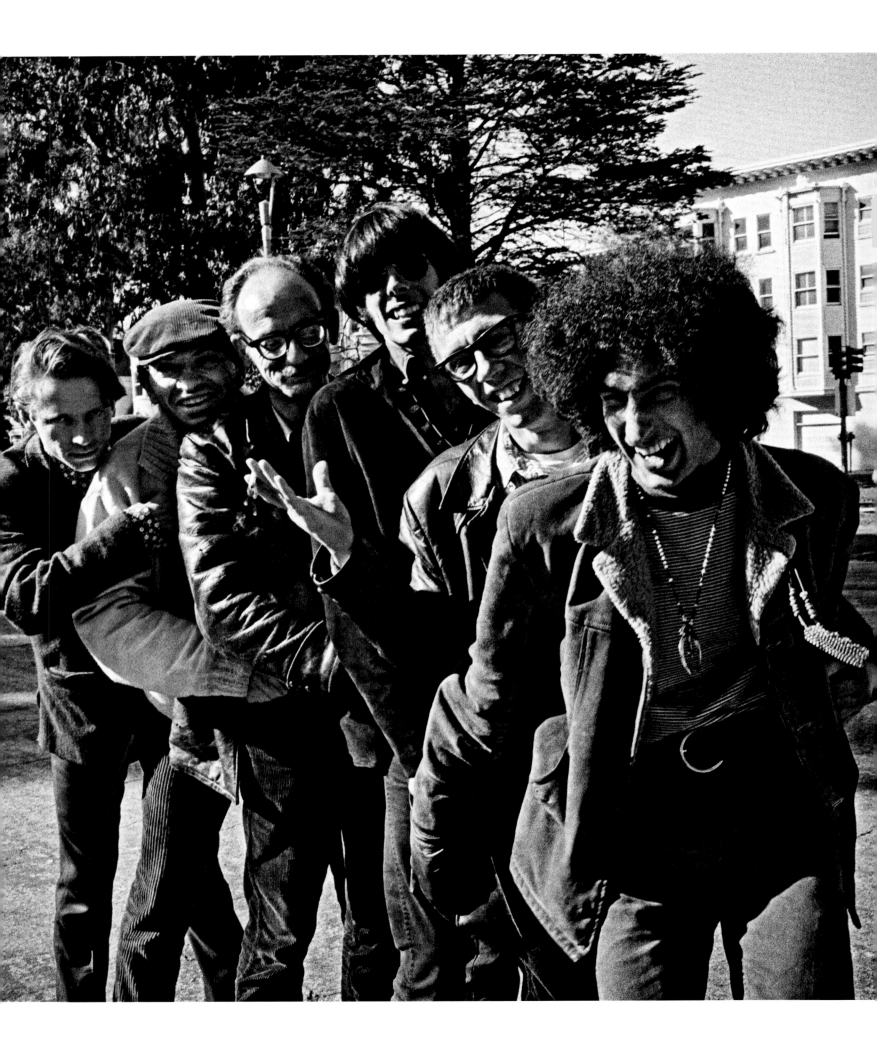

A GREAT DAY IN THE HAIGHT
ONE MORNING THAT SPRING, MARSHALL WENT TO 710 ASHBURY FREELANCING FOR *LIFE*, WHO WERE PLANNING A BIG issue on the new rock music to feature Jefferson Airplane on the cover. Assembled at the Dead's headquarters in full regalia were the members of all five original San Francisco rock bands—Jefferson Airplane, Grateful Dead, Big Brother and the Holding Company, Quicksilver Messenger Service, and the Charlatans.

They didn't know this was a valedictory moment. They were amused enough at the idea of getting their picture in *Life* magazine. They didn't think of themselves as famous people in any way. This zany circus troupe first crowded on the front stairs and took some shots. They meandered off the Dead's front porch down Ashbury to the Panhandle, where they posed for photographs like a yearbook photo for some strange after-school high school debating society. Their scene seemed impossibly blooming, unimaginable as recently as eighteen months before, when they were all still merely bands on the bills at the Fillmore and the Avalon. Marshall posed the band's managers separately and photographed them in a line, each with their hands in the other's pockets. All in good humor, of course.

In 1958, photographer Art Kane took a picture of fifty-seven jazz musicians on a brownstone stoop in New York City for *Esquire*, a photograph that came to be known as *A Great Day in Harlem*. The shot captured a disparate group of artists at the peak of their scene, the high-water mark of their entire art form. This fabled photograph has come to represent a moment in time—and a place—when jazz truly flourished. Almost fifty years later, Marshall's photograph of the five San Francisco bands in Golden Gate Park begins to take on the same patina: a wondrous place, time, and musical scene, now long gone, captured in an evanescent moment.

The Airplane had been crowned, but their reign would be short. The Dead, scarcely known outside San Francisco, were still struggling to find the band's inner voice and had yet to finish the second album. Quicksilver would commemorate the band's ballroom repertoire in a debut album that would take many months to record and, then, would immediately fall apart. Big Brother and the Holding Company were more than a year away from a number one album, *Cheap Thrills*, after which that group would almost instantly disintegrate. The Charlatans were as good as done already.

That spring day, those destinies still lay ahead. That epic photograph—San Francisco Rock, Class of '66—turned out to be a graduation picture. The combination of accomplishment and promise shows in the faces. A sense of belonging permeates the picture. Everybody knew it was special. Nobody knew it was over.

The San Francisco music scene would continue to produce some of the world's most exciting new rock bands for a number of years in a steady stream—Steve Miller Band, Blue Cheer, Sly and the Family Stone, Creedence Clearwater Revival, It's a Beautiful Day, Santana, Boz Scaggs, Tower of Power—all products of the Fillmore and Avalon. San Francisco bands never sounded alike—there never was a "San Francisco Sound"—but they shared many things in common. The San Francisco bands prized originality. Authenticity was more important than entertainment. These five bands that started by providing the soundtrack to tribal rites established that indelible template. Everything snowballed from there. The glory of Woodstock lay ahead. At the time, it seemed like it would go on forever.

(OPPOSITE) *Several of the San Francisco music scene's most influential band managers, including Bill Graham (Jefferson Airplane), Julius Karpen (Big Brother and the Holding Company), Rock Scully (The Grateful Dead), Ron Polte (Quicksilver Messenger Service), and Danny Rifkin (The Grateful Dead), 1967;* (FOLLOWING PAGES) *The five original San Francisco rock bands—Jefferson Airplane, Grateful Dead, Big Brother and the Holding Company, Quicksilver Messenger Service, and the Charlatans, 1967*

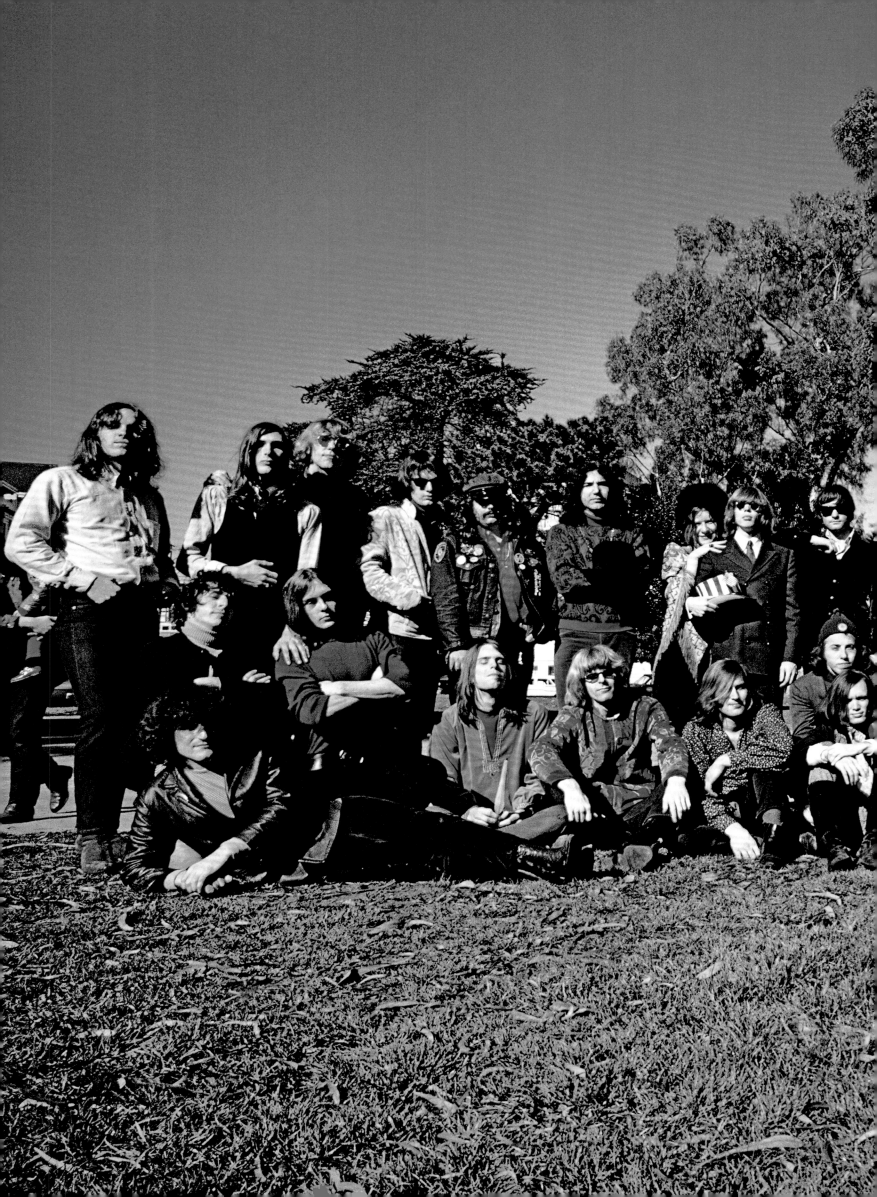

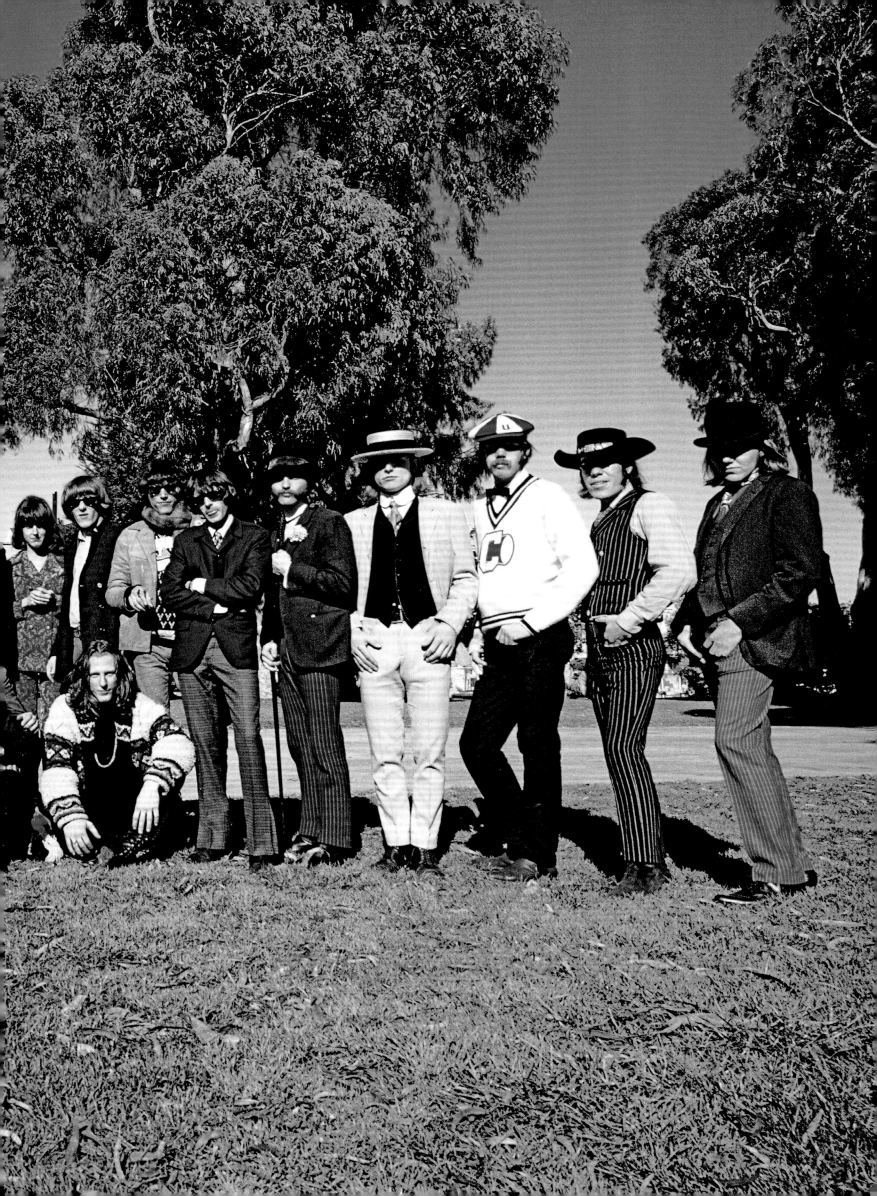

THE DEAD MOVE ON THE HAIGHT WAS FINISHED. THE DIGGERS HAD PRACTICALLY DISSOLVED. THEY HAD STOPPED GIVING AWAY FREE FOOD IN THE PANHANDLE EARLY IN THE SUMMER, AND SOME OF the key members had either left town or succumbed to heroin. After the Free Store and the Psychedelic Shop, other hip stores on the street closed. Mayor Joe Alioto had practically declared war on the neighborhood. There were violent confrontations between police and street people almost daily. In March, one riot went out of control and the Tactical Squad viciously and brutally attacked, pounding people to the ground with riot sticks and assaulting the crowd with gas. More than seventy-five people were arrested.

Mickey Hart was the first one of the Dead to leave. He found a ranch outside Novato in northern Marin County, a three-bedroom house on thirty-two acres renting for three hundred dollars a month, and the barn proved to be a perfect place for the band to rehearse. After Pigpen's girlfriend Veronica almost died from a brain aneurism, she and Pen moved to Hart's ranch for her to begin the painful process of learning to speak again. Garcia and Mountain Girl had already moved to a place in the Richmond district.

The Haight may have been crumbling, but the community spirit hadn't died. Street action was not over. When KMPX staffers walked out on strike in March, they found members of the Dead and British rock band Traffic waiting to play on a flatbed truck outside the studios. Donahue led the triumphant strikers out of the building at midnight to cheers from a huge crowd of supportive listeners outside the studio on the street. The underground radio station had become a hugely important voice in the world, creating a more widespread sense of community and spreading the word. Similar stations were starting up in every city in the country. Donahue was personally holding down nightly airshifts in two cities—San Francisco and Los Angeles—on underground FM rock stations simultaneously through the magic of tape recording. The members of Traffic had only arrived for the band's first U.S. performances that morning and had been met at the airport by Owsley, who gave them all pills to take. After midnight, they were jamming in the streets with the Grateful Dead.

But the Haight was no longer hospitable to the Dead, no longer the quiet little neighborhood whose sidewalks they could casually stroll. The band's music was getting stronger every day, but the darkening mood in the neighborhood was dispiriting to the band, which had put so much heart into the Haight. Word arrived from Mexico that Neal Cassady, one of the original Pranksters, had been found dead on railroad tracks. The band had outgrown the neighborhood. It was time to go.

In March, the city closed off Haight Street to traffic and turned the last two blocks into a cul-de-sac. The next Sunday afternoon, Dead co-manager Rock Scully walked up to the well-known beat cop called Sergeant Sunshine at the corner. "It's okay, man," Scully told him. "We're the music for the afternoon."

The cop pushed aside the police barriers, and with drill team precision, the Dead crew pulled up two flatbed trucks back-to-back across the intersection and strung electrical lines from the Straight Theater. Hell's Angels guarded the lines. The band struck up "Viola Lee Blues," the epic blues-rock showpiece with a walloping crescendo, at full volume, as the usually crowded sidewalks started to fill up even more, spilling into the streets past the closed intersections and stopping traffic. Out of nowhere people came. The Dead's music reverberated for blocks. People were pouring out of their homes in the neighborhood and heading for the street.

The Grateful Dead were saying good-bye to the Haight. One last time, the band pulled out their gear, trundled down the hill, and played for free in the San Francisco sunshine. A final commando raid from the psychedelic rangers. The music drew people out of their houses and into the street. By the third number, Haight Street was filled beyond the band's sight. Every rooftop was crowded, every window open. It was one last giant outdoor acid test.

Marshall ran from the lip of the stage to nearby rooftops, switching lenses madly, trying to capture the sprawling scene. He stood behind the drums and looked out at a sea of people, as the Dead played on. It was another glorious, sunny day in the Haight. It did not seem to anyone like the end of an era.

The Haight is dead, but not gone. The spirit of that moment reverberates to this day. In every yoga class in a strip mall, every Grateful Dead cover band, every lost and long-haired kid too stoned to remember what he is rebelling against, there is a piece of the Haight thriving and growing still. The Great San Francisco Hippie of 1966, a species now almost entirely extinct, walked the earth only a few days, but left behind a lasting legacy of vast, permeating changes in the way we live our lives. More than anything, the hippies were an idea and the idea lives on. To most, it was just a flash on the horizon. But Jim Marshall chronicled up-close and personal that brief, incandescent time. Marshall was there, and the images he brought back were the definitive visual documents of this fantastical era, a time so rare and precious that without Marshall's photographs, people might well wonder if all this ever really happened.

It did. You see its traces everywhere. The Haight lives.

(RIGHT AND FOLLOWING PAGES)
Grateful Dead play live at the Haight Street Fair on March 3, 1968.

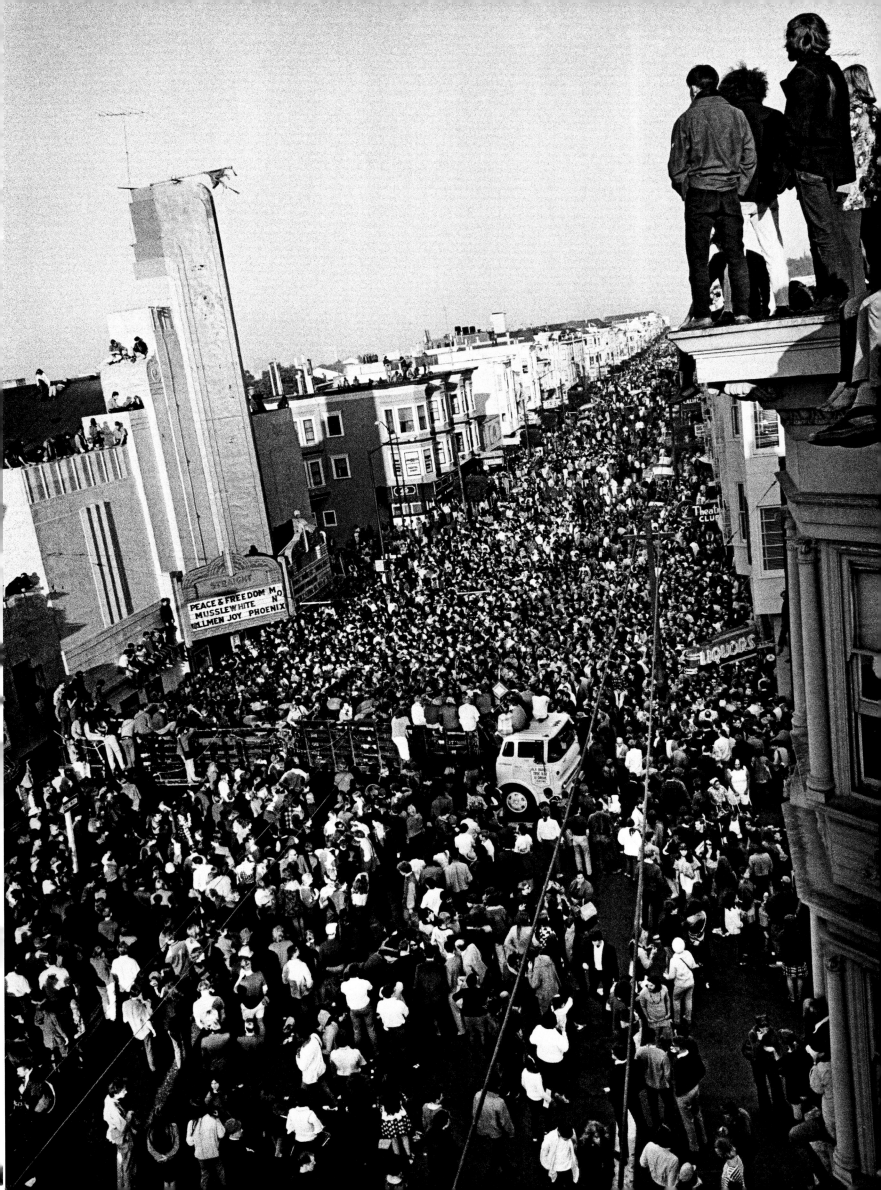

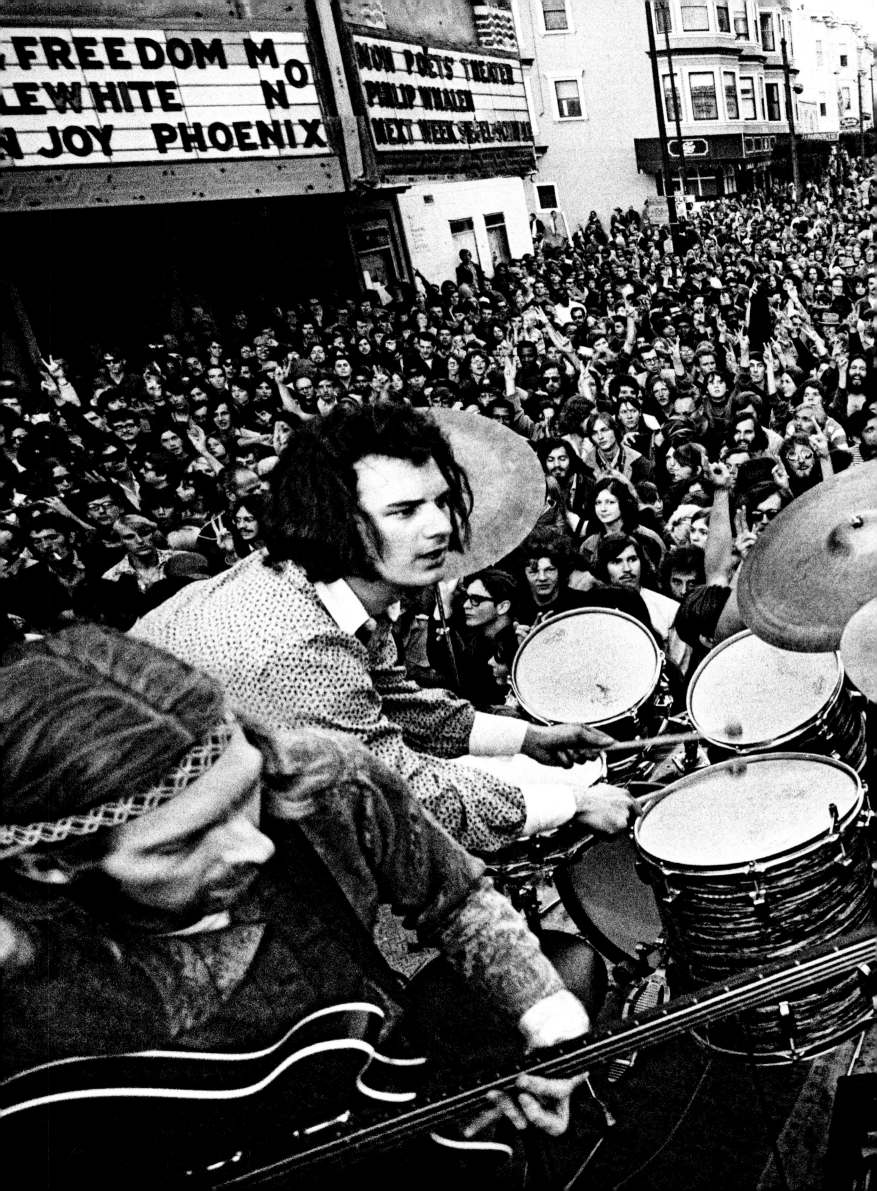

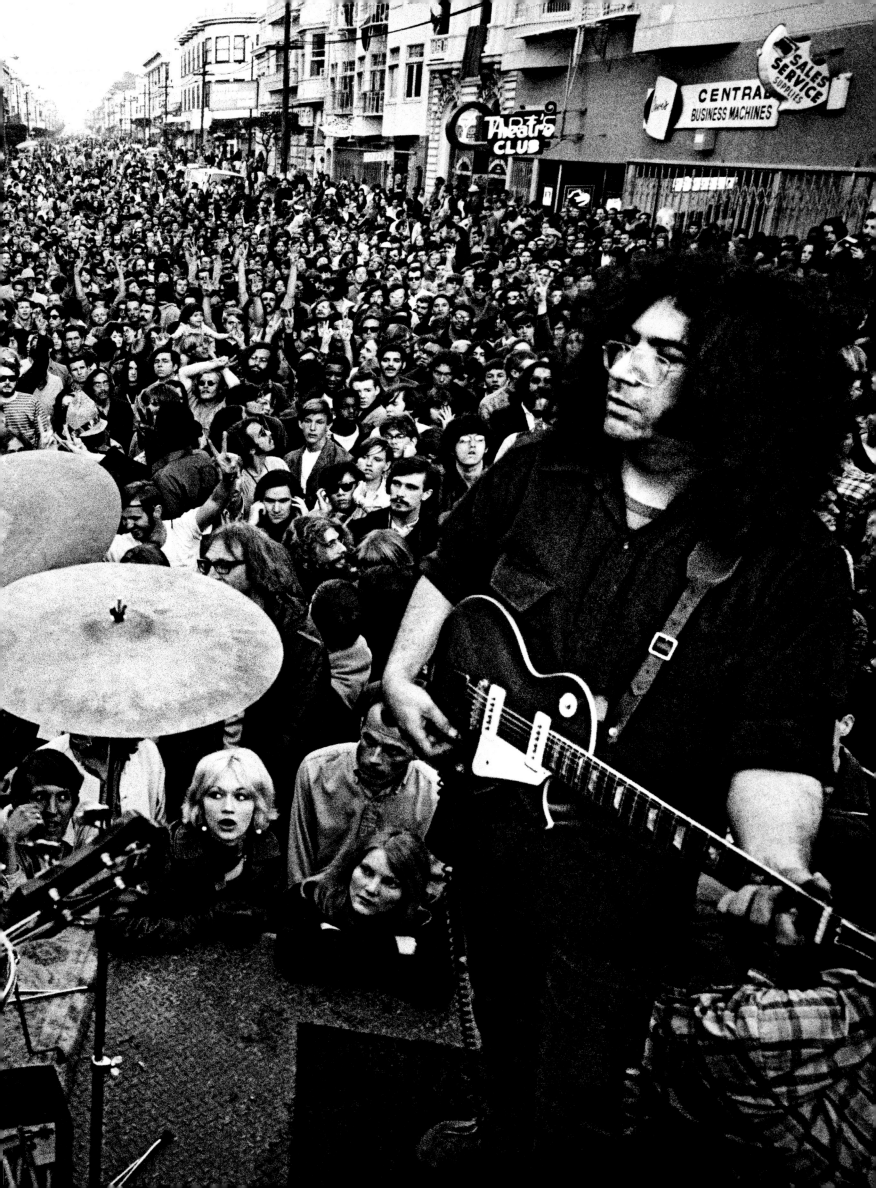

AFTERWORD
BY JOHN POPPY

JIM WAS—IS—A NATIONAL TREASURE. If all he had done was to practically invent rock 'n' roll photography with those spacious, crisply detailed concert shots from onstage and backstage, he would be an artist to remember. Of course, he reached farther. His serenely intimate portraits of musicians whose public business was wild and loud bring us face to face with human beings doing what they can with what they've been given, not so alien from you and me even when they're called Janis, Grace, Joan, Mimi, Jorma, Donovan, Bob, George, Paul, or Jerry. Jim's base was the people of the music world, but his sympathies and concerns reached beyond it to the wider world and other people he cared about.

From the day he bought his first Leica in 1959 to the night he died in 2010, he made more than a million exposures. An astonishing number of them really do expose the person and on occasion the crowd—not in the harsh sense of stripping them naked but in a gentler sense: letting us see them as they might want to see themselves.

Jim saw people at every level of America—in Appalachia and Greenwich Village and the Haight, in jazz clubs and music-filled stadiums, on the streets and in families. He devoted immense energy and determination and discernment to finding the exact right position for a shot, again and again through a momentous half century, and he got in just about everywhere. Not, however, because of his supposedly gruff and irascible presence. At times he was more like a non-presence. He had a gift for fitting in, and he never, ever, drew attention to how important he was. He operated as a photojournalist; at work, even onstage with a band, he would become almost invisible. Janis Joplin, like many others, trusted Jim and knew he had her best interests at heart. He told *Rolling Stone* in one of his last interviews, "I only wanted to make her look good."

He did. In Jim's photos she seems luminous, as if he had distilled a special light for her. He did that for everyone else, too—showed them, you might say, at their best. Look at every photograph in this book and see if you can find a mean one. You won't. Jim had camera technique to spare and an Old Master's eye for where light was coming from, but when you watched him work you understood that those were simply tools in the service of something more beautiful: his sweetness and his respect for his subjects.

(RIGHT) *GIs protesting the war in Vietnam, 1968. The march was led by active-duty soldiers in uniform in full defiance of U.S. Army orders and reflected the increased number of soldiers rebelling against the war, 1968.*

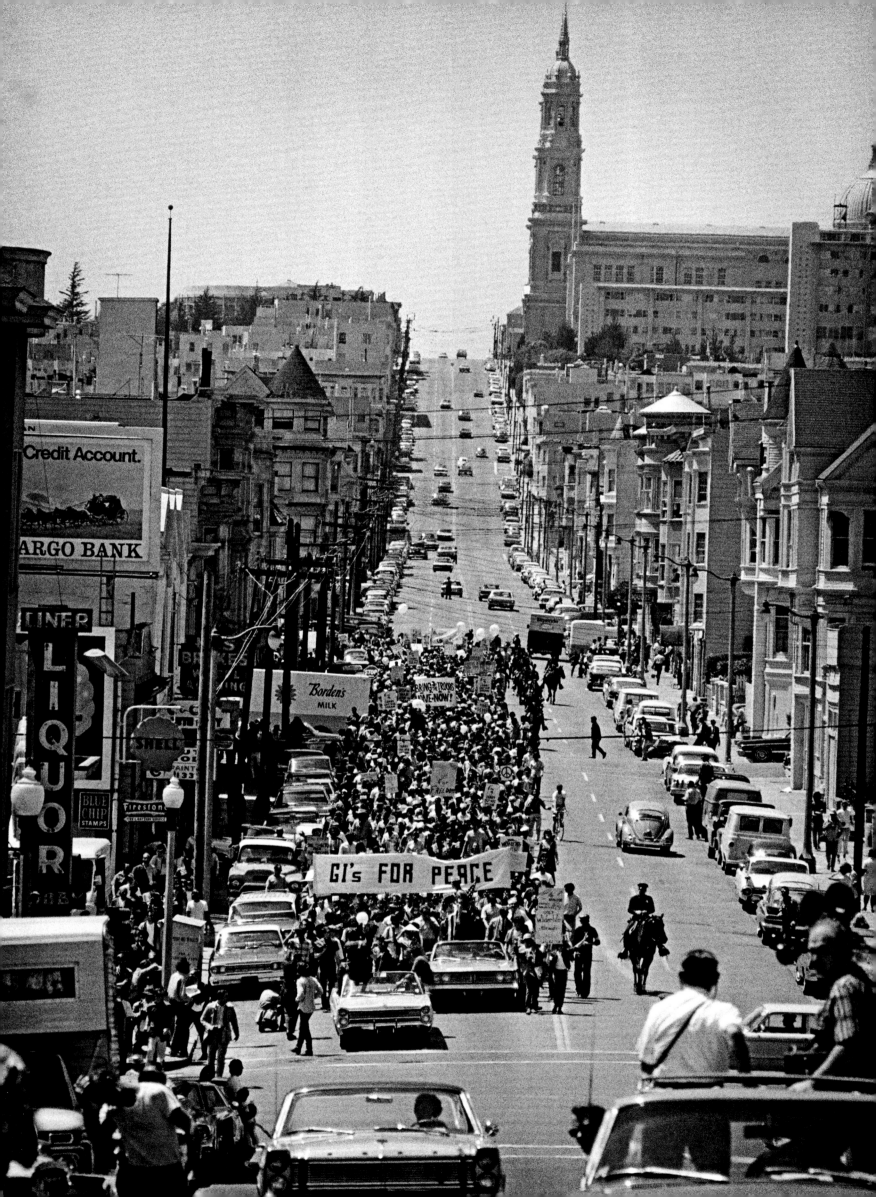

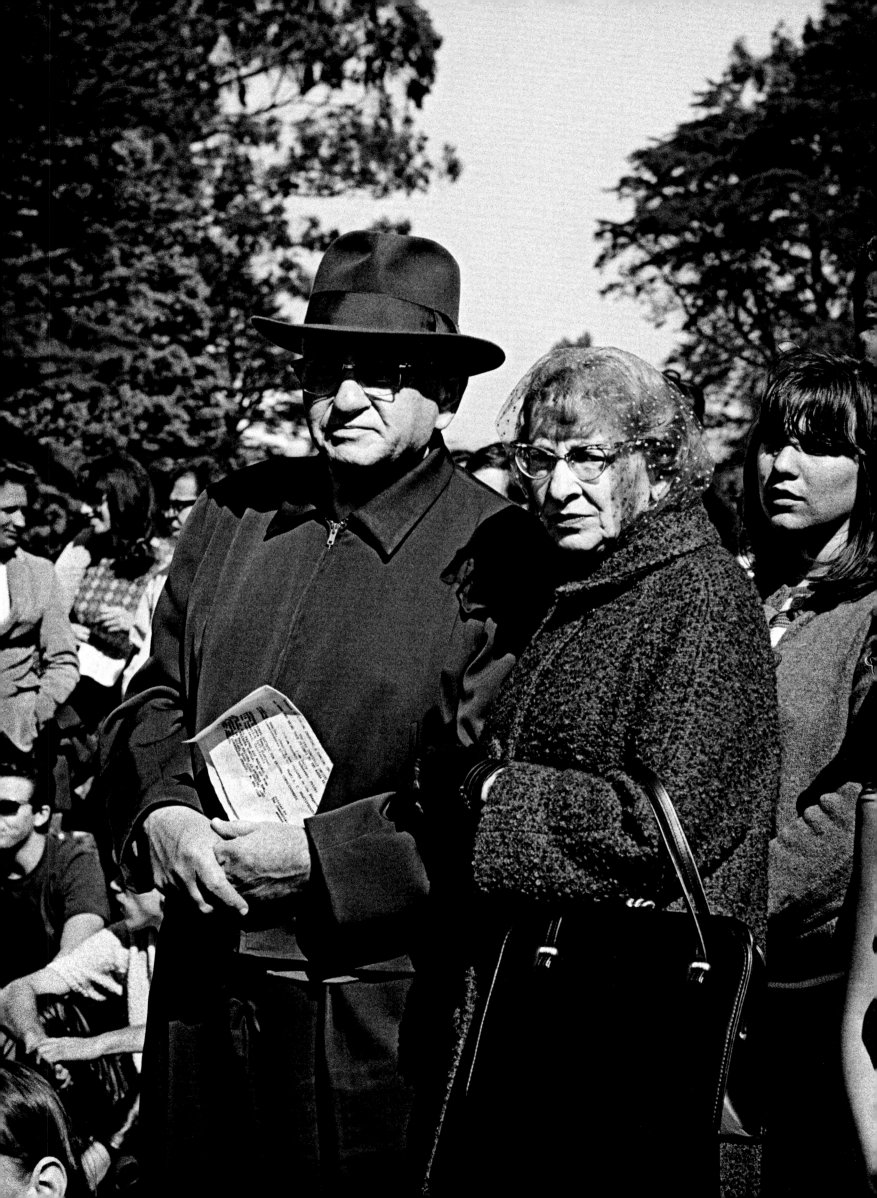

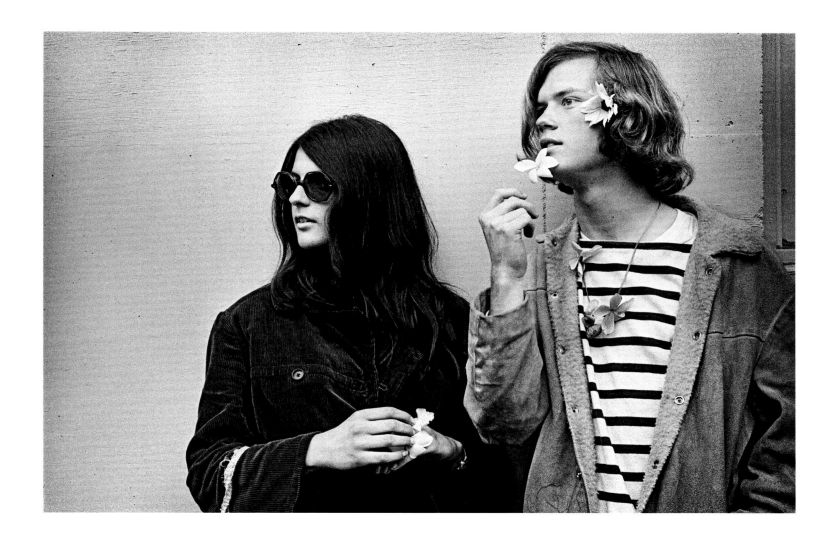

Sweet? The guy who would yell at a band for fidgeting when he'd told them to stand still? Who once hit someone with a Leica? Yes. The temper was a ripple on the surface of a deeply generous, affectionate man, the kind of man who watched out for his mother and proudly offered tastes of her fabulous cooking, especially her dolmas.

The stories Jim and I did for *Look* magazine were not about rock bands. In 1965, a few months after he moved back to San Francisco from New York, he came in with an idea for a piece about the Sigma Chi chapter at Stanford. They had invited their very first black pledge, and the fraternity's national office had suspended them. "Let's go and see who these young men are," Jim said. They were men, all right, declaring that they would have no part in segregation. (The university had done the same in 1957.) The freshman pledge at the heart of the story, Kenneth M. Washington, glowed in Jim's photographs, handsome, tall, and graceful. My remark in the text that his "cool, relaxed manner covers a tautness we see often in these days of speeding change" merely affirmed what Jim had captured in the photos. It is hard to imagine that same article being written today. It was published around the start of the high days of Haight-Ashbury in 1965, and another about a young couple beginning to address the realities of race—he was black, she was white—came as they were winding down in 1969. It was a period of change, and Jim used the same cameras and the same eye to witness it all.

By 1976, he and I felt ready to propose a book of his Haight-Ashbury photos—*The Haight*—to mark the tenth anniversary of the Summer of Love. We wanted to remind readers, I said in the outline, "of the hopes and the dread it aroused . . . It isn't often that we are given a chance to look back and identify precisely the moment at which an entire civilization began to change."

That book didn't happen; it's just as well. Now we have this far more comprehensive visit with Jim's images and people, and this chance to say thank you, Jim, for seeing who we were, and in doing so, showing us who we are and can be.

(THESE PAGES) Young and older couples in the Haight, 1967; (FOLLOWING PAGES) Graffiti at the intersection of Haight and Belvedere Streets, 1967

ACKNOWLEDGMENTS

By Amelia Davis, on behalf of the Estate of Jim Marshall:

We are grateful for Joel Selvin's continued collaboration, friendship, and contributions to Jim Marshall's legacy. Thanks for bringing Jim's photographs alive with your words. Additionally, many thanks to Jorma Kaukonen, John Poppy, and Donovan for their contributions.

Thank you to our editor, Vanessa Lopez, for her patience and true understanding of Jim Marshall's photography. It was a pleasure working with you.

Thanks to Jay Blakesberg for his support and knowledge, and special thanks to Ben Kautt for his brilliant scanning of all the photographs in this book.

Special thanks to Bob Seideman for the use of his photograph of Jim and Janis on the jacket. You captured them in their element! And to Caroline Rustigian Bruderer for coming back into the "Team Marshall" family and providing invaluable input and advice.

Thank you to Bonita Passarelli, my wife and partner in life, who kept me sane and prevented me from developing "Marshall Syndrome"— anyone who knew and loved Jim will know what I mean!

And finally, to Jim . . . we finished what you started.

INSIGHT EDITIONS

Insight Editions
PO Box 3088
San Rafael, CA 94912
www.insighteditions.com

 Find us on Facebook: www.facebook.com/InsightEditions

 Follow us on Twitter: @insighteditions

PUBLISHER: Raoul Goff
CO-PUBLISHER: Michael Madden
ACQUISITIONS: Steve Jones
EXECUTIVE EDITOR: Vanessa Lopez
ART DIRECTOR: Chrissy Kwasnik
DESIGNER: Jon Glick
PRODUCTION EDITOR: Rachel Anderson
PRODUCTION MANAGER: Jane Chinn
EDITORIAL ASSISTANTS: Allison Power, Elaine Ou

Captions for photographs appearing on pages 1–14:

(PAGE 1) *Graffiti in the Haight, 1968;* (PAGES 2-3) *A crowd at the Haight-Ashbury intersection, 1967;* (PAGE 4) *Dancer at a Grateful Dead show in the Panhandle, 1967;* (PAGES 6-7) *Jefferson Airplane in Golden Gate Park, 1967;* (PAGES 8-9) *Janis Joplin at the Palace of Fine Arts, 1968;* (PAGES 10-11) *Jimi Hendrix filming Janis Joplin in the dressing room at Winterland, 1968;* (PAGE 12) *The Grateful Dead, 1967;* (PAGE 14) *Image of a couple embracing, 1967, originally selected by Jim Marshall as a cover option for a possible book of Haight photography*

Insight Editions gratefully acknowledges Jorma Kaukonen, John Poppy, and Donovan. For more information on Donovan, please visit: http://www.donovan.ie.

Cataloging-in-Publication Data is on file at the Library of Congress.

ISBN: 978-1-60887-363-0

ROOTS of PEACE REPLANTED PAPER

Insight Editions, in association with Roots of Peace, will plant two trees for each tree used in the manufacturing of this book. Roots of Peace is an internationally renowned humanitarian organization dedicated to eradicating land mines worldwide and converting war-torn lands into productive farms and wildlife habitats. Roots of Peace will plant two million fruit and nut trees in Afghanistan and provide farmers there with the skills and support necessary for sustainable land use.

Manufactured in China by Insight Editions

10 9 8 7 6 5 4 3 2

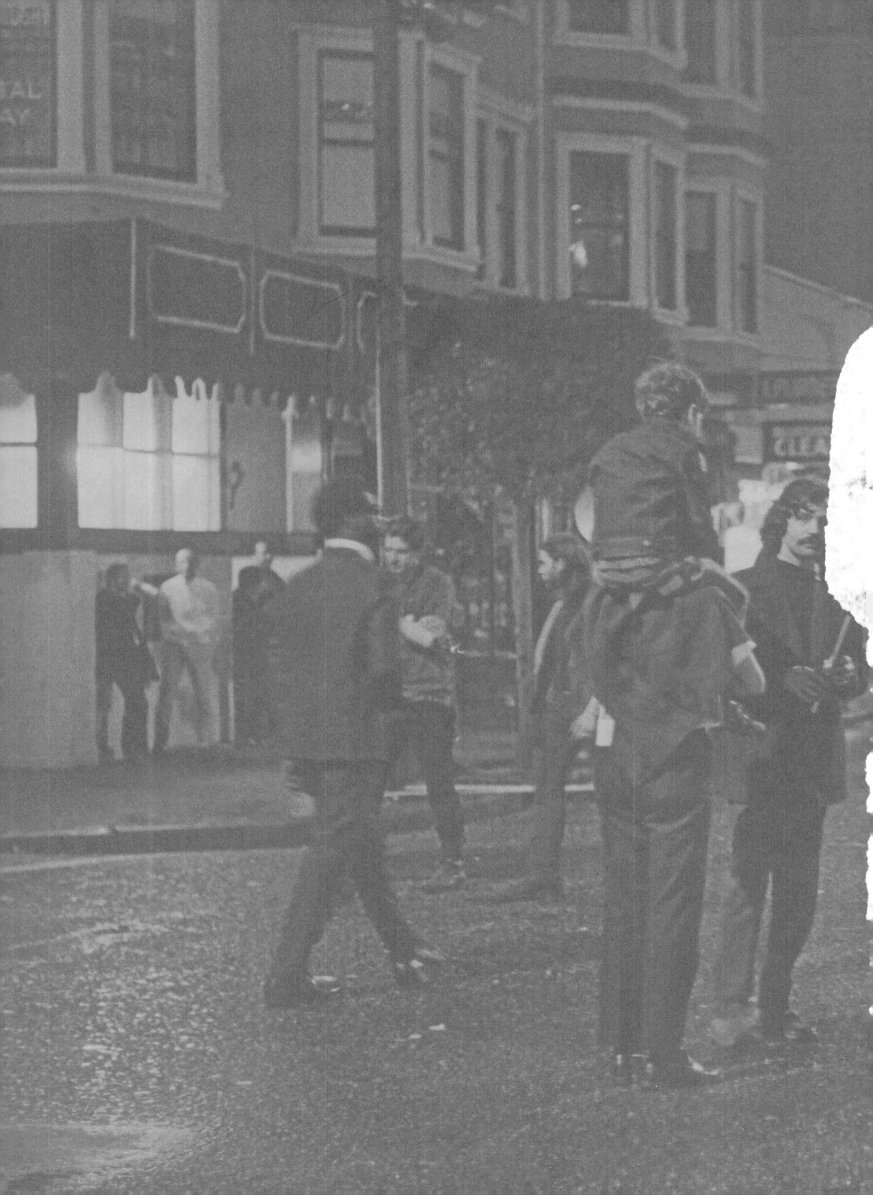